The Trouble with Space
in Painting

Aesthetics and Contemporary Art

Series Editors: Tiziana Andina and David Carrier

Philosophers and cultural historians typically discuss works of art in abstract terms. But the true significance of art for philosophy, and philosophy for art, can only be established through close analysis of specific examples. Art is increasingly being used to introduce and discuss problems in philosophy. And many works of art raise important philosophical issues of their own. But the resources available have been limited. *Aesthetics and Contemporary Art*, the first series of its kind, will provide a productive context for that indispensable enterprise.

The series promotes philosophy as a framework for understanding the study of contemporary arts and artists, showcasing researches that exemplifies cutting-edge and socially engaged scholarship, bridging theory and practice, academic rigor and insight of the contemporary world.

Editorial Board: Alessandro Arbo (University of Strasbourg, Fr.), Carla Bagnoli (University of Modena and Reggio), Leeza Chebotarev (Private Art Advisor), Paolo D'Angelo (University of Roma Tre), Noël Carroll (CUNY), Diarmuid Costello (University of Warwick), Maurizio Ferraris (University of Turin), Cynthia Freeland (University of Houston), Peter Lamarque (University of York), Jonathan Gilmore (CUNY), Luca Illetterati (University of Padova), Gao Jianping (Chinese Academy of Social Sciences), Birte Kleemann (Michael Werner Gallery), Joachim Pissarro (CUNY), Sara Protasi (University of Puget Sound), Shen-yi Liao (University of Puget Sound), Ken-Ichi Sasaki (Nihon University), Elisabeth Schellekens (University of Uppsala), Vincenzo Trione (IULM, International University of Language and Comunication, Milano).

Titles in the Series:
A Philosophy of Visual Metaphor in Contemporary Art, by Mark Staff Brandl
Aesthetics, Philosophy and Martin Creed, edited by Elisabeth Schellekens and Davide Dal Sasso
Aesthetic Theory, Abstract Art, and Lawrence Carroll, by David Carrier
Contemporary Chinese Art, Aesthetic Modernity and Zhang Peili, by Paul Gladston

Faith in Art, by Joseph Masheck
Gaga Aesthetics, by Adam Geczy and Vicki Karaminas
Philosophical Skepticism as the Subject of Art, by David Carrier
The Changing Boundaries and Nature of the Modern Art World,
by Richard Kalina
The Philosophy and Art of Wang Guangyi, edited by Tiziana Andina and
Erica Onnis
The Phenomenology of Paint, by Adam Geczy
The Turn to Provisionality in Contemporary Art, by Raphael Rubinstein
Visual Metaphor and Contemporary Art, by Mark Stall Brandl

The Trouble with Space in Painting

A Critical History

James Hyde

BLOOMSBURY ACADEMIC
LONDON · NEW YORK · OXFORD · NEW DELHI · SYDNEY

BLOOMSBURY ACADEMIC
Bloomsbury Publishing Plc, 50 Bedford Square, London, WC1B 3DP, UK
Bloomsbury Publishing Inc, 1359 Broadway, New York, NY 10018, USA
Bloomsbury Publishing Ireland, 29 Earlsfort Terrace, Dublin 2, D02 AY28, Ireland

BLOOMSBURY, BLOOMSBURY ACADEMIC and the Diana logo are trademarks of Bloomsbury Publishing Plc

First published in Great Britain 2026

Copyright © James Hyde, 2026

Adam Geczy has asserted his right under the Copyright, Designs and Patents Act, 1988, to be identified as Author of this work.

For legal purposes the Acknowledgements on p. xviii constitute an extension of this copyright page.

Series design by Irene Martinez Costa
Cover image: Giovanni di Paolo, Saint John the Baptist Entering the Wilderness 1455–1460, Tempera on wood panel. Art Institute of Chicago, USA, Alamy Stock Photo.

All rights reserved. No part of this publication may be: i) reproduced or transmitted in any form, electronic or mechanical, including photocopying, recording or by means of any information storage or retrieval system without prior permission in writing from the publishers; or ii) used or reproduced in any way for the training, development or operation of artificial intelligence (AI) technologies, including generative AI technologies. The rights holders expressly reserve this publication from the text and data mining exception as per Article 4(3) of the Digital Single Market Directive (EU) 2019/790.

Bloomsbury Publishing Plc does not have any control over, or responsibility for, any third-party websites referred to or in this book. All internet addresses given in this book were correct at the time of going to press. The author and publisher regret any inconvenience caused if addresses have changed or sites have ceased to exist, but can accept no responsibility for any such changes.

A catalogue record for this book is available from the British Library.

A catalog record for this book is available from the Library of Congress.

ISBN: HB: 978-1-35025-366-7
 PB: 978-1-35025-370-4
 ePDF: 978-1-35025-367-4
 eBook: 978-1-35025-368-1

Typeset by RefineCatch Limited, Bungay, Suffolk

For product safety related questions contact productsafety@bloomsbury.com.

To find out more about our authors and books visit www.bloomsbury.com and sign up for our newsletters.

To three of my family members, of different generations: my partner, Liz Koch, a profound book lover, my mother, Susan Hyde, an inspirational enthusiast, and my great-aunt Virginia Egbert, an author, a Princeton art historian and a cultivator of curiosity in children.

Contents

List of Illustrations	xi
Preface	xv
Acknowledgements	xviii
Introduction	1

Part One A History of Art without *Space*: The Thirteenth Century

1	Narratives for the Thirteenth Century	7
2	The Saint of Spectacle	17
3	Christian Pictures and San Francesco	25
4	Painting from San Francesco to the *Navicella*	43

Part Two A History of Art without *Space*: Alberti and Leonardo's Construction of Perspective

5	The Classical Model of Vitruvius	61
6	*De pictura* and Early Perspective	67
7	The Prolific Imagination of Leonardo	79

Part Three *Space* in Philosophy, Religion and Science

8	The Place of Aristotle	91
9	The Decentering of Place	103
10	The Becoming of *Space*	119
11	*Space* Assumes Its Modern Form: Locke, Newton, Leibniz and Kant	139

Part Four The Emergence of Pictorial *Space*

12	Painting: Studies and Dialogue	161
13	The German Founding of Art History	171

Part Five The Space Age

14 Calculating Cubism and *Space* — 193

15 The Modernist Institution of *Space* — 225

16 *Space*: The Creative Phase — 237

17 Painting Extends to 'Real Space' — 245

18 The Last Hurrah of *Space* — 263

Afterword — 281
Bibliography — 287
Index — 299

Illustrations

Figures

1. Nicola Pisano, Presentation of the Christ Child in the Temple, pulpit relief, Pisa Baptistery, 1260. 9
2. Giunta Pisano, Crucifix, tempera on wood panel, Basilica of Saint Dominic, Bologna, 1250–54. 12
3. St Francis, wall painting, Subiaco Abbey, c. 1228. 48
4. The *Navicella* in its original location, engraving, 1673. 56
5. Cesare Cesariano, Diagram of Vitruvius' Human Proportions, illustration in *De architectura* by Vitruvius, 1521. 65
6. Diagram of Alberti's window paradigm. 69
7. Diagram of vision rays apprehending a surface. 72
8. After Michael Baxandall, 'Alberti and the Humanists: Composition', *Giotto and the Orators*. 73
9. Diagram of *De pictura*. 76
10. Leonardo da Vinci, diagram of vision and the occlusion of background, *Traité de la peinture*, 1651. 81
11. Konrad Miller, a modern facsimile of the *Tabula Peutingeriana*, 1887/1888. 95
12. Petrus Apianus, illustration from *Cosmographicus liber*, 1524. 96
13. Giovanni di Paolo, St Thomas Aquinas Confounding Averroës, tempera on wood panel, c. 1445–50. 108
14. Nicolaus Copernicus, illustration from *De revolutionibus orbium coelestium*, 1542. 116
15. Antonio Allegri da Correggio, Vision of St John on Patmos, Dome of San Giovanni Evangelista, fresco, Parma, 1520–1. 124
16. Woodcut of Giordano Bruno's drawings, 1588. 125
17. Illustration from Kepler's *Mysterium Cosmographicum*, 1597. 129
18. Diagram of the trajectory of Mars, Kepler, *Astronomia nova*, 1609. 131
19. Woodcut with Urania, Muse of astronomy, Kepler, *Astronomia nova*, 1609. 131

20	Plenum vortices, engraving from Descartes' *Principiorum Philosophie*, 1644.	134
21	Perceptible Measurements of Perceptible Velocities, Sir Isaac Newton, 1736.	150
22	THE PRINCIPLES OF PAINTING, title page of Roger de Piles, *The Principles of Painting*, 1743.	163
23	William Hogarth, *Enthusiasm Delineatd*, engraving, c. 1761.	165
24	Piero di Puccio, Image of the World, fresco, Camposanto, Pisa, 1389–91.	175
25	Adolf von Hildebrand, *Philoctetes*, marble, 1886.	184
26	Explanation of the Tesseract Using Color Cubes, Charles Howard Hinton, *The Fourth Dimension*, 1912.	202
27	Diagram from Esprit Jouffret's *Traité élémentaire de géométrie*, 1903.	211
28	Georges Braque, *La Mandore*, oil on canvas, 1909–10.	211
29	Georges Braque, *Maisons à L'Estaque*, oil on canvas, 1907.	213
30	Pablo Picasso, *Femme nue*, oil on canvas, 1907.	213
31	Diagram of Four Dimensional Objects from Esprit Jouffret's *Traité élémentaire de géométrie*, 1903.	215
32	Georges Braque, *Fox*, drypoint, 1911.	216
33	Pablo Picasso *Nature morte a la bouteille de marc*, drypoint, 1911.	216
34	Umberto Boccioni, *Spiral Expansion of Muscles in Action*, plaster, c. 1914.	221
35	Photograph of Raymond Duchamp-Villon's plaster model *La Maison Cubiste*, c. 1913.	229
36	From Le Corbusier's *Vers une architecture*, 1923.	231
37	Constantin Brancusi, View of the Studio with *Bird in Space*, gelatin silver print, 1923.	240
38	László Moholy-Nagy, *A II*, oil and graphite on canvas, 1924.	242
39	Josef Albers, *Twisted but Straight*, machined engraving on black laminated plastic, 1948.	243
40	Lucio Fontana, *Ceramica Spaziale*, ceramic, 1949.	247
41	Lucio Fontana, Milan, Italy, April 1955. Photo by Giorgio Lotti / Archivio Giorgio Lotti / Mondadori via Getty Images.	249
42	Preparatory photographs by Shunk-Kender for Yves Klein's *Saut dans le vide*, 1960, Roy Lichtenstein Foundation	253
43	*Le Dimanche, 27 Novembre 1960: Le journal d'un seul jour*.	253
44	Yves Klein buried under *Ci-gît lEspace*, photo: Harry Shunk, 1962.	253
45	Frank Stella, *Raft of Medusa, Part I*, steel and aluminium, 1990.	274

Plates

1. Arnolfo di Cambio, Detail of Tomb Monument for Cardinal de Braye, San Domenico, Orvieto, c. 1282.
2. San Damiano Cross, tempera, on wood panel, Basilica Santa Chiara, Assisi, twelfth century.
3. Giotto, Legend of St Francis: Panel 4. Miracle of the Crucifix, fresco, Basilica San Francesco, Assisi, 1297–9.
4. Cimabue, Christ and Madonna Enthroned, fresco *secco*, east wall of the nave, Upper Church, San Francesco, Assisi, 1277–80.
5. Cimabue, The Madonna and Child (Maestà), fresco *secco*, Lower Basilica San Francesco, Assisi, c. 1280.
6. *Tradio Legis*, Christ giving the Law to St Paul as St Peter awaits the keys to the church, mosaic, Santa Costanza, Rome, fourth century.
7. North wall of the nave, mosaic, Basilica of Sant'Apollinare Nuovo, Ravenna, sixth century.
8. View of the nave facing the apse, Basilica of Sant'Apollinare Nuovo, Ravenna, sixth century. The apse is a twentieth-century reconstruction of a Baroque renovation.
9. The Hospitality of Abraham, *istoria* mosaic, Santa Maria Maggiore, Rome, 432–40.
10. Apse depiction of Christ Pantocrator, mosaic, Monreale, Palermo, late twelfth century.
11. Section of the north nave mosaic, Monreale, Palermo, mosiac, late twelfth century.
12. Detail of the north nave Isaac story, mosiac, Monreale, Palermo, late twelfth century.
13. The Isaac Story, fresco, Plate 3, Basilica San Francesco, Assisi, c. 1280–95.
14. The Isaac Story, fresco, Plate 4, Basilica San Francesco, Assisi, c. 1280–95.
15. Attributed to Coppo di Marcovaldo, St Francis and Scenes from his Life, tempera on wood panel, Santa Croce, Florence, c. 1225–76.
16. Full-size copy of the central portion of the *Navicella*, oil on canvas, Vatican, Rome, 1628.
17. Nicholas Poussin, The Israelites Gathering Manna in the Desert, oil on canvas, 1637–9.
18. Romanian illuminator, Gautier de Metz, *Image of the World*, c. 1301–1400.

19 Master of Fauvel, illuminator, Gautier de Metz, *Image of the World*, *c.* 1320–5.
20 Giotto, details of the upper left and right of the exit wall of the Scrovegni Chapel depicting the Last Judgment, fresco, Padua, 1305.
21 Giovanni di Paolo, predella scene from the Guelfi Altarpiece (The Cosmos and the Expulsion from the Paradise), tempera on wood panel, *c.* 1445.
22 Giovanni di Paolo, predella scene from the Guelfi Altarpiece (Paradise), tempera on wood panel, 18.5 × 16 in, *c.* 1445.
23 Giusto de' Menabuoi, Padua Baptistry's frescoed dome, *c.* 1378. Note below the feet of the Virgin is the Creation.
24 Giusto de' Menabuoi, detail Padua Baptistry's frescoed dome, *c.* 1378.
25 Metropolitan Museum of Art's reconstruction of Giovanni di Paolo's Guelfi Altarpiece.
26 Giovanni di Paolo, St Thomas Aquinas, detail of the Guelfi Altarpiece, tempera on wood panel, 1445.
27 Anonymous, the frontispiece of *Bible Moralisee, c.* 1220–30.
28 Antonio Correggio, The Assumption of the Virgin, frescoed cupola, Duomo di Parma, 1526–30.
29 Antonio Correggio, detail of the St Bernard lunette, The Assumption of the Virgin, frescoed cupola, Duomo di Parma, 1526–30.
30 Thoughtform of the Music of Gounod, according to Annie Besant and C. W. Leadbeater in *Thought-Forms*, 1901.
31 Hilma af Klint, *The Ten Largest, No. 3, Youth*, tempera on paper, 1907.
32 Frank Stella, *Lomb*, paper collage, 1994.

Preface

Evaluating Pictorial *Space* Critically and Historically – A Painter's View

This is an unlikely book. I am a painter who never aspired to write more than an essay, let alone a text of this length. Yet after decades of teaching in art schools, I became increasingly conscious of the emptiness of discussions around *spatial* terms like 'deep space', 'shallow space' and 'negative space'. Some years ago, I arrived late to a class critique where 'convincing space' was being used as a measure of the students' paintings. It struck me as incoherent, so I asked, 'I don't know what you mean by space.' As a playful provocation, I added 'I don't believe in *space* – please use another term.' The group looked surprised, but indulged me. The transformation was remarkable – without the jargon, the discussion tightened, and the painters articulated their thoughts and values more clearly.

With this exchange, I began to wonder what exactly was 'pictorial space' – did this term have a history that informed what it had become in art schools? While there are countless books that apply *space* to painting and architecture, I could not find a critical history of the concept itself. Since it seemed no one else was eager to take it on, it seemed a necessary subject to research and perhaps, write about.

While innumerable books use 'pictorial space' as an explanatory device, as far as I know, this is the first critical and evaluative history of the concept. This approach may be controversial, as it goes against the grain of much of twentieth-century art history. I challenge Erwin Panofsky's explanation of perspective as the means of showing pictorial *space*. I criticize his *spatial* 'window paradigm' as not reflecting what Alberti actually wrote. However, having read Panofsky in my teens, his fundamental insight that artworks reflect and shape their culture had a lasting impact on my interest and faith both in painting and the history of art. This conviction is at the root of the project. I do not consider this book a revisionist history of art, but rather an attempt to peel off what should be recognized as twentieth-century *spatial* discourse from the consideration of works of art where it is anachronistic.

Artists are often suspicious that words are mere gloss to the reality of art works and their making. However, I believe words matter – more precisely, as

examples of material culture – texts open onto the author, time and place of its writing. I try to take historical figures at their word. Looking into what writers and artists said about artworks – or did not say – is most relevant to this project.

As an avid museum-goer for decades, I appreciate that returning to familiar works can yield new insights. This is key to my process – I regard historical texts, as I do paintings, with a critical and affectionate eye. If my interpretations are of interest, it is because of the discipline of looking – a practice honed in the museum and the studio. One might argue that, as a painter, these are observations from – so to speak – the horse's mouth. However, artists often treat artworks outside their time and place as contemporaneous. Although this projection of familiarity can be inspiring and productive for making artworks, in writing this book I break with this approach. There is little in this book that explains my individual painting cosmology other than the conviction that the history of art is essential to my painting. In writing this text I take a view, well expressed by Svetlana Alpers, we best look to historic works not to see ourselves but to see difference and through distance, better see ourselves.

My engagement with both texts and artworks has been guided by a process of discovery. Although the project began as a critique, I advocate for looking at the visual arts in itself and for itself. As a history, this requires close attention to the context in which works were made. However, I regard artworks as objects containing life and strive to let them breathe, even as I analyse them. I refuse to treat artworks merely as symptoms of culture. As much as this book is a critique of the idea of pictorial *space*, the goal is to provide specifics to show that by removing unexamined *spatial* discourse, artworks from early Christian mosaics to Frank Stella's late paintings can be seen afresh.

Having talked with several people about this book, what stands out as most controversial is not my methods or that I am an interloper in scholarly territory, but the premise that makes this book possible. It is the same request I made of my students years ago: to suspend belief in *space*. Having been born into the 'space age' myself, I understand how difficult that is. Yet my research made it apparent that to make sense of how pictorial *space* came to be, *space* itself needs to be seen from a historical perspective.

Space can be understood as empirical, however what that means is that our experiences of sight, movement and measurement are organized under the umbrella of *space*. For *space* to be empirical, the concept of *space* must already be constructed. This is not to deny that *space* is empirical – it is if you believe in the idea of *space* and that it is a good cover for organizing experiences.

Readers may be intrigued by some of the discussions about artworks and their contexts, but if they are unwilling to suspend the belief in *space*, this book will only frustrate. While in medieval times only God was the existential absolute, I recognize that for many of us who study painting, sculpture and architecture, questioning the absolute existence of *space* may be apostasy.

So I begin with a demand for my readers – for my history of pictorial *space* to be grasped, *spatial agnosticism* is required.

Acknowledgements

Although this book was written independently of an academic institution, it could not have been written without the enduring institutions of love and friendship. Throughout the process, I was fortunate to rely on a range of formidable talents and generous minds – those who challenged, corrected and sustained me.

My wife, Liz Koch, read every word in the manuscript (at least twice). To the extent that the sentences and paragraphs are clear and cogent, Liz deserves credit. She was indefatigable in her commitment to making this book the best it could be.

As daunting as this project was, Svetlana Alpers graciously read and critiqued each chapter, step by step. To hold the interest of one of the foremost art historians in the discipline was both a gift and a responsibility. Svetlana's encouragement made giving up impossible – continuing the work became the only option.

Josiah McElheny and I began discussing many of the book's basic ideas over beers in bars, long before I imagined writing them down. Josiah never let me doubt the importance of articulating my thoughts – however controversial – in text.

In a different and equally crucial way, I owe an debt to the poet and professor David Kaufmann. In making an early edit, David cut away over a third of the text, sharpening up its focus and providing a model for purposeful writing.

I was also fortunate to rely on friends whose expertise exceeded mine in the fields my research led me to. I thank Tom Huhn for his clarity on Kant's philosophy; Charles (Mark) Haxthausen for his guidance on late-nineteenth-century art history; Charles Stuckey for his encyclopedic knowledge of nineteenth- and twentieth-century European painting; Evelyn Lincoln for her insights into Sienese painting; and Klaus Ottmann for his understanding of Yves Klein. Michael Lüthy was especially helpful with his challenges to my basic premises, and then pointing me to fruitful directions in my research. While I am deeply grateful for their intelligence and generosity, any overreach or error in interpretation remains my own.

My good friends Keith Wilson, Alexi Worth, Barney Kulok, Shirley Kaneda, Joe Fyfe, Anne Delaporte, Stephen Dean, David Dixon, Andrew Mummery,

Christopher Lew, Richard Woods and Merlin James each brought practical, critical and imaginative dimensions to this project. I relied on their patience, insight and good humor.

This book grew from an essay published in *The Brooklyn Rail* in 2017. I thank Phong Bui for his commitment to publishing this painter's musings, and Charles Schulz for ushering the essay into print. I applaud them both for their belief that artists can – and should – step outside their lanes to contribute meaningful cultural texts.

David Carrier is directly responsible for the existence of this book. Although he had known me as a painter since the 1980s, it was David who first saw that the ideas in the *Brooklyn Rail* essay could be developed into a full-length book. I don't know how he came to it, but David's belief that this book could be written allowed it to be written.

Finally, I thank my assistants, Jonathan Sanchez Noa and Nathan Hauenstein, as well as my editor at Bloomsbury, Colleen Coalter, for sticking by me.

Introduction

A critical history of the concept of pictorial *space* is a novel subject and presents challenges in determining the book's premises, methods and structure.

When researching the term, it became clear that discussions of 'space' were absent from early texts on art, only to enter into discussions about art in the middle to late nineteenth century. However, pictorial *space* is dependent on an idea of *space* that had its first intimations in medieval Europe. So, while the subject of this book is narrow, its chronological arc begins with Aristotle and goes forward to Kant and Poincaré. In the early twentieth century, *space* became a real concern for artists initiating a brief creative phase that ended mid-century with *space* losing its historical content to become the discursive habit of today. As *space* is itself a European cultural construction, *space* is italicized throughout.

In the twentieth century, pictorial *space* became a go-to term to describe artworks, particularly in traditional art historical descriptions of art beginning in thirteenth-century Italy, despite there being no evidence that *space* had relevance at that time. This provides a fertile question that the first two sections address: can a history of the pictorial transformations of Giotto in the thirteenth century and the development of linear perspective in the fifteenth century be told without recourse to 'pictorial space'?

While it is clear that *space* does not appear in early texts about painting, sculpture and architecture, it cannot be *absolutely* proven that, despite their silence, artists and writers of the time were not 'thinking' about *space*. To address this, in these opening sections, I provide a framework of ideas that were of the time and could plausibly inform the artworks. It is key to my methodology that, as much as possible, sources are taken at their word. I primarily follow what is recorded in original texts rather than later art historical interpretations.

Part One opens with an inquiry into how best to discuss the transformation of Western painting ushered in by Giotto's works. I propose four art historical tropes: (1) Naturalism, (2) Classical Revival, (3) Genius and (4) Cultural, Social and Practical Forces. If these tropes were not exactly conceived in a modern

sense, they are, in some form, evident within the emerging painting culture of the time. As such, what follows is a history of art without *space*. However, the goal is not merely polemic, I explore the nature of the paintings and the forces that shaped them, rather than emphasizing applicability of the four explanatory considerations I identify.

Relatedly, Part Two addresses the construction of pictorial perspective in fifteenth-century Italy. Against the contemporary truism that perspective is meant to depict *space*, the question is – if artists had no expressed interest in *space*, what exactly were they up to? I have attempted to make these two sections an observational history of art more than a semantic exercise, even if there is some value in that.

Part Three can be considered as response to the question – granted that *space* is not discussed in medieval and Renaissance documents, would it have been possible for artists to conceive of pictorial *space* at that time and place? Here, the inquiry shifts to the history of *space* itself. Spanning from Aristotle to Kant, the history is, by necessity, much simplified. Even so, it is crucial to explore the conditions that set the stage for the eventual introduction of *space* into discussions about art. For readers coming out of our 'age of space', it may seem that *space* is neutral and empirical. To the contrary, the history of *space* is characterized by a complex array of concepts and disagreements. *Space* manifested itself as a power of extension, philosophically and mathematically and developed in tandem with the expansion of worldly European power. Even as it gained authority, the existence, nature and perception of *space* was unsettled and disputed as *space* evolved over centuries of philosophy and theology.

This section is grounded in two central stories. The first narrative presents the dissolution of the Aristotelian conception of Place to the degree it was in competition with a more powerful Christian God. Following that, I describe how the constituent elements of modern *space* were assembled over a span of centuries. For *space* to be extended into art, *space* would have to be recognized as powerful and be: infinite enough, empty enough, homogeneous enough, mathematical and secular. And *space* would need to be a coherent idea.

Part Four explores how *space* first enters discussions of art. Even with the increasing theorization and discussion about painting from the seventeenth century forward, *space* was slow to make an entrance. To the degree I could determine, pictorial *space* first appears in the mid-nineteenth century in the writing of the Swiss historian Jacob Burckhardt. By the end of the century, with the neo-Kantian treatise of the neoclassical sculptor Adolf von Hildebrand, *space* became a topic to be taken as fundamental to art and an imperative for artists.

Hildebrand's ideas of *space* formed the basis for academic studies such as life drawing and sculpting – even to this day. Further, within Hildebrand's circle were younger art historians who advanced his belief that *space* is fundamental to art and art history. Following Hildebrand, *space* was established as a principle in art history. The 1927 essay *Perspective as Symbolic Form* by Erwin Panofsky secured an institutional role for *space* in art history.

Although Hildebrand's ideas about *space* were taken up in art and art history, pictorial *space* in its most influential twentieth-century form came from the direction of mathematics. Part Five relates *space*'s ultimate expansion into the pictorial arts and asks, 'What is space in art?' and 'How did twentieth-century artists respond to inherited ideas about *space*?'

In the early-twentieth-century, ideas about *space* were complex and imaginative as artists at that time wove strains of mathematics, philosophy and spiritualism into their concepts of *space*. Since Newton, *space* and geometry had become virtually synonymous. With Bernhard Reimann's consolidation of Euclidean, non-Euclidean and *n*-dimensional geometry, *space* became defined beyond three-dimensional experience. The idea of multidimensional worlds as described in such works as Edwin Abbott's 1884 novella *Flatland* seized the imagination of the time. As the interest of science in French painting shifted from color perception to geometric physics, four-dimensional *space* became a subject for Cubism. With Cubism, *space* entered art from the direction of science and technology, ushering in an 'age of space' for painting, sculpture and architecture.

The early twentieth century was a creative time for the novel idea of *space* in art. Following the interest in pictorial *space*, the idea of architectural *space* was advanced. This is unsurprising. As the scientist Jules-Henri Poincaré presented in an influential turn-of-the century text, the idea of *space* is a convenient convention. Painting is freer to play with and perform conventions than the more practical art form of architecture.

Constantin Brancusi's paradigmatic *Bird in Space* brought together Hildebrand's foundational sense of *space* with a technical, Futurist sense of speed. Constructivists developed schematic forms as pictorial emblems of *space* and Josef Albers produced images of *spatial* conundrums with his series of 'optical illusions'. The motivating idea of Lucio Fontana's many *Concetti Spaziali* works with their punctures and slashes, was to extend pictorial *space* outward from the painting to 'real space'. *Space* had become a subject for artists to imaginatively define and represent.

From the admission of *space* into discussions about art around the turn of the twentieth century, *space* was defined by its historical roots: (1) science /

technology, (2) philosophy / metaphysics and (3) spirituality / religion. To these three dimensions, a fourth can be identified – the artistic – which enabled these historical strains of *space* to coalesce in relation to art. This can be noted in the various approaches to *space* in different artists' work. The Constructivists and Fontana operated primarily in the technological mode; Hildebrand and Mark Rothko in the philosophical; and Yves Klein claimed a form of religious, spiritual *space*. However, by the latter half of the century, these historical dimensions of *space* were increasingly dispensed with. At this point, *space* operated unhampered by history in a single *artistic* mode. With the reduction of the legacies of *space* to the artistic mode, the creative phase of artistic *space* ended and became what can be identified as 'discursive space'.

In many respects, we are currently within the discursive phase of *space*, which can be characterized by two principal features: first, *space* is conceived as indisputably real, in that its authority is ahistorical. At the same time, the ubiquity of *space* and its ability to attach itself at will marks the end of its meaning. This second defining feature of discursive *space* is that it has become a prime example of what William Burroughs termed a 'word virus'.

As we are now in the twenty-first century, it is worth asking where does *space* go from here? In its present discursive phase, the extension of *space* may have found its limit. The twentieth century with its automobiles, airplanes, giant ships, missiles and rockets was justifiably dubbed the 'Space Age'. *Space* swallowed its metaphysical sibling, time, to become a single dimension within *space-time*, and *space* expanded to occupy its dominant position in this era. However, the explosive advances in information technology may turn the imagining of our world, and even our physics away from *space* to how information structures the universe.

This book is a greatly enlarged version of a 2017 essay published in the *Brooklyn Rail*.[1] While the book delves into much that was unexplored in the essay and I was able to flesh out themes and amend some details, happily I end in a similar place: that the pictorial is full of fascination and needs no excuses. I repeat from the essay: 'Painting and its associated varieties of picture making are far older and more real than conceptions and prescriptions for *space*. Fashions change. Painting endures.'

Note

1 James Hyde, 'Against Space', *The Brooklyn Rail*, September 2017, https://brooklynrail.org/2017/09/art/AGAINST-SPACE (accessed 2025).

Part One

A History of Art without *Space*: The Thirteenth Century

While many books have presented the history of Western art using a conceptual framework of space, this book is unique as a critical history of that framework. Questions arise. What would constitute a history of space in the visual arts and where would it begin? Given present-day habits, how would one describe and assess the formative eras of Western art without resorting to space? The history of art that follows is defined by working with ideas and values that were at least somewhat part of the culture at the time to present narratives. It is hoped that this procedure can allow fresh interpretations of the late-thirteenth- and fifteenth-century transformations of pictorial art in Italy.

When artists, critics and scholars discuss the emergence of perspective in the Renaissance and the earlier transformations in European painting in the thirteenth century, it is often in terms of pictorial space. If today pictorial space seems to be an invaluable explanatory concept, at the time of these historical developments it was not yet part of the imagination of painting, sculpture or architecture. To the degree that pictorial space aids understanding of the past, it is a concept that only came to exist centuries later. There are consequences of the uncritical projection of a modern framework of thought onto the past. The granting of conceptual authority to an anachronism is deforming, not only to the understanding of the past but also limiting to what we presently value in painting.

If the idea of pictorial space was not yet formed and so unavailable at these historical junctures, how can we describe the accomplishments of these artists working in distant times? Beginning with the early Humanists who followed the lead of ancient texts, four basic frameworks were developed to discuss painting and sculpture: Naturalism, Classical Revival, Individual Genius and Practical, Social and Cultural Forces. These four frameworks have roots anchored in the eras under

discussion and form the parameters of this history. By developing narratives through these four accounts, without recourse to an idea of pictorial space, will pictorial space be missed? Even more crucial is the question of opportunity: What can be seen and appreciated without recourse to this habit of assigning space to these historical pictures? It is as a painter but also as a fresh eye to texts and specific works that I explore the novel questions this method allows.

For example, St Francis of Assisi (c. 1181–1226) is credited with transforming theology and society, but he also performed intensely visual events. Beyond looking at St Francis just as a subject for painting and sculpture, it can be argued that his spectacles transformed pictorial representation.

With the paintings of Giotto Bondone (c. 1267–1337) there was a turning, even a revolution in painting. In this section, I explore the pictorial order of traditional Christian Painting, with its architectural premises of icon and ancillary representations which Giotto inherited. It is important to appreciate this structure to grasp how Giotto reworked its premises. His specific transformations and the circumstances that instigated them are delved into in the context of the frescoes in the basilica of San Francesco in Assisi. With Giotto's elevation of istoria – what was then a minor format within Christian Painting – the structure and organization of Western painting began to shift. The Navicella, Giotto's grand mosaic in the courtyard of old St Peter's in Rome (now lost) is recognized as a key work of the master, but even so, there are reasons why its importance may be underrated.

Later, in the chapter on the fifteenth century, I explore how and why perspectival rendering arose. With close readings of De pictura by Leon Battista Alberti (1401–72), as well as the writings of Leonardo da Vinci (1452–1519), it is clear that pictorial space is not a stated concern. What then were the conditions and impetus that launched this inventive pictorial regime?

The polemic in these sections is muted in favor of looking at and discussing what I, along with many other enthusiasts, find are powerful and exciting works of art. Readers may be committed to the belief that these artists were thinking about space even if they were not explicitly stating it or consciously thinking about space. It is hoped that these historical vignettes will sustain enough interest in the reader to accept the supposition that resorting to pictorial space, as an explanatory device, is not necessary and even limiting.

I begin with the narratives of Naturalism, Classical Revival, Individual Genius and Practical, Social and Cultural Forces.

1

Narratives for the Thirteenth Century

Naturalism

Naturalism and Illusionism, often interchangeable with Realism, are ancient concepts in the discussion of painting and sculpture. The writings of Roman historian Pliny the Elder (23/24–79 CE) were much admired by early Italian Humanists. Here is his famous account of the contest between two fifth-century BCE Greek painters:

> Zeuxis and his contemporary, Parrhasius, it is said, entered into a pictorial contest, with Zeuxis who represented some grapes, painted so naturally that the birds flew towards the spot where the picture was exhibited. Parrhasius, on the other hand, exhibited a curtain, drawn with such singular truthfulness, that Zeuxis, elated with the judgment which had been passed upon his work by the birds, haughtily demanded that the curtain should be drawn aside to let the picture be seen. Upon finding his mistake, with a great degree of ingenuous candor he admitted that he had been surpassed, for that whereas he himself had only deceived the birds, Parrhasius had deceived him, an artist.[1]

This small, potent myth is full of interest. Pliny presents the Classical trope of art as a competition and concentrates on the painters' individual genius. Pliny links art to deception, nature to the real, truthfulness to illusion, and shows that the artists are great for a number of reasons, not the least of which is grace in defeat. While Zeuxis painted the grapes 'so naturally' that it deceived birds, Parrhasius' 'singular truthfulness' is even greater because his rendering of the curtain fooled the human eye – the ultimate measure of nature – of a truly gifted artist. Pliny shows that even as the production of illusion is to be admired, the uncovering of illusion and the superseding of animal perception is revealed to be an even higher form of human achievement. But victory does not necessarily go to the more accomplished painter. Zeuxis' greatness is confirmed by his concession to Parrhasius.

The myth of Zeuxis and Parrhasius shows the high value placed on a series of related terms; naturalism, realism, illusionism and truthfulness. However, it is a tale that makes clear the fictional dimension of these values (birds are certainly not fooled by flat images). Naturalism, realism and illusionism are true fictions, and as such reveal the culture in which they are promulgated. Whereas we might mistakenly assume that the competition between Zeuxis and Parrhasius represents a struggle between culture (painting) and nature (the birds, the human eye), the locus of the narrative is on the painters. Zeuxis and Parrhasius not only embody Nature, they represent Nature at its pinnacle, due to their ingenious ability. With the increasing enthusiasm for Classical texts in Western Europe beginning in the twelfth century, this tale established the value of painting, Nature, artistic genius and mimesis.

Classical Revival

In the early fourteenth century, Giovanni Boccaccio (1313–75) wrote this about his acquaintance (and likely friend), Giotto,

> whose genius was of such excellence that with his art and brush or crayon he painted anything in Nature, the mother and mover of all things under the perpetual turning of the heavens, and painted them so like that they seemed not so much likenesses as the things in themselves; whereby it often happened that men's visual sense was deceived, and they thought that to be real which was only painted.[2]

There are unmistakable echoes of Pliny in this passage; Boccaccio couches his praise of Giotto in the familiar language of Naturalism. Boccaccio continues:

> Now he who brought back to light that art which for many centuries had lain buried under errors (and thus was more fitted to please the eyes of the ignorant than the minds of the wise), may rightly be called one of the shining lights of Florentine glory.[3]

Boccaccio claims that Giotto revived the Classical glories of painting. Boccaccio's mentor and correspondent Petrarch (Francesco Petrarca, 1304–74) coined the term 'dark ages' to describe the previous thousand years. Church Fathers had constructed, reinforced and inhabited the metaphor of Light for the figure of Christ, and relatedly for righteousness and beauty, Petrarch reversed the poles of this metaphor. He imagined a return to Classical forms in rhetoric and visual art, arguing for 'a better age in store: this slumber of forgetfulness will not last forever'.

He went on: 'After the darkness has been dispelled, our grandsons will be able to walk back into the pure radiance of the past.'[4] Earlier revivals sought to capitalize on Classical forms, ideas and techniques that were regarded as dormant, but continuous with the past. In distinction, Petrarch saw a centuries'-long dark age that entailed a break with the Classical past and hoped for its return.

Petrarch's desire for a rupture with the medieval past set the stage for the grand revival that was the Renaissance of the fifteenth century. Even so, there had already been a marked interest in the Classical forms in visual art two centuries earlier. In the mid-thirteenth century, Nicola Pisano (1220/5–84, born two generations before Giotto) embraced the distinctive style of Classical Roman reliefs in his marble reliefs for the baptistery pulpit in his hometown of Pisa. There, Classical sarcophagi had been on public display for centuries. To a contemporary eye, while Pisano's reliefs do refer back to Classical Rome, they are also an odd feast of imaginative revival and skill that feels somewhat crowded (Figure 1). Nicola's sculptures, however, indicate there was a culture in the thirteenth century that sought to appropriate elements of Classical style.

Nicola's assistant, Arnolfo di Cambio (1232/40–1302/10), inherited his master's enthusiasm for Classical form. Arnolfo was said to have studied with

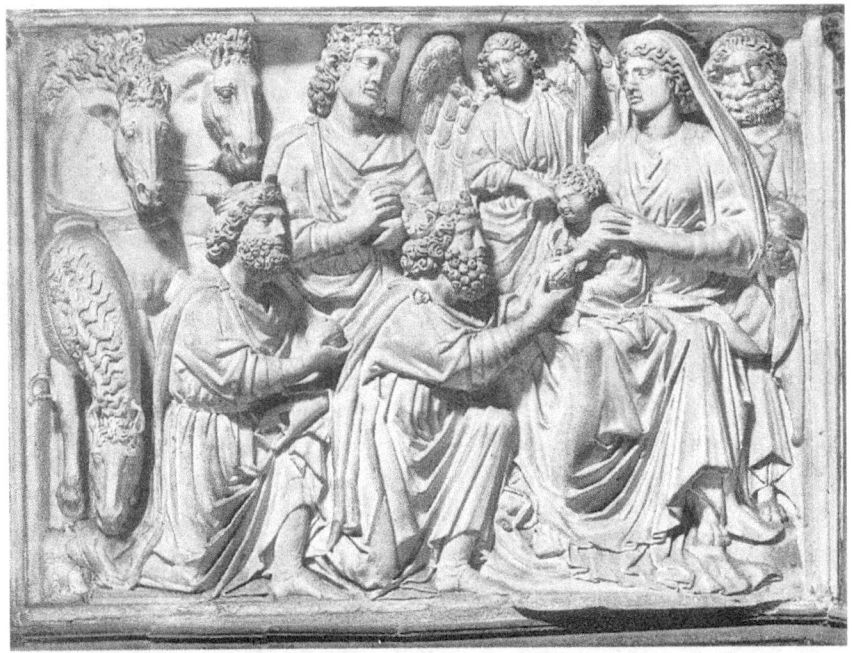

Figure 1 Nicola Pisano, Presentation of the Christ Child in the Temple, pulpit relief, Pisa Baptistery, 1260.

Cimabue, and so likely would have known his contemporary, Giotto, who is also believed to have worked in Cimabue's workshop. Arnolfo became adept at mixing Classical forms with the new French style that became known as the Gothic. His borrowing from Classical sculpture could be quite literal. Within the Gothic tomb monument for Cardinal de Braye (c. 1282) (Plate 1), Arnolfo included an enthroned Madonna and Child. After a recent restoration, it was discovered that the Classically styled Madonna, thought to have been carved by Arnolfo, was actually a sculpture of a Pagan goddess from the second century repurposed for Christian duty.[5]

The dream of a Classical revival was an essential element of late-thirteenth-century visual culture. Later, at the end of the century and beginning of the fourteenth century, Petrarch and his fellow Humanists developed an intense interest in the great Roman writers and poets, thus rendering the Classical revival literary as well as in visual art.

The Individual Genius

By the time Giorgio Vasari (1511–74) wrote *Lives of the Most Excellent Painters, Sculptors, and Architects* in the sixteenth century, the narrative of the artist as individual genius had already been established. Vasari's book made it an institution. Earlier generations had venerated saints and preserved their biographies. Vasari's *Lives* was an unprecedented feat as the book collected and recorded the lives of artists on a grand scale. While Vasari's *Lives* is often clear-eyed and critical, one can also detect a reverential, even religious awe at times. This is certainly the case in his account of Michelangelo:

> There was born a son, then, in the Casentino, in the year 1474, under a fateful and happy star, from an excellent and noble mother, to Lodovico di Leonardo Buonarroti Simoni, a descendant, so it is said, of the most noble and most ancient family of the Counts of Canossa. To that Lodovico, I say, who was in that year Podesta of the township of Chiusi and Caprese, near the Sasso della Vernia, where St Francis received the Stigmata, in the Diocese of Arezzo, a son was born on the 6th of March, a Sunday, about the eighth hour of the night, to which son he gave the name Michelangelo, because, inspired by some influence from above, and giving it no more thought, he wished to suggest that he was something celestial and divine beyond the use of mortals, as was afterwards seen from the figures of his horoscope, he having had Mercury and Venus in the second house of Jupiter, with happy augury, which showed that from the art of

his brain and of his hand there would be seen to issue forth works marvelous and stupendous.[6]

This narrative of Michelangelo's birth with its astrological influence, has the air of hagiographical myth. This is Vasari making a claim for the eminence, if not veneration of artists.

Vasari was writing in the sixteenth century, but in the thirteenth century artists were not yet celebrated. Within the tradition of icon painting in Italy, artists did not assert credit for their handiwork. However, in 1236, there was perhaps the earliest instance of an artist's signature. Giunta Pisano (*c.* 1180, 1202–*c.* 1258) included his name as part of an inscription at the base of the enormous shaped crucifix, some sixteen feet tall, painted for the basilica of San Francesco in Assisi. The icon itself is lost, but the inscription is known through drawings and prints in which it was portrayed before it was damaged from a fall and disposed of (Figure 2). The inscription, recorded in the seventeenth century, reads: 'Brother Elias had this made; Compassionate Jesus Christ have mercy on your supplicant Elias; Giunta Pisano painted me in the year of our Lord 1236, in the Ninth Indication.'[7]

This was a spectacular and innovative icon. Giunta was justly proud of his handiwork and there are several other panels on which Giunta inscribed his name. In the case of this monumental crucifixion, Giunta does not claim sole authorship. Brother Elias of Cortona (*c.* 1180–1253) is credited and must have been engaged in specifying its form. Elias was appointed by St Francis in the last years of his life to direct his Order. Supervising the icon was only a small part of his duties as he oversaw the design and construction of the Basilica of San Francesco itself. Elias' relationship to the icon was further indicated by his depiction as a small kneeling figure nestled in the inscription gesturing to the bleeding foot of the colossal Christ. Through the fifteenth century, the patron who commissioned an artwork was understood to be at least as much a cause of a work as the artist who painted it. In the inscription of Giunta's crucifix, everyone involved is credited the impetus for the icon, even Jesus Christ.

Although Giunta valued his authorship, there were no writers to advocate for his individuality as an artist. The figure of the unitary creator of the artwork only began to be recognized at the beginning of the fourteenth century, following the lead of Dante Alighieri (1265–1321), who wrote of the two highly admired painters of that era:

> So thought Cimabue that in painting
> he held the field, and now Giotto has the acclaim,
> so the fame of the other is dimmed[8]

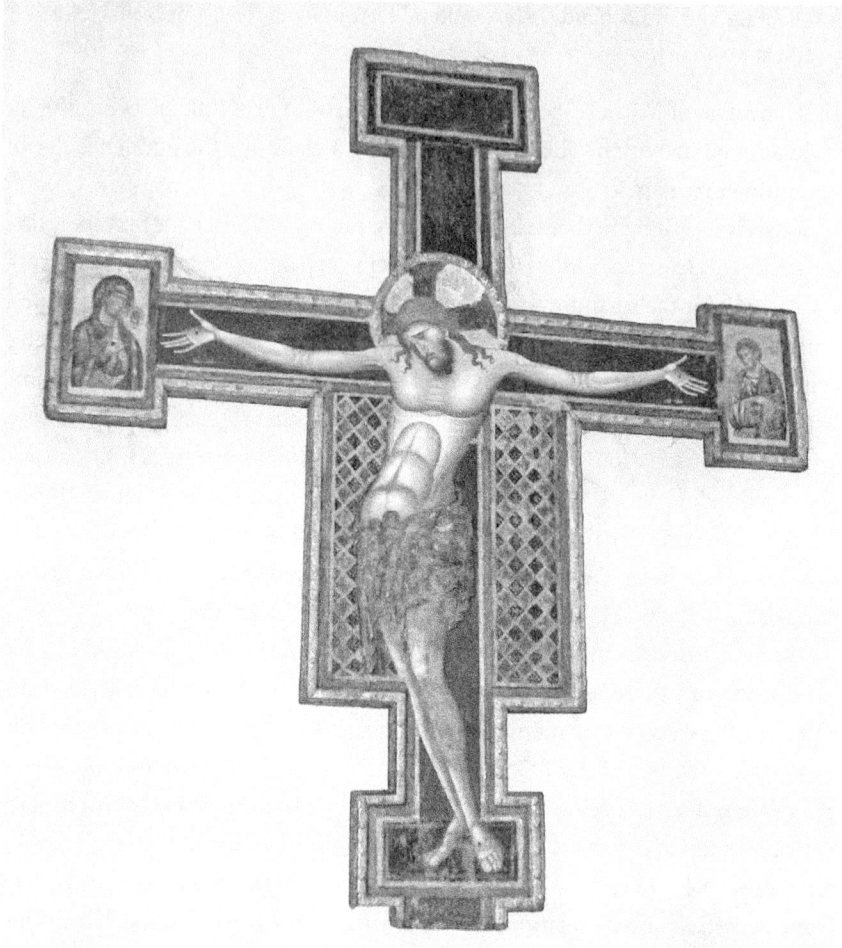

Figure 2 Giunta Pisano, Crucifix, tempera on wood panel, Basilica of Saint Dominic, Bologna, 1250–54. It is similar in format, but smaller and produced later than the lost Assisi crucifix. It was inscribed with, '*Cuius docta manus me pixit Junta Pisanus*' (The learned hand of Giunta Pisano painted me).

These often-quoted lines from the *Purgatorio* (written between 1308 and 1320) are from the mouth of the illuminator Odersi da Gubbio (*c.* 1240–99). Odersi remorsefully explains to Virgil and Dante that artistic vanity is his sin. This would indicate that by the turn of the end of the thirteenth century, Odersi could be seen as an individual artist – even a great one. An artist could only suffer from artistic vanity in a society that recognized individual talent. Dante's connecting of the best known painters of that time, Bencivenni di Pepi, known

as Cimabue (1240–1302), and Giotto Bondone (1267–1337), helped to secure both artists' acclaim as authors of their work and helped to establish their fame, and a nascent sense of their genius.

Cultural, Societal and Practical Forces

The inscription on the monumental crucifix of San Francesco presents its creation as a collaboration of Elias, Giunta and given Christ is credited, there is a religious dimension. This indicates some of the social and practical forces embedded in its fabrication – and acknowledged at the time.

Providing a context for paintings can aid the understanding of how the works were made and received. History enlivens the paintings and the society that they emerged from. While there are aspects of anthropology and sociology to this approach, it is the art historian Michael Baxandall who most lucidly explains the mechanics of this type of undertaking:

> A fifteenth-century, [and, in this case, a thirteenth-century] painting is the deposit of a social relationship. On one side a painter who made the picture, or at least supervised its making. On the other side there was somebody else who asked him to make it, and after he made it, reckoned on using it some way or another. Both parties worked within institutions and conventions – commercial, religious, perceptual, in the widest sense social – that were different from ours and influenced the forms of what they together made.[9]

Between the late twelfth and early thirteenth centuries, much was in flux, with the sack of Constantinople in 1204 being particularly consequential. Beyond the immense transfer of wealth, numerous art objects were brought to the Latin West, including the bronze horses that now stand above the entrance of the Basilica San Marco in Venice and the Byzantine icon of victory, the Virgin Nikopoios, which remains within the church. The basilica's exterior was also renovated using marble stripped from the Hagia Sophia. The conquest of Byzantium brought an array of precious commodities – jewels, gold, silver and marble – as well as sacred relics, including wood from the True Cross. The effect was to bring Byzantine visual culture to the West.

By the end of the thirteenth century, Latin was becoming more widely understood and expressed with increasing rhetorical eloquence. Following Dante's *Divine Comedy*, written in Tuscan, vernacular language began to develop the capacity to articulate complex subjects in a range of voices and styles. As well,

religion, always central to medieval Italian society, was undergoing transformation amid wars and crusades. Within the Church, theology deepened and expanded. New social classes emerged, and technologies imported from the East were further developed. Although the thirteenth century was a period of exceptional change in Europe, *space* had yet to emerge as a distinct category in visual art.

A Braid of Four Narratives

The following chapters discuss the pictorial culture of the time with these four explanatory narratives: Naturalism, Classical Revival, Individual Genius and Practical, Social and Cultural Forces. This is not so much revisionist art history as it is an attempt to strip away the *spatialist* revisionism of the nineteenth and twentieth centuries. Rather than systematically isolating each narrative thread to assess its explanatory power, what follows is an exploration of the relationship between art and ideas. The discussion will focus on the paintings in context, rather than becoming enmeshed in intricacies of methodological critique.

Notes

1 John Bostock and H. T. Riley, *The Natural History of Pliny* [CE 77–79] by Pliny the Elder, trans. with notes and illustrations by John Bostock and H. T. Riley (London: Henry and Bohn, 1855).
2 Giovanni Boccaccio, *Decameron*, written c. 1350 trans. Richard Aldington (New York, NY: Garden City Publishing Company, Inc., [c. 1349–51] 1930), 6th Day, 5th Tale, 328–9.
3 Ibid., 329.
4 Erwin Panofsky, *Renaissance and Renascences* (Stockholm: Almqvist & Wiksell, 1965). Also published by Norwich: Paladin, 1970, 10: Petrarch, Africa, IX, line 453ff., reprinted in Theodore E. Mommsen, 'Petrarch's Conception of the Dark Ages', *Speculum*, 17 (2): 226–42.
5 M. Coccia and L. Morozzi (eds), 'Arnolfo di Cambio: Il Monumento del Cardinale Guillaume De Bray dopo il Restauro: Atti del Convegno Internazionale (Rome-Orvieto, 9–11 December 2004)', *Bollettino d'Arte*, Special edn, 2009.
6 Giorgio Vasari, 'Giovanni Cimabue', in *Lives of the Most Eminent Painters, Sculptors & Architects*, [1540] newly trans. Gaston Du C. De Vere, 10 vols (London: Macmillan and Co., Ltd. and The Medici Society, Ltd., 1912–14).

7 Donal Cooper and Janet Eileen Robson, *The Making of Assisi: The Pope, the Franciscans, and the Painting of the Basilica* (New Haven, CT: Yale University Press, 2013), 64.
8 Dante Alighieri, *Purgatorio* (c. 1321), Canto XI *Credette Cimabue ne la pittura*
9 Michael Baxandall, *Painting and Experience in Fifteenth-Century Italy: A Primer in the Social History of Pictorial Style* (Oxford: Oxford University Press, 1972), 1.

2

The Saint of Spectacle

St Francis' Actions and Expressions

Although he died early in the century – St Francis was, by many measures, the most consequential figure in thirteenth-century Europe. The saint is widely acknowledged as having introduced a profound sense of humility and compassion to medieval culture. His emphasis on the suffering and poverty of Christ as the central concern of Christianity reformed European society. What follows here is a consideration of the visual implications of St Francis' actions.

While St Francis was known for his radical new theology, his life also encompassed a sequence of spectacles which recast visuality at a time when the Church had a virtual monopoly on visual representation. The Church was vigilant against heterodoxy, so St Francis' success was all the more miraculous, as his direct actions could easily have been regarded as heresy.

St Francis and his actions are well described by Erich Auerbach in *Mimesis*:

> At the beginning of the 13th century there appears in Italy a man who embodies, in an exemplary fashion the mixture ... of ecstatically sublime immersion in God and humbly concrete everydayness—with a resulting irresolvable fusion of action and expression, of content and form. He is Saint Francis of Assisi. The core of his being and the impact of his life are centered upon the will to a radical and practical imitation of Christ. In Europe the age of the martyrs had ended, this had come to assume a predominantly mystico-contemplative form; he gave it a turn toward the practical, the everyday, the public, and the popular. Self-surrendering and meditative mystic though he himself was, the decisive thing for him and his companions was living among the people, living among the lowliest as the lowliest and the most despised of them all ... He forced his inner impulse into outer forms; his being and his life became a public event ... everything he did was a scene. And his scenes were of such power that he carried away with him all who saw them or only heard of them.[1]

Although the focus of Auerbach's book is texts, his account of St Francis is an impetus to look to the visual means through which Francis 'forced his inner impulse into outer forms' beyond the written word. The age of mystico-contemplative Christian sainthood that Auerbach identifies stretched from St Augustine of Hippo (354–430) to St Bernard of Clairvaux (1090–1153). These saints retreated from the world into noetic and mystical reverie, and they were honored predominantly for their writing, not their actions. Francis breaks with this saintly tradition by fashioning events that 'were of such power that he carried away with him all who saw them or only heard of them'.

By all accounts, the charismatic young St Francis was an extraordinary preacher. Beyond that, eloquence was only part of his arsenal. St Francis' public events were spectacles, and their narrative was amplified by their theatrical visuality. This was the medium through which Francis compelled his radical piety to public view. In contemporary parlance, St Francis' events went 'viral' through the force of his intuition and his 'irresolvable fusion of action and expression, of content and form'.

In the history of art, St Francis is regarded predominantly as a subject for painting and as a culturally humanizing influence. However, it is worth exploring the effects his spectacles had on painting. Although St Francis was never in the painting trade, many of his public acts were intensely visual performances and much of his life experience was keyed to the visual. St Francis' father, whom the saint famously rejected by stripping off his clothes in the public square of Assisi, was a cloth merchant whom the young Francis assisted. The family traded in an aesthetic business – appreciation of color and texture of material were requisite. From early in his journey to sainthood, St Francis applied a sense of couture to spiritual ends. St Francis designed the frocks of coarse fabric with its rope for a belt that is the signature of the order. Upon returning from the Holy Land, he brought west the tradition of the living creche, a celebrated Christmas event. He gathered up farm animals, straw, a manager, a mother and young child, and preached. Combining piety with absurdity to powerful effect, when he named Jesus, he licked his lips and swallowed because the sound was 'delicious', and he bleated like a sheep calling out 'Beheethelllheeemm'.

In the biographies of St Francis, there are dozens of stories of his miracles. He preached to a flock of birds. In an audience with the pope, he fell into a trance and channelled the Word of the Lord. He healed the sick and kissed the sores of lepers. He turned water into wine, multiplied provisions to preserve a boatload of sailors, cured the sick and crippled, expelled demons, and while not mentioned in the official biography, there is a story of St Francis delivering the town of

Gubbio from a man-eating wolf through gentle negotiation. As Francis gained in fame, tales of his piety and miracles multiplied, advancing the enthusiasm for the saint.

Given all that, there was a single event in the life of St Francis that was uniquely powerful. In his *First Life of St Francis*, a Franciscan friar, Thomas of Celano (c. 1185–1260), recounts the following incident, recorded five years after the event and three years after the death of St Francis:

> While he dwelt in the hermitage which, from the place in which it is situated, is called Alverna, two years before he gave back his soul to Heaven, he saw in a vision of God; a man-like a seraph having six wings, standing over him with hands outstretched and feet joined together, fixed to a cross. Two wings were raised above his head, two were spread out for flight, and two veiled the whole body. Now, when the blessed servant of the Most High saw this, he was filled with exceeding great wonder, but he could not understand what this vision might mean. Yet he rejoiced greatly and was filled with vehement delight at the benign and gracious look, wherewith he saw that he was regarded by the seraph, whose beauty far exceeded all estimation, but the crucifixion, and the bitterness of the seraph's suffering smote him altogether with fear. Thus he arose to speak, sorrowful and glad; and joy and grief alternated in him. He anxiously pondered what this vision might portend, and his spirit labored sorely to come to the understanding of it. And while he continued without any clear perception of its meaning, and the strangeness of the vision was perplexing his heart, marks of nails began to appear in his hands and feet, such as he had seen a little while before in the Man crucified who had stood over him. His hands and feet seemed pierced in the midst by nails, the heads of the nails appearing in the inner part of the hands and in the upper part of the feet, and their points upon them. Now those marks were round in the inner side of the hands and elongated on the outer side, and certain small pieces of flesh were seen like the ends of nails bent and driven back, projecting from the rest of the flesh. So also the marks of nails were imprinted in his feet, and raised above the rest of the flesh. Moreover his right side, as if it had been pierced by a lance, was overlaid with a scar, and often shed forth blood, so that his tunic and drawers were many times sprinkled with the sacred blood.[2]

This is the first incidence of the stigmata on a living man – all subsequent recorded stigmata follow from St Francis' miracle. St Francis' stigmata were the miraculous image of the crucifixion made real on the canvas of the flesh. Its significance was profound for the future of Christianity and for painting – not only for iconography, but for the new forms of painting that were developed in the thirteenth century.

From the otherworldly seraph and the carnal detail of St Francis' wounds, to the saint's confusion of joy and grief, the story is unforgettable. These original stigmata are defined by their radicality in two senses. The stigmata were shockingly novel, and at the same time they seemed to mark a return to the 'age of martyrs', when the passion for Christ was not merely spiritually moving but had the most physical of implications. The story is all the more powerful because, as Thomas de Celano describes the event, the stigmata are a miracle of representation: they are literally the re-marking of the holy signs of the crucifixion on the body of the saint. St Francis' stigmata presented the timeless truth of Christ's sacrifice visually, in the present, directly from God – and outside the authority of the Church.

As a 'little martyrdom', the temporal body of St Francis became an icon – both a living relic of the sublime tragedy of Christ and its picture. The stigmata thematize Christian pathos of suffering and death. Visually, the marks are the unmediated representation of the crucifixion.

Shaped Crucifix Icons Following St Francis

In 1227, a year after St Francis' death, an early supporter was elected pope, becoming Gregory IX. Gregory canonized St Francis in 1228 and announced the construction of the Basilica San Francesco. The saint's spectacles, which had originally taken place outside the walls and the hierarchy of the Church, were now welcomed, documented and painted inside churches across Italy. As the Franciscan Order grew, the brotherhood began to build chapels and churches, even as some of the brethren rejected worldly property. At the same time, the values of the Church shifted in directions that St Francis' life of piety and poverty had initiated, as did the images the Church sponsored, especially the images of the Crucifixion.

In general, medieval representations of the crucified Christ fall into two iconographic types, *Cristus Triumphans* and *Cristus Patiens*. In the *Triumphans* mode, Christ is nailed to the cross, however his eyes are open – he is triumphant over death. Although the *Patiens* icon is similar in its shaped format, its emotional content is entirely different. Christ is depicted as a tortured and dead body. He is portrayed to elicit pathos. Both the *Triumphans* and *Patiens* icons have a long history as Christian representations. Nevertheless, it seems that, until 1236, it was almost entirely the *Cristus Triumphans* that served as the architectural centerpiece in the Latin West. Images of *Cristus Patiens* were commonly relegated

to story cycles and were meant to anticipate a subsequent scene in which a resurrected Christ is shown victorious over death. St Francis' emphasis on suffering and sacrifice brought the *Cristus Patiens* quite literally to the center of Catholic veneration.

The change in the manner of crucifixion icons that characterize the thirteenth century can be noted by comparing the Bologna crucifix of Giunta to the twelfth-century San Damiano crucifix of the *Triumphans* type. Remarkably, it is the very same crucifix that spoke out loud to the young Francis in a ramshackle church in San Damiano close to Assisi, where he was praying (Plates 2 and 3). In St Bonaventure's (1221–1274) *The Life of Saint Francis*, commissioned in 1260, he writes:

> Prostrating himself before an Image of the Crucified, he was filled with no small consolation of spirit as he prayed. And as with eyes full of tears he gazed upon the Lord's Cross, he heard with his bodily ears a Voice proceeding from that Cross, saying thrice: 'Francis, go and repair My House, which, as thou seest, is falling utterly into ruin.'[3]

The Christ in the San Damiano crucifix is just smaller than life-size, with eyes wide open. He is calm and alert in demeanor in His addresses to His viewers. That is hardly imaginable with Giunta's adamantly dead Christ. Both Christs are rendered in a simple legible manner, and while the earlier Christ is painted with the barest of highlights and shadows, the lines of the figure are fluid enough that it could be said to appear more 'natural' to our contemporary eyes, or at least softer than Giunta's somewhat metallic rendition of Christ.

In Vasari's *Lives* he refers to the thirteenth century as 'that unhappy century', a disparaging remark about the *maniera greca*, the Byzantine style of Giunta's *Cristus Patiens*. His assessment accurately captures the melancholic mood of many paintings from the mid-century, and, certainly, the unhappiness he describes is connected to Giunta's enormous crucifix in San Francesco, which, even more than unhappy, communicates *passionate* misery.

This intensity is the key to the 'realism' of Giunta's portrayal. Today, realism in painting is usually measured by its optical, even photographic, likeness. If that is the case, the *Cristus Triumfans* in San Damiano may count as more 'natural' than Giunta's suffering Christ. But Giunta's Crucifixion is meant to lessen the distance between the worshiper and Christ by increasing the worshiper's empathy and identification. Christ's sacrifice – the Truth of Christianity that St Francis advocated for – becomes the striking reality that Giunta's icon brings home. Comparing these two figures of Christ, Giunta's *Cristus Patiens* has an emotional realism that the serene and regal *Cristus Triumphans* of San Damiano cannot match.

The power of a painted icon is not merely a function of its visual representation, but like religious relics, it is the connection to what is sacred that makes it holy. It is the logic of relics to bring the holy and miraculous past into physical proximity. In his book on the history of the 'Holy Image', Hans Belting writes that in the medieval East and West, 'No significant distinctions were made between image and relic, since cult images were by nature relics, even if they were not actually parts of bodies. Finally, the icons ... provided tangible proof of all the famous legends in which they played so spectacular a part.'[4] In context, both the San Damiano crucifix and Giunta's icon operate as relic as well as image (also consistent with St Francis' stigmata).

Although Giunta's Byzantine *maniera greca* was infelicitous for Vasari, it was not merely a style but the style of painting from the Holy Land. As such, the reliquary power of proximity of the *maniera greca* is potent. Due to its origin in the East, the *maniera greca* offers a connection to where Christ walked, taught and breathed – thus binding biblical holiness to the present of thirteenth-century Italy. Following St Francis' stigmata, the thirteenth-century *Cristus Patiens* icons brought the sacred image of Christ's suffering into the proximate present through their tragic images, but also amplified it through the reliquary logic of the Eastern style.

Thirteenth-century Italy was remarkable in terms of the changes in society and culture that brought new pictorial imagination and new forms of icons. There was a burgeoning interest in Classical Roman forms and the *maniera greca* gained popularity. Following the spectacles of St Francis, there was demand that Christianity's pictorial representations reflect the saint's emotional intensity. As a crusading Church sought to expand the borders of the Christian world, the inspirational theology of St Francis was useful. Despite that St Francis' spectacles were independent from the authority of the Church, he never argued against the Church. His commitment was to follow the command he heard while praying at San Damiano: 'Francis, go and repair My House ...' Although St Francis' sense of pictorial spectacle originated outside the Church, it shaped how Christians felt about the suffering of Christ, and how they pictured Christianity in their churches and paintings.

Notes

1 Erich Auerbach, *Mimesis: The Representation of Reality in Western Literature*, trans. Willard R. Trask (Princeton, NJ: Princeton University Press, [1946] 1953), 162.

2 Thomas of Celano, *The First Life of St Francis* [*c.* 1229], trans. A. G. Ferrers Howell (London: Methuen, 1908), part 2, chapter 3, http://franciscanseculars.com (accessed 2024).
3 St Bonaventura, *The Life of Saint Francis* [*c.*1262] (London: Published under the auspices of the International Society of Franciscan Studies, J. M. Dent and Co. Aldine House, 1905), 14.
4 Hans Belting, *Likeness and Presence: A History of the Image before the Era of Art*, trans. Edmund Jephcott (Chicago, IL, and London: Chicago University Press, [German original 1990] 1994), 195.

3

Christian Pictures and San Francesco

So thought Cimabue that in painting
he held the field, and now Giotto has the acclaim,
so the fame of the other is dimmed.[1]

Dante's comparison of Cimabue and Giotto in his *Purgatorio* is paradigmatic, despite being an incidental moment in his picture of the moral Cosmos. It can be seen as more than just the competition of individual painters like the face-off between Parrhasius and Zeuxis. Between Cimabue and Giotto a revolution begins. The revolution did not overthrow tradition but marked a turning point in the organization of Christian Painting. Even as Vasari credited Cimabue as giving 'the first light to painting' and as surpassing 'the manner of the [Greek or Byzantine] masters who were teaching him', his work remained a modification – 'a little more lively and more natural and softer'.[2] However, with Giotto, the purpose, the place and the means of representation were put into play. It is within the work of Giotto and his immediate followers that the very structure of traditional Christian painting was re-formed. Between the start of the thirteenth century with the radical spectacles of St Francis and Giotto, Western painting began a process of reimagination and a new phase of invention.

Complexity and Contradiction at the Basilica San Francesco

There is a unique location where the wall paintings of Cimabue and Giotto (or Giotto-esque painters) exist together and can be compared. Experts disagree as to whether the frescoes in the Basilica San Francesco in Assisi were painted by Giotto, although the evidence strongly leads to his authorship. As they are undeniably Giotto-esque, for the purpose of this narrative, Giotto will serve as the principal author. These frescoes are remarkable for their confluence of painting, architecture and pictorial theology, and are pivotal to the pictorial turn between the works of Cimabue and Giotto.

At the opening of the thirteenth century, following a millennium of practice, pictorial representation was expressed by the Church through imagery and architecture, each reinforcing the other. Theology determined subject matter and the hierarchies of images, while church architecture regulated their order and provided the context for the presentational framework. It was not only representations of Christ the Virgin, saints and holy images, but their architectural placement that made theology alive and potent. As the public-facing repository of Christian images, it is churches where theology and visual representation profoundly intersect. The relationship of imagery and architecture is essential to the logic of Christian Painting. The interior walls of San Francesco include some of the most significant paintings by Cimabue and Giotto, and are exemplary in showing just what the order Christian Painting entailed. In the case of the new frescoes said to be Giotto's, the ordering of Christian Painting was not overturned but revised from within.

The Basilica San Francesco was built on the side of a hill, at the perimeter of Assisi, the city of St Francis. Construction of the basilica commenced with the pope setting the foundation stone in 1228, the day after St Francis' canonization and two years after his death. The basilica is composed of an upper and lower church. The lower church was complete enough for the saint to have been interred there a mere two years after his canonization. The upper church took longer, but still proceeded swiftly and was consecrated in 1253. It has a higher interior and was built directly over the lower church on the same floor plan. The difference in height allowed for flat vertical walls that would provide generous locations for paintings.

As first the vicar-general, and the minister general for the Franciscan Order, Brother Elias was responsible for the design and construction of the Basilica. It is characteristic of the energetic Elias that a fashionable new style was chosen for the church's form. A century earlier, Abbe Suger (1081–1151) embarked on the rebuilding of St Denis, an early Christian abbey church on the outskirts of Paris. Suger's renovations generated a new French style – the Gothic – that emphasized the skeletal tectonics of the masonry construction to create light-filled interiors rather than broad walls suitable for mural painting. The master masons who implemented the specifics of Suger's building program are unknown, and the style is foreign enough to the Romanesque conventions of the time that these skilled designers may have been practiced in Spanish or Islamic architecture. The seventeenth-century British architect, Christopher Wren's speculates that 'the Gothic style should more rightly be called the Saracen style'.[3] While it is not known precisely how the Gothic originated, like Islamic architecture, the Gothic

interest in expressive tensile structure precluded large flat planes that were essential for figurative wall paintings.

When the church of San Francesco took up the stylizations of St Denis, the forms of Gothic architecture were still developing. St Denis' early-to-mid-twelfth-century innovations included the rose window at the entrance and at the other end of the church, the windowed, light-filled apse. These design elements were later featured in San Francesco. St Denis' large, peaked windows on the aisles were only added at the turn of the fourteenth century. As such, the architectural format of St Denis in the thirteenth century was close to how San Francesco is today. The architecture of San Francesco bears the indeterminate quality of a style that is not fully formed. In retrospect, then, San Francesco is a mix of building styles – Gothic at the entrance and in the apse while the middle nave retains its more traditional logic. In essence, San Francesco has a Gothic head and entrance but a Romanesque body. Going forward, integrating the distinct decorative regimes of the Romanesque and Gothic presented difficulties, and an opportunity for invention.

San Francesco faced challenges even during the planning and construction of the basilica. Contention broke out shortly after St Francis died, as the order split into two factions. The spiritual Franciscans were determined that the order maintain St Francis' ascetic life of poverty and were against raising money for the basilica. In opposition were the Conventuals, who envisioned a future for the Franciscans more in line with traditional monastic orders, including construction of churches and schools. In 1230, the pope intervened in the controversy with an edict that supported funding the construction and decoration of the basilica. Still, either for ideological reasons or lack of funds, it seems that the decoration stalled. Only in 1253, did a later pope arrange funding appropriate for a church of its significance.[4]

The challenge of San Francesco's decorative program was to reconcile two distinct styles of adornment – not entirely compatible – of Romanesque and Gothic architecture. In both cases, the church's apse is significant as the head or terminus of the church. Within Romanesque church architecture, the standard half-dome (a form with roots predating Imperial Rome) is the culmination of its pictorial scheme. This semi-dome is the location for the most essential and sacred images in the church. In Gothic architecture, the apse is also a key element, with theological significance as a metaphoric crown of light. The Gothic apse is suitable for small images rendered in stained glass but leaves no place for monumental painted images. In Gothic churches, flat surfaces are reduced to a minimum, replaced by sinewy columns and tall windows. In San Francesco, the

nave with its broad walls still demanded images, but lacked the culminating center that is the apse.

Cimabue's Murals in San Francesco

It is generally accepted that Cimabue completed his murals for San Francesco before 1290, and perhaps as early as 1275 – certainly before the murals in the nave often credited to Giotto. Cimabue's sixteen-panel mural cycle in the apse and transept is the largest work he is known to have completed. With its size, color, complexity and attention to painterly details, it was considered his masterpiece. The murals are relatively low, and located below the tall windows of the apse and around the transept behind the altar. As they are also at a distance from the congregation, when they were painted they were dominated by Giunta's dour crucifix.

Vasari writes about the murals in San Francesco:

> This work, being truly very great and rich and well executed, must in my judgment have astonished the world in those days, painting having been so long in such darkness, and to myself, who saw it in the year 1563, it appeared most beautiful, and I marvelled how Cimabue could have had such light in the midst of such heavy gloom.[5]

Cimabue's paintings no longer look like this. As was the common practice of the time, Cimabue's murals were painted *secco*, rather than the more permanent technique of *buon fresco*, which was uncommon in thirteenth-century Italy. Cimabue's *secco* technique entailed the mixing of colors with a variety of glues over dry plaster. Whereas in *buon fresco* the shades of white are produced by leaving the background plaster unpainted and sometimes applying lime water, Cimabue used a lead white, incompatible with the alkaline nature of the walls. Unfortunately, over the centuries, humidity caused the alkalis from the lime plaster to seep to the surface and to react with the lead white, turning it black. This gives the murals the uncanny appearance of a photographic negative. While today the compositional outlines and skill of the details can be seen, the effect of the darkened murals is tenebrous and far from Vasari's description (Plate 4).

Cimabue's cycle of paintings in San Francesco is the most ambitious of his known work. Unfortunately, there are only a few traces in the upper basilica where his sumptuous and measured color and his sympathetic manner of painting faces can be fully appreciated. In *De pictura*, Alberti describes how faces

should be portrayed: 'the surfaces will be joined so that pleasing lights flow down into gentle shadows and so that not any roughness of angles appears, rightly we will call this face beautiful and graceful'.[6] One hundred and fifty years after Cimabue's death, Alberti's description well describes Cimabue's softening of the figurative stylizations of the *maniera greca*. Vasari praises Cimabue (the first artist who he discusses in his book on artists' lives): as 'exercising himself without ceasing, [so that] in a short time nature assisted him so greatly that he surpassed by a long way, both in drawing and in coloring, the manner of the [Greek] masters who were teaching him'.[7] Here, Vasari is precise – Cimabue was better at color and drawing than his masters. However, in terms of architectural organization, Cimabue's paintings are well within the thousand-year tradition of Christian Painting. While in the thirteenth century there was a new emotional realism that *Cristus Patiens* icons like Giunta's embodied, the tradition of the central iconic image surrounded by the grandeur due to God was very much part of Cimabue's pictorial organization.

While repetition of format is essential to Christian Painting, innovation within the tradition was possible. Cimabue's cycle of murals in the transept and the apse maintained the established pictorial hierarchies and vivid magnificence. However, there are two crucifixion scenes on each of the transept walls facing away from the nave that integrate the emotional realism of the *Cristus Patiens* icons and the richness of traditional Christian Painting. The two crucifixion wall panels are the largest of the mural panels but are only visible from behind the altar. In both panels, the hosts of heaven and earth provide a chorus of splendor and sorrow. On the left, facing the nave, Christ is depicted alive on the cross, suffering as a Roman soldier prepares to pierce His side with a spear. On the right, He has already died. Placed together, these scenes position the altar—the liturgical center of the church and site of the life-giving mass—at the precise moment of Christ's death. If this interpretation is correct, the two crucifixions present an unusual convergence of iconography and architecture, yet fully consistent with the theological and architectural parameters of Christian Painting.

The cycle of Cimabue's paintings in the upper church is so damaged that the details of the depictions are difficult to make out, even if it can be determined that each panel hews to the traditional order of Christian painting. However, there is a small mural by Cimabue in the lower church which is in far better condition and displays the delicacy and beauty of Cimabue's handiwork and painterly logic. The Madonna and Child (Plate 5) is of a standard type of the Byzantine *nikopoia*, also referred to as a *maestà*, Italian for 'majesty'. Seated in a throne at the peak of the grouping is the Madonna with the Christ child on her

lap, with his hand raised in benediction. Two angels on each side support the heavenly throne and on the right is St Francis with his characteristic habit and the stigmata. The painting did not entirely escape damage. Likely in the fourteenth century, a door was cut into the left side of the mural wall and the most leftward figure (and a slice of the angels' wings) were lopped off and the reduced grouping was reframed with a decorative border. The cropped-out figure was almost certainly St Anthony, a Franciscan Brother who was canonized four years after St Francis and often paired with him in paintings.

Symmetry is a foundational rule in Christian Painting. This is a symmetry that encompasses human form allowing for fluidity, variations and, at times, exceptions. Essential to pictorial symmetry is its frontal visual address. As a format, this symmetrical address organizes the hierarchy of the painting's figures in a clear unity – to emphasize and celebrate the central image. Cimabue's centralized and symmetrical compositions grasp attention and reward it. In the configuration of this *maestà*, a crescendo directs the viewer to the paramount figures. Both the theological message and the pictorial organization insist on the centrality of the Virgin and Child.

Cimabue's *maestà* is a devotional image, an object of veneration. As such, all its figures present themselves to the worshiper. They do not interact with each other. It is an image of regal glory, rather than the depiction of a mother's love for her child. Indeed, the four angels amplify the painting's majesty, not its intimacy. To the extent that the picture presents a story, the rustic St Francis (and likely St Anthony) are emblematic of earthly poverty. They stand in contrast to the paradise above and invite us to worship, as they do, the glorious Madonna and Child.

Physicality and Tactility

By the time Cimabue painted this *maestà*, there was also a long history of painting appealing to touch and tactility through eyesight. Iconodulity triumphed over Iconoclasm in the Byzantine East by the eighth century. Rather than icons being rejected as sacrilegious and destroyed, it was determined respectful worship of icons was a physical act that could include kisses. In the Catholic West, as late as 1562, the Council of Trent decreed:

> Moreover, that the images of Christ, of the Virgin Mother of God, and of the other saints, are to be had and retained particularly in temples, and that due honor and veneration are to be given them … because the honor which is shown

them is referred to the prototypes which those images represent; in such wise that by the images which we kiss, and before which we uncover the head, and prostrate ourselves, we adore Christ; and we venerate the saints, whose similitude they bear: as, by the decrees of Councils, and especially of the second Synod of Nicaea [of 787], has been defined against the opponents of images.[8]

Contemporary accounts of painting tend toward optical considerations, and so physical and tactile elements of painting are often ignored. However, the physical and tactile can be recognized in such diverse paintings stretching from Titian to Vincent van Gogh to Robert Ryman. Cimabue's *maestà* addresses the viewer / devotee directly and physically through its essential hierarchy. The saints present the interior grouping of figures with angels who hold up the throne, which is the seat of the Madonna, who supports the Christ child, who lifts His hand in blessing to the beholders.

While the wall painting is smooth and flat, tactility is a theme. The heavenly Madonna and Child are significant as the height of spirituality so that not even the angels touch them. Tactility is recouped in the rendering of the throne. Its vertical supports are rendered as a pattern of circles and segments – in conjunction with the touch of the angels' delicate fingers the pattern gains a knobby tactility. Propriety of touch is maintained and in the case of the throne, heaven is shown as resplendent and abstract, but is made palpable almost to touch.

Traditional Christian Painting

As previously noted, the formula of traditional Christian Painting (including the *maniera greca*, the Italian name for the Byzantine style) is basic – a central icon with flanking figures organized symmetrically, if not precisely geometrically. This ancient order can be observed as early as in a fourth-century mosaic at Santa Costanza in Rome – a fragment of the church's decoration, much of which is now lost (Plate 6). There are many differences between Santa Costanza mosaic and Cimabue's *maestà* in San Francesco, including their material and medium, their iconography and their period style, but their similarities are striking. In the Santa Costanza mosaic, there is an Adonis-like Christ in a typical Classical contrapposto pose at the iconic center rather than Mother and Child. In Christian Painting, the central figure is interchangeable as long as it is deserving of veneration. The iconic center could contain Mother and Child, a youthful smiling Christ, a man on a cross or an omnipotent colossus. Less commonly, the

emblem of the cross, a throne or the hand of God suffices to hold the architectural center. In all these cases, the central figures grasp and absorb the onlookers' attention.

In the mosaic of Santa Costanza, on either side of Christ, who stands over the four rivers of Paradise, there are two apostles rather than the four angels of Cimabue's *maestà*. With their rapt attention toward Christ, they honor and enhance His centrality. The mosaic in this apse is small and four sheep form what, in a larger work, would likely form a procession. Despite the differences, the picture's address, which compellingly acknowledges the viewer's gaze, is consistent with the *maestà*, as is the typology of the central iconic representation with secondary figures on either side. The pictorial organization of Christian Painting was enduringly consistent during its over thousand-year run in the West. (And it should not be forgotten that this pictorial order is still in force in the Orthodox Christian East.)

The pictorial order of Christian Painting, from its ancient origin through the Renaissance, can be characterized by the correlation of architectural and narrative hierarchies. From an architectural standpoint, this correlation is expressed by: the overarching importance of placement; the sizing of the figures; the emphasis on the center as the dominant location both pictorially and architecturally; the unification of the principal figure of veneration with the religious narrative emplaced architecturally; and the symmetrical and often repetitive ordering of figures flanking the iconic center. The significance of the imagery of the flanks is limited to a deferential role to the central theme and image. These images that flank the central icon can assume smaller but still important roles – they fill the architecture but occupy less prominent places. They glorify and visually highlight the iconic center, as do the angels and saints in Cimabue's *maestà* and St Peter and St Paul in the Santa Costanza mosaic.

The glorification of the iconic center is expressed with great pageantry in the sixth-century mosaics of the Basilica Sant'Apollinare Nuovo in Ravenna (Plates 7 and 8). On each side of the nave a host of saints form a sumptious and exquisitely rendered procession toward the apse. On the north side almost two dozen female saints (and the three Magi) line the wall to honor the Virgin with Christ on her lap. Male saints on the right form a procession towards the enthroned, mature Christ. The line of saints echoes the steady rhythm of the church's columns and would have been aligned with the movement of worshipers.

The Basilica Sant'Apollinare was built in the early sixth century as an Arian church. Although Christian, Arianism was an anti-Trinitartian theology deemed

heretical after losing its competition with Orthodox Catholicism. Imagery that hewed too closely to the discredited set of beliefs was removed. While most of the line of saints remained, the original apse and the sections of procession closest to the apse were eliminated. Even without the essential culminating iconic figure, in Sant'Apollinare, the empowering role of the ceremonial flanks is evident.

The Icon and *Istoria*

The structure of traditional Christian Painting is both simple and flexible. It can be observed that, within Christian image-making there are two modes: the Icon and *Istoria*. Their dichotomy is doctrinal, clearly manifested in picture type and was made explicit at the Second Council of Nicaea of 787. The council was recognized by both the Orthodox and Roman Catholic churches (even after they split), which restored icons to their place of glory following their suppression during the period of Byzantine 'image breakers', officially it declared: 'Anathema to those who do not salute the holy and venerable images.'[9]

The attending Bishop Theodosius testifies:

> Moreover, I am well pleased that there should be images in the churches of the faithful, especially the image of our Lord Jesus Christ and of the Holy Mother of God ... Likewise there may be painted the lives of the Saints and Prophets and Martyrs, so that their struggles and agonies may be set forth in brief, *for the stirring up and teaching of the people, especially of the unlearned*.[10]

There are two forms of Christian depiction that function as complementary. The first and central image type is the icon. It is through the veneration of icons that the supplicant may share in the holiness of the painted image. The second class of images, *istoria*, depict stories for edification and teaching. As such, this form of representation is a text made visual, but was not regarded equally. Just as the central iconic figure had precedence over the figures surrounding it, so did the iconic figure and its surrounding figures take precedence over narrative scenes.

The two forms of Christian representation are often integrated, but are designed to produce two distinct types of representation and elicit two types of response. St Thomas Aquinas (*c*. 1225–74) expressed the established Church doctrine on the use of images when he described their three commendable functions: 'Simple people ... are instructed by them as if by books.' Another was to stimulate remembrance: 'The mystery of the Incarnation and the examples of

the saints may be the more active in our memory through being daily represented to the eyes.' Finally, images could prompt 'feelings of devotion ... being aroused more effectively by things seen than by things read'.[11] The iconic mode inspires sublime feelings of devotion, while the narrative mode serves memory and instruction.

The conception of two forms of Christian representation, the icon to be venerated and the *istoria* to inform, was written about early in the Renaissance. Leon Battista Alberti (1404–72), an astute observer of artworks, defines the two types of painting that can gain honor for artists as the Colossus and *Historia* in Latin (or *Istoria* in Italian). The colossus corresponds to the icon. The second type, *istoria*, represents events, and is more open in format. This is the type to depict stories, and was of interest to Alberti, who was deeply engaged in the revival of ancient Roman literary form. The subsequent discussion follows Alberti's division of the Icon and the *Istoria* to explore how the two function within Christian Painting.

Istoria in Sant'Apollinare and Santa Maria Maggiore

It is easy to overlook the small panels up by the rafters in Sant'Apollinare. They are overwhelmed by the vibrant color of the mosaics and the glamorously rendered saints in the nave. Above the parade of saints, between the arched windows, prophets are portrayed in a statuesque frontal manner. Above their heads, images of decorated semi-domes enhance the sculptural presence of the saints. Between these semi-domes, scenes of the life of Christ stand over the windows. At one-fourth the size of the panels of the prophets and at a long reach from the floor, these *istoria* mosaics are not prominent images, nor are they essential to the theological decoration of the church, despite the stories they illuminate.

We can compare Sant'Apollinare to Santa Maria Maggiore in Rome. An earlier Roman church of the mid-fifth century, Santa Maria Maggiore has a similar narrative cycle of biblical scenes, but this cycle is far more integral to its decoration than the *istoria* scenes in Sant'Apollinare. Depictions of Old Testament stories (Plate 9) line the sides of the nave and find their fulfilment in the New Testament themes at the head of the church. Although some of the mosaics have been lost, forty-two original panels remain. These *istoria* pictures are located just above the capitals of the columns, and occupy thirty-four panels in the nave, with many of the panels containing upper and lower scenes. There is a pagan precedent for a parade of

consecutive scenes. Less than a mile from the church is Trajan's column, with its spiral bas-relief showing events of the emperor's exploits, which likely still had some color at the time the mosaics were created and could have served as a model for the coloring as well as the processional order.

The decorative cycle of Santa Maria Maggiore had the function of uniting the Old and New Testaments. The original half-dome mosaic in the apse was reworked by Jacapo Torriti (active 1270–1300) in the late thirteenth century, with the iconic presentation of Christ crowning the Virgin. Some perimeter areas of the half-dome are probably original and it seems that Torriti updated the original central image of the coronation. If so, the religious logic of decoration of the church as a whole is clear. The Old Testament prepares us for the coming of Christ. The *istorie* are handmaidens to the icon.

Monreale

Like Sant'Apollinare and Santa Maria Maggiore, many of the great churches, such as the Hagia Sophia in Istanbul and San Marco in Venice, have been altered over time, leaving their iconography somewhat scrambled. There is, however, a church in which the pictorial logic that stretches from the decorations of early Roman churches to Cimabue and beyond, is almost entirely intact. The Norman king of Sicily, William II (1153–89), began the construction of his royal church, Monreale, just outside of Palermo in 1172. Despite its completion almost a century later in 1274, its representational decoration is consistent in appearance and organization. The church has the only virtually intact example of medieval Christian / Byzantine mosaic design at that scale that remains today.

The interior of Monreale dazzles, with its over 70,000 square feet of mosaics depicting a proliferation of iconographic and decorative cycles set on a background of glittering gold tesserae. The reflecting light of the glass mosaics is wholly different from the architectural light that Abbe Suger was pioneering in the north at St Denis during the same decades. Gothic light is strong, directional and spiritually abstract, even penetrating, as through stained glass windows. In distinction, mosaic surfaces present light refracted in lavish tactility. At the time of King William, Sicily was home to Byzantine, Muslim and Jewish populations, in addition to the Catholic majority and the Norman aristocracy. The architecture of the cathedral reflects this, and the varieties of input from these varied cultures has been well noted. The pictorial order of Christian Painting, from its early origins through the Renaissance, embody grandeur as a fundamental mode as is

unmistakable in Monreale. For our present purposes, it is the iconic structure of the Christian / Byzantine mosaics that is to be considered.

The mosaics in Monreale contain some 120 scenes with close to a thousand figures. Despite a splendor that can shade into glamor, even glitz, the pictorial organization is clear and theologically rigorous. At the head of the church, an enormous Christ is portrayed from the chest up in the standard iconic mode of the *Pantocrator* (Plate 10). He offers a blessing with one hand and holds a book in the other. This is Christ at His most potent. He is the all-powerful, sustainer of the Cosmos. His head is some 10 feet high at the end of the apse and He can be seen from the entirety of the church nave. If presented as a full figure, this colossus would stand almost 50 feet tall and His feet would rest on the marble entablature where the mosaic begins. This Christ is severe but thoughtful. He acknowledges the onlooker's gaze with an expression of wisdom and offers the surrounding scenes and figures for edification, each one delegated to its appropriate place in both the narrative of salvation and the order of the cosmos.

This almighty, all-knowing Christ oversees the central nave, which is decorated with Old Testament narratives, beginning on the north wall with the creation of heaven, earth and its water. The Old Testament narratives move left to right, on two levels encircling the nave. The Old Testament cycle concludes with Jacob wrestling the angel on the south wall. In Monreale, all histories, and all *istorie*, inexorably start and end in Christ. Mosaics of Christ's life and miracles circulate around the aisles and transept of the church (Plates 11 and 12). The aisles end with smaller half-domes with St Peter on one side and St Paul on the other taking the iconic position. Monreale, it seems, aspires to make manifest the full scope of the Bible. Within Monreale's comprehensive theology the crucified Christ is portrayed, but revealingly it is relegated to a minor location that can only be seen from behind the altar. While Christ's death is necessary, its display is downplayed. God's *kenosis* – His renunciation of divinity – is merely a moment in the history of salvation. The point of Monreale's decoration is the infinite glory, not the temporary humiliation, of the Lord.

In comparison to the interior of the Basilica San Francesco, Monreale projects a decorative architectural unity. In Monreale, the stories of the Bible are brought together in a narrative flow that shows all history revolving around and resolving in the Pantocrator. As in Santa Maria Maggiore, the New Testament fulfils the Old Testament. Monreale's consistent background of reflective gold and its hierarchies and symmetries of saints and *istoria* present image and architecture as a whole. With the Fathers of the Church, St Peter and St Paul portrayed in the

lesser apses on either side of the colossal Christ, the Church and King William's church are unified.

Monreale may be unique in its inventive variation of the way that *istoria* is structured. *Istoria* scenes are generally set within frames. In the nave of Monreale, however, each of the *istoria* scenes flows into the next for the entire length of the nave. In Monreale, there are two levels of *istoria* mosaics on each side of the nave that present Old Testament stories. Although the pictorial design on the upper level is punctuated by windows and the lower level by arches, the landscape of the background is continuous on both levels. The sequence of scenes in the lower cycle parade across the architecture, wending through a hilly background that is ingeniously determined by the peaks of the arches. While vertical bands separate scenes, they serve more as architectural embellishments than as divisions. *Istoria* is presented in a rhythmic flow.

This integration of *istoria* into the processional logic of the iconic order was a creative variation within the Christian pictorial order. Bringing *istoria* out of its boxed architectural frames into the larger frame of the church itself offers lively immediacy to the religious experience of witnessing history. In the tradition of Christian pictorial structure, the flanks that honor the central icon could be *istoria* scenes as in Santa Maria Maggiore, or a magnificent procession as in Sant'Apollinare Nuovo. The great church of Monreale merges these two modes so that all history can be experienced as a grand parade to celebrate Christ's glory. Monreale is a glittering theological machine.

The Essentials of Christian Painting

To understand the transformation between Cimabue and Giotto, it is important to grasp the essentials of the tradition of Christian Painting within which Cimabue worked:

1. First, it is architectural. Not only did image making predominantly take place on the walls of churches, it was the operating metaphor that secured Christ to the Church, and Church hierarchies to church buildings. Within the Christian pictorial tradition, painting (painterly mosaics being considered a form of painting) is part of the architecture and its structure is expressed through the architecture in which it appears.
2. Traditional Christian Painting addresses the body. As opposed to the optical 'realism' of later Western painting, its appeal is haptic and tactile. Its subjects

occupy the present and manifest presence. To that end, Christian Painting is presentational as much as it is representational. It embraces splendor, as it generously cloaks its viewers in sumptuous experience. The symmetry of the organization of Christian Painting links it to the bilateral human body and so heightens physical empathy between picture and viewer.

3. Traditional Christian Painting has two modes: the icon and *istoria*. The icon is the votive center of the picture. Its function is to bring its viewer closer to God, and its medium is the image of holy presence. It augments its power and influence through the addition of ancillary figures. (Simple icons, however, can dispense with these figures completely.) Whether many or few, these figures increase the aura of the icon in the fashion of a halo. As such, these figures are organized symmetrically, forming wings of chorus or procession, to enhance the central icon. *Istoria* is more detached than the emotionally demanding icon. Its role is to deliver an informative narrative. *Istoria* edifies, while the icon inspires. Although *istoria* has an essential theological function, it cannot hold the traditional authoritative position of the icon – the demands of faith are made to exceed the claims of experience. *Istoria* pictures may adopt some of the visual structure of the icon with a center and flanks, but since its role is didactic, its foremost requirement is legibility. The central icon is elevated and celebrated by ancillary figures, and *istoria* exists in its lesser role, to enhance the ultimate authority of Christianity's central figures.

4. Traditional Christian Painting can look static, however that does not acknowledge the ancillary figures' direction of movement towards the central image. The purpose of the icon is to hold place. Through its stable presence, the icon's address does not move laterally, but inwardly towards the main figure and outwardly to the devotee. One could say there is no *space* in traditional Christian Painting. This is not to say that it is flat. The Middle Ages did not recognize a dialectic between the flat and the *spatial*. Instead, one could say that, just as traditional Christian Painting is an architectural art, it is, at its most fundamental, an art of place.

Transformations in Christian Painting

Significant to Christian Painting's long appeal, is its flexibility and ability to adapt. Icons can be small and personal, or encompass the entirety of a church. Within its framework of images there is imaginative variation: the marrying of the processional logic of figures flanking the central icon with *istoria* in Monreale;

the fusing of the emblem of the cross with the figure of Christ in the shaped crucifix icons. In Cimabue's double-crucifixion scenes on each side of the transept of San Francesco, both *istoria* and icon collaborate to locate the place of life-giving mass with the precise moment of Christ's death. Christian Painting's simplicity does not preclude innovation.

Following Suger's renovations in St Denis, Gothic architecture grew in popularity. In churches, large windows and expressive tectonics supplanted the Romanesque and Byzantine marriage of image and wall. And so Christian Painting had to adapt and find a new format. During this period, the altarpiece went from being an unusual, often Byzantine import to a standard of Christian Painting in the West. With its figures often less than life-size, altarpiece paintings could not achieve the physical impact of wall cycles or colossal icons. Still, the splendor, the central prominence of the icon and the symmetry of its flanking figures remained. At the same time, *istoria* scenes became formalized and found their place at the base of the altarpiece as its predelle.

Altarpieces became prominent as part of the developing Gothic idiom and they emphatically follow the architectural tenets of traditional Christian Painting. Although it seems to have gone unremarked, the Gothic variation of Christian Painting contains an innovation characteristic of the new style. Distinct from traditional Roman (and Romanesque) architecture which establishes itself with rhythm and repetition, Gothic architecture is distinguished by sliding scales of miniaturization. Once this is recognized, it is clear that altarpieces are nothing if not churches in miniature. Altarpieces are a scaled down, hyper-realized collection of architectural motifs with openings filled with pictures. Christian wall painting, which lost its place on the walls of Gothic churches, is reconstituted in miniature within the elaborate architectural frames of altarpieces. Exploiting their freedom afforded by their small size, altarpieces could become intricate fantasias of Gothic architecture. In the intensity of rendering architectural form, altarpieces bring a vivid sense of tactility to the experience of the paintings.

Traditional Christian Painting is distinct in typology from Western painting that succeeded it. But the forms of Christian Painting go on to nourish painting in subsequent centuries. Painterly tactility and haptics, architectonics in painting, emotional realism, the interest in frontality and presence, are all issues that are within the rigorous and imaginative tradition of Christian Painting – and remain viable painters into the present.

Leo Steinberg opens his book on Leonardo's *Last Supper*, with queries about the painting, 'Is there anything left to see? and, Is there anything left to say?'[12] Steinberg answers in the affirmative, and fills his book with insights into the

iconography of the painting and the manner of its perspectival depiction. He writes brilliantly about the painting's architectural context. Still, he expresses some frustration when he complains about its composition: 'Since almost everything in the picture seemed to relate to the central character, how escape the tedium of continual back reference to the same figure?'[13]

What Steinberg neglects is that within the traditional format of Christian Painting, the 'continual back reference' to the central iconic figure is *the whole point*. In this way, the *Last Supper* corresponds to the Byzantine format of Monreale. As at Monreale, Leonardo's Christ is the iconic figure at center. In both cases, all figures flow toward and from Christ. In terms of pictorial organization, the *Last Supper* is fundamentally of the icon rather than the *istoria* type.

With terms like 'The Sanctification of Space',[14] and '*spatial* construction', Steinberg is writing within a modern conception. This semiotic of pictorial *space* tends to slight the logic of Christian Painting, even to the extent that the older tradition is often treated as outside of historical consideration. But *space* can only go so far to elucidate a painting of Leonardo's time and world view. Leonardo produced voluminous notes with scarcely any mention of *spazio*. However, the significance of the relationship between the central icon of Christ with ancillary figures would have been familiar and urgent to contemporaneous viewers.

Without the modern and deforming concept of pictorial *space*, there is an opportunity to see how artists, and one in particular, developed a new paradigm for pictorial organization through working within the principles of Christian Painting. The next chapter will explore the mechanics of that transformation and how and why *istoria* painting came to take a preeminent place in Western painting.

Notes

1 Dante, *Purgatorio* [*c*.1310], Canto XI.
2 Giorgio Vasari, 'Giovanni Cimabue', *Lives of the Most Eminent Painters*, 5.
3 Diana Darke, *Stealing from the Saracens: How Islamic Architecture Shaped Europe* (London: Hurst & Company, 2020), 3.
4 Trinita Kennedy (ed.), *Sanctity Pictured: The Art of the Dominican and Franciscan Orders in Renaissance Italy* (London: Philip Wilson Publishers. Published in conjunction with the exhibition at the Frist Center, Nashville, TN, 2014), 4.
5 Vasari, *Lives of the Painters, Sculptors and Architects*, 7.
6 Leon Battista Alberti, *On Painting: A New Translation and Critical Edition*, trans. and ed. Rocco Sinisgalli (Cambridge: Cambridge University Press, 2011), 55.
7 Vasari, *Lives of the Painters, Sculptors and Architects*, 4.

8 *The Council of Trent: The Canons and Decrees of the Sacred and Oecumenical Council of Trent*, ed. and trans. J. Waterworth (London: Dolman, 1848), 234–5. Hanover Historical Texts Project, *Concilium Tridentinum: Documenta Omnia*, 87, Documenta Catholica Omnia, https://www.documentacatholicaomnia.eu/03d/1545-1563,_Concilium_Tridentinum,_Documenta_Omnia,_EN.pdf (accessed 2024).
9 'Session 1', Second Council of Nicæa, ed. Labbe and Cossart, *Concilia*, vol. 7, col. 53, www.newadvent.org (accessed 2024).
10 Ibid., emphasis added.
11 Aquinas, *Scriptum super sententiis*, as quoted in Patricia Lee Rubin, *Images and Identity in Fifteenth-Century Florence* (New Haven, CT: Yale University Press, 2007), 178.
12 Leo Steinberg, *Leonardo's Incessant Last Supper* (New York, NY: Zone Books, 2001), 1.
13 Ibid., 15.
14 Ibid., 171.

4

Painting from San Francesco to the *Navicella*

Istoria in San Francesco

In the Basilica San Francesco, sometime after Cimabue completed the murals in the apse and transept, within the decade of 1290, a group of very different artists were commissioned to create pictures for the nave of the church. There is no documentation of who these painters were as the records of the Basilica were destroyed around 1800, when Napoleon's army commandeered the church. The nave of the upper basilica is divided into three levels of painting panels. The upper two levels present a sequence of biblical scenes, with the Old Testament on the north wall and the New Testament on the south wall. These biblical *istoria* scenes are related in format and appearance to traditional Christian Painting and the figures bear a resemblance to those in the *istoria* mosaics of Monreale. The lower level contains one of the best known medieval painting cycles. In twenty-eight wall panels it depicts the legends of St Francis. Commonly, but also contentiously, the fresco cycle has been ascribed to the youthful Giotto as the primary painter.

Large sections of the two upper levels of the nave are lost but in terms of their style and technique, they are more like Cimabue's painting in the transept than the St Francis cycle below. There are two panels on the second level that stand out from the others. These two panels depict the story of Jacob and Esau and, in common with the frescoes on the first level, break from earlier *istoria* paintings (Plates 13 and 14). Their technique is also different. The panels of Jacob and Esau were not painted *al secco* like other paintings on the upper level, but are painted in true fresco like the St Francis paintings below.[1]

These newer paintings significantly differ from the old in two aspects of style. In appearance, the figures are modelled with a more sculptural appearance. Distinctively and breaking with tradition, the figures' primary interactions are with each other, rather than appealing to their viewers. The figures are integrated within the scene, rather than to the architecture of the church.

Comparing how tactility functions in the two Isaac Story panels in distinction to traditional Christian Painting is also revealing. Tactility plays a central role in the two Isaac panels but differently from icons in which touch is a potent element of the pictures' physical appeal. Instead, touch is represented as a theme in the story. The frescoes portray the biblical story of Isaac, his wife, Rebekah, and his sons Esau and Jacob, presenting the story in two concentrated instants. In the first panel, the image of Isaac touching the hand of his son Jacob sets the narrative in motion.

The story recounts how the aged and blind patriarch Isaac is tricked by his wife Rebekah. She has schemed to ensure that her preferred child, Jacob, receives the inheritance meant for her older son, Esau. Isaac promises Esau, the eldest of his sons, his blessing and the inheritance that the blessing implies. But, first he requests that Esau hunt and bring him a meal. Esau dutifully leaves to hunt for his father's dinner. Rebekah, overhearing the conversation, and favoring the younger of her twins, Jacob, plots for his succession over Esau. She sends Jacob to slaughter a kid goat so that she can prepare the meal for her husband and fashion gloves and a collar from their skins. The older son, Esau, is hirsute and Jacob dons the goatskin so that when his blind father touches his hand he will think it is Esau. In the first panel, Isaac is supported in bed by a servant. Rebekah, in a blue cloak, holds open a curtain while Jacob, in hairy collar and gloves, holds a bowl of food. His father grasps his gloved hand (thinking it is Esau), and while the plaster section that portrayed Isaac's other hand is lost, presumably he is making the sign of benediction. Thus, what is depicted is the moment that Jacob and his mother mislead the father into bestowing the blessing meant for Esau to Jacob, and thereby the family inheritance.

In the second panel, Isaac has reclined back in bed and refuses to bless the real Esau, even as Esau offers his father a spoonful of the dinner he prepared. The maid, holding a pitcher, looks on. While we only see the back of her cloak, and not even her head, we know Rebekah has turned and exited. It has been pointed out that this is likely the first instance of a figure portrayed from the back in Christian Painting. Although quite damaged, on the right Jacob can be distinguished as he hurries away through an open door.

It is a story of a successful swindle, full of drama, adeptly represented in two panels. There is abundant drama containing themes of vision, blindness, tactility, deception, food and inheritance that is presented to the fresco's viewers. Tactility, in the Isaac fresco, is one of a complexly intertwined set of themes within the overall presentation of the story. In the frescoes, touch has been abstracted to a theme within a narrative. In contrast to the mosaics in Monreale and Cimabue's

sense of tactility which is directed toward the bodily viewer, tactility, here, is directed away from physicality and instituted as an element in the drama. This reflects a new prioritization of *istoria's* drama over the physical experience of the architectural icon in traditional Christian Painting.

In comparing San Francesco to Monreale, we can see how *istoria* is re-envisioned in the Isaac story frescoes. In Monreale, despite their activities, the figures look out from their positions on the wall in an address to the congregation. As such, its *istoria* functions like a sermon with the various scenes serving as examples within the narrative directed to an audience. However, the Isaac story in San Francesco functions more like theater, with the protagonists entirely engaged within the drama and separated from its viewers. Each panel represents a potent instant within the story. The figures through their gestures perform the drama rather than serving as markers of the narrative script. The figures are intimately specific and are fully embedded in sequential dramatic moments.

Although liturgical theater has a long history, few medieval texts survive. However, their popularity is indicated by their suppression by a papal bull in 1210, which forbade clergy from participating. In *Mimesis*, Auerbach points out, the aim of these liturgical plays was to make the biblical past vitally present: 'The ancient and sublime occurrence is to become immediate …; it is to be a current event which could happen at any time, which every listener can imagine and is familiar with …'.[2] This is also an apt description of the theatrical effect and the emotional realism of these frescoes.

There are other dimensions of theater that can be detected in the frescoes of the Isaac story. While modern commentators have characterized the depictions of the interiors as indicative of a new sense of pictorial *space*, theater sets can serve as a more contemporaneous model. The architectural settings as seen in the Isaac story are as rigorously specific as the characters' gestures. Further, repeating the depiction of the room from one panel to the next, from the same vantage point, asserts a continuity of the place. As the architectural setting is constant, the position of actors is presented sequentially. This sets up dramatic entrances and exits to give the narrative its propulsive force.

While even less is known about the architecture in which thirteenth-century mystery plays were performed than the texts of the plays, later illustrations of pageant carts indicate that some contained several levels of living tableaus and stage sets. The individual stage sets, with their small interiors and elaborate architecture bear a striking resemblance to the interiors we see in the San Francesco Isaac story. Continuity between theater sets and the frescoes makes sense as the theater stage is a pictorial frame. While the degree of the influence

of liturgical plays on painting (and vice versa) cannot be known, it could only have contributed to the era's pictorial imaginings.

Authorship and the Nave of San Francesco

Within scholarly circles, there is an ongoing debate over the attribution of the Isaac story frescoes that likely will never be resolved. That said, it is generally agreed that these panels are distinct from the panels that can be attributed to Cimabue and from the rest of the upper biblical scenes in the nave. In terms of their facture (fresco), and the sculptural impression of the figures as well as the strikingly new pictorial order of the *istoria*, they are closer to the twenty-eight frescoes panels that make up the legend of St Francis than to Cimabue's paintings. While some ascribe the Isaac frescoes to Giotto, not everyone agrees. Although it is tempting to ascribe these panels to a single, gifted innovator, this kind of attribution is anachronistic. These frescoes were a team effort, from the Church authorities who commissioned the works to the unnamed artisans who ground the pigments. Fresco simply demands too much work in too short a time for these murals to have been the accomplishment of a single individual. At least two dozen people, and likely more, would have been required.

Modern scholarship has determined the nave was painted, at least, substantially between 1288 and the closing years of the thirteenth century.[3] During this period, personnel would likely have changed and work could have been interrupted and then restarted. There are many possible explanations for the inconsistencies of this cycle of murals. It is hard to deny, though, that the frescoes in San Francesco constitute a sea change in painting. The frescoes in the nave of San Francesco present a paradigmatic moment in the history of painting – they are transformational and inaugurate a powerful new tradition of *istoria* painting.

Of all the masters who have been proposed as being associated with the San Francesco frescoes, Giotto is the only one to immediately pick up on the innovations first seen in San Francesco. In the Scrovegni Chapel, definitively painted by Giotto between 1303 and 1305, the *istoria* scenes are rendered along the same lines. In common with both painting cycles is the use of fresco technique, figures rendered in a sculptural manner and a pointed sense of theater – all of which were pioneered in San Francesco. Decades after the San Francesco frescoes were commissioned, Giotto decorated the Bardi Chapel in Florence with scenes of St Francis' life and death. Notably, in several of the panels, elements

from San Francesco were incorporated indicating a connection with the earlier paintings. As such, it is hard to dispute that the innovations in the San Francesco Isaac story and the St Francis legend are fundamentally Giottoesque, even if the paintings were not entirely 'by' Giotto.

The Commission of St Francis Cycle

From the outset, the commission for the St Francis legend presented fundamental problems for the painters. The hybrid architecture of the church posed a conundrum – the substitution of a windowed Gothic apse for the traditional pictorial field of the semi-dome meant that there was no place for a single arresting image to unite the cycle. Instead, Giunta's colossal *Cristus Patiens* was mounted on the rood beam by the altar, which interrupted the flow of images into the transept by occupying the architectural center of attention. Although the tortured and dead God-Man on the cross is essential to Christian theology and crucial to its pathos, it is difficult to crown an *istoria* cycle with this image. To provide the Franciscans' most important church with a coherent series of images could not have been simple. However, San Francesco made it even more difficult, because its architecture is caught between two incompatible design programs. The problem could not be solved by familiar means. Something new was required.

The painters' pictorial solutions to the architectural issues that the nave of San Francesco presented set in motion what would become a new regime of painting that upended the ancient organization of Christian Painting. Instead of attempting to order the *istoria* panels in a way that subordinated them to the church architecture as whole, the resulting frescoes showed that *istoria* panels could stand on their own.

The Image of St Francis

The cycle of the St Francis Legend in San Francesco's nave had difficulties beyond its architecture. There was a fierce controversy over the essence of St Francis and how he should be represented. The spiritual Franciscans insisted on following St Francis' example adhering to a rigorous life of holy poverty, while the conventional Franciscans advocated submitting to the Church's authority as a more traditional monastic order. Although St Francis lived and performed his

miracles largely outside the Church, he always supported the papacy. Should the saint be depicted as the 'poor man' or should he be presented as endorsing the glory of the Church and reflect its splendor?

The earliest surviving depiction of St Francis was painted just a few years after his death, on the walls of the Benedictine Abbey in Subiaco, where he had stayed some years earlier (Figure 3). The anonymous wall painting might be a likeness, but not quite a portrait. It might serve as a testimonial to his presence at the Abbey, but it is not a votive picture. The painting shows the saint in a refreshingly informal manner, youthful and charismatic. Even so, a very different St Francis was quickly to become the standard image of the saint.

In the icon panels that followed in the next decades, St Francis is depicted as haggard and somber, quite distinct from the Subiaco wall painting and from the later depictions in the nave of San Francesco. The inventive Giunta Pisano may have originated this new icon format of the saint surrounded by small depictions from his life. An early work attributed to him appears to establish its structure.

Figure 3 St Francis, wall painting, Subiaco Abbey, c. 1228.

A later, expanded version attributed to Coppo di Marcovaldo (*c.* 1225–*c.* 1276) adopts a similar tone and organization but includes twenty scenes, in contrast to Giunta's six (Plate 15). Coppo's votive image of St Francis stands at the center, almost life-size. St Francis is flanked by small *istoria* pictures of his life and death. Although the format of the altarpiece is minimal, it can be seen as a church, both in elevation and plan. The figure of St Francis serves as the body of the church, and the *istoria* scenes act as pictures on the aisle walls. St Francis was welcomed by the Church, and supported by popes during his lifetime. However, in Coppo's icon, there is something misaligned about St Francis *as* a church. It was standard for saints to be housed within architectural forms, but St Francis was paradigmatically different.

At the top of the panel (in the crucial place of the apse if the church and icon analogy holds), two angels hover above the saint's head and a scroll presented by the hand of God reads, 'Heed with No Restraint the Teachings of this Life.' However, the symbiosis of icon and *istoria* is unsettled here. The depiction of the saint lacks the sublime pathos of a *Cristus Patiens*. We are principally called to venerate the saint by imitating his life, not by contemplating his suffering. To put this another way, the *istoria* panels, which portray his actions and miracles, are just as important, if not more, than his image as an icon.

St Francis' imagistic actions occurred mostly outside the Church, culminating in the stigmata in which the true image of Christ represented the living saint's body. This was a profound break with the Church's monopoly of religious images. One response was the *Cristus Patiens*, in which the truth of Christ's suffering is painted on the shaped cross. Just as the Church grasped that St Francis was a persuasive emissary beyond its precincts, there needed to be a pictorial response to depict St Francis' worldly spectacles. The challenge was to fuse the outer mundane with the inner sensibilities of the Church.

To engage this issue, the repertory of Christian Painting offered an opportunity – *istoria* was available to be repurposed. Cut loose from its duty to form a chorus or a procession as in Monreale and in Coppo's icon, *istoria* could frame and honor an event, an action, rather than a holy figure. *Istoria*, like the saint himself, could resonate within the Church and lead the imagination of its audience outside the church walls to see an expanded spirituality in the wide world.

So it is that in the first panel of the St Francis Legend in the nave of San Francesco, a new St Francis makes his entrance. Like a starring actor making his debut, he is graceful, even beautiful. Here, St Francis is no longer the suffering *poverello*, the 'poor little man' as Giunta and Marcovaldo represented him (Plate 16). In the new fresco cycle, St Francis is portrayed as befitting a courtier and

emissary of God. The theologian, St Bonaventure (1221–74), produced a new official hagiography in 1260, an account that superseded Thomas of Celano's original, which the Church then consigned to oblivion. While the two biographies overlap, their descriptions of the young Francis are strikingly different. In Thomas' book, Francis 'surpassed all his friends in the worthlessness of his pursuits: he was their ringleader, always the first to suggest mischief, a zealot in the cause of folly'.[4] In contrast, St Bonaventure's Francis is pious from the start. St Bonaventure tells us that from an early age, Francis 'could scarce ever hear words telling of the love of God, and remain unmoved in heart'. St Bonaventure writes that 'the charm of his gentleness and his courtly bearing'[5] presaged his future holiness.

In the St Francis Legend, the subject of each of the *istoria* panels in the nave directly corresponds to a passage from St Bonaventure's text. The first panel of the Legend illustrates the first anecdote in Bonaventure's hagiography:

> A certain citizen of Assisi, a simpleton as was believed, yet one taught of God, whensoever he met Francis going through the city, would doff his cloak and spread the garment before his feet, declaring that Francis was worthy of all honor, as one that should ere long do mighty deeds, and was on this account to be splendidly honored by all the faithful.[6]

The first panel depicts the dramatic action of the simple man, and more (Plate 16). The event takes place in the central piazza in Assisi, where the townsfolk form an audience that casts a critical eye on what they see in front of them. To the left, two men converse together and they are impressed: one gestures to the handsome Francis, who steps gracefully onto the cloak. The two townsfolk on the right react to the incident less approvingly and frown at the oddness of the scene. The painting's audience, then, is presented with two different reactions with which they may – or may not – identify. Like the frescoes of the Isaac story, this panel offers us dramatic flourishes that go beyond the rudiments of the story.

In the tradition of Christian Painting, each picture type moves toward its goal. Icons aim at sublimity and devotion, *istorie* aim at didacticism and knowledge. The strength of icons and *istorie* lies with their constraint. They should include nothing extraneous that will distract from their fundamental purpose. But in the *istoria* of the Simple Man, the townsfolk enjoy individual particularities that go beyond what is required for the anecdote. The abundance of pictorial details make tangential narratives intriguingly possible.

For example, the Temple of Minerva (a familiar Roman landmark in Assisi) has been given a rose window; the sign that it is a church. Although it would

become a church years after the fresco cycle was painted, at the time it was the town prison, as indicated by the depiction of bars on two windows. Through its long history to the present, the actual Temple of Minerva, however, never included a window in its pediment. In the painting, the rose window is located high on the centerline of the panel. It occupies the sacred center of the picture. What does this mean? Could it signal the victory of the Church over Paganism The Church over prison? Or was it a piece of artistic freestyle? Intriguingly, directly across the nave, the fresco shows the liberation of Pietro the Heretic, the only other panel that depicts a prison. Here, interpretation can go in many directions, and maybe too far, but it is instructive that *istoria* allows for intricate and subtle readings. Such flexibility and richness made *istoria* attractive.

While the function of *istoria* was to instruct, the *istoria* scenes in San Francesco were newly expansive. By bringing greater detail and complexity to painting, these frescoes demanded sophisticated responses from their viewers. The paradigmatic new *istoria* mode now offered a larger pictorial range and could present richer stories.

Organization and Order in *Istoria*

Although the pictorial strictures for icon paintings are flexible, they are firm. The dominance of the center, of symmetry and of repetition elicit and hold the viewer's attention. Just as importantly, icons do more than represent their subjects. They establish relationships and hierarchies on which their meanings depend. Legibility is equally important for *istoria* pictures. However, because the structure of *istoria* is less constrained, the organization of the pictures can be more open. *Istoria* pictures tend to move from left to right (as does the pathway of reading in the West). In itself, the organization of *istoria* does not address its viewer with the frontal clarity of an icon painting. An *istoria* presenting the life and works of a saint need not display sublime power (or tragedy) as did icons of Christ. Rather, a more measured display of the saint's holiness would be required. The *istoria* panels in San Francesco's architectural context did not have a central iconic figure to lead to. Rather, they had to stand on their own, which required something of the magnetic power of icons, but without a central image to worship.

The first panel of the St Francis Legend performs two important tasks. It introduces the new courtly St Francis and thus foreshadows the honor the Church will bestow on him. The panel also initiates a new pictorial strategy for *istoria* scenes by taking up the centering logic of the icon. Because the purpose

of *istoria* is narrative rather than devotional, the central position is at the crux of the depicted story.

In the panel of St Francis and the Simple Man the young Francis is on the left stepping toward the votive center. Other than the rose window depicted on the temple, the center is unoccupied. More precisely, it is absent of figures, but not empty of dramatic significance. In Christian Painting, the center is always significant and in this panel that significant center lies midway between Francis and the simple man. The pictorial center of the panel aligns with the dramatic crux of the event. The emphasis is on Francis' movement, towards the central place that he will come to occupy. In this picture, the hierarchical language of iconicity has not been overturned, it has been repurposed to focus on the narrative.

Variations in the geometry of centering as a means of creating significance appear throughout the fresco cycle. In five of the twenty-eight panels, the saint's halo is positioned along the central vertical axis. Vertical lines play a crucial role in the pictorial structure: buildings are consistently shown with their vertical edges rendered perfectly plumb. In nearly a third of the twenty-six narrative panels, the middle division of the panel aligns with a column or architectural edge.

In virtually every fresco, the center of the panel or the vertical line through the middle coincides with the narrative's emotional or dramatic pivot. This axis serves as a hinge, joining the left and right halves to form a cohesive narrative scene. A dynamic symmetry emerges: in this pictorial organization, both sides reinforce the central drama. Unlike traditional icons, whose flanking elements crescendo toward a dominant central figure, the *Legend of St Francis* offers a different construction. Innovatively, in the majority of panels, the left and right sides form a visual order that frames the central event and shapes the depicted anecdote.

Toward a New *Istoria*

As is the case with the story of Isaac, each *istoria* panel in the St Francis Legend is its own framed stage. The figures are contained within each scene and do not gesture beyond the frame.

The viewer's gaze is anchored at the middle point of panels. There is no adjustment for the angle of viewing: each panel assumes that it is seen on a horizontal line that extends from the midpoint of the painting to the viewer's eye. In contrast, the *istoria* narratives in Monreale provide for rhythmic and

mobile viewing of the figures who traipse along the wall, with the processional of the parade of saints at the Basilica Sant'Apollinare Nuovo where the viewers move with the parade. In Monreale, the figures serve as the architectural measure for the *istoria*, while in San Francesco, the rectangular frontal plane of each *istoria* scene acts as the architectural unit (Plates 3 and 16). The frontality of viewpoint and the strongly framed scenes establish the panel's relationship to the architecture of the church. This frontality of view is a hallmark of the Giottoesque style. Similarly, in the Scrovegni Chapel Giotto presents his scenes as frontal pictorial blocks. Nevertheless, two panels in the Scrovegni Chapel do not fit this pattern. On both sides of the arch leading to the apse, pictures propose the fiction that the viewer is looking through to the ceiling of a non-existent transept. These pictures are neither icon nor *istoria*, but a witty and novel form of architectural decoration that is consistent, coming from the artist who would reimagine *istoria*.

The great accomplishment of the *istoria* frescoes in San Francesco is that for the first time in Western painting, *istoria* had the gravitas of icon painting, while still being able to inform and educate. If the San Francesco frescoes are not as lavish as the mosaics in Monreale, they are finely detailed and gorgeous. Although in St Francis' death, there is sadness, the cycle does not attempt to achieve the fever pitch of pathos that characterizes the icons of *Cristus Patiens*. In the St Francis legend, the emotions are empathetically of this world, not cosmic.

The frescoes in San Francesco represent a genuine turn in the relation of the icon to its subsidiary images – the *istoria* scenes. Until these paintings, there is no cycle of *istoria* known to us today that functions with the equivalent independent authority of the St Francis cycle. The challenges of the church's architecture and the demands of a new understanding of St Francis led to a new importance for *istoria* painting and geometric dignity for this genre of painting. The reprioritizing of pictorial fundamentals in San Francesco represents a revolution in Christian Painting.

The *Navicella*: Turning to Giotto

Within a decade from the inventive frescoes of San Francesco, the newly developed *istoria* picture was accorded the pride of place previously reserved for icons. An enormous mosaic was commissioned for the most prominent architectural complex in the Christian West, within the grounds of St Peter's

Basilica in Rome. This represented a major and inescapable indication of institutional approval of *istoria* innovated in San Francesco.

The 31 by 43-foot mosaic, which came to be known as the *Navicella* (the little ship), depicted the biblical scene (related in Matthew 14:24-32), in which Jesus walks on the water (Plate 17). It showed eleven of the twelve Apostles variously huddled in a small ship on a storm-tossed sea. At the far right of the picture, the twelfth apostle, St Peter, was shown standing outside the boat, reaching for the hand of an upright Christ. Contemporary viewers would have recognized in the *Navicella* an allegory of the Church (symbolized by St Peter) in peril, but ultimately saved by faith.

The *Navicella* mosaic was a political billboard, advertising the authority of the Roman papacy. Although the date of the mosaic was contested for many years, a recently discovered document from the archive of St Peter relates that the cardinal and canon of St Peter's, 'arranged for the little ship of St Peter to be made of exquisite mosaic work by the hand of the highly famous painter Giotto' in 1298.[7] This earlier date means the mosaic was part of Pope Boniface VIII's facelift of Rome, likely with an eye to the Jubilee of 1300. Boniface, who became pope in 1294, was a vigorous advocate for the Church and its temporal power. Within a decade, though, the Church was beset by a period of turmoil: Boniface was murdered, and the papal court removed to Avignon.

At first glance, it seems odd that Giotto was awarded such a prestigious commission. He was not a mosaicist. In fact, the *Navicella* seems to have been his only work in that medium. Coming from Florence, not Rome, this meant that Giotto was chosen over brilliant and established local mosaicists, such as Pietro Cavallini (1259–*c*. 1330), Jacopo Torriti (active 1270–1300) and Filippo Rustiti (*c*. 1255–*c*. 1325). Michael Viktor Schwarz writes:

> The dating of the Navicella mosaic to the years immediately before 1300 is important: it shows that the young Giotto was a protagonist in the contemporary Roman art scene, embedded in a culture that his patron experienced as a renewal of ancient Rome. Hand in hand with this, Giotto's early works in remote Assisi, associated with the emergency name 'Isaac Master', can be linked to the metropolis on the Tiber. The hothouse, in which Giotto's art matured was the Rome of the papal curia and its visual culture, shaped by (late) antique models and modernized by (late) Byzantine impulses. It was an art scene that would not have been possible in any other place.[8]

The canon of St Peter's, Cardinal Jacopo Stefaneschi, who hired Giotto, must have seen something singular in the Florentine that made him see beyond technical experience and civic loyalty. After all, this was a unique commission. Until this mosaic, there is no known example in the history of Christian Painting of an *istoria* scene of this size assuming such a prestigious place. If, as Schwarz argues, Giotto had taken the principal role in designing the Isaac story and the St Francis cycle in San Francesco, there would have been good reason for Stefaneschi to contract Giotto for the mosaic. It should be noted that at that time (and for some decades after), only Giotto could compose such a complex and powerful *istoria* picture – and this was recognized at the highest levels of Christian authority.

The Remarkable Mosaic

While it is generally agreed today that the Scrovegni Chapel in Padua represents Giotto's foremost achievement, for over two hundred years, it was the *Navicella* mosaic that was considered his great masterpiece. It is the only 'modern' artwork Alberti mentions in his treatise *De pictura*, and Vasari owned a drawing of the *Navicella* by Parri Spinelli (c. 1387–1453). With its spectacular size and dramatic sweep, it impressed everyone who saw it, not only writers and painters. Nowadays, we can only imagine the shimmering effect of sunlight on the golden tesserae of its background and its subjects rendered in bright glassy colors. That it was seen as a fresh and modern picture is indicated by the way that it was taken up by other painters. Unfortunately, the *Navicella* was almost entirely lost in the rush to demolish the old basilica of St Peter's to make way for the late Renaissance structure that stands today. We are fortunate that there are a few renditions of the mosaic, including a full-scale oil-on-canvas copy owned by the Vatican (but not on display) to show us what it looked like before its destruction.

The *Navicella* did not depict a stable icon at its center. Rather, it presented Christ's disciples in a fragile little boat in a storm. Above the boat's billowing sail, the requisite four Evangelists would have been seen in the top corners. Just below them, naked Pagan gods blew the winds that threatened the boat. On the bottom left, a fisherman ignores the sacred drama unfolding before him and on the right was a donor image of Stefaneschi, shown praying, both in, and to the entire picture.

Contemporary commentators noted the beauty of the ship and the forceful depiction of the sail, but the image of a topsy-turvy boat must have been a

strange stand-in for a venerable icon. Although the drama proceeded left to right (as was standard to *istoria*) and found its terminus in the drama of St Peter and Christ, the Christ figure was uncharacteristically far off center. Still, He was portrayed frontally and formally, facing outward to viewers like Christ the Pantocrator. He was larger than the other figures but inhabited a relatively small area in the larger pictorial field. The mosaic thus offered a deft fusion of the narrative flow of *istoria* and the *gravitas* of an icon. Its drama was clear and relatable. The fisherman on the left, sometimes said to be a self-portrait of Giotto, was not part of the narrative but as he was oblivious to the miracle before him, it introduced something of the mundane to the *istoria* depicting the supernatural event.

Never in the thousand-year tradition of Christian Painting had the architectural placement of images – so essential for their significance – been reimagined as radically as with the *Navicella*. The central location previously reserved for iconic sacred images such as Christ the Pantocrator or a *maestà*, now was occupied by a single *istoria* picture (Figure 4). With high theater and gravitas, the picture transgressed the architectural boundaries that had separated icon and *istoria*. Its pictorial center – the devotional site of icons – was occupied by the ship (the Church) and not by Christ, who was literally sidelined. The fate of the papacy, as

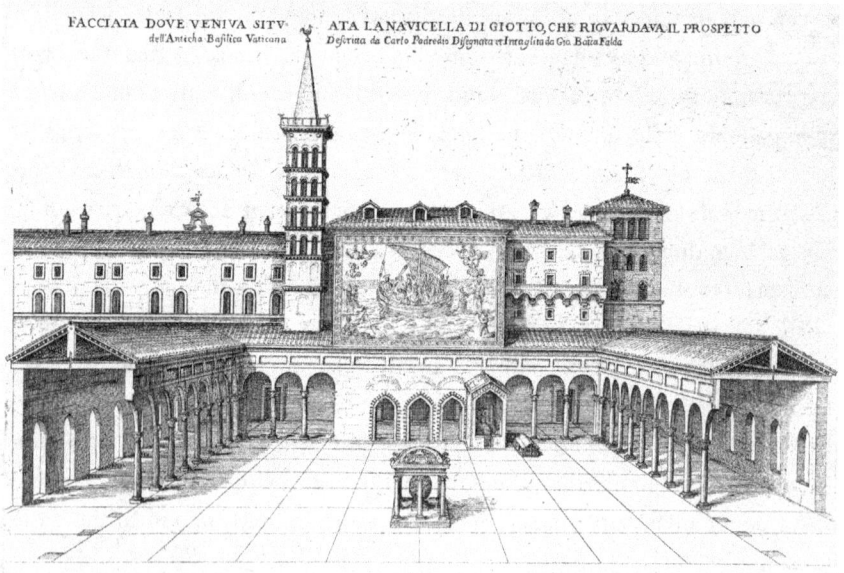

Figure 4 The *Navicella* in its original location as seen from the front of St Peters, engraving, 1673.

linked to the fate of the Church, has literally assumed central importance. For the first time in the history of the Western Church, a single *istoria* was given the significant central architectural place rather than as a sacred icon.

Within the early decades of the of fourteenth century Giotto's novel reimagining of *istoria* was seized upon. Following the *Navicella*, several painters were commissioned to produce grand *istorie*. As well as Giotto's own fresco cycles in the Scrovegni Chapel of Padua, between 1336 and 1341 Buonamico Buffalmacco (*c*. 1290–*c*. 1340) produced a grand fresco, *The Triumph of Death* for the cemetery in Pisa. In 1338, Ambrogio Lorenzetti (*c*. 1290–1348) unveiled his *The Allegory and Effects of Good and Bad Government*, commissioned for the town hall in Sienna. These paintings are repercussions of the revolution the frescoes in San Francesco and the *Navicella* initiated.

Writing in the mid-fifteenth century, Alberti claims that painting an '*istoria* gives greater renown to the intellect than any colossus' ('colossus' refers to icon images).[9] It is Alberti's position that *istoria* is not so much a format as a field of possibilities. By negotiating the complexities of proportion, composition, inscription and propriety, *istoria* can attain the vaunted heights of Classical rhetoric. The poetry available to *istoria* is greater than anything hierarchic icon painting can achieve. The advantage of *istoria* over the colossus and the iconic mode is its range and difficulty. Through the creative performance of painting an *istoria*, the artist's intellect is displayed. Although Alberti discusses several ancient painters and refers to ancient paintings, there is a single modern painting he cites: Giotto's *Navicella*.

The Turning

The new structure of *istoria* as Giotto developed it emphasizes: (1) The emotional drama of the story rather than merely its instructional or sumptuous presentation. (2) A tightly bounded framing of the scene within the borders of its 'stage'. As such, figurative images interact with each other within the scene rather than with the surrounding architecture and viewer. (3) A revised relationship of picture to architecture so that the framed depiction is the architectonic unit rather than a figural icon. (4) A creative expressing of centering, symmetrical order and repetition as means to clearly present the story, but also to dignify the *istoria* by appropriating presentational strategies from icon painting. These four elements represent the transformational beginning of fundamental pictorial order and the turn of Christian Painting to History Painting.

Giotto's novel reimagining of *istoria* was seized upon. If not immediately, within two decades following the *Navicella*, several painters produced large *istorie*. Buffalmacco and Lorenzetti painted *istorie* to create sweeping narratives of images and actions. Certainly *istoria* did not immediately replace the iconic structure of Christian Painting. Although its figures are more 'natural', Leonardo's *Last Supper* is fundamentally Christian Painting in type, even as that structure is simultaneously rationalized with optical perspective. By the time Jean-Auguste-Dominique Ingres (1780–1867) was painting, the tradition of Christian Painting in the West had mostly collapsed. Much has been made of Ingres' Classicism, however, with such paintings as his portrait of Napoleon enthroned and his Jupiter and Thetis, it can be seen Ingres understood the powerful format of Christian Painting – even Byzantine painting – and how to apply it for fresh expressiveness. Today, despite what is considered our open view to history, Christian Painting is often conceived as foreign to the tradition of Western painting, often conceived as beginning in the Renaissance. This reflects the thoroughness of the revolutionary pivot to History Painting that was initiated in the Basilica San Francesco.

Notes

1. Millard Meiss and Leonetto Tintori, *The Paintings of the Life of St. Francisco in Assisi with Notes on the Arena Chapel* (New York, NY: New York University Press, 1962), 8.
2. Auerbach, *Mimesis*, 151.
3. Cooper and Robson, *The Making of Assisi*, 5–6.
4. Thomas of Celano, *First Life of St. Francis of Assisi*, trans. with an introduction and notes by Christopher Stace (London: Society for Promoting Christian Knowledge, 2000), 8.
5. Saint Bonaventure, *The Life of Saint Francis of Assisi* Translated by E. Gurney Salter, E.P. Dutton, 1904. eCatholic2000, www.eCatholic2000.com. Accessed 2024.
6. Ibid., Chapter 1.
7. Michael Viktor Schwarz, *Giotto the Painter, Volume 2: Works* (Vienna: Böhlau Verlag, 2023), 226.
8. Ibid.
9. Alberti, *On Painting*, Book 2, section 11.

Part Two

A History of Art without *Space*: Alberti and Leonardo's Construction of Perspective

There is much in the thirteenth century that proceeds and follows the turn from Christian Painting to History Painting. By the last quarter of the century, the northern Italian town of Fabriano had invented methods of producing paper in quantity, and at less expense than parchment from animal skins. Abundant paper allowed disegno—the Italian word encompasses plans, designs as well as pictorial rendering— free reign to shape subsequent painting. It is fascinating to imagine how Giotto developed his painting within the framework of disegno, especially as his only drawing that has come down to us is the architectural design for the campanile of Florence. Giotto, both as the preeminent painter of his generation and the subject of tales of his ingenuity and wit, points to the development and the values of the new istoria painting. Within a hundred years, the historical figure of Giotto was elevated from his background as a Florentine artisan to ultimately be claimed as a figure of Naturalism itself. The positive public reception of Giotto, as the genius shepherd-boy fictionalized in Ghiberti's and Vasari's stories, shows the value placed on narratives of Genius, Classicism and Naturalism embedded in the history of painting.

In early stories, of his life as an artisan-painter, Giotto is shown as directing targeted but not unfair repartees at his 'betters', such as an esteemed Florentine jurist and the king of Naples. These stories of Giotto's canniness and jocularity relate to how Giotto's paintings were understood. As humor and a more detailed vernacular Italian language were being developed by such writers as Boccaccio and Sachetti, Giotto was presented in their stories as sharp-witted but magnanimous. Giotto's overturning of convention in these stories runs parallel to the accomplishment of his painting, indicating public appreciation of Giotto's novel painterly intelligence.

In the interest of maintaining the focus on the history of pictorial space, the subject of the Part Two shifts to the development of pictorial perspective in the Renaissance. By the fifteenth century, geometry and mathematics had become an essential part of primary education and commerce in Italy, providing a mathematically literate audience for paintings. As artists were enmeshed in literary culture and in the practical calculations of business, they were no longer merely artisans. With the challenges associated with creating istoria scenes, painters' roles became closer to poets and Humanists to satisfy an increasingly sophisticated audience. Famously, the revival of Classicism exploded in popularity to define the Renaissance, even with its name. While there are no paintings of Classical subjects by Giotto (and no indication that he painted such scenes), following Giotto, artists such as Mantegna, Botticelli and Raphael, defined their personas as painters with subjects from Greek mythology and Roman poetry.

Within the great revival of Classicism, there was a uniquely influential text for artists: Vitruvius' (c. 60–c. 10 BCE), De architectura. A military engineer of Augustan Rome, Vitruvius' single work, his ten books on architecture, became the foundation for European architecture for centuries. Vitruvius was a singularly essential figure for painters. His organizational principles of measure, proportion and geometry, as both description and a program for making, permeate Renaissance perspective.

Vitruvius' writing is cited by Alberti, Ghiberti and Leonardo, as they developed perspective to their own ends. While Vitruvius offered minor instances of perspective, I argue it was his organizational principles that formed the basis of Renaissance perspective.

Today it is commonplace to characterize Renaissance painters as having developed 'perspectival space' in painting. As we will see, in Renaissance texts, space is not a stated concern. The questions then are, where did the interest in pictorial perspective come from and why was it enthusiastically taken up? The fifteenth-century artists who were creating perspectival pictures and wrote about their process all drew diagrams. As such, rather than resorting to anachronistic ideas about pictorial space, it is worth investigating the diagrammatical nature of perspective.

For modern viewers shaped by centuries of theological, philosophical and mathematical theorizing about space, finding space in Renaissance perspective is not difficult. Although this may make sense in the present, there is no evidence it did so for those who made the paintings and interpreted them at the time. Instead, we can look for more contemporaneous explanations. There is a case that for Alberti, Piero, Ghiberti and Leonardo, it is the love of diagramming that best informs the structure of Renaissance picture making.

5

The Classical Model of Vitruvius

Vitruvius, *De architectura*

In the fifteenth century, in the midst of a culture preoccupied with mathematics and Classicism, it is unsurprising that Vitruvius' *De architectura* was keenly studied. Of all the books inherited from antiquity, this text had a singular impact on artists. Over the centuries, *De architectura* was never quite 'lost'. Charlemagne's adviser and engineer, Einhard (*c.* 775–840), was enthralled by Vitruvius and his book was a staple in the scriptoriums Charlemagne established. However, in 1415, when the bibliophile Poggio Bracciolini found *De architectura* among a trove of Classical texts in a Swiss monastery, Vitruvius became newly celebrated among Humanists and artists, and in that sense they 'rediscovered' the ancient architect. Rather than merely reconstructing the ancient Roman's writings, the Renaissance artists seized and adapted the rudiments of Vitruvius' habits of order and organization to their interests and, through this imagination, projected Vitruvius into the future.

Alberti was particularly attentive to Vitruvius. His great tome *De re aedificatoria* (*On the Art of Building*, 1443–52) was written in ten books as a direct response to the ancient author. Alberti's *De pictura*, which for the first time presented a full-fledged philosophy of picture making, is in key ways Vitruvian, while also gathering up other Classical sources. Today, the 'Vitruvian Man', Leonardo's diagram of human proportion – a nude man within a square and circle – is the quintessential emblem for the 'Renaissance Man', as recognizable as the *Mona Lisa* or the *Last Supper*.

De architectura is unique among the ancient texts that fuelled the Classical revival of the fifteenth century. Containing some sixty thousand words, *De architectura* is large, dense, detailed and expansive. In Vitruvius' dedicatory passages to Augustus, he claims *De architectura* was unique for its time, and that is likely true. *De architectura* is a compendium turned into a text, rather than the product of an author. There are virtually no historical mentions of Vitruvius –

nothing is known about Vitruvius the man other than what he reveals in *De architectura*.

De architectura is not only about the design of *aedificii* (buildings). The books include instructions for the proper education of an architect; the history of architecture from its primitive beginnings; the siting and planning of cities; types of public construction, city walls, harbors, baths, treasuries, prisons, basilicas, theaters and open forums; private dwellings in town and in the country; types of temples and their plans; and the proportions, proper placement and decoration of columns. Additionally, *De architectura* encompasses technical engineering for construction, including specifications for foundations and walls; types of marble and brick; methods for slaking lime and making concrete; types of wood; plumbing with lead and terracotta; and cisterns, wells and aqueducts.

In his inclusive definition of the art of building, Vitruvius also identifies the making of timepieces and the construction of machinery, in addition to *aedificii* as two other departments of *architectura*. Further, Vitruvius devotes one of the ten books to Astronomy and Astrology. Another of the books is devoted to architectural painting, which ranges from the specifics of techniques and pigments to the decadent state of contemporary painting.

De architectura, over its long history of recognition and interpretation, frustrated those who wished it was more linguistically graceful, but it can be argued that in the redundancies of syntax and heavy-handed repetitions, Vitruvius' language has a logic of its own. Rather than lithe argumentation, Vitruvius stacks words like bricks. The effect is sentences that are encampments of information. Because of this, many of Vitruvius' sentences are more coherent if diagrammed rather than edited to a more graceful form. Despite Vitruvius' often unconventional phrasing, his book is formidable in its organization of the enormous range of material covered. *De architectura* takes order both as its subject and its principle.

Vitruvius' Perspective

Vitruvius' grand sprawl of *De architectura* contains theories, stories and practical advice that would have been of interest to artists. But there are only two short passages in which he outlines perspectival construction. Perspective did not hold the interest of Vitruvius as it would of Renaissance artists. Still, Vitruvius' passages on perspective indicate that rudimentary forms of linear perspective were within the Classical Roman imagination. Despite detailed discussions of

pigments and painting history, there is little weight put on descriptions of perspectival technique. Vitruvius describes the rendering of a building with receding sides as *scenography*, not in the chapters on painting, but in the section defining architectural terms of: plan, elevation and,

> As for *scenography*, it is the shaded rendering of the front and the receding sides as the latter converge on a point.[1]

In this passage, scenography concerns the portrayal of buildings as independent objects, rather than the construction of an overall view or a container for objects.

In another chapter, Vitruvius' scenography corresponds to theatrical backdrops. In *De architectura*, Vitruvius writes about producing perspectival backgrounds for theater, with a consideration of optics:

> namely how the extension of rays from a certain established center point ought to correspond in a natural ratio to the eyes' line of sight, so that they could represent the appearance of buildings in scene paintings, no longer by some uncertain method, but precisely, both the surfaces that were depicted frontally, and those that seemed either to be receding or projecting.[2]

If today we can see the pictorial appearance of receding or projecting forms as a function of the idea of *space*, for Vitruvius, it is the building surfaces, not the medium they exist in, that produces the gestalt of receding or projecting.

These two passages could have inspired the early Renaissance use of one-point perspective. Several of Giotto's frescoes have rudimentary 'scenographic' perspective and Masaccio's more rigorous perspective is similar to Vitruvius' description, as can be seen in his fresco showing Christ's discussion of tribute money in the Brancacci Chapel (1424–8). On the right of the picture, Masaccio painted a building that corresponds to Vitruvius' method. However, Renaissance perspective quickly developed a more thorough complexity than a basic scenic background. This is the case with Alberti's detailed explanation of surfaces, rays and inscriptions in his *De pictura*.

The Vitruvian Diagram

There is a less noted but apparent aspect of *De architectura* that could not have failed to affect artists who were fascinated by Vitruvius. Although Vitruvius wrote his book in the midst of the golden age of Roman literature – the age of Ovid, Virgil, Livy and Cicero – Vitruvius' language reflects his non-literary profession.

In distinction to rhetoricians and poets, Vitruvius was an artilleryman, who, as part of Julius Caesar's military campaigns, would have been engaged to design and supervise siege machines, forts and encampments, rather than the craft of language. If not beautiful literature, the theories, stories and practical advice of Vitruvius would have been of keen interest to artists. There was more to be drawn – literally drawn – from the text. Vitruvius was as much a figure for artists to emulate as Roman rhetoricians were for the literary Humanists. To respond to and to practice Vitruvius was not to write, but to draw and especially – to diagram.

In order to 'see' Vitruvius, Renaissance artists would need to habituate themselves to the mechanics of diagramming. Diagrams are a distinct form of pictures. As instructional scaffolding, diagrams are neither purely imagistic, linguistic or mathematical. They can be defined as a special class of picture that describes and predicts how things are seen and understood. Diagramming was a habit Vitruvius encouraged. At several points in his book, he instructs the reader to take out a straight-edge and compass to diagram the specifics of what he is discussing.

Vitruvius' practical diagramming distinguishes him from Euclid, the other instigator of diagrams in the Renaissance. The subject of Euclid's *Elements* (thirteen books, *c.* 300 BCE) is pure geometry, while Vitruvius' subjects bear on the concrete. Euclid's subjects are abstract mathematical figures, whereas Vitruvius focuses on worldly objects conceived as structures and to be structured: machines, temples, theaters, music, the qualities of wood and stone. Vitruvius' subjects such as the proportions of the human body, the winds, movement of the planets and the meanings of astronomy are to be organized geometrically to show the relationships of their elemental components.

Vitruvius' book interprets objects as parts measured to wholes, with an incessant impetus to draw these elements in geometric proportion and coordination. His drawing and diagramming habits were promoted in the text as necessary for detailed understanding (Figure 5). The graphic interpretation of Vitruvius' text became a habit for artists such as Alberti, Piero, Ghiberti and Leonardo – the Vitruvian diagram was key to structuring Renaissance perspective. It cannot be overemphasized that pictorial thinking in the Renaissance was beholden to Vitruvius' imperative to pick up a compass and a straight edge.

The type of perspective advocated by Alberti, Piero, Ghiberti and Leonardo is not simply a pictorial technique but a variety of methodologies that give structure to painting. Perspective provides constraint, but is open and fluid enough for artists to apply it expressively and with individual scope. In this, perspective shows its diagrammatical nature. Perspective, like diagrams, does not determine the pictorial scene but enables parsing and contrasts along creative lines that

The Classical Model of Vitruvius

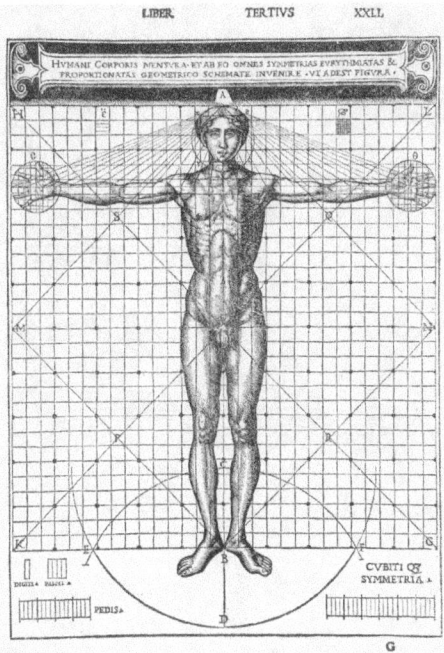

Figure 5 Cesare Cesariano, Diagram of Vitruvius' Human Proportions illustration in the edition of *De architectura* by Vitruvius, 1521.

include optical information and the imagery of the picture. It is the structured but open order of diagramming that distinguishes what is now known as 'Renaissance perspective'.

Today 'perspectival space' may seem to be part of the natural order, but for Renaissance artists, it was mathematics that was natural and God-given, as well as practical in a society in which measurement and calculation were daily activities. Certainly within the culture of Classical revival, the Roman architect from the Golden Age would be worthy of emulation. While it may lack the flair of 'perspectival space', what Renaissance artists were constructing can more precisely be called 'diagrammatical perspective'.

Notes

1 Vitruvius, *The Ten Books on Architecture*, trans. Ingrid D. Rowland (Cambridge: Cambridge University Press, 1999), 24–5, written ca. 15 BCE.
2 Ibid., 86.

6

De pictura and Early Perspective

Alberti and the Window Paradigm

In the first paragraph of Erwin Panofsky's influential essay, *Die Perspektive als symbolische Form* (1927), translated as *Perspective as Symbolic Form*, he writes:

> We shall speak of a fully "perspectival" view of space not when mere isolated objects, such as houses or furniture, are represented in "foreshortening," but rather only when the entire picture has been transformed – to cite another Renaissance theoretician – into a "window," and when we are meant to believe we are looking through this window into a space.[1]

There is a lot to consider here. First, there is an almost five-century gap between the experiences of Panofsky and the 'Renaissance theoretician', Leon Battista Alberti, to whom Panofsky is referring. Intervening are transformative events such as Newton's physics, the mathematics of calculus, non-Euclidean geometry and topology, photography, Impressionism, Cubism and Einstein's theory of relativity. By 1927, when the essay was published, *space*, absent at the time of Alberti, had become a natural assumption in mathematics, science and in art.

In Panofsky's quote, it is assumed that 'perspectival view', 'foreshortening' and the window he refers to are secondary to the presiding concept – *space*. For Panofsky, *space* is total, fundamental, and its authority, unquestioned. In contrast, in Alberti's writing about architecture, painting and perspective, there is no equivalent to Panofsky's *space*. One cannot explain this as a lack of ability or imagination. Alberti was one of the most disciplined and articulate thinkers of his era; he was a mathematician, a painter, an architect, a scholar, and as a writer, he was precise in Latin and eloquent in vernacular Italian. Within the general culture in Alberti's time, only God was allowed the completeness and fundamentalism that is often associated with *space* five centuries later.

Alberti wrote a number of texts, but it is in Alberti's *De pictura* (c. 1435–50) where Panofsky interprets Renaissance painting as the attempt to transform 'the

entire picture into a "window" and ... through this window into a space'. To grasp Alberti's thinking, it is worth a close look at the passage from *De pictura* that Panofsky refers to. It begins with an explanation of the 'intercision':

> Up to this point, almost all [things] that have been said by us concern the visual action or the knowledge of the *intercision*. But since the matter pertains not only to what the *intercision* is and to those [things] of which it is formed but also to how it is realized, of this *intercision* it must be said according to what technique it is expressed through painting.

The passage continues:

> Therefore, all other things about it left aside, I will say what I myself do when I paint. First I trace as large a quadrangle as I wish, with right angles, on the surface to be painted; in this place, it [the rectangular quadrangle] certainly functions for me as an open window through which the *historia* is observed and there I determine how big I want men in the painting to be.[2]

Alberti's passage describes a practical and colloquial model for beginning a painting with a focus on *historia* not *space* (Figure 6). The passage, taken as an entirety, makes it clear that this 'window paradigm' is an aid to understand the mechanics of the 'intercision' – a plane that intercedes or 'cuts' across what Alberti calls the 'pyramid of vision'. It is a technical term that describes vision inscribed on a surface. Alberti is aware that a book on the pictorial fundamentals of painting had never been written before. As such, Alberti creates his own system of terms to speak about picture making which are uniquely his. 'Intercision' is one such term.

The intercision is the plane that slices through the 'pyramid of vision' – 'all the straight lines [of vision rays] lead from this surface plane to meet at a single apex – the eye of the viewer. The base of the pyramid is the surface seen,'[3] and the base is a circumscribed planar surface on which images are drawn.

In the case of Alberti's window, the perimeter of the window is a physical analogy for the edges of the intercision. The intercision becomes the painting surface, and the window frame, the borders of the picture. Contemporary imagination may see Alberti's window as a premise for photography. But this is a stretch. Instead, both the intercision and the window are part of a construction site laying out his view of a painting. There is sense to this, as Alberti was, by his own admission, an infrequent painter, but an engaged architect.

The key term, in Alberti's model, in which the window sets the boundaries for the pyramid of vision, is *istoria*. It is the type of painting that is the 'superlative work of a painter'.[4] *De pictura* is a mere practical guide to painting; its purpose is

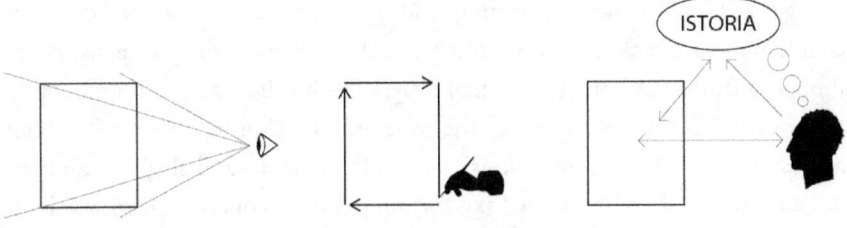

1. Pyramid of Vision 2. Circumscribing the Intercision 3. Sighting *Istoria*

Figure 6 Diagram of Alberti's window paradigm.

to define and expand upon the proper methods for producing what Alberti advocated as the pinnacle of painting – an *istoria*.

The Pyramid, the Intercision and the Veil

Alberti is creative in constructing new terms but he did not come up with 'perspective' nor does it appear in *De pictura*. On the heels of Alberti's book, it is Piero della Francesca (*c.* 1415–92) who settles on the term 'perspective', titling his treatise, *De prospectiva pingendi* (*On the Perspective of Painting*, [1474–82]). Despite this, Alberti's geometry and practical optics for painting were so vivid, that shortly after the treatise circulated, Alberti's pictorial mechanics were defined as 'perspective'.

Alberti recommends another perspectival construction of painting that is both imaginative and practical. He offers a familiar object as a helpful explanation of his intercision. He proposes using a gridded piece of cloth to stand for the base of the mathematical pyramid of vision in order to align physical picture-making with optical veracity:

> I think nothing more advantageous can be found than that which I am accustomed to call an *intercision* among my friends, the use of which I am first to devise. It is as such: a thin veil of open texture, dyed in any color, with thicker threads, if you choose, portioned into parallel squares and held taught on a frame. And I place this between the object to be represented and the eye so that the visual pyramid penetrates the weave of the veil.[5]

The grid on the veil allows the view to be seen as a single surface as opposed to the multiple surfaces within the pictorial view, which the picture will define as

a single surface. An attentive reading of *De pictura* reveals that Alberti does not conceive picture making, nor even the world, in terms of three dimensions as thought of today. Alberti knows that a pyramid has height, width and depth, however in his discussions about the pyramid of vision he writes only about angles, triangles, lines, proportions, parallel lines, bands and shapes – all two-dimensional. Rather than a third axis forming a dimension, Alberti writes about the world as a dynamic conglomeration of two-dimensional surfaces that coalesce in how the world is seen. Painting is a surface, as such it corresponds to what can be circumscribed on that surface. Alberti continues:

> This intercision of the veil has many advantages, first, its surface is always immoble so after setting the boundaries you will find there the apex of the pyramid, something very difficult to do without the *intercision*.[6]

The 'apex of the pyramid' is, again, the eye of the artist looking at the world, which in subsequent drawings and prints of artists employing Alberti's grid or veil is often shown as the tip of a vertical stick in front of the artist, used as a stable apex viewpoint. And,

> A further advantage is that the position of the outlines and the boundaries of the surfaces can be easily established with certitude when painting on the panel …[7]

The window paradigm along with its figure of the pyramid and the grid of the veil tend to dominate modern analysis of *De pictura*. These are fascinating sections of Alberti's book. However, a reading of the text as a whole reveals that Alberti's mention of the open window is a minor analogy, and while he clearly delights in his invention of the veil, it is far from central to *De pictura*. Perceptual picture making, what Alberti would approximately describe as watching and following Nature, is an essential element of painting, but it is only a piece of a richer, more complex framework of what Alberti envisions for painting. These are the rudiments that provide methodology to attain painting at its most worthy.

The Three Books

Around every turn in *De pictura*, the reader will discover that Alberti is infatuated with triads. *De pictura* is constructed in three books: (1) *Rudiments*, (2) *the Painting* and (3) *the Painter*. Alberti also organizes his model for painting in

threes, often in sequence from simple to complex, and from small to grand. For Alberti, threes are often indicative of significance and indeed are the minimum required to show proportion: if *a* is to *b* as *b* is to *c*, then the three quantities are in proportional relation. Good proportion is at the heart of *De pictura* – it is both method and goal.

In the first book, Alberti proposes that:

POINTS→ are extended to become→ LINES are joined like 'threads in a cloth' to become→ SURFACES

Alberti advocates for geometry and mathematics as key to explaining the rudiments of painting. As well, Alberti promotes 'good, common sense', as indicated by his analogies of material objects such as a cloth and a window. Alberti explains that the Point is a sign that can be seen on a surface, 'The painter, in fact, strives to represent only things that are visible under light.'[8] On the most basic level, this indicates what perspective meant for Renaissance artists. For Alberti and his peers in painting, perspective was the means for organizing visual things – objects – in painting.

Alberti's tripartite organization continues with vision rays. At the time, there was a debate whether eyesight receives or projects rays in order to see. Alberti dodges the issue by urging us to imagine the rays as 'very fine threads', without giving a direction to them. Again, Alberti resorts to a triad. Alberti identifies three rays that convey the surface of objects to the artist's eye – that will ultimately be painted. They are: Extrinsic, Median and Centric. Extrinsic rays show the 'extreme of the surface' or the perimeter of a shape and, as well, the perimeter of the painting panel. The Median rays show the Reception of Light of the Surface; it determines color and changes color 'like the chameleon'. The third ray is the Centric Ray and it is the 'Prince of Rays'. Every shape – in tandem with every surface – is made recognizable by its own Centric ray, which rules the other two types of rays. The painting surface has its center point but also contains the three types of vision rays converging to organize the picture. As well, so does every depicted shape. This is a fantastically plural vision of perspective (Figure 7).

As indicated by Alberti's discussion of the three rays, his thinking is distant from current ideas about perspective. This is its specific value. Alberti's perspective does not confirm modern ideas of pictorial *space*, or even how *space* came to be conceived after Newton. It is a reminder that the pictorial ordering of perception is complex, culturally coded and ultimately a creative imagining.

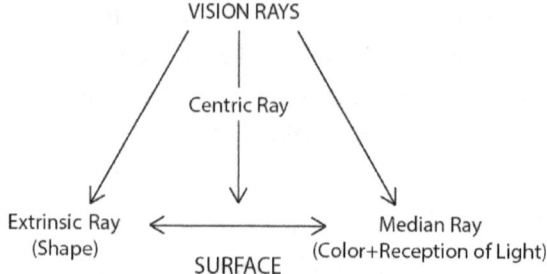

Figure 7 Diagram of vision rays apprehending a surface.

Although Alberti does not define *space* as an issue for perspective or painting, in *De pictura*, he introduces a painterly consideration that would in short order be expanded upon to be considered an essential element of painting. In Book II, Alberti focuses on the painting itself: 'Painting is accomplished through – *circumscriptio, compositio et luminum receptio* – Circumscription, Composition, the Reception of Light.'[9] The perimeter of a shape is recorded by Circumscription. The painting and shading is produced through realizing the Reception of Light. Circumscription and the Reception of Light are not regular expressions for painting today. However, while much of the terminology of *De pictura* did not develop far beyond the immediate reception of Alberti's treatise, Composition was to become an important element of painting.

When Alberti coined *Compostio* it did not have the definition of the painting's gestalt or its general organization. Alberti imported the term from Latin rhetoric to explain the proportional segue of parts to wholes. Writing on the emergence of composition in painting, Michael Baxandall comments, '*Compositio* was a technical concept every schoolboy in a Humanist school had been taught to apply to language. It did not mean what we mean by literary composition, but rather the putting together of elements: words go to make up phrases, phrases to make clauses, clauses to make sentences' (Figure 8).[10]

In Baxandall's diagram, he makes the analogy of Alberti's Composition in painting and Latin rhetoric exact. In doing so, Baxandall presents the diagrammatical division and the proportional construction of parts to wholes that underpins Alberti's conception of painting. It can be said that *De pictura* is literary, not only due to its many references to stories of ancient painters and the subject matter of their paintings but also in how Alberti conceived the structure of painting as parallel to the structure of Latin rhetoric. However, by the time Leonardo was writing about painting, composition had developed to denote how figures and elements in the picture are arranged to heighten expression and create a harmonious whole – quite close to how it is commonly used today.

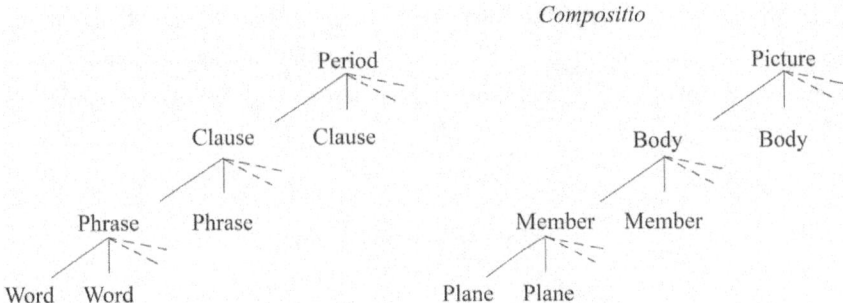

Figure 8 After Michael Baxandall, 'Alberti and the Humanists: Composition', *Giotto and the Orators*, (in light of the present discussion: Plane = Surface, Picture = Istoria) 131.

Alberti's *Space*

For modern readers who are convinced that Alberti was thinking about *space* despite not using the concept to explain pictorial construction, it may be informative to investigate how he applied *space* in his text. Although Alberti uses *spatium* in *De pictura*, it has neither the meaning nor the prominence that it has gathered today. Unlike Composition, *space* did not emerge as a concept in painting following the reception of Alberti's text or from Renaissance picture-making in general.

Spatium appears in nine sections in *De pictura* and makes its entrance in the sixth section of the first book. Alberti has just explained that only what is visible is pertinent to painting. In this section of text, he aligns his mathematical conceptions with practical experience, and *spatium* is introduced as a measurable distance along an outline. 'Indeed, there is a quantity of *space* between two distinct points along the outline on the surface, which the eye, as it were, measures ...'[11]

Later, in the section of the window analogy, Alberti uses *spatium* several times as a measurable distance to criticize an inaccurate method of rendering geometric pavement. It is revealing that despite his use of *spatium* in proximity to the window analogy in *De pictura*'s text, there is no looking through the window into a *space*. Instead, the *spaces* are divisions and additions on the surface of the panel – *space* here is limited, practical, mathematical and diagrammatical. In the subsequent section, Alberti employs *spatium* somewhat more expansively – 'Indeed there is a parallel *space* between the two equidistant lines.' Here *space* is more than linear distance on a diagram, it is a band – also measurable – on a diagram on a (painting) surface. In the second book of *De pictura*, *space* is a shape to be shaded. There is only a single instance in which *spatium* is independent from the surface of the painting or a diagram. In the final book, *spatium* appears

once. In this case, Alberti elucidates the propriety of how figures should move with their parts in relation to each other and that one foot should be no further than the *space* of one foot from the other. Even here *space* does not escape Alberti's diagrammatical logic.

Translating Alberti's *Space*

In Cecil Grayson's 1972 translation of *De pictura* there is a passage in which *space* might seem to extend further than the planar diagram. Here, *space* has an expansive, modern connotation. First, the Latin passage:

> Principio quidem cum quid aspicimus, id videmus esse aliquid quod locum occupet. Pictor vero huius loci spatium circumscribet, eamque rationem ducendae fimbriae apto vocabulo circumscriptionem appellabit.[12]

Which Grayson translates as:

> In the first place, when we look at a thing, we see it as an object which occupies a space. The painter will draw around this space, and he will call this process of sketching the outline, appropriately, circumscription.[13]

Translating, especially very old texts, is always a compromise between precise rendering of terms and bringing familiarity to what is, by definition, a foreign text. In Greyson's translation, 'An object which occupies a space,' makes sense in current usage, but Alberti uses *locum occupet*, which is better translated as 'occupies a location' or 'occupies a place'. In Rocco Sinisgalli's 2011 translation, Alberti's passage in Latin is more precisely translated as:

> First of all, when we watch an (object), we certainly see that there is something that occupies a place. The painter will define, then, the extent of this place and will call a similar process of tracing [*circumscribet*] the edge, [*fimbriae*] with the appropriate term of the drawing of the profiles, [*circumscriptionem*].[14]

What the Sinisgalli translation lacks in contemporary sounding refinement, it compensates with specificity. This fine-grained translation makes it clear that Alberti is not describing drawing an 'object which occupies a space', rather he is describing a diagrammatical program for making a painting. The 'extent of the place' is the frame of the picture. From there, outlines of the subjects are circumscribed.

If we look at Alberti's model of vision from the twenty-first century, it is not a view to a homogenous three-dimensional world of forms within *space*, that is to

be rendered on a two-dimensional surface. Alberti's perspective, one might say, is made up of two-dimensional surfaces that form, reform and inform by means of these three types of vision rays. Alberti's is a different structure of three-dimensional perspective. Alberti's surfaces have height and width, but with the Centric ray determining the distance of the surfaces from the eye, surfaces are not entirely integrated to become three-dimensional forms. Instead, Alberti's model describes seeing as the apprehension of surfaces (of the objects that we see) shunting along vision rays. The vision of these surfaces is presented and controlled by Median rays so that the surfaces slide along the tracks of the three vision rays. Further, the implication is that each and every shape contains its own Centric point – each shape then contains its own 'perspective'.

If we allow Alberti 'the palm' as the first to write about painting perspective, his categories form a dimensional model (of threes) for painting: Point, Line and Surface; Centric, Extrinsic and Median Rays; Circumscription, Composition and the Reception of Light on Surfaces. With its shuffling of surfaces along a web of vision rays, it is remarkably plural, dynamic and discontinuous. It is a vivid accomplishment of Renaissance imagination.

The Value of *Istoria*

It is in *De pictura* that *istoria* is first cited as the penultimate type of painting and it contains what Alberti most values. *De pictura* is a unique text without any precedence. It stands at the beginning of treatises on painting and on perspective. But far more than the section in which Alberti analogizes the window, this passage is paradigmatic of *De pictura*:

> The superlative work of a painter is not a Colossus, but *istoria*. Greater is the praise for ingeniousness in an *istoria* than in a Colossus.[15]

De pictura's purpose is to lay out 'proper and esteemed' methods to paint, not merely painting, but the most praiseworthy of painting: the *Istoria*. As Giotto demonstrated, *istoria* had a capacity for invention beyond pictorial narratives. Not only was Giotto's *Navicella* mosaic the solitary modern picture in *De pictura*, but it is also the only Christian one. Although Alberti was an ordained priest, the future of *istoria* that Alberti envisions, if not explicitly Pagan or Classically pre-Christian, is not that of Christian Painting. Alberti puts into writing what Giotto accomplished over a century before: that *istoria* as the premier form painting should take the honorary place of an icon. And *De pictura* is the how-to guide. If at times it is

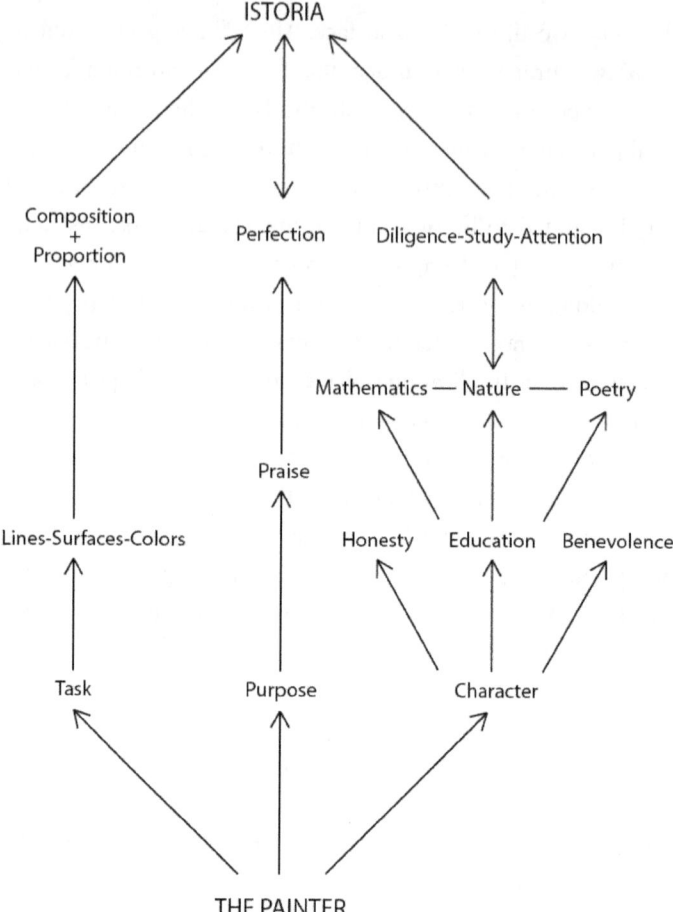

Figure 9 Diagram of *De pictura*.

difficult to separate what Alberti defines as painting from the more specific *istoria*, it is clear that for Alberti the only painting that really matters is *istoria*. *Istoria* is given great scope, particularly in the third book, in which Alberti describes Classical subjects and anecdotes about Classical painters (mostly taken from Pliny). Alberti mixes a zeal for the ancient past with the most current technical sensibilities – *De pictura* is polemic for *istoria* – painting's antiquarian future.

Other Views on Perspective: Ghiberti and Piero

A reading of *De pictura* on its own terms makes it clear that Alberti developed his conception of perspective as part of his project of advancing *istoria*, not as an

idea of pictorial *space*. Following Alberti's release of *De pictura* in 1435, Lorenzo Ghiberti (1378–1455), Piero della Francesco (*c.* 1415–92) and Leonardo da Vinci (1452–1519), produced texts on painting including perspective. Like Alberti, each of them presents painting as Humanist and mathematical. However, as concerning perspective, each artist brings to it different attitudes and goals. Distinct from Alberti, Ghiberti cites Christian and Muslim natural philosophers as well as Classical authorities. Ghiberti brings a larger group of references to his investigation of 'how the faculty of sight functions, how visual (images) are made, and in what way the theory of painting and sculpture should be established'.[16]

Piero's treatise on painting perspective *De prospectiva pingendi*, opens by describing the three principle parts of painting: *disegno, commensuratio* and *colorare*; close approximations of Alberti's Circumscription, Composition and Reception of Light on Surfaces, as the tripartite division. Of these three parts, Piero informs us that in his treatise he 'intends to discuss only *commensuratione*, which we call *prospectiva* …' Commensurate proportion resembles Alberti's *Compostio*, but while for Alberti, Composition leads to Classical tropes, Piero's *commensuratione* leads to the geometry of seeing and inscription. During his lifetime, Piero was known as a mathematician as much as a painter. Piero's expository language which opens each of the three books of *De prospectiva pingendi* is merely a foreword to the main act, which consists of highly specific notations for diagrams as well as his exquisite diagrammatical figurative drawings.

In the fifteenth century, a keen interest for perspective was increasingly established. Texts by Alberti, Ghiberti, Piero and Leonardo declared perspective could recreate painting. Perspective, in idea and practice, was capacious and flexible enough for each to develop their own individual interests. Leonardo's writing on perspective was in the form of notes that were incomplete and in some cases lost. When they were finally assembled, it was Leonardo's ideas about perspective that had the greatest impact on painting.

Notes

1 Erwin Panofsky, *Perspective as Symbolic Form*, trans. Christopher S. Wood (New York, NY: Zone Books, 1991); originally published as 'Die Perspective als 'symbolische Form', in *Vortrage der Bibliotek Warburg*, [1927].

2 Alberti, *On Painting*, 4. While Sinisgalli translates Alberti's Latin forms of 'intercision' to 'cut', here it remains as 'intercision'. As concise as Sinisgalli's

translation of 'intercision' to 'cut' is, it is retained as 'intercision' as it shows Alberti in his technical mode.

3. Ibid., 9.
4. Leon Battista Alberti, *De pictura* (Italy: 1439–41), Book II, section 35, 72.
5. Leon Battista Alberti, On Painting *and* On Sculpture: *The Latin Texts of* De pictura *and* De statua, ed. Cecil Grayson (London: Phaidon, 1972), Book II, section 31, 66 and 68; for this text, unless otherwise noted, is translated by the author from Grayson's critical edition of the Latin.
6. Ibid.
7. Ibid.
8. Alberti, *On Painting*, 23.
9. Alberti, On Painting *and* On Sculpture, ed. Grayson, 66.
10. Michael Baxandall, 'Alberti and the Humanists: Composition', in *Giotto and the Orators* (Oxford: Oxford at the Clarendon Press, 1973), 131.
11. Alberti, On Painting *and* On Sculpture, ed. Grayson, Book I, section 6, 41.
12. Ibid., Book II, section 6, 66.
13. Ibid., 67.
14. Alberti, *On Painting*, Book II, section 6, 68.
15. Alberti, *De pictura*, Book II, section 35, 72.
16. Lorenzo Ghiberti, *I commentarii*, ed. Lorenzo Bartoli Giunti Gruppo Editoriale (Florence: Giunti Gruppo Editoriale, 1998), Book II, 92.

7

The Prolific Imagination of Leonardo

Leonardo's *Trattato di pittura*

By the time he died in 1519 at the age of sixty-seven, Leonardo da Vinci had produced over 10,000 pages of notes and drawings. Famously, his topics ranged from anatomy to natural phenomena and machines to architecture. Of the many artists that defined the Italian Renaissance, none produced more writing and drawings. Painting and perspective were of major interest for Leonardo and his notebooks contain many observations, precepts and theories on these subjects.

During his lifetime, Leonardo wrote about and shared his insights into painting in manuscript form, but a treatise on painting was not published during his lifetime, although it seems this was his intention. When Leonardo died, his texts on painting were scattered through his voluminous notes. Leonardo's longtime assistant, friend and painter in his own right, Francesco Melzi (1491–1570), inherited the master's drawings, notes and supplies, and took up the immense task of bringing the master's ideas to finished form. This project occupied Melzi for decades, perhaps to the end of his life.[1] Melzi's edit of Leonardo's notes resulted in some 1,008 chapters, albeit some as short as a couple sentences. This version was lost for decades, finally to be rediscovered in the Vatican Library and then only published in 1817.

By the early seventeenth century, after fragments of Leonardo's texts circulated informally, there was momentum to publish his notes on painting. After going back and forth between Paris and Rome for decades, a group of Leonardo enthusiasts, including Nicholas Poussin, edited Leonardo's writings to produce a text that was shorter than Melzi's but still substantial. It was printed in Paris in 1651 and was considered the standard text of Leonardo's writing on painting up to the nineteenth century.

Leonardo's Perspective

As can be gathered from his notebooks, for Leonardo, experience, and its study, *scienza*, is the great authority for knowing the world and understanding painting. Further, Leonardo writes, perspective is the 'guide and gate' for the *scienza* of painting.[2] Leonardo's perspective is distinguished from the linear perspective of Alberti, Piero and Ghiberti by his expansion of perspective into three types:

> Perspective, as it pertains to painting, is divided into three principal parts, of which the first deals with the diminution that affects the size of bodies at different distances. The second part is that which treats the diminution of the color of these bodies. The third is that which diminishes the recognizability of shapes and of the edges belonging to these bodies at different distances.[3]

In Leonardo's posthumous treatise, linear perspective is hardly developed beyond the work of Alberti and Piero. It seems he had written a separate text on linear perspective, which had some circulation, but is lost. The focus here is on the second and third types of Leonardo's perspective which are developed in this treatise and are his own innovations. The second type, 'aerial perspective' (the effects of air) or 'color perspective' are implicated in each other. Like linear perspective, color perspective entails diagrammatical logic, in which geometry and experience are bound together. Leonardo states:

> Thus, here we have proven what the proportional diminution of colors is, or rather, their loss, which is in proportion to their distance from the eye looking at them. This only occurs with colors that are at an equal elevation, because for those at uneven elevations, the same rule is not observed, since the colors exist in air that differs in thickness, which obstructs these colors differently.[4]

Leonardo's third type of perspective, 'the recognizability of shapes' or acuity, is, like aerial or color perspective, the product of the particularities of human vision. With this type of perspective, diminution is not inherently geometric, but physiological. It is a novel concept – the observation of the limits of human sight (Figure 10). Leonardo relates that to represent a form at distance, the edges should be soft, and the shape should be represented in some extreme cases as splotches of color. The forms should have less contrast and appear less distinct:

> The first things to be lost upon moving away from umbrageous [opaque] bodies are their edges. Secondly, at a greater distance the shadows that separate the parts of adjoining bodies are lost. Third, the thickness of the legs and feet. Thus, successively, the smallest parts are lost until, at a great distance, only a mass of indistinct shape remains.[5]

De la maniere de faire paroistre les choses comme en saillie & détachées de leur champ, c'est à dire, du lieu où elles sont peintes.

Figure 10 Leonardo da Vinci, diagram of vision and the occlusion of background from Chapter 341, *Traité de la peinture*, 1651.

Searching for *Space* in Leonardo's Texts

It is clear from Renaissance writing on perspective (Alberti, Piero della Francesca and Ghiberti) that pictorial *space* was not part of their imagination. However, with Leonardo's treatise, there is a case to be made that Leonardo had something of a notion of *space* that was part of his conception of painting:

> The science of painting includes all the colors of surfaces, and the forms of the bodies bounded by them, as well as their nearness and distance, including the proper degrees of diminution, according to degrees of distance. This science is the mother of perspective, or visual lines.[6]

This passage might serve as proof for those who are convinced the purpose of Renaissance perspective is to show *space*. Although *space* is not mentioned here by name, it can be argued that a 'science of painting' that includes 'nearness', 'distance' and 'degrees of diminution according to degrees of distance', together add up to a relevant concept of *space* as part of painting. It is also possible to argue the opposite, that what is presented here is a list of separate but related elements of painting rather than a holistic concept of *space* that inflects the structure of painting. As for the word itself, in Leonardo's treatise, *spatio* is mostly applied within the bounds of measurable diagrammatical functions as it is in

Vitruvius', Alberti's and Piero's texts. However, on occasion, Leonardo uses *space* in novel ways:

> Equal illumination from these lights will occur when the space surrounding the two lights is of equal color, darkness, and lightness; unequal will occur when the space around the two lights varies in darkness.[7]

Here Leonardo applies *space* as a term that represents part of the observable world, not merely within the bounds of diagrammable measurements. Although the subject is light and its perception, *space* informs difference and experience, even if the goal is to render this observation on the surface of a panel. Similarly, this short statement opens a late chapter of the *Trattato della pittura*:

> A most important part of painting are the fields [in the background] of painted things.[8]

This statement shows that Leonardo believed that the painterly context of the painted subjects was a principal concern. One could argue this is at least somewhat a conception of pictorial *space*. Leonardo urges painters to vary the color of bodies against the background color because,

> if this edge is of the color of this field, undoubtedly this section of the painting will prohibit the noticing of the edge of the figures, so this choice of depiction is to be refuted by the intelligence of good painters, since the intention of the painter is to make his [or her] bodies appear on the foreside of the [background] fields: and in the above mentioned case the opposite happens ...[9]

Whether the passage is interpreted as indicating a conception of *space* in painting or as a helpful design tip to make the picture and its figures more legible, the essential question, as concerns the subject of this book, is; how did subsequent generations understand the meaning? If Leonardo's ideas about the relations of background to foreground, and his identification of *space* as that which surrounds objects coalesced into a nascent idea of pictorial *space*, it would appear as a legacy of Leonardo.

Leonardo's Legacy

The most immediate impact of Leonardo's painting can be seen in the *tenebroso* manner of his followers Bernardino Luini (*c.* 1481–1532) and Giovanni Boltraffio (*c.* 1466–1516), who got their start in his studio, but in immediate terms,

Leonardo's influence did not extend much beyond northern Italy. Subsequently, the Mannerist fashion of the late Michelangelo, Raphael and Parmigianino were not entirely in tune with the gravitas of Leonardo's *Scienza*. After the Mannerists, Carlo Borromeo's Counter-Reformation orthodoxy demanded a simple and emotionally direct form of painting that was fulfilled by Caravaggio and his followers such as Jusepe de Ribera, Luca Giordano and the Gentileschis. The high drama and extreme forms of chiaroscuro (Leonardo advocated for moderate chiaroscuro) of the Caravaggistas fulfilled the Church's demands, but were at odds with Leonardo's open and expansive view of painting.

The decades following Leonardo's death were not favorable for his vision of painting. What is more, Leonardo did not finish many paintings and so his impact, in terms of painterly appropriation, was less identifiable than with Michelangelo, Raphael and Caravaggio. While the extreme chiaroscuro of the Counter-Reformation painters may have channelled an element of Leonardo's studies of light and shadow, the emotional content of Counter-Reformation painting is more in line with the tragic *Cristus patiens* icons of the thirteenth century than with the complex and studious sensibility of Leonardo.

By the sixteenth century, painters' guilds had morphed into academies which came to dominate the practice of painting in Europe. It is documented that Leonardo's treatise found appreciation and further, became foundational in these academic contexts.[10] With Leonardo's writings finally available, his treatise became a cornerstone of artistic learning. Ironically, while Leonardo urged visual observation as more valuable than the authority of masters, his words were the primary medium through which his ideas came to artists. Almost immediately after the treatise was published, it was implicated in academic controversies. And, within the newly formed Académie Royale de Peinture et de Sculpture, the book was employed in the institutional clash over whether color and light or linear perspective should be taught as the foundation for painting. Despite, or perhaps due to, these controversies, Leonardo's treatise became foundational to subsequent academies of painting.

As an example of the impact of Leonardo's writing, Martin Kemp has written that 'if we set the 1651 texts beside Nicholas Poussin's The Israelites Gathering Manna in the Desert, painted in 1637–9, the match is very close (Plate 18). We are invited to read the narrative as a series of varied figures reacting to the central event of the miracle according to their diverse roles, ages, genders, and temperaments.'[11] Poussin has thus followed Leonardo's recommendations for figural composition and proportion. Additionally, the landscape in which the

figures are set is also characteristic of Leonardo's treatise. The application of aerial perspective – painting the light and color of air – suffuses Poussin's landscapes. The sky with its clouds, the light and softened colors of the mountains can easily be seen as visual transcriptions of several of Leonardo's chapters. Although we would not necessarily link Poussin to Leonardo stylistically, much of what Leonardo writes about is present in Poussin's paintings – perhaps more so than in Leonardo's own.

On 20 January 1648, at the Palais-Royal, the child King Louis XIV, his mother Queen Regent Anne of Austria and the entire Royal Council approved the founding of l'Académie Royale de Peinture et de Sculpture. Within three years, the French and Italian editions of Leonardo's text on painting were published and, if some of its theories were debated, the treatise was attentively read. Many of Leonardo's ideas were internalized in the academy's program, as it grew to be the premier academy of painting and sculpture in Europe until it was abolished during the French Revolution.

If Leonardo's legacy included a concept of pictorial *space* it would certainly be detected in this context – minutes of the lectures and conferences of the academy from 1648 to 1792 are well documented. From a modern viewpoint, Leonardo's ideas about closeness, distance, perspective and the pictorial dynamics between object and background might add up to a conception of *space* or at least the ingredients to form such an idea. However, the question is not how we in the present regard such matters, but whether the idea of *space* developed as part of the programs of the academy.

On 3 June 1668, Sebastien Bourdon, one of the founders of the academy presented as part of the academy's lectures, a dissertation on a single painting by the Carracci brothers. In his lecture, he spoke about the *espace* of the painting, however it was simply to describe that 'the painting is only three feet wide by two feet high'. Significantly, he noted, despite the obstacle of such a *petit espace*, the Carracci painting embodied the six *grandes beautés* of painting. These preeminent elements of painting are: Light, Composition, Line, Expression, Color and Harmony.[12] For Bourdon, e*space* in painting is only physical size and not a valued pictorial element as were the six *grandes beautés*. *Espace*, as recorded in the academy's archives, most commonly refers to measurement of size and time. We can extrapolate from the context of the academy that for Bourdon and his fellow artists, there was no *space* to be gleaned from Leonardo. Simply put, *space* was not significant to picture making. If indeed Leonardo had a fledgling concept of pictorial *space*, the minutes of l'Académie Royale de Peinture et de Sculpture indicate that idea never took flight.

Notes

1. Leonardo da Vinci, *Treatise on Painting [Codex Urbinus Latinus 1270]*, trans. and annotated by A. Philip McMahon, introduction by Ludwig H. Heydenreich, Vol. 1 (Princeton, NJ: Princeton University Press, 1956), xi–xliii.
2. Claire Farago, 'On the Origins of the *Trattato* and the Earliest Reception of the *Libro di pittura*', in Claire Farago, Janis Bell and Carlo Vecce, with a foreword by Martin Kemp, *The Fabrication of Leonardo da Vinci's* Trattato della Pittura: *With a Scholarly Edition of the* editio princeps *(1651) and Annotated English Translation*, Vol. 2 (Leiden: Koninklijke Brill NV, 2018), chapter 23, 623.
3. Farago, Bell and Vecce, *The Fabrication of Leonardo da Vinci's* Trattato della Pittura, Vol. 2, chapter 340, 854–5.
4. Ibid., chapter 107, 685–6.
5. Ibid., chapter 292, 808–9.
6. Da Vinci, *Treatise on Painting*, Vol.1, 4.
7. Farago, Bell and Vecce, *The Fabrication of Leonardo da Vinci's* Trattato della pittura, Vol. 2, 715.
8. Ibid., 851, translation by the author.
9. Ibid.
10. See Claire Farago (ed. and introduced), *Re-reading Leonardo: The Treatise on Painting across Europe, 1550–1900* (Aldershot: Ashgate Publishing, 2009; London and New York, NY: Routledge, 2016).
11. Martin Kemp, 'Forward', in Farago, Bell and Vecce, *The Fabrication of Leonardo da Vinci's* Trattato della pittura, xii.
12. Jacqueline Lichtenstein and Christian Michel (eds), *Conférences de l'Académie royale de Peinture et de Sculpture, Tome III: Les Conférences au temps de Jules Hardouin-Mansart 1699–1711* (Paris: Beaux-Arts de Paris éditions, 2009), 241.

Part Three

Space in Philosophy, Religion and Science

The process of writing this book has been one of questioning and discovery: Could a history of art be written without resorting to narratives of pictorial space? If the reader has made it this far, it seems the answer is 'yes'.

The premise of the previous lines of inquiry is based on four key narratives: Naturalism, Classical Revival, Individual Genius and Practical, Social and Cultural Forces, anchored within the timeframes under discussion. One need not agree with all my insights or conclusions to recognize this approach proved sturdy enough for extended discussions. Without the occluding effects of pictorial space, the architectural nature of Christian Painting came into sharper focus, as did the specifics of Giotto's turn to istoria (especially concerning the Navicella) and Alberti's advocacy of this type of painting. The importance of the Vitrivian diagram is widely acknowledged, yet its role has been underrated as the foundation of Renaissance perspective. This is especially striking, given that Alberti, Ghiberti, Piero and Leonardo certainly drew diagrams as Vitruvius' De architectura urged.

At this point, a new question looms: Since there is no evidence that these historical artists thought about space in relation to their work, what was the process through which the idea of space in art became commonplace? To make sense of this, a different tack is required. Although the previous chapters make up a prehistory of space in art, the questions now shift to the history of the formation of space as an idea that could be brought into the pictorial realm.

It is apparent that space did not arrive fully formed like Athena sprung from the head of Zeus. Instead, space emerged to take its modern form through fits and starts, through disagreements and controversies, spanning some five centuries.

Every history has its frame and perspective. This history is limited to the inheritance of the cultures of the ancient Mediterranean. While most histories of

space *treat* space *as evolving from archaic origins to empirical accuracy, the approach here is different. Rather than attempting to define the essence of space or its truth, this history is attentive to how* space *was constructed as an idea to serve a variety of realities at different times. The endeavor here is to describe the development of contours of space that would finally allow it to be internalized as universal in discussions about art.*

In the history I will present, there is a fundamental and consequential transformation that cannot be ignored. Following Aristotle's Physics, *Place became a potent idea. The sense of 'To Be Is to Be In Place' finds its physical and visual analogy in a world based on an earth-centerd and finite Cosmos. What follows here is the exploration of the historical potency of Place and the forces that precipitated the Cosmos based on the existential logic of Place to give way to an universe of infinite mathematical space. As Aristotle's Place lost its imaginative hold,* space *was constructed, stage by stage, on the ruins of Place.*

Following the chapter on Aristotle's concept of Place, I discuss images of the finite Cosmos as paradigmatic of Place. Unlike Time represented by the ancient god Cronus, space *was never granted form as an allegorical figure, nor was there any associated imagery until the twentieth century. Place, as linked to Aristotle's Cosmos, manifests in the centering circular images that medieval artists employed to portray the Cosmos. In the following chapter, I argue that there is a well-known painting that displays the sidelining of the Aristotelian Cosmos in favour of the immeasurable measure of St Augustine's all-powerful Christian God. This painting can be seen as an emblem of the decentering of Place and the intimation of* space *rising as the power of extension.*

Subsequent chapters in Part Three discuss the gathering of the constituent features that were necessary for space *to become modern, even as Place is diminished. Bruno grasped and promoted infinite* space *as pure extension even to his personal detriment. Although Bruno sets the idea of infinite* space *in motion, it is not until Newton that an influential figure of natural philosophy would fully claim infinity for* space.

Further chapters examine the difficulties and contradictions in defining space. *Descartes argued that* space *is identical with extension, meaning that it consists of all bodies, at all times, making a void impossible. Descartes' contemporary Otto von Guericke took the opposite view, passionately defending the vacuum and the concept of the void. Locke claims empirical experience for* space, *while Newton, though not going that far, developed an entirely mathematical absolute* space. *At the same time, Newton introduced the deistic notion that* space *is the 'sensorium of*

God' – a possibly heretical idea that provoked Leibniz into a fierce debate, pitting his relational space against Newton's absolute space.

Part Three concludes with Kant's meticulous parsing of both Leibniz's relational model and Newton's absolute framework, leading to his own revolutionary conception of space. Kant extended space from a universal order to an 'a priori intuition', making it the precondition for all experience of the external world. This transformation positioned space as the fundamental archetype for all representation and perception, ultimately setting the stage for space to enter discussions of artworks. It is indicative of the trouble with space, not just in art but in general, that even after Kant, it took almost a century before artists and writers began to embrace pictorial space with frequency.

8

The Place of Aristotle

Aristotle's vision of the Place based Cosmos, articulated in his *On the Heavens* and *Physics*, was widely accepted as intuitive across Mediterranean and European cultures. It was further reinforced by the second-century mathematician and astronomer, Ptolemy in his *Almagest*, which elaborated on the geocentric Cosmos of Aristotle. Although Aristotle's writings were mostly lost to Western Europe from the collapse of Rome in the fifth century until the twelfth century, he was a central figure in the Muslim intellectual tradition. Aristotle's idea of Place can be seen in pictorial forms of the Islamic world, as exemplified by their carpets. These exquisite physical and visual objects link domestic and religious functions and orient an individual's Place to community and to Mecca. With their elaborate borders, heavenly floral motifs and involved geometries, the carpets are profoundly Placial. If not figurative, the carpets are bodily and tactile, and paradigmatically define the logic of Place.

In Aristotle's time, there were several competing models of the universe, including the atomist theories of Democritus and later, Epicurius which proposed an infinity of atoms in an uncenterd and infinite universe. However, Aristotle's cosmology contained an intuitively powerful idea – the central importance of Place – 'To Be is to Be in Place'. This is reflected in his physics of a finite Cosmos, composed of nested spheres on which the sun and the planets orbit around the earth. It is notable that, although Vitruvius was familiar with the atomists and so their infinite universe, when he wrote about astronomy and astrology, he adhered to the Aristotelian model.

Tópos and *Kenós*

Aristotle lacked a single word that encapsulated *space* as commonly understood today. Ancient Greek had a constellation of terms, each often translated into English as *space*, yet each carries a distinct meaning. The Greeks had several words for what surrounds, encompasses, encloses or envelopes the body (*sóma*): *chóra*, *tópos*, *kenón* and *diástēma*.

- *Chóra* generally denotes a region, town or area
- *Tópos* signifies place or location
- *Kenón* refers to the void, emptiness or nothingness
- *Diástēma* indicates an interval, segment or measured distance

Although *diástēma* most closely approximates the Classical and medieval Latin *spatium*, it is notable that none of these Greek terms directly evolved into *spatium* – the Latin root from which *space*, *spazio* and *espace* are derived.

Within this constellation of terms, it is *Tópos* – Place – in its relation to *Sóma* – Body – that is central to Aristotle's physics. Aristotle asserts 'the existence of place (*tópos*) is held to be obvious …'[1] He also insists, 'things which exist are *somewhere* … and because motion in its most general and proper sense is change of place …'[2] Place is the fundamental basis for being in the world – it defines experience and determines the order of the Cosmos.

In contrast, region (*chóra*) and distance (*diástēma*) are secondary descriptive terms within the larger concept of place (*tópos*). Aristotle places the Void (*kenón*), pure emptiness or nothingness, in its own class. He asks of the Void, 'whether it exists or not, and how it exists or what it is.'[3] His discussion of the Void in *Physics* is more technical than that of Place, but his conclusion is firm: Place suffuses and governs the Cosmos, rendering the existence of the Void impossible.

Aristotle rejects the Void because it would imply Place is nothing. If the Void were to exist, it could not simply be an empty place, for Place is inherently connected to bodies. Nor is Aristotle willing to legitimate the Void as an abstraction of Place. For Aristotle, the Void is less than nothing – it cannot exist.

Sóma and *Tópos*

For Aristotle, Body and Place are symbiotic: 'just as every body is in place, so, too, every place has a body in it.'[4] Key to Aristotle's logic that Place constitutes an obvious phenomenon is its relationship to the Body. Aristotle maintains:

> Hesiod too might be held to have given a correct account of it when he made chaos first. At least he says: 'First of all things came chaos into being, then broad-breasted earth,' implying that things [*Sóma*] need to have place [*Tópos*], first, because he thought, with most people, that everything is somewhere [*Chóra* – a region], and in place [*Tópos*]. If this is its nature, the potency of place [*Tópos*], must be a marvelous thing, and be prior to all other things.[5]

For Hesiod (who lived at the time of Homer), Chaos was the Abyss, the great Gap, but while Hesiod goes to describe the genealogy of the gods, following his reference to Hesiod, Aristotle proceeds with a different narrative and links the 'broad-breasted' Body of the earth to 'the potency of place'. Here Aristotle presents the natural order of the Body requiring Place and Place anticipating Body. Place, bound as it is to Body, is opposite to Chaos, which we might define as a state of incoherence between Body and Place.

Tópos, as characterized by Aristotle, both orders the grand questions of Creation and Being, and is experienced intimately, thereby linking the personal to the Cosmos. A body cannot be infinite because 'it is the nature of every kind of sensible body to be [some place]'.[6] And, 'In general, if it is impossible that there should be an infinite place, and if every body is in place, there cannot be an infinite body.'[7] Neither can Place, like the Body that inheres to it, be infinite. Qualifying infinity, Aristotle says, 'magnitude [in terms of extension of the body and of place] is not actually infinite, but by division it is infinite'.[8] This relates to Zeno's paradox of motion; for Aristotle, there is always the potential of dividing distances infinitely. While the universe is infinitely divisible, it does not extend infinitely outward. Aristotle's universe is a finite Cosmos. Finally, it should be noted that Aristotle's *Tópos* is not merely a passive container:

> [Because bodies are material objects composed of the] elementary natural bodies – namely, fire, earth, [air and water are the other two of Aristotle's four elements] and the like show not only that place is something, but also that it exerts a certain influence. Each is carried to its own place, if it is not hindered, the one up, [fire and air] the other down [earth and water].[9]

Today, there is a habit to think of *space* as a neutral, homogeneous and infinite medium, in which the smallest particles to the largest galaxies reside. This view, however, is essentially incompatible with Aristotle's Cosmos. For Aristotle, all bodies inhere to their Place, which through materiality – fire, earth, air and water – actively influences where the Body resides.

Beyond the edge of the final sphere of the finite Cosmos, there is only the perfect and eternal material / non-material Quintessence which medieval Christians appropriated for the realm of God. This Aristotelian conception of the Cosmos – what we now consider *space* and outer *space* – dominated the understanding of the Mediterranean and European world for almost two millennia. Although the West traces much of its thinking to Classical Greece, it is remarkable how foreign and incompatible the Aristotelian Cosmos is to present consciousness.

Models of the World and Cosmos

Aristotle's Cosmos was not the sole model of the physical and metaphysical world. Democritus conceived of an infinite universe a century before Aristotle and in many ways Aristotle's ideas are a response to Democritus. Democritus' idea that the infinite universe was composed of an infinite number of uncuttable atoms was expanded on by Epicurus shortly after Aristotle's death. However, Aristotle's earth-centerd model of the Cosmos enjoyed wide acceptance in the Classical era and later. Written at the beginning of the reign of Augustus, Vitruvius' *De architectura* cites Pythagoras, Democritus, Plato, Epicurus and Aristotle in several contexts. Although Vitruvius does not address the disputes about the essence of the universe, he presents a description of the round earth surrounded by spherical orbits of planets and the zodiac as uncontroversial. During the span of the Roman Empire, images of the Cosmos were not widespread, although there are examples of the twelve Zodiac encircling Helios. At that time, cosmic forces were mostly represented as figurative allegories and as mythical dramas.

In Vitruvius' *De architectura*, *spatium* designates a measurable span or distance. *Spatium* as measure or span is exemplified in the Roman *itinerari*, a list of cities and towns that included the distances between destinations was the principal method for presenting the Roman web of roads and towns. In Book X of *De architectura*, Vitruvius describes a 'hodometer', a cart used for measuring distances. Although maps were not common, there is a remarkable medieval copy of a map, thought to have been originally drawn up in Vitruvius' time. Named after an early-sixteenth-century collector, the *Tabula Peutingeriana* is a simplified rendering of Roman roads stretching from the English channel to the borders of India (Figure 11). It is a fascinating object, measuring over 22 feet, but only a foot or so high. Like a contemporary subway map, the geographical context is subsumed into a schematic presentation of destinations and measurements.

Although its picturing is of the quantifiable world and not an imagining of the universe, the *Tabula Peutingeriana* reflects the value Romans put on measurement and extension. It can be said the *Tabula* represents the Roman utilitarian concept of *spatium*, but not *space* in a modern sense.

With the enthusiastic reception of Aristotle's *Physics* and *Metaphysics* in the twelfth century, Europeans began representing the Cosmos in a geometric form with the circular earth ringed with bands representing the planetary orbits. In the middle of the thirteenth century, Gautier de Metz published *Imago Mundi* (*Image of the World*), an encyclopedic theological poem that expounded an

Figure 11 *Top*: Konrad Miller, a modern facsimile of the *Tabula Peutingeriana*, 1887/1888. *Below*: Detail of southern Italy and Sicily.

Aristotelian / Ptolemaic concept of the Cosmos. The book was almost immediately disseminated in illustrated form. It was so popular that copies were translated from Latin into French, Italian, Spanish, English and Romanian.

As can be seen in the reproduced illuminations, there were variations of the mandala-like depiction of the Cosmos (Plates 19 and 20). Here, the four Aristotelian elements of Earth, Water, Air and Fire are consistently represented as rings at center, and the seven bands of the planetary spheres of the moon through Saturn. In some earlier representations of the Cosmos, hell is depicted at center, and later versions often show a *mappamundi*, a view of the earth from above. Figures of the zodiac may or may not be included, and the number of bands can vary at the outer rings beyond the bands of the planets. However, the image and the conception behind it remained consistent for over three centuries. The clarity of the parameters of Aristotle's Cosmos and the force of its simplicity encouraged both consistency and minor variations in its depictions.

There is magic to medieval illuminations of the Cosmos that can still evoke the 'marvelous potency' of Place, expressed by Aristotle. They are a reminder that the potency of Place, now subjugated to the modern idea of *space*, has not been entirely extinguished.

As late as the sixteenth century, Aristotle's concept of the Cosmos was promoted and visualized as can be seen in the illustration from the *Cosmographia*, written by one of the foremost astronomers and mathematicians of the time, Petrus Apianus (1495-1552) (Figure 12). At the center of the depiction is the bountiful earth with its water, moving outward this segues to a band of air (with clouds), then to the band of the fiery region, with flames – the domain of comets and asteroids. This section is composed of Aristotle's four elements: Earth, Water,

Figure 12 Petrus Apianus, illustration from *Cosmographicus liber*, 1524.

Air and Fire. Extending further, there are the bands of the Moon, Mercury, Venus, the Sun, Mars, Jupiter and Saturn. Three more bands represent spheres of the stars and two bands divided in twelve for the figures of the zodiac. Beyond the spheres of Apianus' Cosmos, and the limits of the *Primum Mobile*, there is the inscription COELUM EMPIREUM HABITACULUM DEI ET OMNIUM ELECTORUM (Empyrean Heaven, Abode of God and Chosen Omens).'

Apianus' book was published in 1524, the year after Nicolaus Copernicus' *On the Revolutions of the Celestial Spheres* was released, the tract that famously advocated the sun was at the center of the celestial system. Apianus' diagram exhibits how enduring Aristotle's model of the Cosmos (and *Tópos*) was. It is an image of a world view at the intersection of astrology, astronomy and theology soon to be rendered obsolete.

By the time Apianus drew his diagram of the Cosmos, the science that the image represents was well established. Completed two centuries earlier, around 1305, Giotto's *Last Judgment* in the Scrovegni Chapel shows two angels flanking

the window at the topmost reaches of the wall (Plate 21). The angels peel back the *Primum Mobile*, revealing a section of jewelled kingdom beyond the boundary of the Cosmos. This can be taken as Giotto's depiction of *space* – the abode of God in empyrean heaven, beyond the earth-centerd Cosmos.

The Place of Pictures

Place, as marvellously potent, is not static – it is an authoritative organizing principle. As such, Place could only be a force in structuring imagistic representation. On the most basic level, with the exception of miraculous images (*Acheiropoieta*), pictures are formed by artists placing material and images on a background or surface. On the most immense scale, it is Place that forms the earth-centerd Cosmos, and intimately, it shapes lived experience of a finite body in its finite Place. As Edward S. Casey writes in his philosophical history of Place: Place is 'sensed in concrete landscapes as lived, remembered, or painted'.[10] Place then has artistic significance, and further, it affects and even controls that significance. As essential to Aristotle's physics, Place was key to medieval science, and inextricable from theology. The questions are then: What are the representational orders constructed along the lines of 'pictorial place'? What do they look like? How did Place shape the presentation of images?

The history of Christianity is marked by contention surrounding the legitimate place of images – or even if images had a place within the religion. The Spanish Synod of Elvira of 305–306 stated, 'There shall be no pictures in churches, lest what is worshiped and adored be depicted on walls.'[11] Although, from the start, images were essential for how Christianity communicated its values and stories, simultaneously there was a deep distrust of their power. The figural content of Christianity is not surprising as the religion emerged within Classical culture, in which images formed the imaginative basis for social, political and religious relations and institutions. In stark contrast to Classical Paganism, Christianity's other inheritance, Judaism, prohibits worship of 'graven images'. As Christianity became the state religion of Rome, it proceeded to reject Paganism, ultimately to its obliteration. The Old Testament prohibition against idolatry was an effective means of separating Christianity from the many gods worshiped across the Mediterranean. The fitful rejection of images over the early centuries of Christianity can be understood as part of that process. The peril posed by idols was recognized – the Synod of Elvira even prohibited Christians from allowing their slaves to have their personal idols on the master's property.

As the proscription against images served to define Christianity against Paganism, it risked losing an originary, crucial element of Christianity. The body of Christ, His Passion and the sublimity of the Virgin Mother are vital figural structures at the heart of the faith. The Bible maintains, 'The Son is the image of the invisible God, the firstborn over all creation.'[12] Images – and these images in particular – were poignant and powerful means for building Christian knowledge and communities. Famously, the dispute between Iconodules and Iconoclasts turned violent during the eighth and ninth centuries, beginning with the Isaurian dynasty in Constantinople, but by the end of the ninth century, icons and imagery were definitively restored. Still, over the long history of Christianity, the place of images was never entirely secure. Disputes flared into and through the Reformation.

The Second Council of Nicaea of 787 was emphatic about the centrality of pictures to Christian doctrine – one could say there was pride in the place of pictures:

> We decree with full precision and care that, like the figure of the honored and life-giving cross, the revered and holy images, whether painted or made of mosaic or of other suitable material, are to be exposed in the holy churches of God, on sacred instruments and vestments, on walls and panels, in houses and by public ways, these are the images of our Lord, God and savior, Jesus Christ, and of our Lady without blemish, the holy God-bearer, and of the revered angels and of any of the saintly holy men.[13]

Before even addressing descriptions of images, the previous text designates places for images – from the holy churches of God to Christian towns and roads. In Aristotelian fashion, Place is given its due. Concerning the order of the depicted figures, 'our Lord, God and saviour, Jesus Christ', is first, followed by – again resonating outward – 'our Lady without blemish, the holy God-bearer' and then the 'revered angels' followed by the 'saintly holy men'. Both of these instances are similar as they both display a visual-logical continuity to Aristotle's central earth-ringed spheres within spheres radiating to sequentially complete the Cosmos. The hierarchy of Christ, the Virgin, angels and saints is visually ordered in the architecture of Christian Painting.

Even after pictures were firmly established in Christian worship, there was a need to specify how they would fulfil their purpose. The Nicaean text proceeds to distinguish the image from idols in that, 'who venerates the image, venerates the person represented in that image' rather than the image itself. While 'respectful veneration' is the primary objective of images, additionally, figures

which the 'more frequently they are seen in representational art, the more are those who see them drawn to remember and long for those who serve as models ...' This describes secondary purposes of pictures, which is to present models to be emulated, and aid in memory – it is the acknowledgement that representational art has didactic value. St Bonaventure (1221–72), as well as writing the official biography of St Francis, wrote about the purpose of images. In Christianity, images 'were introduced on account of a triple cause, namely on account of the ignorance of simple folk, on account of the slowness of affections and on account of the weakness of memory'.[14] Writing almost five hundred after the Council of Nicaea, St Bonaventure presents similar themes that correspond to veneration of the image in order to quicken the affections, and second, that images had the didactic value of assisting memory and tutoring the illiterate on the stories of the Scriptures and 'the virtuous deeds of the saints'.

Christian Painting is the emphatic articulation of architectural Place. While Christian Painting is often referred to as 'church decoration', it has force and purpose. There is an Aristotelian logic to church decoration – every image has its place and every place has the image proper to it. The two defining types of Christian Painting, Icon and *Istoria*, literally and figuratively each take their place to fulfil their hierarchical roles. Although Alberti's ambition was to reprioritize the two, elevating *istoria* above the Icon, the 1,000-year tradition of Christian painting shows how effective this divided structure was in aligning purpose and form to Place. The figure of the icon, grand in scale and power, is the very institution of the center, whether on a panel, church wall or within an altarpiece. The colossal figure is predominant and its iconicity entails successive surrounding spheres of images: processional imagery of saints, martyrs and other worshippers. The surrounding images serve to emphasize the icon's centrality and scale, which is tantamount to its importance. In terms of the priority of images in panel paintings, sacred buildings and within altarpieces, the central icon – defined by its Place – dominates. Place defines the tradition of Christian Painting: the structure and power of representation and imagery flow from, and into Place.

The Alternative *Spatium* of St Augustine

For centuries, to the degree that *space* was conceptualized, it had an ancillary role to the potent role of Place. Some Pagan philosophers such as Democritus and Epicurus (and his follower, Lucretius) wrote about infinity of the universe, but this did little to disturb the general imagination of an earth-centerd Cosmos. In

this context, infinity had little more force than an intellectual proposition. With the Christian establishment of the 'Almighty God, the All-creating and All-sustaining, the Architect of heaven and earth', as St Augustine calls God, infinity became both a philosophic circumstance and an essential power of God.

St Augustine (354–430 CE) was a North African Roman citizen and a Church Father. He is best known for his primary shaping of Christian orthodoxy, but in his advocacy for Christianity, which was competing with other religions and heresies, he delved into metaphysics. St Augustine is often quoted, asking:

> For what is time? Who can easily and briefly explain it? Who can even comprehend it in thought or put the answer into words? Yet is it not true that in conversation we refer to nothing more familiarly or knowingly than time? And surely we understand it when we speak of it; we understand it also when we hear another speak of it.[15]

St Augustine devotes the thirty-one chapters of Book VI of his *Confessions* to the conundrums of time, God and creation. In distinction to Aristotle who elaborated far more extensively on Place than time, St Augustine did not produce a chapter on *spatium* as he did for *tempus*, however due to his belief in an All-powerful God, his Christian *spatium* is defined significantly differently from the Pagan philosophers, including Aristotle. This Christian *spatium* can be glimpsed in several passages in his *Confessions*. Although St Augustine was writing some four hundred years after Vitruvius, the practical meaning of *spatium* is consistent. Like Vitruvius, *spatium* is most commonly used as a span (often of time) and a bounded, measurable segment. But unlike Vitruvius, St Augustine is concerned with *spatium* in reference to the metaphysics of God. In his *Confessions*, St Augustine reports being challenged by unbelievers, 'Is God a finite corporeal form, has he hairs and nails?'[16] In response, St Augustine expresses that 'God is a spirit,' that He cannot be 'defined by a certain space rather than by infinity':[17]

> So too, You [God], the life of my life, so great, penetrating the entire mass of the world through infinite spaces everywhere, and beyond it in all directions through immensity without limit, so that the earth would hold you, the heavens would hold you, everything would hold you, and would be bounded in you, but you would be nowhere.[18]

God is immeasurable *spatium* – a theological contradiction – as *spatium* signifies a measurable span. Contradictions redouble the mystery and power of God. Likewise God: 'Most High and Most Near, Most Secret and Most Present ... who is wholly everywhere and nowhere in place, not shaped by some corporeal

form: you created man after your own image and, behold, he dwells in place, both head and feet.'¹⁹ Even as St Augustine denies the literal corporeal form of God, he redeems the closeness of God and man, in imagery as each dwells in their Place, head and feet.

St Augustine's Christian *spatium* is significant. Unlike Aristotle's Place, which is defined by its bounded form, the Place of the Christian God is infinite, everywhere and nowhere. Theological *spatium* – immeasurable measure – is where God dwells and where it dwells within Him: *spatium* is a limit made limitless through God and in God. For St Augustine, God is so intensively bound to all Place and all extension that *spatium* cannot be inert or passive. In St Augustine's Christian form, *spatium* is not merely a segment of measurement. As an extension of God, *spatium* intimates infinite power. And so the power of *space* is defined as extension.

Notes

1 Aristotle, *Physica*, trans. R. P. Hardie and R. K. Gaye. *The Works of Aristotle*, ed. W. D. Ross (Oxford: Oxford at the Clarendon Press, [350 BCE] 1930), Book 3, part 5.
2 Ibid.
3 Ibid.
4 Ibid.
5 Ibid., Book IV, part 1. The original terms of Aristotle are added to the translation.
6 Ibid., Book III, part 5.
7 Ibid.
8 Ibid, Book 3, part 6.
9 Ibid., Book IV, part 1.
10 Edward S. Casey, *The Fate of Place: A Philosophical History* (Berkeley and Los Angeles, CA, and London: University of California Press, 1997), 78.
11 '81 Canons of the Synod of Elvir, [c. 300]', *Strannik Journal*, strannikjournal.wordpress.com/historic-confessions/81-canons-of-the-synod-of-elvira/ (accessed 2024).
12 Holy Bible, New International Version (Grand Rapids, MI: Zondervan, 2011), Colossians 1:15.
13 'The Second Council of Nicaea of 787', Papal Encyclicals Online, www.papalencyclicals.net/councils/ecum07.htm (accessed 2024).
14 'St. Bonaventure on the Veneration of Images' [c. 1270], *Lyfaber*, 11 November 2008, lyfaber.blogspot.com/2008/11/st-bonaventure-on-veneration-of-images.htm (accessed 2024).
15 St Augustine, *Confessions*, Book VI, chapter XIV [c. 400], Outler, Albert C. (Translator). Grand Rapids, MI: Christian Classics Ethereal Library. 193

16 'et utrum forma corporea deus finiretur, et haberet capillos et ungues' (St Augustine, Confessiones, Liber III, Caput VII, Georgetown University Faculty Web Pages, faculty.georgetown.edu/jod/latinconf/latinconf.html (accessed 2024)).
17 Ibid., 'certo spatio definita, quam per infinitum'.
18 'ita etiam te, vita vitae meae, grandem per infinita spatia undique cogitabam penetrare totam mundi molem, et extra eam quaquaversum per inmensa sine termino, ut haberet te terra, haberet caelum, haberent omnia et illa finirentur in te, tu autem nusquam' (ibid., Liber VII, Caput I).
19 'tu autem, altissime et proxime, secretissime et praesentissime, cui membra non sunt alia maiora et alia minora, sed ubique totus es et nusquam locorum es, non es utique forma ista corporea, tamen fecisti hominem ad imaginem tuam, et ecce ipse a capite usque ad pedes in loco est' (ibid., Liber VI, Caput III).

9

The Decentering of Place

The images that illuminate the manuscripts of Gautier de Metz articulate something of a standoff between Aristotle's Place and the infinite power of God that St Augustine expresses. In the illustrations, God is shown in regal majesty – an image of His rule over the Cosmos. These illuminations of the Cosmos are significant and informative, not motivational like a Madonna and Child or Christ on the cross, nor are they narrative as in *istorie*. The images function as descriptive emblems of Aristotle's Cosmos, with its requisite elements and planetary bands, and essentially God presides in His (infinite) Place over the world. This format remained consistent even centuries later, with Apianus' more scientific image of the Cosmos. Although it was possible for the balance of an all-powerful God in heaven and a Cosmos ordered by the potency of Place to hold for a while, it was unsustainable.

The history detailing how *space* came to supplant Place is a large subject and there are fascinating studies that track its complexities.[1] While it is somewhat of a simplification, St Augustine's Christian *spatium* provided an early framework for an expansive *space* to be conceived. Wrapped up with God, *space* increasingly gained definition to become a power to compete with and ultimately vanquish the Aristotelian conviction in the potency of Place. Although the authority of Place was never total, the history of the demotion of Place entails how *space* as a power of extension would displace the status of Place.

Several conditions were requisite for *space* to gain priority. The grip of Place on the collective imagination had to be loosened. As well, *space* would need to gain definition – a challenge for something often defined as nothing. Even more urgently, *space* would have to contain and display power and show it justified, social and political forces beyond such intellectual pursuits as metaphysics, science and theology. For *space* to pre-empt Aristotle's 'wonderful potency of Place', the power of extension which is at the core of St Augustine's *spatium* would have to gain credence.

The Expulsion and the Cosmos

It should be noted that the diminishing of Place in European imagination was a centuries-long process. However, there is a singularly original painting, a small picture in a ten-panel altarpiece that exemplifies the forces that undermined Place. While the painting's representations and theology did not cause the weakening of Place, the painting is evidence of the ideas at work that had already begun to challenge its authority. The panel, painted in about 1450, by the Sienese painter and illuminator Giovanni di Paolo (1403–82), depicts the Expulsion from Eden, and most originally, it simultaneously presents the image of the Aristotelian / Ptolemaic Cosmos (Plate 22). The painting in the Metropolitan Museum of Art is described as showing a Creation scene with the Expulsion. While the picture certainly presents the Expulsion, there is a more comprehensive explanation of what is being depicted with the image of the Cosmos.

Giovanni's depiction of the Cosmos is both gorgeous and specific. The lapis lazuli blue rings and the red and white ring directly correspond to Apianus' later scientific drawing: earth is at the center, depicted with oceans, hills and the network of four rivers flowing from the central mountain peak. Beyond the white border of air encircling the earth and its waters follows a red band representing the fiery region, then, in sequence, the pale band of the Moon, then Mercury, Venus, a white band for the sphere of the Sun, followed by the darker bands of Mars, Jupiter and Saturn. At the outer edge of Giovanni di Paolo's Cosmos there is a single astrological sphere in distinction to Apianus' three, but, by the standards of the time, Giovanni's Cosmos is scientifically precise. Despite the wearing-off of much of the twelve zodiac signs painted in gold, they can be identified, and were requisite for a fulsome depiction of the Cosmos.

The Expulsion is easily recognized, despite missing some of the characteristic iconographic markers – the sword of the angel banishing Adam and Eve and the gates of Eden. The interest of the painting lies in the most unusual merging of the image of the Cosmos conjoined with the Expulsion, Here, the potency of the Aristotelian Cosmos intersects with the dynamic power of God.

Giovanni was a manuscript illuminator as well as an icon and *istoria* painter. In this tradition, it was not uncommon to portray two events in one frame to create a narrative arc. Consistent with that practice, Giovanni's Cosmos / *Expulsion* picture links actions: God, flying above, speeded on by an engine of seraphim, points to the earthly center of the Cosmos while staring directly at the sinners as they are forced from paradise. Despite the exquisitely rendered

Cosmos on the left and the depiction of the expulsion scene on the right, it is God and His power that is central to the narrative. God's golden illumination suffuses the painting, touching the wings of the archangel and shines onto the leaves of the golden fruit trees of Eden.

This is not the Lord, Christ in the equable Pantocrator mode. God is depicted in extreme motion, forcing the Cosmic disk, left to right, flattening the lush paradise as the Archangel Michael hustles Adam and Eve out of the garden. God appears to be bulldozing Paradise as the Cosmos rolls toward the sinners like a celestial millstone. Behind the Cosmic disc the horizon is lowered and the Garden has become a barren void; even the rays of God's golden light do not reach the ground.

Although the Metropolitan Museum describes Giovanni's painting as depicting the Creation (as well as the Expulsion), it is unlikely that a thorough inquiry into the painting's unusual iconography was pursued. The iconography of the painting is not unrelated to other works, however, it seems there are no other paintings that show the Cosmos and the Expulsion in one frame. Because Giovanni has depicted God and the Cosmos, it does not necessarily follow that he is representing the Creation. To appreciate what is more likely the subject of Giovanni's painting, a comparison to another depiction of the Cosmos may be helpful.

In Padua, some 150 miles from Siena, Giusto de' Menabuoi (c. 1320–91) executed a powerful picture of heaven and history for the interior dome in the Baptistery of the Duomo (Plate 24). At its top, a mid-length Christ the Pantocrator is ringed by seraphim and further surrounded by a circular chorus of over one hundred saints. Despite the different architectural framing of Giusto's dome to the basilica of Monreale, the imagistic ordering of dominant Pantocrator to subservient *istoria* is consistent in both instances. The placial hierarchies of centering, symmetry and the architecture ordering of the representations follow the same principles.

Beginning the cycle of *istoria* scenes, just below the feet of the Virgin, Giusto painted a Creation scene that bears reference to Giovanni's panel (Plate 25). There are enough similarities for one to wonder if Giovanni cribbed parts of it for his own purposes, as he was known to do in other instances. Giovanni's *mappamondi* looks beholding to Giusto's, and it can be noted that Giovanni's speeding God and Giusto's enthroned God are both located between the positions of Aquarius and Pisces on the wheel of the zodiac. Still, the differences are more revealing than the similarities. In the Paduan fresco, God is in the familiar, peaceful Pantocrator mode, blessing His Creation and gesturing to the

world with an open palm. The enthroned God creating the Cosmos had been a staple of Christian imagery for centuries. The forceful God as portrayed in Giovanni's painting is also an established part of Christian iconography and this is how He is commonly portrayed in expulsion scenes as in the renowned fresco by Masaccio. Unique to Giovanni's picture, however, is the forceful God linked to the Cosmos.

The iconographical issue that Giovanni's painting presents is that the forceful God, not the serene creator, is portrayed as dominating not just Adam and Eve but also the Cosmos. This is not an image of God in creating mode. The question is, what does the picture represent, if, as it appears, God is not being depicted creating the Cosmos?

Between the Power of God and the Potency of Place

Giovanni di Paolo was regarded during his career as a canny and adept illustrator. Even before painting the Guelfi Altarpiece (of which the Cosmos / Expulsion panel was a part), he was commissioned by King Alfonso of Naples to illuminate Dante's *Paradiso*, a theological poem of cosmic proportion.[2] As such, it would have been within his capacity to illustrate some of the finer complexities of contemporary theology.

Here is Article 49 of the 219 Condemnations promulgated on 7 March 1277, by the Bishop of Paris, Etienne Tempier, at the encouragement of the pope:

> It is to be condemned 'That God could not move the heavens [i.e. the Cosmos] with rectilinear [lateral] motion; and the reason is that a vacuum would remain.'[3]

It is hard to imagine a more literal illustration of the all-powerful God sliding the Cosmos to the right, and, while He was at it, leaving a vacuum behind, than in Giovanni's panel.

If Giovanni's panel includes the portrayal of Article 49 of Tempier's Condemnations, as it appears to, the iconography functions as a whole. The subject of this is a painting of God's forceful power. And it is specifically the force of God's power to administer justice to sinners and to dominate the potency of Place that the Condemnation addresses.

With this single condemnation, two Aristotelian principles are made anathema. Foremost, Article 49 establishes – as Church doctrine – that indeed God has the power to move the Cosmos. Additionally, the all-powerful God is not to be constrained by debates over whether or not a vacuum can exist. Both the

impossibility of decentering the Cosmos and the impossibility of the existence of a vacuum are key concepts in Aristotle's *Physics*. If this is what Giovanni's painting represents, it shows God triumphant over the Placial order of the Aristotelian Cosmos. Why would this theological subject be urgent to represent? Here, we must look to the painting's context as part of a ten-panel altarpiece.

Although the Condemnations were issued just more than a century before Giovanni's commission, the conditions that the edict responded to had remained relevant. Beginning in the twelfth century, texts of Aristotle were translated from Arab sources and became available to European universities. The interest did not diminish and as more translations became available there was increased passion for Aristotle among European scholars, causing discomfort to some Church authorities.

It was in response to this rise of Aristotelianism that Tempier issued the Condemnations. At root, the Christian grievance was that the omnipotence of God was reality and should not be constrained rationally or even experientially: it was also to be condemned that believing what is 'self-evident or could be asserted from things that are self-evident'.[4] Any idea that might diminish Christian faith was to be condemned. While Aristotle's concept of Place in many ways suited the Church, the Christian god, as infinitely powerful, could not be limited by the finitude of Aristotle's Cosmos in its Place. The Condemnations represent a backlash. For Tempier, St Augustine's framing of the infinite power of God was a sword to smite the Aristotelians. The Condemnations pitted true faith against the theories of theologians and professors, who were seen as promoting Classical rationality beyond Christian faith.

It is generally acknowledged that the Condemnations were targeting the influence of Aristotle as promulgated by one of the most thoughtful and charismatic theologians of the era, St Thomas Aquinas (1225–74). Although during his lifetime St Thomas was influential and generally well respected, he was also controversial. Even after he died, his writings were attacked as being radically Aristotelian. It is significant that the Condemnations were released three years to the day after St Thomas' death.

There were suspicions that St Thomas was a follower of the Muslim Aristotelian, Ibn Rushd (Averroes), who St Thomas respectfully engaged in his Confessions, referring to him as the 'Commentator' of the 'Philosopher', Aristotle. It was considered heretical by conservative churchmen for allowing the truth of reason to stand alongside the truth of faith. However, in 1323, St Thomas was canonized, and respect for his theology, much of which involved weighing the competing claims of Pagan philosophy and Christine doctrine, continued to

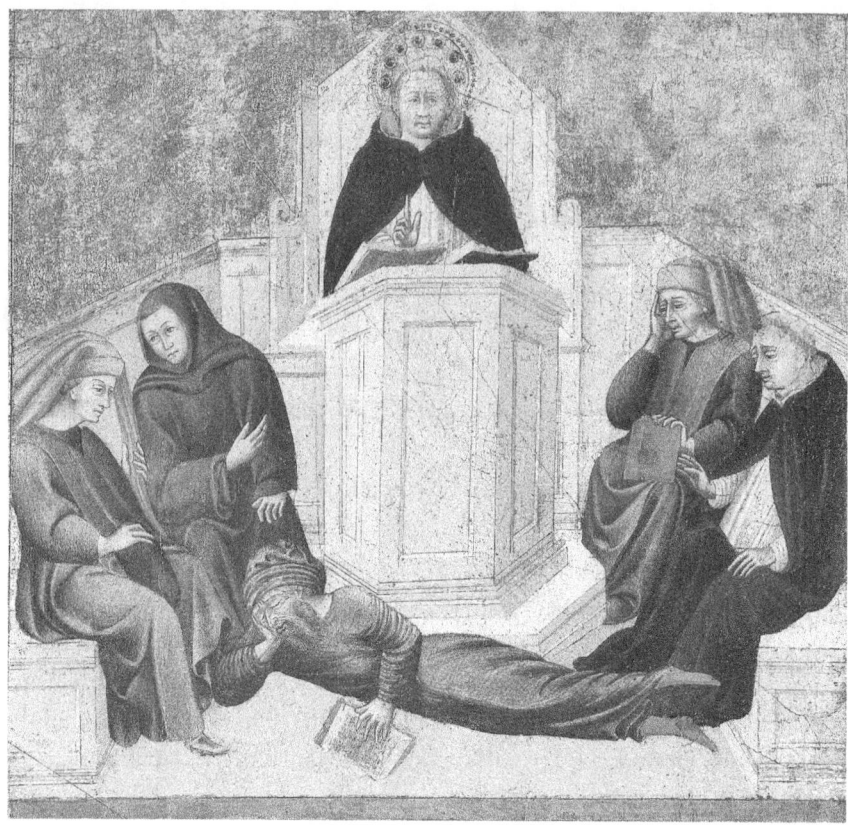

Figure 13 Giovanni di Paolo, St Thomas Aquinas Confounding Averroes, tempera on wood panel, 9.7 × 10.3 in, *c*. 1445–50.

increase. Although St Thomas firmly disavowed the extremes of 'Averroism', his writings show great consideration of Ibn Rushd's insights relating to Aristotle. The Condemnations were withdrawn two years after St Thomas' canonization in 1323, however Averroism had come to stand for radical Aristotelianism. While St Thomas and his measured Aristotelianism became doctrine for the Church, a campaign to separate St Thomas' theological positions from Averroism was instituted.

The program to separate St Thomas from Averroes was still ongoing over a century later at the time Giovanni painted the Guelfi Altarpiece which the panel of the Cosmos and Expulsion were part of Guelfi Altarpiece (Figure 13). Within a few years of the altarpiece commission, Giovanni painted a small panel depicting St Thomas in a pulpit confounding Averroes, who is prone on the ground.

The Place of St Thomas Aquinas in the Guelfi Altarpiece

Giovanni's panel showing St Thomas and Averroes indicates that the competition between Aristotelian ideas and Christian fundamentals was still a live issue at the time Giovanni painted the Expulsion and the Cosmos. Giovanni's *Expulsion and the Cosmos* picture was the first of what were five predella panels (although three of the panels are lost) belonging to an altarpiece commissioned by the Guelfi family for a Dominican church in Florence (Plate 26). Above the smaller *istoria* panels of the predella are the icons – at center is a *maestà* of Virgin and Child. Flanking the twin pillars of the church are St Peter and St Paul, and the outermost panels portray St Dominic and St Thomas. Consistent with the scholarly values of the Dominican Order, all the saints hold books, but St Thomas' book is open and the only one with a glowing nimbus (Plate 27). Culled from the Old Testament and a standard for Dominicans (the order of St Thomas), the Latin motto reads, 'My mouth shall discuss truth, and my lips shall detest the impious.' This, then, is the context of Giovanni's *Expulsion* and Cosmos painting. The altarpiece in many ways is standard fare; it follows the form of dividing images of veneration from narrative pictures within the architectural form of an altarpiece. However, the cycle of images should also be understood in light of St Thomas, the scholarly saint who mediates between the philosophy and science of the ancient Greeks and Christian faith. Additionally, the commissioning of a painter, known for his cultured illuminations, should allow us to imagine that this predella could contain an unusual and sophisticated narrative.

A Unified Narrative

As a product of brilliant and subtle illuminator of manuscripts, the subject matter of Giovanni di Paolo's altarpiece can be posited as forming a narrative whole. Even if Article 49 explains one of the predella panels, it should be understood within the totality of the pictorial cycle. Despite three of the predelli being lost, the predella panel assumed to flank the Cosmos / Expulsion scene depicting the reunification of souls in paradise exists (and is also in the Metropolitan Museum of Art). Can these two predella scenes be understood as coherent together?

We begin with the first panel. The dominant figure that links the Cosmos to the Expulsion from Eden is God, but it is not God in general but God in his most forceful mode. One could say, Giovanni does the logic of Article 49 one better: not

only does he demonstrate in his painting that God can move the Cosmos and create a void, but at the same instant Giovanni also shows the power of God to expel sinners from Paradise. Further, not only does Giovanni portray God moving the heavens and earth, but he also shows why God would do so. Because of their impiety, justice demands Adam and Eve be displaced to earth. As Adam and Eve are forced from their original place in Paradise, God directs them with a pointing finger to the Cosmos, ready to receive them. Man and Woman will take their rightful, but diminished, Place at the center of the Cosmos. The visually embodied narrative demonstrates God's great power over Place, but also that He uses His power righteously. God does not use His power capriciously nor to disintegrate Place. Infinite God is supreme and the potency of Place is preserved. The two halves of the picture-narrative come together to form an *istoria* of the Place of humankind – a resolution worthy of the conciliatory nature of St Thomas.

It can be noted that in Giovanni di Paolo's painting, while Adam and Eve are being punished, they appear more stunned than distraught. An interesting comparison can be made to Masaccio's *Expulsion* (likely painted a few years before Giovanni panel), in which the Archangel brandishes a sword and Adam and Eve are weeping inconsolably – the God of Masaccio is an avenging God. In contrast, Giovanni's God appears more stern than wrathful. God loves humankind, who He fashioned after His image. However, Justice must prevail. Furthermore, the theme of Love and Justice continues in the sequential panel in the predella to the right.

In this second panel, the theme of Love and reunification predominates. Like Giovanni's Cosmos / *Expulsion* panel, the iconography of Giovanni's Paradise is highly original. In this painting, souls in Paradise meet and embrace in pairs. Typically, redeemed souls are shown in a heavenly choir centerd around God (as in the dome of Padua), but in this Paradise, souls are reunited with loved ones. At the time Giovanni painted the altarpiece, the Dominicans fostered an intellectual interest in Classical literature. Giovanni's depiction of Paradise is evocative of Plato's *Symposium*, in which it is discussed that men and women long to reunite with their other half in love (Plate 23):

> we must praise the god Love, who is our greatest benefactor, both leading us in this life back to our own nature, and giving us high hopes for the future, for he promises that if we are pious, he will restore us to our original state, and heal us and make us happy and blessed.[5]

To allow Giovanni and his audience some neo-Platonism into his imaging of Paradise would have been within the culture of the times. Whether or not Plato

was on Giovanni's mind, his painting of Paradise depicts a return to Paradise. The two panels show the same flowery landscape, the trees with golden fruit and even the pair of rabbits. There is an elegant narrative arc in the sequence of the representation between the two panels. Following the Fall from Grace – the rupture between Man and God – is the representation of Paradise as the reunification in Love in the adjacent panel.

The content of God's Love and Justice would have been intimately familiar to Giovanni, a Sienese citizen and the illuminator of Dante's *Paradiso*. Canto XVIII describes God as a divine artist who paints the heaven with birds and lights to spell the Old Testament commandment: *Diligite iustitiam qui iudicatis terram* – Love (or Cherish) justice, you who rule the earth. These were words the Sienese people lived by; the motto was emblazoned in their city hall and so, rooted in both secular and heavenly courts.

Loosening the Centrality of Place

Whether Giovanni's panel illuminates the Creation, as the Metropolitan Museum of Art describes, or Article 49 of Tempier's Condemnation declaiming God's power over the Cosmos, the iconography remains startlingly unique. Bucking the pictorial convention of placing the Cosmos at the picture's middle, Giovanni's Cosmos is off-center. Even to today, the asymmetry of the Cosmos' place unsettles. This effect makes for an analogue – which can be seen from the distance of today – of Tempier's Condemnation that maintains the force of God, against the centerd Cosmos of Aristotle.

Tempier's Article 49 (which condemns teaching that the Cosmos could not be moved by God) and Article 34 (which condemns teaching God could not create multiple worlds) can be understood as marking an inflection point in the intellectualization of Place, the Cosmos and science. Pierre Duhem (1861–1916), an innovative physicist as well as fervent Catholic, who is generally credited as the first historian of medieval science, reflects on Tempier's Condemnations:

> If we were obliged to assign a date to the birth of modern science, we would undoubtedly choose 1277, when the Bishop of Paris solemnly proclaimed that a multiplicity of worlds could exist, and that the system of celestial spheres could, without contradiction, be endowed with straight line motion.[6]

To the degree that 1277 represents a milestone in science, it allowed that physics did not have to hew to Aristotle. While not all historians agree the

Condemnations mark the beginning of modern science, it certainly marks an early and profound loosening of Aristotle's Placial order and an impetus for the extension of *space*.

Utopia – The Ungrounding of *Tópos*

The Condemnations of 1277 provided an opening to question Place in the Aristotelian universe. In the thirteenth and fourteenth centuries, there were theological and philosophical debates on the deistic nature of infinitude and power – and, at the same time, there were very worldly extensions of power at work. Following the remuneratively successful Fourth Crusade (which culminated with the sack of Constantinople in 1204), there were crusades against the Cathars in the south of France (1209–29), the Baltic Crusades and the Prussian Crusade of 1217–74 (which eventually Christianized the last European Pagan state, Lithuania in 1387). To the west, the Battle of Las Navas de Tolosa (1212), marked the beginning of the Christian reconquest of Iberia and to the east, multiple crusades established Christian states in the Holy Land. Over the subsequent centuries, Christianity, as a secular authority, was expanding geographically as well as philosophically. If God was omnipotent in His power of extension, it had resonance in the real-world projection of force. European map-making, adventure and exploration would only increase with the recognition of the New World at the end of the fifteenth century. In this new imagining of the world, the finitude of Place might be seen as limiting the power of Christianity, like its God, to project force. Extension was becoming an attractive alternative to centering. Place was becoming smaller and incommodious to the power of extension.

Place as a personal, social, theological and metaphysical model was successful but it was always somewhat contested. Aristotle's *Tópos* was itself a response to the more anarchic atomism of Democritus. In the early fifteenth century, Poggio Bracciolini (c. 1416–17) discovered a manuscript of *De rerum natura* (*On the Nature of Things*), a didactic poem by Lucretius (c. 99 BCE–c. 55 BCE) advocating for Epicurus' ideas including his atomism. The poem was shared in Humanist circles and was first published in 1473, cementing its popularity. It has been argued that the rediscovery of *De rerum natura* marks a turning point in supplanting the finite Cosmos by an infinite universe. Even as the poem makes a case for atoms in an endless empty void, there was not yet observational or experimental evidence to overturn the comprehensive and comprehensible power of Place. Still, like Tempier's Condemnations, *De rerum natura* offered the

possibility of rethinking the Cosmic order and entailed a further undermining of Place.

The diminishment of the authority of Place (*Tópos*) in the late Middle Ages is evident in St Thomas More's *Utopia*. While not a direct assault on the authority of Place like atomism of Epicurus and Tempier's Article 49, *Utopia* represents a disturbance of Place that is both diffuse and unresolved. *Utopia* was published in 1516, half a century after Giovanni's Expulsion, and less than a decade before Copernicus' model of a heliocentric universe was published. The neologism 'utopia' is a pun on *Tópos*. With the prefix of the Greek '*ou*', it is 'not-place' or 'no place'. If a not-place might have been unsettling, the title could also be parsed as *Eutopia* or 'good place' due to the prefix '*eu*' meaning 'good'. The contradiction of two titles was encouraged by More himself, who wrote in the addendum of the second edition, 'Wherfore not Utopie, but rather rightely my name is Eutopie, a place of felicitie'. As indicated by the multiple meanings of its title, More equivocates. More's Utopia, piggybacked to *Tópos*, is cryptic, unsteady and symptomatic of its time when the authority of Place – still essential to sensing, imagining and depicting the world – was beginning to falter.

At this time, *Tópos*, like its shadow, Utopia, had become shaky. The creation of a Utopia would become a clarion imperative associated with *space* in the twentieth century. But, as a literary artefact of its age, the indeterminacy of *Utopia* either as 'No-Place' or 'Good-Place' reflects that the sovereignty of *Tópos* was weakening. Unlike in Giovanni's picture and Aquinas' accommodating theology, Place is unredeemed.

Challenges to the Geocentric Cosmos

In the sixteenth century, there were several factors, more actual than noetic, that shook the world view of Place. The European discovery of a new continent to the west excited the imagination, but was also unsettling. In St Thomas More's odd little book, he placed the island of Utopia on the coast of Brazil, just south of where Rio de Janeiro is today, in the opposite direction of eastern Arabia or Sri Lanka, where literal-minded map makers had posited the location of Eden. Famously, Copernicus' careful observations and calculations indicated that the earth was not the immobile center of the Cosmos, instead it was the sun around which the planets circled – a point that challenged both the orthodoxies of Aristotelian science and Christian doctrine. However, the most dislocating event to the European sense of wholeness was the chain of events that began the year

after St Thomas More published *Utopia* and was set in motion by a very different public text.

In 1517, Martin Luther (1483–1546), a young professor of theology at the University of Wittenberg, issued *Disputatio pro declaratione virtutis indulgentiarum*, known as the *Ninety-Five Theses*. These disputations were not aimed at the Church as a whole but at the commercial abuse of indulgences to mitigate sinful behavior through charity. The *Theses* were primarily intended to rectify a theological detail – albeit, one with economic account – within the Church. However, what began as a limited criticism metastasized to form a reformation with a momentum that broke apart the European unity of the Church and its sense of Place.

As the emergent Lutheran and Calvinist Churches challenged the unity of the Catholic Church, there was a backlash. The sanctioning institution of Catholic doctrine, the Inquisition, took the opposite tack of Bishop Tempier centuries earlier and condemned theories refuting the Aristotelian and Ptolemaic earth-centered Cosmos. Famously, this culminated with the trial and imprisonment of Giordano Bruno (1548–1600) and Galileo Galilei (1564–1642). From the perspective of the Inquisition, there was good reason to condemn these theories, as it did formally in 1616. The Church's existential hierarchy – its form and shape – was a mirror of the logic and structure of Place it shared with Aristotle's Cosmos.

It is not a contradiction that in the thirteenth century the power of Place was seen as limiting the expansive potency of God (and His earthly agents) and, in another century, that Place was claimed for the defence of orthodoxy. Rather, it is an indication of both the power of Place and the all-too-human ways power is wielded.

Copernicus and Galileo

Between 1510 and 1514, Copernicus began circulating a six-page manuscript outlining his basis for the heliocentric cosmos among a select group of friends. Copernicus was cautious enough to hold off printing the completed text until 1543, the year he died. While the Catholic Church came to condemn heliocentrism, initially there was support from Church authorities such as Bishop Tiedemann Giese (1480–1550), a patron to Copernicus, and who was eventually buried next to him. No less than a cardinal, Nicholas Schönberg (1472–1537), wrote to Copernicus in 1536 to congratulate him on his new model of the cosmos and to entreat him 'to communicate this discovery of yours to scholars, and at the earliest possible moment to send me your writings on the sphere of the universe'.[7]

It can be noted for those who objected to heliocentrism on biblical grounds, the book of Genesis does not explicitly define that the earth is at the center of the universe, rather, the centrality of the earth is implied by a minor passage in the Book of Joshua. During the battle in Gibeon, God heeded Joshua's plea to stop the sun and the moon in the sky so he could finish the encounter in daylight. It was not only the Catholic Church who resisted heliocentrism. Luther's aversion to this new theory of the heavens was recounted by a comrade. Referring to Copernicus and his heliocentrism, Luther says: 'This is what that fellow does who wishes to turn the whole of astronomy upside down. Even in these things that are thrown into disorder I believe the Holy Scriptures, for Joshua commanded the sun to stand still and not the earth.'[8] Luther clearly grasped heliocentrism's potential to break the orthodoxy of the Cosmos, even as he was splintering religious unity in Europe.

Although heliocentrism contradicts the specifics of the Aristotelian tradition of astronomy, it is still within its metaphysics of Place. The diagram of the solar system that was included in Copernicus' *De revolutionibus orbium coelestium*, is a version of the type of diagram of the Cosmos that Apianus published (Figure 14). In Copernicus' rendition, the earth and the moon are relocated but the circular representation of the nested spheres – the very emblem of Place – remains intact. Galileo, like Copernicus, follows the visual format of geocentric celestial spheres in his conception of the universe. Place, embedded as it was between common sense and metaphysics, was slow to lose its grip on the imagination of even the best scientific minds of the Renaissance.

Although Copernicus was well read in Antique metaphysics, he primarily focused on texts that were mathematically useful, such as Pythagoras and Ptolemy. Astronomy was for Copernicus, the consummation of mathematics. Even with a keen interest in the motion of planets, he did not stray to theorize issues of infinite *space*. Indeed, Copernicus' interests and talents were directed more toward correcting problems in the ecclesiastical calendar and advising the Prussian court on monetary policies than in engaging metaphysical questions. To the degree that Copernicus discussed the Cosmos as a whole, he is traditional: Platonic in terms of the perfection of abstract forms and Aristotelian in that Copernicus' universe is bounded.

Although it came to be viewed as such, Coperincus' heliocentrism was not an immediate challenge to Church doctrine nor to the structure of Place. However, within a few decades after Copernicus' death, a charismatic figure, Giordano Bruno, emerged to unravel the authority of Place as fundamentally as Copernicus' heliocentrism would eventually dissolve the idea of earth-centerd Cosmos. Although during the first half of the sixteenth century the authority of

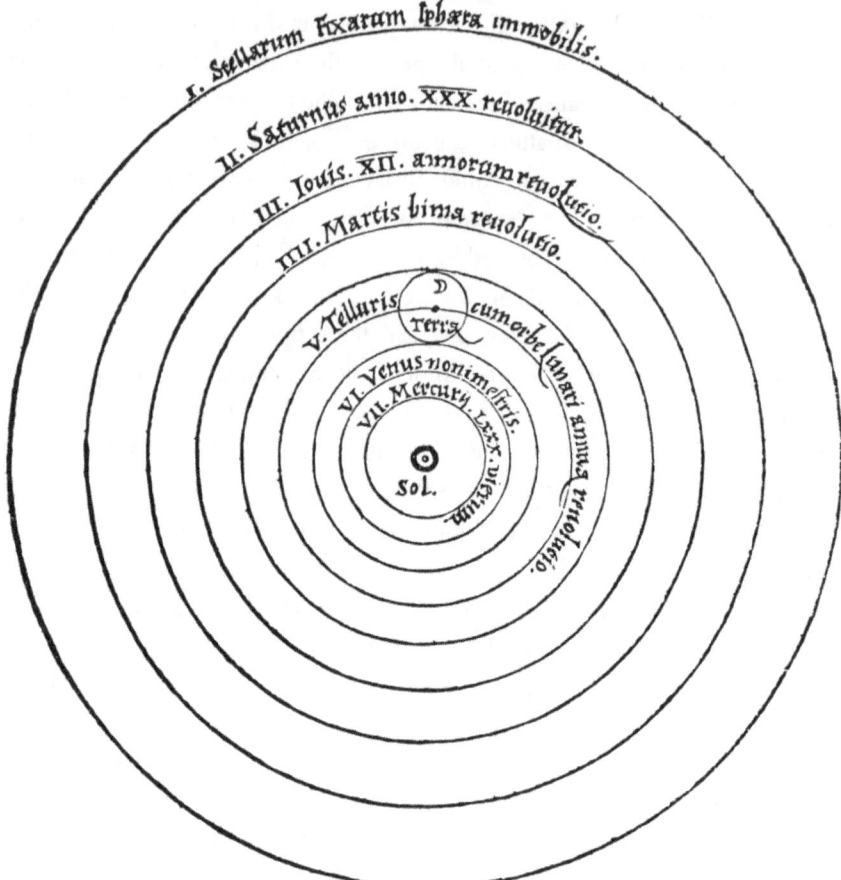

Figure 14 Nicolaus Copernicus, Illustration from *De revolutionibus orbium coelestium*, 1542.

Place and the habits it entailed were listing toward disarray, there was yet to be an alternative that could compete with the potency of Place. Bruno seized the idea of infinite extension and imagined that it was powerful enough to challenge the authority of Place. Infinity – stretching outward – cannot be contained by the limitations of Place. Place, as Aristotle understood it, could not be infinite and so it fell to *space* to fill that void.

Notes

1 See Alexandre Koyré's books, particularly, *From the Closed World to the Infinite Universe* (Baltimore, MD: Johns Hopkins University Press, 1957); and Edward S. Casey's books, especially, *The Fate of Place*.

2 See John Wyndham Pope-Hennessy, *Paradiso: The Illuminations to Dante's Divine Comedy by Giovanni di Paolo* (London: Thames & Hudson, 1993).
3 Edward Grant (trans. and ed.), *The Condemnation of 1277: A Selection of Articles Relevant to the History of Medieval Science*, A Source Book in Medieval Science (Cambridge, MA: Harvard University Press, 1974), 46.
4 Ibid., 48.
5 Plato, *Symposium* [c. BCE 385–370], trans. Benjamin Jowett, Project Gutenberg, 2008, www.gutenberg.org/ebooks/1600 (accessed 2024).
6 Pierre Duhem, *Le Système du Monde: Histoire des doctrines cosmologiques de Platon à Copernic*, Vol. 2 (Paris: Librairie Scientifique A. Hermann et Fils, 1914), 411, 1906–1913; and Vol. 3 (1915), sec. 4, 1913–1959. Cited in 'Pierre Duhem', *Stanford Encyclopedia of Philosophy*, plato.stanford.edu/entries/duhem/#HisSci (accessed 2024).
7 Nicholas Schönberg, *Letter to Copernicus*, 1 November 1536, trans. Edward Rosen, 1472–1537, WebExhibits, www.webexhibits.org//calendars/year-text-Copernicus.html (accessed 2024).
8 Martin Luther, *Table Talk*, Vol. 54, *Luther's Works*, ed. and trans. Theodore G. Tappert (Fortress Press, 1967) [June 4, 1539], 358–9.

10

The Becoming of *Space*

Infinite Bruno

Giordano Bruno was a passionate advocate for an infinitely extended universe filled with infinite worlds. For Bruno, infinite extension was limitless projection, breaking all boundaries of Place. The imagining of extension had already manifested itself in European map making, adventure and exploration. Prophetically, Bruno saw the power of infinite extension in its *spatial* form would only increase with the colonization of the New World and the escalating abstraction of economies developing at the end of the sixteenth century. In addition to its cosmological implications, Bruno recognized that in its infinite form, late medieval *spacium*, the Latin variant for *spatium*, contained power. That it could supplant the authority of Aristotle's Place only made it more attractive. Even as Bruno's writing is enormously thoughtful, he manifests joy in overriding convention. Bruno, by the force of his words and personality, demonstrated the power of the infinite – as *space*. This *space* would overwhelm the sureties of Place in the following centuries. Through Bruno's passion for infinite extension, *space* began its ascent to capture the primary position of Place.

Bruno's turbulent relation to authority characterized his life. Immensely talented, he was famed for his prodigious memory and his mnemonic system, which he taught. Bruno was from a modest family, but due to his feats of memory and intellect he was invited to audiences with the pope and some of the most powerful courts in Europe. Although ordained as a Catholic priest, he revelled in traditions and ideas beyond the boundaries of doctrine. During his peripatetic adventures around Europe, he converted to Calvinism and then to the Lutheran Church, only to be excommunicated by all three major divisions of Christianity at the time. And so it could be said, Bruno was well practiced at heresy. While he avowed his Christian beliefs, when it came to challenging Aristotelian thought, he was a passionate heretic. In 1583, Bruno lectured at Oxford, which was then a bastion of

Aristotelian orthodoxy. In a published text, reflecting on the experience, he referred to the scholars at Oxford as 'a pack of asses [who] sell themselves as seers, and offer bladders as lanterns'.[1] Bruno's sense of decorum did not recognize limits.

Today, Bruno may be best known for being burned at the stake in Rome's Campo de' Fiori by the Inquisition. Bruno's trial lasted eight years and the resulting *auto-da-fé* could have been caused by several perceived blasphemies. The precise list is lost but reconstructions of the eight articles of the heresy charges include his advocacy for the plurality of worlds and the infinity of existence, which are most relevant to Bruno's historical impact on the conception of *space*. While theology was basically the same between the thirteenth century and the end of the sixteenth century, the Church was in a different mode. It was set on securing rather than expanding its dominions.

Although the Bible only describes the creation of one Cosmos, it does not preclude that God created others. Bruno inserted himself within this theological discourse by not only insisting on the actuality of other worlds but also for their necessity, 'I considered it a thing unworthy of divine goodness and potency that being able to produce, as well as this world, another, and infinite others, that it [divinity] should [merely] produce a finite world.'[2] He does not credit God and is presumptuous. It is Bruno who designates himself the seer of infinite worlds. Self-confident to the point of arrogance, Bruno was a persistent detractor of Aristotle, who he referred to as 'the stupidest of philosophers'. Bruno embraced Copernicus' heliocentrism but it is doubtful he was attracted to Copernicus' mathematical actuaries of planetary orbits, although he would have appreciated its confounding of the Aristotelian world view. Further, the sun was an ancient and poetic symbol. In Bruno's *Songs of Circe*, written as part of a mnemonic exercise, the sun is presented as an idolatrous figure. While the text is posed as an allegory, the texture of the writing is pagan and pungent. Circe summons her father the sun:

> Be here at the sacred wishes of your daughter Circe. If you so wish, we will raise altars before you. Here for you is the smell of incense, and the smoke of red sandalwood. And thrice I whisper barbarous and secret incantations. The purifications are completed.[3]

The language of this passage is far closer to the primitivism of Hesiod than the measured thinking of Copernicus or Aristotle. It was the poetical metaphysics of Bruno that provided infinity with utility and the texture of experience. To the degree infinite *space* is synonymous to modern *space*, these linked conceptions did not originate from observational science such as practiced by Copernicus.

Referring to how the Mysteries of Neoplatonic speculation and Hermeticism (Bruno's stock in trade) conditioned modern science, Giorgio Agamben observes:

> Only because astrology (like alchemy, with which it is allied) had conjoined heaven and earth, the divine and the human, in a single subject of fate (in the work of Creation) was science able to unify within a new ego both science and experience.[4]

Bruno opens the Third Dialogue of *De l'Infinito, Universo e Mondi* with his surrogate character, Filoteo (lover of divinity), saying:

> Therefore there is one heaven, the immense space, the bosom, the universal continent, the ethereal region, through which everything flows and moves. Therein innumerable stars, celestial bodies, globes, suns and worlds are perceptibly seen, and infinities are rationally argued for. The immense and infinite universe is the composition that results from this space and the multitudinous bodies it includes.[5]

For Bruno, it is no longer Place that binds the Cosmos, but *space*, in its infinitude, that bears the universe. In Bruno's reference of 'immense space' to a 'bosom', there is an echo of Hesiod's 'broad-breasted earth', which is first to emerge from the chaos of creation. But for Bruno, who avidly studied ancient philosophy, it is not the earth but the 'immense space' that is the nourishing bosom for the infinite universe. Furthermore, beyond the infinite 'universal continent' housing innumerable worlds, infinite *space* has the power that also defines it: infinite extension.

Bruno's fascination with the power of infinite *space* can be noted within this passage from *The Ash Wednesday Supper*, written at the same time as *On the Infinite, the Universe, and Worlds*. With characteristic brio, Bruno (of Nola) writes:

> The Nolan's achievement ... has released the human spirit with its capacity for knowledge from its false prison of turbulent air where the distant stars could only be seen as if through narrow chinks. Its wings were clipped, so that it was prevented from flying upwards and piercing through the mist of clouds to see what really lies up there.[6]

And continues, displaying his imagination as Christ-like:

> Here, then, you see the man who has soared into the sky, entered the heavens, wandered among the stars, passed beyond the boundaries of the universe ... By the light of sense and reason, and with the key of diligent inquiry, he has opened

those cloisters of truth which it is given us to open, stripped the veils and coverings from the face of nature, given eyes to the moles and sight to the blind who were unable to contemplate her image in the mirrors which reflect her on every side. He has loosened the tongues of the mute who were unable and unwilling to unravel hidden meanings, and has healed the lame who were loath to make that progress of the spirit which the base and corruptible flesh could not achieve.[7]

If Bruno is immodest, even sacrilegious in his realization of infinite *space*, he is also clear-eyed. Here he compares Tiphys (helmsman to the Argonauts) to Christopher Columbus. This passage is prophetic about how infinite extension, the power of infinite *space*, would come to fuel emerging economies of capital and European expansion:

If in our times Columbus is exalted ... then what shall be said of the man who has found the way to fly into the sky, to leap over the circumference of the stars, and to leave behind him the convex boundary of the universe? Tiphys and his like discovered how to disturb the peace of others, how to violate the local genius of a place, how to confuse those things which nature had kept apart, how to duplicate one's faults through commerce, how to add new vices to old and propagate new follies by means of violence, how to introduce unheard-of forms of madness where before they were unknown. Finally they demonstrated that wisdom lay in strength, and introduced the arts of tyranny and murder, for which they developed ever more refined instruments and techniques. The time will come when the natives of those places, having learnt their lesson only too well, will discover in the inevitable course of events how to repay us in the same coin, perhaps even improving on the wickedness they were taught.[8]

In addition to outlining the power of the mechanics of infinite *space* to 'violate the local genius of a place', to confuse, to 'propagate new follies by means of violence', Bruno speaks about its power to supplant wisdom and then develop 'ever more refined instruments and techniques' of 'tyranny and murder'. Written almost three centuries before Karl Marx's critiques of capitalism and colonialism, Bruno is devastating in his condemnation of infinite *space* as an enabler of the vices of capitalism. This is no less remarkable as he damns the same power of imagination he exalts. Bruno was prophetic about the perils that infinite *space* would cultivate – indeed, this conception of infinity was part of the list of indictments that caused his tongue to be impaled through his cheeks and burned alive in 1600. However, *space* as it was revealed to Bruno, contains the power of endless extension, but does not hold safety. *Space* – defined as extensive – can never be safe. It seems, it was not principally his freethinking on the infinity

of *space*, but his advertising and selling of it that was a factor leading to his *auto-de-fe*.

The possibility of infinite *space* was proposed by Democritus, and later by Epicurus and Lucretius, but also by theologians more contemporaneous to Bruno, Nicole Oresme (1325–82) and Nicholas of Cusa (1401–64). There is, however, an important distinction between Bruno and these earlier philosophers. For them, infinite *space* is passive; a premise for an infinite universe. For Bruno, infinite *space* meant the power of infinite extension. This *space* functioned metaphorically for Bruno: it allowed for 'flying upwards and piercing through the mist of clouds' and empowered this 'man who has soared into the sky, entered the heavens, wandered among the stars, passed beyond the boundaries of the universe'. Bruno realized that *space* could be powerful enough to undo Aristotle's 'marvellous potency of Place'. Bruno was Christian, but his advocacy for the power of infinite extension was problematic because, as St Augustine had established, *space* was a function of the immeasurable, and immeasurably powerful God. With Bruno's seizing of the power of extension, God is diminished as *space* ascends. From the perspective of this history of *space*, Bruno's passion is so vehement that Bruno himself could be said to be an allegorical figure of infinite *space*.

A twelfth-century pseudo-Hermetic text, which Bruno certainly knew of, plainly describes God as 'a sphere of which the center is everywhere, and the circumference nowhere'.[9] Bruno made the consequential step to conceive the universe and its *space* this way. In this newly uncentered and unbounded Cosmos, without its bodily midpoint or its peripheral edge, Place is dissolved into infinite *space*. For St Augustine and in Tempier's Condemnations, it is only God who is infinite, however with an infinity of worlds and extension, *space*, the medium of the new universe, is triumphant over Place. Infinite *space* would, in time, become the medium of astronomy (as opposed to placial logic of astrology). Relentlessly extensive, *space* could now expand beyond the boundaries of the Cosmos. Here a possibility is opened, even if heretical, that God moves within *space* – so that *space* is larger than God.

Bruno's Pictures

It is possible but not known, if, in his extensive travels, Bruno saw the fresco domes in Parma, masterpieces of Renaissance painting by Antonio Allegri da Correggio (1489–1534). The two domes portray ascensions, one of St John and

Figure 15 Antonio Allegri da Correggio, Vision of St John on Patmos, Dome of San Giovanni Evangelista, fresco, Parma, 1520–1.

the other of the Virgin. They are vivid analogues to Bruno's heavenly flights. Baroque painting which was contemporaneous to Bruno is replete with images of saints piercing the clouds en route to heaven. One might wonder if the Baroque pictorial order had an impact on Bruno's metaphysics of *space* – or vice versa. However, texts about painting from that era are silent about *space* in painting. 'Baroque space', while it may conjure a pictorial style for a contemporary art historian, was a non-existent concept at the time (Figure 15).

Bruno could be a lively, as well as intense writer, and at times cited painting to clarify a topic. Even when Bruno, the great enthusiast of infinite *space*, writes about painting, *space* is absent, instead what is discussed is pictorial and representational:

> In this [the thinker's contemplation of the 'universal fabric' of the world] he can be compared to a painter who is not satisfied with painting [an ordinary *istoria* scene] but tries to fill in his canvas, and make his art conform to nature, by introducing rocks, mountains, trees, fountains, rivers, and hills. So he depicts a royal palace here, a forest there, a glimpse of the sky above, and on one side the

half of a rising sun. As he continues he adds a bird, a pig, a deer, an ass, or a horse, showing here a head only, there a horn, of one beast the hindquarters, of another the ears, of another again the entire description. Each one is portrayed in an attitude and gesture which differentiates them from the others, so that the observer finds greater satisfaction in the way in which the figure is, as they say, represented.[10]

Bruno describes the pleasures of comprehending whole figures by seeing only parts and aspects of what is represented. For Bruno (as it was for Alberti), the pictorial whole is not set in *space*, but in *istoria* painting (*ritratto de l'historia*, as Bruno). In another passage, Bruno writes about distance in relation to the picture, but it is an analogy of how if one is too close to a painting the whole picture cannot be seen.

The gruesome death of Bruno could be considered as the last great spectacle of the power of Place. As an ending, it was also a beginning, befitting of Bruno, of an indefatigable ascendancy of *space*. Place as the dominant container of segments of *space* was in a process of demotion. Place was to be relegated to minor locations within an extensive and limitless *space*. Bruno imagined infinite cosmoses floating in the dominant medium of infinite *space* (not unlike the imaginative circular figures he represented in his book of mathematics, Figure 16). In the following centuries, in science and philosophy, the qualities of *space* would

Figure 16 Woodcut of Giordano Bruno's drawings in *One Hundred and Sixty Articles against the Mathematicians and Philosophers of This Time*, 1588.

continue to be debated, but in the process, *space* would become regarded as empirical (Locke) and considered absolute (Newton), even as such power was reserved only for God in pre-modern Europe.

Kepler's Mathematization of the Universe

In the seventeenth century, there was little agreement as to what constituted the universe and the medium in which it operated. With the relocation of the earth in the Copernican cosmos and the mystical anti-Aristotelian texts of Bruno that were circulating, conceiving the universal order was uneasy. In an elegiac poem titled 'Anatomy of the World' of 1611, John Donne (1571–1631) wrote:

> And new philosophy calls all in doubt,
> The element of fire is quite put out,
> The sun is lost, and th'earth, and no man's wit
> Can well direct him where to look for it.
> And freely men confess that this world's spent,
> When in the planets and the firmament
> They seek so many new; they see that this
> Is crumbled out again to his atomies.
> 'Tis all in pieces, all coherence gone ...[11]

For Donne to observe that the new philosophy crumbled 'all coherence' is indicative of how the priority of Place in the heavens and on earth was in a state of disintegration. Despite Bruno's enthusiasm for the power of infinite extension, the authority of Place was yet to be reconstituted as the power of *space*. *Space* lacked coherence and could not as yet serve as a confident abstraction of experience. *Space* as extension would inevitably become the imaginative, spiritual and the temporal power that transformed the European world view, but at Donne's time, there was not yet a stable definition of *space*. The 'new philosophy' was hardly consistent; theorists disputed and contested the definitions and descriptions of the universe, and with it, *space*. Even as Place was disrupted, the construction of the idea of *space* was buffeted by competing ideas and traditions: Christian versus Humanist, spiritual versus practical, metaphysical versus observational, void versus plenum, and whether or not *space* entailed infinity.

In uncertain times, mathematics was testable and demonstrative, and it had a tradition. Geometry was long associated with the creation and functioning of the Cosmos. Although their metaphysics differed, both Plato and Aristotle

proposed a Cosmos composed and determined by divine geometry. In addition to the geometry of spheres upon which the planets were fixed, Plato designated the forms of polyhedra as the shapes of the four elements: the cube for earth, the tetrahedron for fire, the octahedron for air, the icosahedron for water and, finally, the dodecahedron for the delineation of the universe as a whole, as it is this shape that approaches the perfection that is the sphere. Plato's conception of the Cosmos as ideal in form matter was founded on the belief that geometry operated as a supreme machine. In the Middle Ages, the idea that the Cosmos was a product of supreme geometry further developed. Depictions of the creation of the world showing God as a geometer with a compass became common by the thirteenth century (Plate 28). The image of God as a divine craftsman, an inheritance from Plato's *Timaeus* and instituted into medieval Neoplatonism, is indicative of how Christianity cultivated Classical metaphysics.

At a time when both philosophers and scientists were often mathematicians, Johannes Kepler (1571–1630) was singularly engaged in the subject. In his published works, Kepler follows his name with the appellation, 'Mathematician'. Kepler was a pious Christian and further developed the tradition of the Cosmos fashioned by divine geometry. Kepler writes:

> If God were to consent to [my] wishes, my mathematics would always be ready to propose, either from astronomical exercises, or from the contemplation of the works of God, or from the harmony of the universe, pleasures certainly not unworthy of a Christian man, as consolations for his troubles.[12]

Harmony is a principle theme for Kepler and the field of mathematics is paradigmatic for resolution. Kepler sought harmony in such contexts as reconciling religious denominations, Church and state, and sought to bring the antique philosophy of Plato and Aristotle into dynamic coherence with Christian doctrine. It was Kepler's unshakable faith that mathematics was bestowed upon the Cosmos by God. He believed mathematics permeated the immense and the miniscule, the mundane and the extraterrestrial, observation and calculation, proportion and sound: it is through mathematics that the world becomes universal and God's harmonies are revealed.

In Kepler's *Mysterium Cosmographicum* (1596), his first major treatise, he refined the modern heliocentrism of Copernicus by applying Plato's polyhedral forms to a Copernican Cosmos. Kepler believed that his model, which brought Plato's elemental solids in agreement with Aristotle's spheres, could not be

the outcome of chance, without the special attention of the Artisan: accordingly it follows that the Creator, the source of all wisdom, the everlasting approver of order, the eternal and superexistent geyser of geometry and harmony, it follows, I say, that He, the Artisan of the celestial movements Himself, should have conjoined to the five regular solids the harmonic ratios arising from the regular plane figures, and out of both classes should have formed one most perfect archetype of the heavens: in order that in this archetype, as through the five regular solids the shapes of the spheres shine through on which the six planets are carried, so too through the consonances.[13]

The Cosmos as composed of spheres layered like an onion had been the familiar idea of the universe for centuries, but as Kepler conceived it, it was robustly three-dimensional. Up until Kepler's book, images, diagrams and even European astrolabes – the tools for measuring distances and locations on earth and in the sky – were virtually always flat. Although the Cosmos was abstractly considered to be three-dimensional, how it was measured and represented was two-dimensional. In the fifteenth century, artists such as Uccelo, Piero and Leonardo, as well as several highly accomplished intarsia artists, depicted polyhedra, however this three-dimensional imagery was not applied to representations of the Cosmos (although Botticelli's depiction of Dante's Purgatory comes close). In Kepler's illustration from *Mysterium Cosmographicum*, the Cosmos is portrayed as palpably three-dimensional (Figure 17).

It is recorded that Kepler made models of this illustration in folded paper, which he intended to have fabricated in silver so it could function as a punchbowl.[14] It is representative of Keplers' mathematical imagination to discover consonances on and between various scales – from the intimate to the immense and between two and three dimensions.

Kepler's 'punchbowl' cosmos is exemplary. It is a fully envisioned model of the universe based on the principles of the Classical cosmologists. Ironically, within a decade of the publication of his *Mysterium Cosmographicum*, Kepler was compelled through his own observational data to create a new mathematical understanding of the universe. This nascent idea of the Universe would supersede his exquisite model of cosmic geometry.

Even as Kepler's theory of the Cosmos composed of Platonic polyhedra developed the perfect ideal of its geometry, there was a problem. Kepler could not dismiss a deviation of less than 10 per cent between his model and the planetary observations Kepler made in conjunction with Tyco Brahe (1546–1601). The orbit of Mars, as observed from earth, and determined through numbingly meticulous trigonometric calculations of the planet's position and

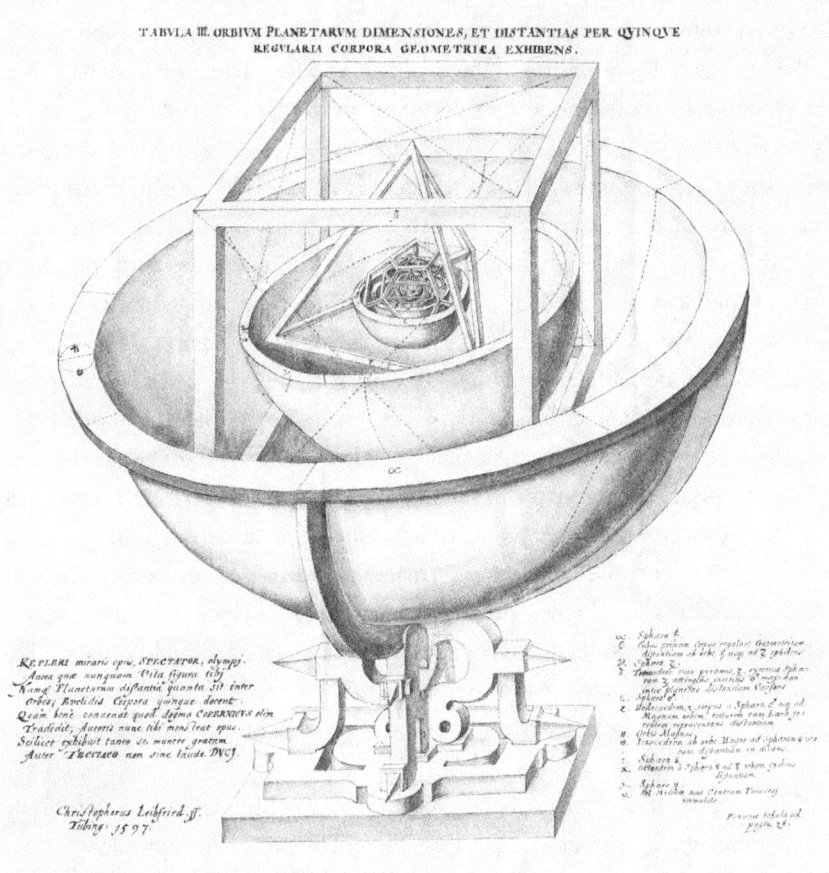

Figure 17 Illustration from Kepler's *Mysterium Cosmographicum*, 1597.

movement, produced eccentric orbits (Figure 18). Earlier in his *Mysterium Cosmographicum*, Kepler wrote, his research would follow 'wheresoever the closeness of the numbers leads'.[15] Despite his convictions and the elegance of his polyhedral model for the cosmos, Kepler did follow the raw numbers, even in the face of their incompatibility to his exquisite model.

With new reliable data and careful calculation, Kepler found it was not possible to sufficiently explain the movement of Mars around the sun with the existing spherical models, including his own. As his drawing in *Astronomia nova* (1609) shows, the trajectory of Mars appears to be an inconsistent and tipsy tangle. After exploring an asymmetrical egg-shaped path and ovals, in 1604 Kepler found that the geometry of an ellipse best explained the data. Although

Kepler's model of the elliptical orbit of Mars reflects a planar description (not dissimilar from earlier cosmic diagrams), there is a new dimension of complexity in the mathematics of ellipses. (Interestingly, modern science has determined that planets move, not spherically around the sun, but on an 'orbital plane', which, although it wobbles, is roughly two-dimensional.) As such, in his *Astronomia nova* (1609), Kepler published that the orbit of Mars around the sun was elliptical and further concluded that all the planets have degrees of elliptical orbits.

With the conclusions of *Astronomia nova*, not only was the perfect circular order of the Cosmos upended but the relationship between geometry and the Cosmos was also repurposed. It is remarkable that less than a decade apart, Kepler's two models reflect fundamentally different views. The ideal geometry of the Cosmos with planets fixed on spheres (as in Kepler's earlier model) had given way to a universe without a patently ideal order. In the new model, 'the planets complete their courses in the pure aether, just like birds in the air'.[16] In this new universe, geometry – an increasingly arithmetical and algebraic geometry – was purposed to discover, to calculate and describe causes and effects rather than display God's ideal design of the heavens. This process 'gives rise to a powerful sense of wonder, which at length drives men to look into causes'.[17] For Kepler, the mechanics of the universe 'are within the grasp of the human mind; God wanted us to recognize them by creating us after his own image so that we could share in his own thoughts'.[18]

Consistent with Kepler's self-identification as a mathematician, he generally avoided the ambiguities of metaphysics. This included the metaphysics of *space* (confessing to Galileo that infinite *space* was unimaginable). In his writings, Kepler refers to the medium through which the planets move as 'pure aetherial air', but does not delve into its composition. Whether full or empty, what was necessary for Kepler was that planetary bodies move unimpeded. It is revealing that in Kepler's *Astronomia nova*, a dense text of almost three hundred and fifty pages, *spacium* and its related form *spacio* appear less than a dozen times. In most cases, it is the traditional concept of *space* as span or measure, in distance or time, consistent with its historical Latin usage. In the book, *space* is also employed to mean place as in *suo spacio*: 'its space' or 'its location'.

Due to Kepler's faith in mathematics, as both abstract and practical, he envisioned a mathematics that was total and universal. His mathematics was reason in motion, applicable and imaginative. Portrayed in *Astronomia nova*, the allegorical figure of Urania, the muse of astronomy rides a triumphal chariot perched on a diagram of the elliptical orbit of Mars. The scaffold-like lines in the

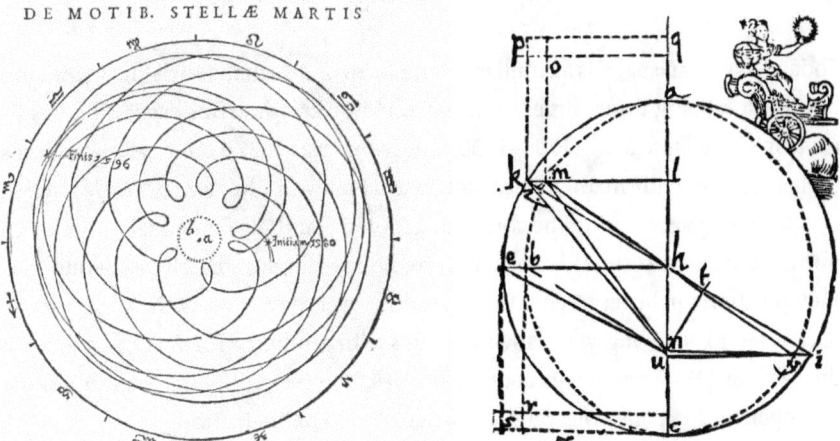

Figure 18 *Left*: Diagram of the trajectory of Mars through several periods of apparent retrograde motion as seen from earth, Kepler, *Astronomia nova*, 1609.

Figure 19 *Right*: Woodcut with Urania, Muse of astronomy, holding the laurels of victory riding the orbit of Mars, Kepler, *Astronomia nova*, 1609.

diagrammatical section of the drawing display the trigonometric geometry that shows the difference between what was considered an ideal circular path and the more accurate elliptical path of the planet. She holds high a laurel wreath to signify the conquest of the god of war, or at least the mathematical complexities of Mars' planetary orbit (Figure 19). It can be noted that, in contrast to the aggression of Bruno's infinite *space*, Kepler's mathematics is pacific. Kepler's vision of the universe resolves, not in *space* but in a mathematical God. Having made humans in His own image, in His grace, He has given humankind mathematics as a means to ponder, if not entirely understand His design.

For *spacium* to become *space* as conceived in the manner of Newton and Locke, several ingredients were required. *Space* would have to be unbounded (if not infinite) extension. It would require emptiness or fluidity; not necessarily an absolute void, but open enough not to obstruct the movement of bodies. Between these foundational elements of *space* a third follows. For extension to operate within this openness, it must have a degree of uniformity so that everywhere conditions are the same. Characteristically, modern *space* is homogeneous. Kepler did not conceive of his mathematics or his astronomy framed as *space*. However, Kepler's mathematical ideation of the universe, extensively unbounded, open and homogeneous, established the conditions for *space* to be constructed mathematically, which would come to be an essential element of modern *space*.

All Body or Nothing: Descartes

Today, 'Cartesian space' is a familiar term, a form of shorthand to define *space* as an infinite, totalizing three-dimensional grid. However, while this expression has its roots in René Descartes' (1596–1650) *La Géométrie* (1637), the treatise concerns itself narrowly with mathematics, not *space*. Following Kepler, in *La Géométrie*, Descartes begins to unite the forms of geometry and algebraic mathematics, to form a coordinate system. As such, two- and three-dimensional shapes, along with their position can be represented as equations. Over the centuries, the West became habituated to believing *space* is synonymous with geometry. However, this was not the case for Descartes, or his contemporaries. The concept of *space* as an infinite homogeneous expanse was yet to be articulated as mathematical.

As well as his mathematics, Descartes applied himself to the philosophical tradition of metaphysics, writing 'though we have mastered all the arguments of Plato and Aristotle, if yet we have not the capacity for passing a solid judgment on these matters … we should have acquired the knowledge not of a science, but of history'.[19] Unlike Copernicus, Galileo and Kepler, Descartes developed his judgment in relation to science, history and theology. Descartes' metaphysics takes as its subjects, infinity, the essentials of matter, the body, extension and the void. This results in Descartes' *space* being far more strange and fascinating than present conceptions of 'Cartesian space'.

As concerns the infinity of the universe: like Galileo and Kepler before him, and distinct from Bruno, Descartes does not commit to infinity. Neatly, he only assigns *infinity* to the immaterial God, solidly within the theology of St Augustine. The extent of matter and the medium it moves in is *indefinite* – so that while the universe cannot match God in infinity, it is unbounded, so that Descartes' geometry does stray into theology.

As concerns the material of the universe: like Democritus and Epicurus, Descartes writes, 'matter is in fact [divided] into an indefinite number of particles, although these are beyond observation'.[20] However, he breaks with the atomists, because atoms, as 'uncuttable', violate God's omnipotence:

> [Democratius'] … philosophy was rejected in the first place, because it presupposed certain indivisible corpuscles, which hypothesis I also completely reject; in the second place it was rejected because Democritus imagined a void about them, which I demonstrate to be an impossibility.[21]

Descartes aligns with Aristotle as regards the void:

> As regards a vacuum in the philosophic sense of the word, i.e. a space in which there is no substance, it is evident that such cannot exist because the extension of space or internal place, is not different from that of body. For, from the mere fact that a body is extended in length, breadth, or depth, we have reason to conclude that it is a substance, because it is absolutely inconceivable that nothing should possess extension ...[22]

A void is impossible because anything three-dimensional, 'extended in length, breadth, or depth', must be a body. Descartes assigns the power of extension – the very power that Bruno accorded to *space* – to the Body. For Descartes, *space* takes the vaunted position of Aristotle's Place. For Aristotle, *Tópos* is compellingly real – as defining of, and defined by the Body; similarly for Descartes, *espace* is real because it is Body.

In order for *space* to have the extensions of length, breadth and depth, it cannot be nothing. The universe, then, consists not of an infinite void with infinite atoms, nor is it a conforming Place – nested Place within spherical Place until its extension ends at God's limit. Like Aristotle, Descartes' metaphysics will not allow a vacuum to surround the corpuscles. All is corpuscles. Body and extension reflexively define the other. For Descartes, the universal *espace* is full of corpuscles, it is indeed fullness itself – as a medium, it is a *plenum*.

Descartes posits that Body and *space* are each wrapped up in one another and are therefore, continuous. But there is a cost in Descartes' totalizing of the Body in, and as, *space*. Unlike Aristotle, Descartes rejects everything he considers not essential to the Body, such as whether it is solid or liquid, its hardness, its color, its weight and its temperature. Finally:

> After examination we shall find that there is nothing remaining in the idea of body excepting that it is extended in length, breadth, and depth; and this is comprised in our idea of space.[23]

It is a stunning act of reduction that for Descartes' conception of *space*, it is necessary that 'there is nothing remaining in the idea of body', except 'length, breadth, and depth'. In order that space is full and corpuscular, Descartes evacuates everything that is particular, every characteristic of the Body. In distinction, in the Aristotelian tradition, Place is the elemental home for bodily specifics. In substituting *space* for Place in its conjunction to body, every discriminating feature of the Body is dissolved in deference to the great power of three-dimensional extension. In Bruno's writing, the awesome force of extension is proclaimed, celebrated and even criticized, however while Descartes' *spatial*

extension is rational in its profile, it not only deracinates Body from Place, but it also leaves it as only the barest of entities. Descartes' metaphysics display the empiricism of Place surrendering to the new empire of *space*. In Descartes' universe, *space* is given fullness, but at the cost that all but the most minimal outlines of the Body are voided.

The overlaying of Kepler's universal mathematics to the conception of *space* was far from immediate. Descartes, Kepler's younger contemporary by twenty

Figure 20 Plenum vortices, engraving from Descartes' *Principiorum Philosophie*, 1644.

years, developed a totalizing geometry, a coordinate system of locations on a grid with three axes, but it was not integrated with his idea of *space* as indefinitely full of corpuscles. At the scale of planetary movements, it is the corpuscles that form vortices that push the planets around their orbits, as illustrated in the 1644 engraving published in his *Principiorum Philosophie* (Figure 20). The difference between how Descartes writes about *space* – busily full everywhere – and the modern expression 'Cartesian space', is remarkable. It is a reminder that modern assumptions about *space* as mathematical and empirical are cultural constructions that are often projected backward onto history.

All Body or Nothing: Guericke

The seventeenth century represents an unstable era in the definition of *space*. Born six years after Descartes, Otto von Guericke (1602–86) takes up the issue of vacuum and void:

> Nevertheless, I have to say that it grieves me today that I still feel there is a need for disputes with their arguing and counter-arguing because the leaders of the new philosophy themselves do not agree on what, if anything, fills the Cosmos. They stumble on the very threshold of the new science. For some time now philosophers have been in keen dispute among themselves about the vacuum. Does it, or doesn't it exist? If it does, what is its nature?[24]

Guericke was not the towering figure that was Descartes, but he reasoned well and was an ingenious inventor. With much of the same science available to Descartes, Guericke comes to opposite conclusions:

> I have, in fact, carried out such experiments and my efforts have not been misguided in so far as I have discovered various ways of experimentally exhibiting the very vacuum, whose existence has been so universally denied.[25]

Guericke made good, not only on demonstrating how a vacuum can exist but also by theatrically exhibiting the vacuum's power. First performed in 1654, Guericke applied his invention of a vacuum pump to two 20-inch copper hemispheres assembled to create an airtight sphere. He then evacuated as much air from within as his pump could manage. The assembled hemispheres were hitched between two teams of horses. Guericke demonstrated to his audience that the two teams of horses, straining in opposite directions, could not pull apart the vacuum-sealed hemispheres.

For Guericke, 'nothing' takes on a grand and primordial authority. 'Likewise we say that heaven and Earth were created from nothing …'[26] Nothing, Guericke's empty *space*, is coextensive with God, predating His creation of everything. While for Descartes *space* demanded fullness, for Guericke *space* is marvellously Nothing. In Guericke's book *De Vacuo Spatio*, he waxes poetic:

> Nothing contains all things. It is more precious than gold, without beginning and end, more joyous than the perception of bountiful light, more noble than the blood of kings, comparable to the heavens, higher than the stars, more powerful than a stroke of lightning, perfect and blessed in every way. Nothing always inspires. Where Nothing is, there ceases the jurisdiction of all kings. Nothing is without any mischief. According to Job the earth is suspended over Nothing. Nothing is outside the world. Nothing is everywhere. They say the vacuum is Nothing; and they say that imaginary space – and space itself – is Nothing.[27]

Notes

1 Giordano Bruno, *The Ash Wednesday Supper*, La Cena de Le Ceneri [1584], ed. and trans. Edward A. Gosselin and Lawrence S. Lerner (Hamden, CT: Archon Books, 1977), 193.

2 Giordano Bruno, *The Expulsion of Triumphant Beast* [1584], trans. and ed. Arthur D. Imerti, with an introduction and notes, (New Brunswick, NJ: Rutgers University Press, 1964), 51.

3 Giordano Bruno, 'Cantus Circaeus', in *Opera Latine Conscripta* [written ca. 1582–1591], ed. V. Imbriani and C. M. Tallarigo, Vol. 2 (Neapoli: Apud Dom. Morano, 1886), 186.

4 Giorgio Agamben, *Infancy and History: On the Destruction of Experience*, trans. Liz Heron (London and New York, NY: Verso, 1993), 20.

5 Giordano Bruno, *De l'infinito, universo e mondi*, in *Dialoghi italiani I: Dialoghi metafisici* [c. 1584], ed. Giovanni Aquilecchia, with notes by Giovanni Gentile, 3rd edn, 2nd repr. (Florence: Sansoni, 1985); electronic edn published by Liber Liber, 31 October 2006, www.liberliber.it, 35, translated from the Italian by the author.

6 Giordano Bruno, *The Ash Wednesday Supper: A New Translation*, trans. and annotated by Hilary Gatti, Lorenzo Da Ponte Italian Library (Toronto: University of Toronto Press, 2018), 35.

7 Ibid.

8 Ibid., 33.

9 Alexandre Koyré, trans. of '*De Docta Ignorantia*' by Nicholas of Cusa, in Alexandre Koyré, *From the Closed World to the Infinite Universe* (Baltimore, MD: Johns Hopkins University Press, 1957), 18.
10 Bruno, *The Ash Wednesday Supper: A New Translation*, 11. It should be noted I translated '*far il semplice ritratto de l'historia*' as 'painting a mere *istoria* scene', as it is the type of painting endorsed by Alberti.
11 John Donne, *Selected Poetry and Prose* (London and New York, NY: Methuen, 1986), 137.
12 Johannes Kepler, *Mysterium Cosmographicum: The Secret of the Universe*, trans. A. M. Duncan (New York, NY: Abaris Books, 1981), 45.
13 Johannes Kepler, *Harmonies of the World*, Apple Books ebooks; and Johannes Kepler, *Harmonies of the World*, trans. Charles Glenn Wallis, [1613] 1939, Global Grey ebook, 2019, 31.
14 James R. Voelkel, *Johannes Kepler and the New Astronomy*, ed. Owen Gingerich (Oxford and New York, NY: Oxford University Press, 1999), 34–5.
15 Kepler, *Mysterium Cosmographicum*, 165, Chapter XVI, 'A Particular Comment on the Moon, and on the Material of the Solids and Spheres'.
16 Johannes Kepler, *New Astronomy*, trans. William H. Donahue (Cambridge: Cambridge University Press, 1992), 126.
17 Ibid., 115.
18 Johannes Kepler, 'Letter (9/10 Apr 1599) to the Bavarian Chancellor Herwart von Hohenburg', *Johannes Kepler: Life and Letters*, ed. Carola Baumgardt and Jamie Callan (Oxford: Philosophical Library, 1953), 50.
19 René Descartes, *The Philosophical Works of Descartes: Rendered into English*, trans. Elizabeth S. Haldane and G. R. T. Ross, vol. 1 (London: Cambridge University Press, 1911), 6.
20 Ibid., 267.
21 Ibid., 298.
22 Ibid., 262.
23 Ibid., 259.
24 Thomas E. Conlon, *Thinking about Nothing: Otto von Guericke and the Magdeburg Experiments on the Vacuum* (Kington: The Saint Austin Press, 2011), 113.
25 Ibid.
26 Ibid., 147.
27 Edward Grant, *Much Ado about Nothing: Theories of Space and Vacuum from the Middle Ages to the Scientific Revolution* (Cambridge: Cambridge University Press, 1981), 216.

11

Space Assumes Its Modern Form
Locke, Newton, Leibniz and Kant

The Triumph of *Space*: Locke's *Space* as Experience

Over the course of the seventeenth and into the eighteenth century, debates about what constituted *space*, many of which are metaphysically unresolvable, established *space* as a not entirely defined but important concept. Opinions on the subject ranged from Descartes' formulation of a plenum of corpuscles to Guericke's scientific and mystical belief in the Void. Whether *space* was infinite or merely indefinite was not settled.

As interest developed around disputes about *space*, the idea of Place was not erased but diminished to a mere component within the overarching idea of *space*. John Locke (1632–1704), did not so much deny as belittle Place in his 1690 *An Essay Concerning Humane Understanding*: 'our idea of place is nothing else but such a relative position of any thing …' Locke further reduces Place to a function of *space*:

> though it be true, that the word place has sometimes a more confused sense, and stands for that space which any body takes up …

Place gives way to *space* to become only a 'particular consideration' within the dominant idea of *space*:

> The idea, therefore, of place, we have by the same means that we get the idea of space (whereof this is but a particular consideration), viz., by our sight and touch; by either of which we receive into our minds the ideas of extension or distance.[1]

In this passage, *space* purloins the bodily content of Place. Place bears the existence of Body, but it is the human sensorium that grasps – 'by our sight and touch' – physical effects of *space*, which, through the intellection of experience,

establishes *space* as real – *space* and experience are elided. In Locke's writing, Place is downgraded and *space* is granted empirical status – to this day, a common assumption about *space*:

> I shall begin with the simple idea of space. I have showed above, that we get the idea of space, both by our sight and touch; which, I think, is so evident, that it would be as needless to go to prove, that men perceive, by their sight, a distance between bodies of different colors, or between the parts of the same body; as that they see colors themselves; nor is it less obvious, that they can do so in the dark by feeling and touch.[2]

Although Locke maintains that our idea of *space* is 'so evident', the passage above makes clear Locke's *space* between bodies is an abstraction derived from visual perception. Because Locke sees this 'simple idea of space' is so linked to experience he refrains from any attempt to prove or investigate his assertions.

Locke's idea of *space* derives from the perceiving and abstracting human body, not the generalized idea of the Body. Like the priority Aristotle claimed for Place, Locke assigns *space* precedence. But the similarity ends there. Aristotle's Place is world-filling, while Locke's *space* is empty and blank. Locke argues that, 'All ideas come from sensation or reflection.' For Locke, human understanding is constructed by nurture, not nature; the mind is blank at birth, 'a white paper, void of all characters, without any ideas'.[3] It can be noted that Locke's metaphysics as concerns *space* mirrors his philosophy of human understanding, in that *space* is an empty foundation for the ideation of experience.

In the long and complicated Christian history of Place, the Cosmos, infinity, extension, the void, the universe and *space*, God was singularly essential. Locke proposes a potent innovation to the ongoing construction of the concept of *space*. For Locke, *space* is founded on human perception, rather than theoretical modelling. In the historical drift from religious doctrine to physical experience to physical experiment, Locke's formulation of *space* provided another angle for experimental science, in the form of physical sensation, to enter the complex of competing strains of theology and metaphysics that characterize the debates on the nature of *space* in the eighteenth century.

There is a political dimension to Locke's elevation of *space* as the authority to dominate places. Place now serves as deracinated locations subject to the power of self-evident *space*. In Locke's overarching but unprovable blank *space*, this totalizing *space* defines the places bodies occupy. With Locke, Bruno's prophecy of extensive *space* represented by Tiphys has come to pass: 'how to violate the local genius of a place, how to confuse those things which nature had kept apart …'[4] To the degree

that the force to establish and maintain overseas colonies resides in the power of extensive *space*, the British Empire and Locke's *spatial* empiricism were hand in glove.

Newton – *Space* as Absolute

Locke was enthralled by Isaac Newton (1642–1727), writing 'the commonwealth of learning is not at this time without master-builders ...', among them the 'incomparable Mr. Newton'.[5] Although ten years younger than Locke, Newton's *The Mathematical Principles of Natural Philosophy* of 1687 had a profound impact on Locke's evolution away from Cartesian ideas of *space* as a body itself, composed of a plenum of corpuscles to the concept of 'void space' containing solid substances. Newton's conception of *space* as total and unmoving is key to his physics. However, Newton does not go so far as Locke in claiming that *space* is entirely empirical. Instead, Newton argues, 'True motions of particular bodies differ from apparent ones because the parts of that immovable space in which those motions are performed do not come under the observation of our senses.'[6] For Newton, actual *space* is not physical enough to impress upon human senses, it exists independently from the relationships of the bodies within it. Newton's extra-relational absolute *space* was the conceptual foundation that allowed him to bring, as his aptly titled *magnum opus* indicates, 'Mathematical Principles' to bear on 'Natural Philosophy'.

In an early unpublished manuscript (*c.* 1670), Newton is specific about the method of his studies on the mechanics of the movement of bodies – it is motion that would define his physics and mathematics. In this text, Newton's mechanical frame of the world is cast. He begins with an orderly list of definitions:

Def. 1. Place is a part of space which something fills evenly.
Def. 2. Body is that which fills place.
Def. 3. Rest is remaining in the same place.
Def. 4. Motion is change of place.[7]

Space, as the background for the system, is motionless and empty of place and body. Place, a subset of *space*, has its function to mediate between *space* and body as a descriptor of motion. Although the relationship of God and *space* is of great concern for Newton, for his mechanics he appeals to a different authority – mathematics. Like Descartes, Newton strips Body of its sensible qualities, and reduces it to dimensions, mobility and solidity (density is later included as it

relates to gravity). But this is not so much philosophical as a practical means to calculate motions of bodies:

> Moreover, since body is here proposed for investigation ... is extended, mobile and impenetrable, I have postulated only the properties required for local motion.[8]

The abstracted and reduced body prepared Newton's world to be framed in mathematized *space*:

> So that instead of physical bodies you may understand abstract figures in the same way that they are considered by Geometers when they assign motion to them, as is done in Euclid's *Elements* ...[9]

The thirteen books of Euclid never leave the ideal world of geometry for the physical domain (although his mathematics were successfully applied to phenomena over the millennia). Nor did Euclid propose a background 'space' for his geometric figures. A more contemporary example was relevant for Newton – Kepler's mathematics of the cosmos, which extend the logic of Euclid's geometry to universal order. However, Kepler avoided the metaphysics that *space* entailed, either due to the controversies it entailed or simply regarded it as unnecessary for his explanations. For Newton, even with all its complications, *space* is the territory where mathematics converges on practical phenomena.

Newton posits two types of *space* – 'absolute space' and 'relative space' – but is not content to leave the two apart. He integrates them into hierarchical order. Absolute *space* is the background for all *space, spaces* and bodies. 'Relative space' is minor and mundane – common people have 'no other notions but from the relation they bear to sensible objects':

> Relative space is some movable dimension or measure of the absolute spaces; which our senses determine by its position to bodies; and which is vulgarly taken for immovable space; such is the dimension of a subterraneous, an aerial, or celestial space, determined by its position in respect of the earth.[10]

Relative *space* is close to experience, but it is only apparent – not accurate. It is relegated to a subset of absolute *space*. Although Newton's and Locke's ideas are mostly in step, there is a gap between them concerning what the reality of *space* entails. For Locke, the reality of *space* is established by reflecting upon perception, 'we get the idea of space, both by our sight and touch ...' While for Newton, that 'which our senses determine by its position to bodies' is apparent rather than true. Newton's two types of *space* are distinguished by: 'absolute or relative, true or apparent, mathematical or common'. Emphatically:

> Absolute space, in its own nature, without relation to anything external, remains always similar and immovable.[11]

Newton requires a dominant *space* that would be regulated by mathematics and would entail mathematical control for other subsets of *space*. For Newton, the key distinction between absolute and relative *space* is its mathematics:

> Absolute and relative space are the same in figure and magnitude; but they do not remain always numerically the same.[12]

The innovation of Newton's totalizing absolute *space* is to give an expression – that of *space* – to Kepler's mathematical universe. Absolute *space* for Newton is mathematical, not physical – it is the combination of mathematics and *space* that reveals the construction of the physical universe. Although Newton does not go as far as Locke in insisting that *space* is empirical, it is his emphasis on experience (mostly in a mechanical mode) that is the rationale for marrying *space* to a mathematical ordering of the universe.

As motion became the subject for celestial to mundane physics, *space* and time became linked as the absolute coordinate dimensions of the world. This can be noted in the increasingly common phrase 'time and space', substituting for Locke's 'time and place'. The mathematics of limits and derivatives were explicitly involved with motion. And, fundamentally as Aristotle explicated at the dawn of metaphysics, 'time is directly the measure of motion'.[13] If mathematics was to totalize and regulate *space*, Time was to become its scientific and metaphysical partner.

God's Sensorium

Newton's avidity for mathematics as God's truth is close to Kepler's. Additionally, Newton bonded mathematics and geometry to *space*. As such, for Newton, *space*, like God 'endures always and is present everywhere'. While for Newton, relative *space* and place were minor descriptors, his absolute *space* was on the scale of the Absolute Being. Such a vaunted concept of *space* had theological as well as metaphysical implications. It is as a religious natural philosopher that Newton brings these concerns to his absolute *space*:

> Space is an affection of being [as] being. No being exists or can exist which is not related to space in some way. God is every where, created minds are somewhere, and body is in the space that it occupies; and whatever is neither everywhere nor

anywhere does not exist. And hence it follows that space is an emanative effect of the first existence of being, for if any being is postulated, space is postulated.[14]

There were other dimensions to Newton; close to a tenth of his writing involved alchemy, he also wrote private biblical interpretations which at times shaded toward heresy, and he had a great fascination with historical civilizations, biblical chronology and the Apocalypse. This wild variety of interests led a twentieth-century Newton enthusiast to refer to him as the 'last of the magicians'. It is Newton in all his complexity who asks:

> Is not Infinite Space the sensorium of a Being incorporeal, living and intelligent, who sees the things themselves intimately, and thoroughly perceives them, and comprehends them wholly by their immediate presence to himself?[15]

It requires a singular imagination, both primitive and modern, to posit infinite *space* as the sensorium of God – that through Newton's absolute *space* the Absolute Being sees, hears and feels everything throughout the universe. Newton commenced with publishing the 1706 edition of *Opticks* that included this rhetorical question as a 'query'. However, almost immediately, he registered that his opinion, so bluntly stated, might have theological risks. Although he could not stop the presses, he managed to lay hands on most of the print run, cut out this question and replace it with a more anodyne version:

> does it not appear from phenomena that there is a Being incorporeal, living, intelligent, omnipresent, who in infinite space, as it were in his sensory, sees the things themselves intimately, and thoroughly perceives them?[16]

In the later passage, 'as it were' does the work to soften the starkness of the conception, but only somewhat. It seems that a copy with the original query made its way to the continent and to Gottfried Wilhelm Leibniz (1646–1716). After several decades of disputes with Newton, Leibniz was prepared to call out Newton's eccentric theology of *space*.

The Dispute

Leibniz and Newton's fundamental disagreement over the definition and nature of *space* belies Locke's belief that *space* is self-evident. The complex technical nature of their dispute is indicative that *space* is not merely an empirical given but is, at its core, subject to interpretation and debate.

Although Newton's and Leibniz's relations began cordially (with a cagey but not unfriendly correspondence in 1676), the competition of two of the century's most brilliant minds famously degenerated into bitterness. The quarrel began over who first developed the mathematical program of limits, infinitesimals, differentials and integrals; the mathematics of what Newton termed 'fluxions and fluents', but is now known by Leibniz's term: Calculus.

The last great contest between the two began in 1715 with an exchange of letters and concluded with Leibniz's death in 1716. The debate was public and conducted in view of British and German royalty. Leibniz initiated the exchange with a letter to the Princess of Wales, Caroline of Brandenburg-Ansbach, who was married to the future king of England (Leibniz was familiar with Caroline from the time she was Electress of Hanover and one of his mentees). His missive to the transplanted German, opens with:

> Natural religion itself, seems to decay (in England) very much. Many will have human souls to be material: others make God himself a corporeal being.[17]

The aspersion toward those who will have 'human souls to be material' was directed at Locke, but with the accusation of those who 'others make God himself a corporeal being' is aimed directly at Newton, he follows with:

> Sir Isaac Newton says, that space is an organ, which God makes use of to perceive things by.[18]

Although Newton does not go so far as to call *space* an organ of God, Leibniz seized the opportunity to perform a theological vivisection of Newton's idea of God's Sensorium. In the following letters, Leibniz offers 'demonstrations against real absolute space, which is an idol of some modern Englishmen. I call it an idol, not in a theological sense, but in a philosophical one.' He continues with his great criticism of Newtonians, 'These gentlemen maintain therefore, that space is a real absolute being.'[19]

Newton, who was known to have an aversion to public dispute, did not respond directly to Leibniz. Instead, Samuel Clarke, a young follower of Newton, took up the challenge to contend with Leibniz. Well practiced in theology and metaphysics, and cordial with the Princess Caroline, Clarke was a choice interlocutor for fending off Leibniz. A year after Leibniz's death, it was Clarke who edited and published the correspondence.

Clarke holds the line against Leibniz:

> The word sensory does not properly signify the organ, but the place of sensation. The eye, the ear, etc., are organs, but not sensoria. Besides, Sir Isaac Newton does

not say, that space is the sensory; but that it is, by way of similitude only, as it were the sensory.[20]

And Clarke continues, emphasizing that *space is like* the sensorium of the Omnipresent Being:

> Sir Isaac Newton considers the brain and organs of sensation, as the means by which those pictures are formed: but not as the means by which the mind sees or perceives those pictures, when they are so formed. And in the universe, he doth not consider things as if they were pictures, formed by certain means, or organs; but as real things, form'd by God himself, and seen by him in all places wherever they are, without the intervention of any medium at all. And this similitude is all that he means, when he supposes infinite space to be (as it were) the sensorium of the Omnipresent Being[21]

The quarrel goes back and forth about the definition of organs and sensorium, but the argument of whether *space* is the place of God's Sensorium is merely the proscenium for the drama that unfolds. What is at stake is the validity of two incompatible metaphysics regarding the nature of the universe. Newton holds that *space* is real and absolute – that it exists independently of bodies. Leibniz disagrees: *space* is not a form of being – certainly not a part of the Omnipresent Being, nor where this being resides – *space* does not exist independently, but entails the organization and relations of bodies. Leibniz argues against Newton's Absolute Space for a more complex idea of *space*, cautioning about distinctions between 'abstracts and concretes'.

Leibniz's Relational *Space*

Leibniz outlines and numbers the general conceptions that frame *space* and defines it against Newton's Absolute Space:

[1] That it is not absolutely nothing, is most evident. For of nothing there is no quantity, no dimensions, no properties.
[2] That it is not a mere idea, is likewise most manifest. For no idea of space, can possibly be framed larger than finite; and yet reason demonstrates that 'tis a contradiction for space itself not to be actually infinite.

Here, Leibniz acknowledges *space* is not a simple idea – this is exemplified by the conundrum of whether it is finite or infinite.

[3] That it is not a bare relation of one thing to another, arising from their situation or order among themselves, is no less apparent: because space is a quantity, which relations (such as situation and order) are not.

Leibniz does not accept that *space* strictly exists, that is, as absolute and independent of bodies. Additionally, it is not merely relational, but relationally complex. *Space* is more involved than the situation and order of things because it must also be considered as a quantity.

[4] That space is not body, is also most clear. For then body would be necessarily infinite; and no space could be void of resistance to motion. Which is contrary to experience.

In this case, Leibniz's conception of *space* does not contradict Newton's, but is squarely against Descartes' idea of *space* as an indefinitely extended body.

[5] That space is not any kind of substance, is no less plain. Because infinite space is *immensitas*, not *immensum*; whereas infinite substance is *immensum* not *immensitas*.

Here, Leibniz is insisting that *space* is more abstract than concrete. Characteristically, Leibniz is nuanced: infinite *space* is *immensitas*, the form of the Latin word 'immense', meaning *space* is *immense* or boundless. This is in contrast to *immensum* in that the thing itself contains the quality of immensity (as does God).

[6] It remains therefore, by necessary consequence, that space is a property, in like manner as duration is [to time]. *Immensitas* is τοῦ *immensi*; just as *aeternitas* is τοῦ *aeterni*.²²

With Leibniz's list, *space*-as-a-property is finely drawn. At the end of Leibniz's parsing of the nature of *space*, he widens the frame to include duration as related to time, which is comparable to the relationship of *space* to coexisting objects or substances. Passage [6] is a translation from the original French in which Leibniz includes Latin and the Greek word, 'τοῦ', embedded in the vernacular language. The frame of the definition of *space* is now further extended to the history and languages of the philosophy from which the metaphysics of *space* emerged. Clearly, Leibniz intended that this passage cannot be fully translated into one language, however it is precise in indicating that the complications of this subject, like *space* itself, are immense.

The first five of Leibnitz's six conceptions present *space* in negative terms: what *space* is not. In its most positive light, the five negative statements indicate

that *space* is that which surrounds objects or substances. However this does not fully define *space*. Leibniz is carefully elliptical in his concluding definition, allowing *space* a positive appearance, not as something, but as a property, or quality of immensity.

Against Newton's mathematics and theology of *space*, Leibniz answers with detailed philosophy. Newton frames *space* simply and positively – both with his relative and absolute *space*, and even with its theological manifestation. It is not surprising that Leibniz is frustrated by Newton's ideas; 'mere Chimeras, and superficial imaginations. All this is only grounded upon the supposition that imaginary space is real':[23]

> These are Imaginations of philosophers who have incomplete notions, who make space an absolute Reality. Mere mathematicians, who are only taken up with the conceits of imagination, are apt to forge such notions; but they are destroyed by superior reasons.[24]

In this passage, Leibniz lays out the fundamental difference between the two in their debate over the nature of *space*. Newton's great success was not in his philosophy but in his mathematics. Today it is possible to appreciate the extravagance of the concept of *space* as God's Sensorium, but this was not theology to be lauded in the eighteenth century – it was certainly blasphemy to assign God animal parts. It was as the 'Mere Mathematician', not as a philosopher, that Newton forged his physics to become the standard of reality. By uniting Kepler's celestial mathematics to the idea that *space* is perceptual, *space* could function as mathematically experiential. The mathematization of *space* provided a powerful tool for quantifying, controlling and ultimately, experiencing reality.

Newton's Absolute Space, with its monotheistic overtones, dominates all Relative Spaces. Leibniz, however, is more circumspect, he holds:

> space to be something merely relative, as time is, that I hold it to be an order of coexistences, as time is an order of successions. For space denotes, in terms of possibility, an order of things which exist at the same time, considered as existing together; without enquiring into their manner of existing. And when many things are seen together, one perceives that order of things among themselves[25]

By insisting that *space* is the perception of 'that order of things among themselves', the hierarchy of Newton's Absolute Space is upended, *space* is rendered relative, relational and plural. *Space*, for Leibniz, is only apparently absolute within a particular frame.

In the competition between Newton and Leibniz to define *space* in the eighteenth century, Newton was the definitive winner. Newton's mathematics –

the mechanics of his physics – formed the basis of how the West imagined the universe through the nineteenth century. During his lifetime, Newton was celebrated. He was given a grand funeral and interred in a sculpted marble sarcophagus in Westminster Abbey, the resting place of royalty and the first of a line of cultural figures. Leibniz, while a respected figure, lacked the popular support that England granted Newton. Leibniz's funeral was ill-attended and he was buried in an unmarked grave. This was perhaps the nadir of the respect and interest granted to Leibniz. In the early twentieth century, Albert Einstein's Theory of Relativity presents a case against *space* as a single and absolute frame, resurrecting several of Leibniz's concepts. Although Leibniz arrives at his relative *space* through philosophical reasoning rather than physics, Einstein's Relativity demonstrated Newton's *space* was not forever Absolute.

Representations of Newton's *Space*

In the seventeenth century, *space* arrived as an amalgam of contradictions and disputes. As the idea of *space* took hold of the European imagination, differences of opinion as with Newton and Leibniz's debate only increased its topicality. *Space* had penetrated culture. While Leibniz's parsing of *space* was too sophisticated to be illustrated, in some instances, Newton's *space* was pictured. These pictures did not launch an idea of pictorial *space*, but were illustrations of Newton's mathematization of heaven and earth, with *space* serving as the cipher between the two.

The architect Etienne-Louis Boullée (1728–99), portrayed Newton's *space* in his proposal for Newton's Cenotaph. There is a difference between 'architectural space' as a concept for structuring buildings and the monument Boullée conceived (but was never built) to honor Newton. Boullée proposed a grand geometric architecture, representing immensity that imitated the heavens and celestial spheres. Boullée's architecture took up imagery associated with Newton's science but fell short of conceiving *space* as a generative principle for architecture.

The frontispiece of the first English translation of Newton's *The Method of Fluxions and Infinite Series* of 1736 is a fascinating illustration of Newton's mathematics, which is now called 'calculus', operating in the mundane – displaying the productive joining of *space* and mathematics (Figure 21). Set under a cloudy sky in the English countryside, a fowler and his dog are hunting. The hunter and dog are portrayed at two sequential moments and a diagram overlaying the scene

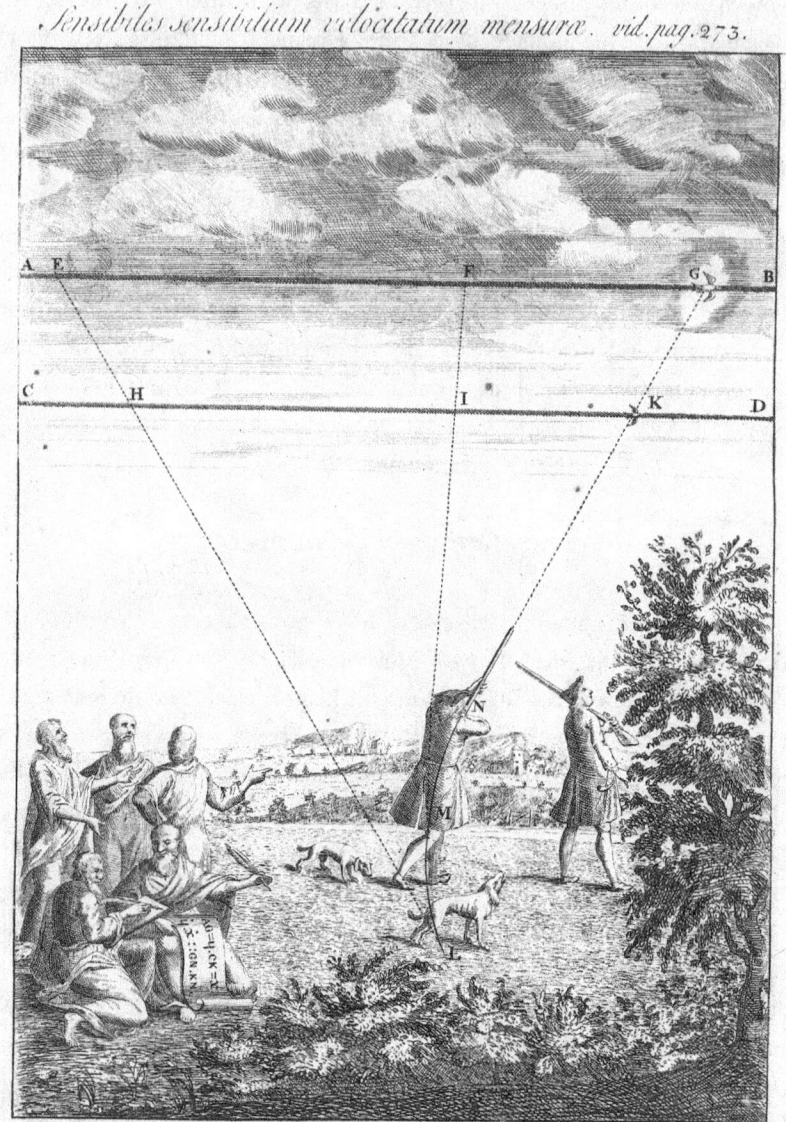

Figure 21 Perceptible Measurements of Perceptible Velocities, Sir Isaac Newton, *Method of Fluxions*, 1736.

describes the geometry of their movement and the parallel lines of two birds (AB and CD) in flight. The fowler will attempt to shoot both birds with one bullet. According to Newton's description (on page 275 as the illustration notes), the fowler's eye was originally at L (the spot toward which the dog in the first instance stares). The fowler advances toward the lines of the two birds in flight and his eye then takes position M and finally N, where the fowler is represented aiming his gun. The picture depicts several rates of movement, and illustrates how the geometry of the birds flying across the sky can be framed in proportion to the curve of the fowler's varying positions marked by L, M, N. The world is represented in relation to geometry defined by Newton's mathematics of Fluxions and Fluents.

It is not a finely wrought picture, but it is paradigmatic of Newton's absolute *space* – a term that opens onto a framework that is effective in analysing and justifying the world of objects through the mathematical conception of *space*. There is a revealing comparison: as distinct from perspectival diagrams, the diagrammation in the frontispiece overlays the scene. With perspectival pictures, the geometry is embedded within the imagery to shape the picture's structure. With the frontispiece, it is the picture that is the background support for the explanatory diagram.

The content of the frontispiece extends beyond its utility of explaining the specifics of Newton's calculus. There is an audience of five toga-clad philosophers who note and discuss, not the hunting scene, but its mathematics, and perhaps even its metaphysical content. The frontispiece serves not merely as an illustration but also as an allegory of the achievement of Newton's calculus. Further, it can be said to represent the triumph of *space* as the basis for the mundane and the mathematical.

Kant's Institution of *Space*

The early-eighteenth-debate between Leibniz and Newton showed that *space* was not easily nor entirely defined. The mechanics of Newton's Absolute Space produced a succession of accurate planetary predictions, including the paths of comets and the pattern of the tides, as well as information on how objects moved on earth; this formed the core of what was becoming recognized as physics. However, despite the successes of the practical implications of mathematizing *space*, *space* was still unsettled – theological and especially metaphysical issues remained. Although the mathematization of *space* was effective, questions and

controversies about the exact nature of *space* persisted: whether it was absolute or relational, a void or composed of some content. Additionally, how *space* is comprehended was debated. Is *space*, as Locke insisted, real and perceived as such, or is it understood as real by reflecting on phenomena, or is it an imagined mental construction?

Emmanuel Kant (1724–1804) developed his philosophy over half a century of writings in relation to the major thinkers of the era, including Leibniz, Newton, Locke and Descartes. The debate between Newton and Leibniz was a starting point, an impetus, from which Kant forged a unique and consequential idea of *space*. Coming from the Leibnizian tradition, Kant in his early text, the 'New Doctrine of Motion and Rest' (1758), advocated for *space* based on the relations of its contents: 'Even though I might imagine a mathematical space empty of all creatures as a container for the bodies, this would not help me. For how might I distinguish its parts and the various places that are not occupied by anything corporeal?'[26]

Ten years later, in a short essay from 1768, 'Concerning the Ultimate Ground of the Differentiation of Directions in Space', there is a shift toward Newton's concepts of *space*. Kant was not as focused on mathematics as Newton, noting that the differences between 'cognition in mathematics and cognition in philosophy are substantial and essential'.[27] However, he endorsed the Newtonian geometrization of *space*: 'Accordingly, nature is completely subject to the prescriptions of geometry, in respect of all the properties of space which are demonstrated in geometry'.[28]

'Concerning the Ultimate Ground of the Differentiation of Directions in Space' opens with issues of universal laws as concerns geometry, however Kant brings a different line of deliberation to his thinking on *space*. While Leibniz and Newton primarily focused on *space* as a disembodied abstraction, Kant takes a Lockean turn, to insist that human perception is physically bound to *space*:

> Concerning the things which exist outside ourselves: it is only insofar as they stand in relation to ourselves that we have any cognition of them by means of the senses at all. It is, therefore, not surprising that the ultimate ground, on the basis of which we form our concept of directions in space, derives from the relation of these intersecting planes to our bodies.[29]

The essay, which explores and weighs ideas of *space* offered by Leibniz, Newton and Locke, concludes with what is Kant's innovative idea – to make *space* pre-experiential and pre-metaphysical:

absolute space is not an object of outer sensation; it is rather a fundamental concept which first of all makes possible all such outer sensation.[30]

Kant resolves issues of earlier debates by framing *space* as neither purely relational nor an absolute entity but rather, as an *a priori intuition* structuring all human perception.

As befits the conundrums of *space*, to follow Kant's detailed and technical response to the state of defining *space* that he inherited is complicated. This, in itself, is revealing – Kant's great effort indicates that *space* is neither simple or self-evident – *space* is a complex cultural object.

The Judgement of *Space*

It is generally considered that Kant's *Critique of Pure Reason* of 1781 is the demarcation between earlier nascent ideas and his mature philosophy. Although formulated a decade earlier, Kant's dissertation 'On the Form and Principles of the Sensible and the Intelligible World' (1770) lays out his innovative idea of *space* as 'pure intuition'. Kant lists five principles (A through E) of *space*:

A. *The concept of space is not abstracted from outer sensations.*

This denies *space* a strictly empirical basis; to have outer perception, 'presupposes the concept of space; it does not create it. Likewise, too, things which are in space affect the senses, but space itself cannot be derived from the senses.' Here, Kant sets in motion his claim that *space* must precede perception.

B. *The concept of space is a singular representation* embracing all things *within itself*; it is not an abstract common concept containing them *under itself*.

Principle B. separates the concept of *space* from the form or type of common concepts. It is not a concept among other concepts. It does not serve to distinguish its contained elements but in its totality contains them all, 'For what you speak of as *several places* are only parts of the same boundless space ...'[31] *Space* is a foundational concept and logically precedes the common variety of concepts.

C. *The concept of space is thus a pure intuition*, for it is a singular concept, not one which has been compounded from sensations, although it is the fundamental form of all outer sensation.

This is Kant's definition of *space* at its plainest: the concept of *space* as (*a priori* and) pure intuition. It defines *space* as fundamental to the human experience of the world preceding all sensible experience, as well as the logic of thought and representation. Kant's metaphysics is often defined as 'Transcendental Idealism'. This is the view that *space* (and time) are pure intuitions that, while beyond human comprehension, shape and control all sensible phenomena and human thought.

D. *Space is not something objective and real*, nor is it a substance, nor an accident, nor a relation; it is, rather, subjective and ideal; it issues from the nature of the mind in accordance with a stable law as a scheme, so to speak, for coordinating everything which is sensed externally.

Here, Kant refines what intuition is, that it is: inherent to the human mind, it is subjective and because the intuition of *space* completely coordinates the mind and the senses, it is an ideal because it exists eternally within the human mind.

E. Although the *concept of space* as some objective and real being or property be imaginary, nonetheless, *relatively to all sensible things whatsoever*, it is not only a concept which is in the highest degree true, it is also the foundation of all truth in outer sensibility.[32]

Here, Kant insists *space* is not objectively real, but a formal principle of imagination that creates our reality. *Space* is the foundation of the representational structure of the world and the means through which to experience it in order to recognize it. Kant posits that *space* itself is the condition for all imagination and sensibility. *Space* is not something proven through experience; rather, it is the underlying framework that makes experience possible.

Kant reverses the order of the empirical fundamentalism of Locke's *space*. Rather than subjective experience defining *space*, Kant argues that *space* is the basis of all experience. *Space* is true beyond proof.

The Means and Ends of *Space*

By the mid-to-late eighteenth century, the newly established parameters of *space* made it a concept familiar to contemporary sensibility. In its becoming modern, it accrued characteristics developed over centuries. If we take 1277 as the beginning of the European disintegration of Place, at that time there was nothing but the force of God beyond the limits of the Cosmos. However, with the

recognition of the power of God over Place, the power of limitless extension was imaginable. If, at first, *space* was inchoate, its success entailed not so much resolving its metaphysical issues but by exemplifying its power and usefulness. By the time Newton theorized *space*, the existential bonds of body to its place were severed, now bodies existed in the blank abstraction of mathematical relations: their position and movement calculable. Even if, by the eighteenth century, *space* was neither surely nor entirely infinite, total, continuous, three-dimensional, homogeneous and mathematical, it was saturated enough with these concepts to gain its conventional definition as geometric and real.

Although *space* is elemental to Kant's philosophy, he constrains *space* in the place it had traditionally made its home, and from where medieval *spacium* emerged. Kant was a pious Christian who wrote treatises on the existence and nature of God, however unlike his predecessors, God did not enter his discussion of *space*. This was the last characteristic that *space* would assume to become normal in its modern form – that whether *space* is an empirical, mathematical or philosophically intuitive construction – it would be secular. This is perhaps Kant's greatest *spatial* innovation: his elaborate and persuasive philosophy of *space* took the place of theology and God. There are instances in the late nineteenth century in which *space* became earnestly spiritual. However, Kant's thoroughly secular metaphysics of *space* caps the great tradition, initiated by St Augustine, of the theology of *space*. By the end of the eighteenth century, considerations of *space* were conventionalized to be free of God.

The habits of *space* are defined by their inherent habit of extension. With Newton's Absolute Space, it would seem, *space* could extend no further, however Kant's *space* transcends metaphysics. Kant's philosophy does not disturb the practical world of Newton's physics, but finds new territory for *space* to expand into. *Space* as intuition not only brought *space* into the human mind but also extended it to surround and entail all recognition, cognition and imagination. Kant grants *space* further extension in its totality and a novel form of infinitude – for the world to be *recognized*, *space* is extended to eternity – what was and what will always be. For humanity, the world without *space* would not only disappear but also never could have been, nor could ever be:

> Space is a necessary representation, *a priori*, that is the ground of all outer intuitions. One can never represent that there is no space, though one can very well think that there are no objects to be encountered in it. It is therefore to be regarded as the condition of the possibility of appearances, not as a determination dependent on them, and is an *a priori* representation that necessarily grounds outer appearances.[33]

In Kant's philosophy, *space* occupies a vaunted position of potency. The sublime power of *space* in Kant's philosophy is due its universality – for Kant, *space* is always and everywhere true. It is worth noting that there is a long history – much of the history of humankind outside of modern Europe – in which *space* was not a necessary recourse to understanding and being in the world.

Notes

1 John Locke, *An Essay Concerning Humane Understanding*, Vol. 1 (1690), based on the 2nd edn, Books I and II (London: Eliz. Holt for Thomas Basset, 1690), chapter XIII, section 10, 111, Project Gutenberg, www.gutenberg.org/ebooks/10615 (accessed 2025).
2 Ibid., Book II, Chapter XIII, section 4, 106.
3 Ibid., Chapter I, 56.
4 Bruno, *The Ash Wednesday Supper: A New Translation*, 35.
5 Ibid., 7.
6 Isaac Newton, *The Mathematical Principles of Natural Philosophy*, trans. Andrew Motte, Vol. 1 (London: Printed by Andrew Motte, 1729), 17. Originally: Isaac Newton, *Philosophiae Naturalis Principia Mathematica* (London: Joseph Streater, 1687).
7 Isaac Newton, *A Selection from the Portsmouth Collection in the University Library, Cambridge*, chosen, ed. and trans. A. Rupert Hall and Marie Boas Hall (Cambridge: Cambridge University Press, 1962; paperback edn, 1978), 122.
8 Ibid.
9 Ibid.
10 Newton, *The Mathematical Principles of Natural Philosophy*, Book I, 9.
11 Ibid.
12 Ibid.
13 Aristotle, *Physics*, Book 4, part 12.
14 Newton, *A Selection from the Portsmouth Collection*, 136.
15 Richard S. Westfall, *Never at Rest: A Biography of Isaac Newton* (Cambridge: Cambridge University Press, 1983), 647.
16 Samuel Clarke and Gottfried Wilhelm Leibniz, *The Leibniz-Clarke Correspondence: Together with Extracts from Newton's Principia and Opticks*, ed. H. G. Alexander (Manchester: Manchester University Press, and New York, NY: Barnes & Noble, 1956), appendix A, 'Opticks, Query 28', 174. Gottfried Wilhelm Leibniz and Samuel Clarke, *A Collection of Papers, Which Passed Between the Late Learned Mr. Leibnitz and Dr. Clarke, in the Years 1715 and 1716, Relating to the Principles of Natural Philosophy and Religion* (James Knapton, 1717).

17 Ibid, 11.
18 Ibid., 11.
19 Ibid., 25.
20 Ibid., 21.
21 Ibid., 13.
22 Ibid., 120–1.
23 Ibid., 38.
24 Ibid., 64.
25 Ibid., 25–6.
26 Immanuel Kant, 'New Doctrine of Motion and Rest' [1758], in *Natural Science*, ed. Eric Watkins, trans. Lewis White Beck, Jeffrey B. Edwards, Olaf Reinhardt, Martin Schönfeld and Eric Watkins (Cambridge: Cambridge University Press, [1758] 2012), 401.
27 Immanuel Kant 'Concerning the Ultimate Ground of the Differentiation of Directions in Space' [1768], *Theoretical Philosophy, 1755–1770*, trans. and ed. David Walford, in collaboration with Ralf Meerbote (Cambridge: Cambridge University Press, 1992), 256.
28 Ibid., 398.
29 Ibid., 366.
30 Ibid., 371.
31 Ibid., 396.
32 Ibid., 'On the Form and Principles of the Sensible and the Intelligible World' [1770], all quotations, 395–8.
33 Immanuel Kant, *Critique of Pure Reason*, Immanuel Kant, *Critik der reinen Vernunft* (Riga: Johann Friedrich Hartknoch, 1781), trans. Paul Guyer and Allen W. Wood (Cambridge: Cambridge University Press, 1998), section 1, 'On Space', A 24, 175.

Part Four

The Emergence of Pictorial *Space*

This book addresses a narrow subject – the concept of space in art. In Parts One and Two, I did not discuss pictorial space in Giotto's paintings as it was unavailable as an idea, and, at this time, space itself was unformed. At the beginning of the thirteenth century, St Francis' spectacles, most powerfully in the case of the stigmata, can be understood as having transformational pictorial implications. Further, at the end of the thirteenth century, there was a momentous recasting of the traditional priorities of icon and istoria. This change can be seen in the Basilica San Francesco. And, within a dozen years, paradigmatically – and literally – Giotto's Navicella assumed what had been the rightful place of an icon at the center of St Peter's courtyard.

A detailed look at Alberti's De pictura, the primary document of the Italian Renaissance on perspective, makes plain there is no space discussed. Alberti is specific about the purpose of this geometry – it is an essential component to the painterly construction of an istoria. As other artists applied and shaped the geometry that became known as 'perspective' to their own ends, there was a common thread. The diagram – individual, complex, mathematical and organizational – best reflects what was the basis and attraction of perspective. Consideration of space in painting was not part of the Renaissance.

Part Three entailed something of a detour from the history of space in art to the European construction of space itself. Here, we saw the reason space was not found in Renaissance discussions about painting. Space was a concept that had barely begun to be imagined and constructed over the weakening framework of Place. A detailed history of this transformation is beyond the scope of this book, but it is important to note there were implications for visual art. It is incoherent to look at icons in terms of space, but it can be noted that the architectural organization of church decoration is resoundingly Placial. And in contemporaneous texts, the place

of images within Church doctrine was discussed. The iconicity of Christian Painting is premised on the order of Place.

Part Three followed how space *expanded from Vitruvius' measurable span and the immeasurable measure of God that St Augustine expresses to an essential category in Kant's philosophy. While* spatial *issues such as infinity, the void, whether* space *was absolute or relational, an imagined order or empirical, were still unsettled by the end of the eighteenth century, the debates calmed.* Space *was recognized to be infinite enough, empty enough and homogenous enough to be mathematized and finally secularized. The new physics of* space *was so successful that* space *became practical enough to be almost visible. Now that it had achieved definition, importance and interest,* space *became available in discussions about art.*

In Part Four, we shall investigate the process by which space *extended its reach to the arts.*

12

Painting: Studies and Dialogue

Félibien's Academics

It is not surprising that the late-seventeenth and early-eighteenth-century discussions of *space* in physics and philosophy should cast their shadow on the discourse of the visual arts. What is perhaps surprising is that it took nearly two centuries for *space* to become a common term in discussions of painting. Descartes' ideas were widely studied, and within the intellectual circles of London and Paris, the writings of Locke, Newton and Leibniz were recognized as novel but considerable. *Spatium*, *espace* and *space* were securely part of the philosophic and scientific landscape, but not yet part of the imagination or intuition of art.

The centralization of the French state under the Sun King led to the creation of new credentializing institutions such as the Académie royale de peinture et de sculpture in 1648. This encouraged the development and founding of similar institutions across Europe. As a result, academic training, rather than apprenticeship, increasingly became the method of learning the basics of art, and the academies promoted lectures and treatises. And so, the mid-1600s saw a new interest in self-conscious and reflective texts on visual art.

After the publication in France of Leonardo's *Traité de la peinture* in 1651, other, more contemporary, treatises on painting began to appear, such as André Félibien's *Des principes de l'architecture, de la sculpture, de la peinture, et des autres arts qui en dépendent: Avec un dictionnaire des termes propres à chacun de ces arts* in 1666 (The Principles of Architecture, Sculpture, Painting, and the Other Arts that Depend on Them: With a Dictionary of Terms Specific to Each of These Arts). Félibien writes, 'Painting is an art that, through lines and colors, represents all the objects of nature on a flat and smooth surface, such that there is no body that one cannot recognize.'[1] The book designates *Composition*, *Dessein* and *Coloris* as the essential principles of painting, 'all three of which depend on reasoning and execution, which are known as Theory and Practice;

reasoning is like the father of Painting, and execution like the mother'.[2] Composition entails almost everything that might be expected, except for the notion of *space*:

> The choice of poses, the arrangement of draperies, the appropriateness of ornaments, the placement of settings, buildings, landscapes, the various expressions of bodily movements, and the passions of the soul, and finally everything that imagination can create, and that cannot be imitated directly from nature.[3]

For Félibien, Drawing (Dessein) concerns 'the form of the bodies being represented, showing them simply with lines as they appear'. As such, 'It demands knowledge of anatomy, which is the science of bones, muscles, and nerves as they appear externally in the human body.' Again, Félibien does not mention *space*. When Félibien comes to Coloring (*Coloris*) as an element of painting, it concerns not only tint and hue, but also, 'light and shadow'. Additionally, he cites 'the effects of the luminous or transparent, the nature of the illuminated body, the aspect of the observer, and the different degrees of reflection'.[4] As it happens, though, Félibien does not mention *space*.

Félibien constructs a hierarchy of artists – Michelangelo, Raphael, Leonardo, Giorgione and Titian – for emulation and he advocates for a hierarchy of genres with historical, religious and allegorical subjects at the top. Thus we can see that by Félibien's time, *istoria* had secured the importance that Alberti had envisioned nearly two centuries earlier, however a sense of *space* in art is still centuries in the future.

De Piles and the Dialogues of Painting

Following Félibien's treatise by two decades, Roger de Piles (1635–1709), published several popular painting treatises (between 1668 and 1708). Although he was eventually admitted to the Academy, de Piles was often at odds with its orthodoxies. Writing outside the academic structure, de Pile's discussions of painting are enlivened by a vocabulary that is richer than Félibien's. The cover of the English translation of de Piles' *Cours de peinture par principes avec un balance de peintres* shows De Piles' expansive vocabulary for art (Figure 22).

There is no small loquacity to de Piles' principles – he cites twenty-four. One can imagine if there was even an inkling of pictorial *space*, it would have made the list.

THE PRINCIPLES OF PAINTING,

Under the HEADS of

Anatomy	Contraſt	Harmony	Paſſion
Attitude	Colouring	Hiſtory	Portraiture
Accident	Deſign	Invention	Sculpture
Architecture	Diſpoſition	Landſkip	Style
Compoſition	Draperies	Lights	Truth
Claro-obſcuro	Expreſſion	Proportion	Unity, &c.

In which is Contained,

An Account of the *Athenian, Roman, Venetian* and *Flemiſh* SCHOOLS.

To which is Added,

The BALANCE of PAINTERS.

BEING

The Names of the moſt noted PAINTERS, and their Degrees of Perfection in the Four principal Parts of their ART: Of ſingular Uſe to thoſe who would form an Idea of the VALUE of *Paintings* and *Pictures*.

Written Originally in *French* by Monſ. DU PILES, Author of *The Lives of the Painters.*

And now firſt Tranſlated into ENGLISH. By a PAINTER.

LONDON:
Printed for J. OSBORN, at the *Golden Ball*, in *Pater-noſter Row.* M.DCC.XLIII.

Figure 22 THE PRINCIPLES OF PAINTING, Under the HEADS of Anatomy, Attitude, Accident, Architecture, Composition, Contrast, Coloring, Design, Disposition, Draperies, Claro-obscuro, Expression, Harmony, History, Invention, Landskip, Lights, Proportion, Passion, Portraiture, Sculpture, Style, Truth, Unity, &c., Roger de Piles, 1743. Title page of Roger de Piles, *The Principles of Painting under the Heads of Anatomy ...* (London: Printed for J. Osborn, at the Golden Ball, in Pater-noster Row, 1743).

Today, de Piles is best known for his *Balance de peintres*, an addendum to his *Cours de peinture* in which he rates the merits of fifty-six painters according to four categories: *Composition, Dessein, Coloris and Expression*. De Piles writes about his project of ranking, 'Opinions are too various in this point, to let us think that we alone are in the right. All I ask is, the liberty of declaring my thoughts in this matter, as I allow others to preserve any idea they may have different from mine.'[5] This is the manner of de Piles – not hard judgment, but discursive consideration. De Piles' table is an invitation to audiences beyond painters and academicians to discover the delights of painting, offering methods for discussion and developing taste.

Cours de peinture par principes ... published in 1708, the year before de Piles died, is mostly a collection of lectures given at the Academy (after finally gaining admission to the institution less than decade before). In the preface, de Piles writes, painting's true

> Idea strikes and attracts everyone: the ignorant, the amateur painters, the connoisseurs, and the painters themselves. It does not allow anyone to pass indifferently by a place where there is a painting that bears this character without being surprised, without stopping, and without enjoying for some time the pleasure of surprise. True Painting is therefore that which calls us (so to speak) by surprising us: and it is only by this force of the effect that it produces, that we cannot help approaching it as if it had something to tell us.[6]

The strike of the painting on its viewer is a pleasant provocation – a surprise that calls out and speaks to the viewer. De Piles' experience of painting is animated and diverting. For de Piles as well as other enthuisasts discussing paintings, the painting itself can become an interlocutor – prompting dialogue.

By the middle of the eighteenth century, painting was developing new language for new purposes. Denis Diderot (1713–84) wrote enthusiastically about the sensibility of the work of contemporary artists, drawing on a vocabulary based on his encyclopedic knowledge. In England, William Hogarth (1697–1764) ups the intensity of discussions around painting with his 1761 etching *Enthusiasm Delineatd* (Figure 23). Passion and the valuing of art is satirized in a depiction of a preacher high in a pulpit offering a riotous congregation painterly images – however, the rabble is more concerned with their own consuming and worshiping of art. In this melange of art and religion, Hogarth mocks both. Hogarth's print is both an invitation to dialogue and a commentary on it – although in its extremity, it is unlikely de Piles would have appreciated such agitation.

Through the eighteenth century, the language and conceptions of painting were enlarged and popularized. Félibien's three elements of painting were

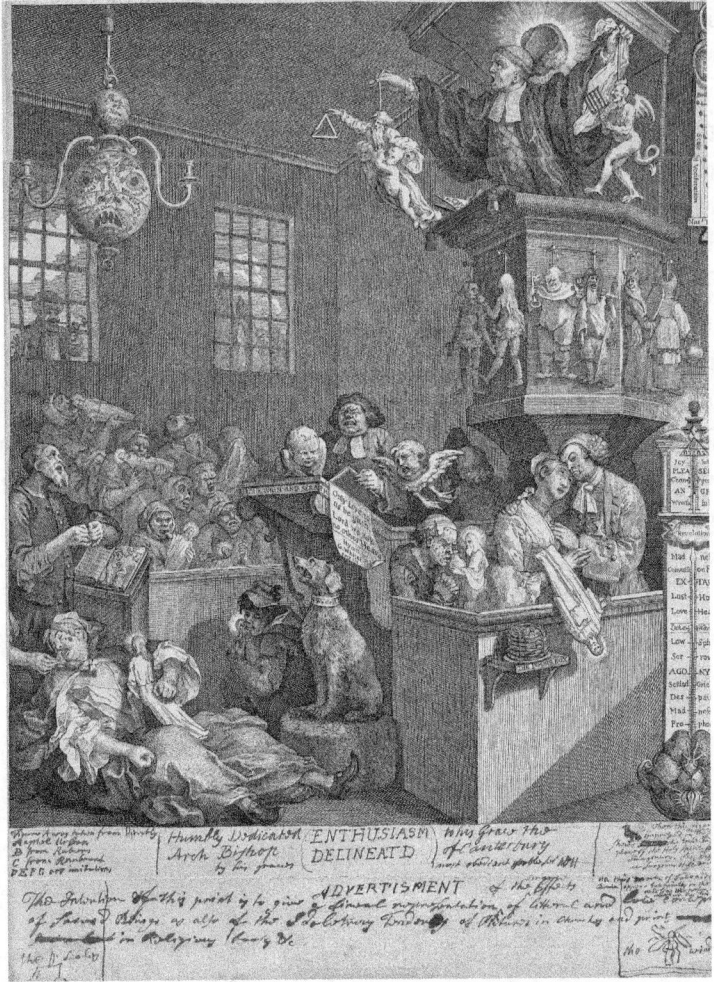

Figure 23 William Hogarth, *Enthusiasm Delineatd*, engraving, *c.* 1761.

expanded to two dozen listed on de Piles' title page. Painting had become linguistically ornate. However, even as there was a surge of enthusiasm to exchange and dispute conceptions about painting, pictorial *space* still was not part of the conversation.

Space Delineating the Object of Painting

At the close of the seventeenth century, *space* was an esoteric subject of theology, metaphysics and what would become the discipline of science. As such, it is

unsurprising that in their decades of writing about art, de Piles, and Félibien before him, never made *space* a painterly consideration. Nor was *space* part of the conceptual apparatus of Jean-Baptiste Du Bos (1670–1742), who wrote a popular treatise, *Critical Reflections on Poetry and Painting* (1719, used even into the nineteenth century as a textbook). He was certainly familiar with the concept of *space* as he was an intimate friend and translator of Locke. The great German tastemaker and chronologist of ancient art, Johann Joachim Winckelmann (1717–68), never had recourse to describe sculpture, painting or architecture as defined by *space*. It can be noted that these discussions did not require the concept to be sophisticated and urgent.

By mid-century, however, *space* began to enter discussions about art – at least, in a distanced manner. Gotthold Ephraim Lessing (1729–81), although an admirer of Winckelmann's scholarship, was critical of his joining of painting and poetry as fundamentally similar in their aspiration for universal beauty. Instead, Lessing offers his own formulation of *Ut pictura poesis*, emphasizing the difference of painting and poetry due to their outer forms. In his text of 1764, *Laokoon: oder über die Grenzen der Malerei und Poesi* (*Laocoon: An Essay on the Limits of Painting and Poetry*), Lessing offers that proceeding from 'first principles ... that painting employs wholly different signs or means of imitation from poetry, —the one using forms and colors in space, the other articulate sounds in time ...' He further writes about the difference of painting and poetry:

> Objects which exist side by side, or whose parts so exist, are called bodies. Consequently bodies with their visible properties are the peculiar subjects of painting.
>
> Objects which succeed each other, or whose parts succeed each other in time, are actions. Consequently actions are the peculiar subjects of poetry.
>
> All bodies, however, exist not only in space, but also in time.

Therefore:

> The rule is this, that succession in time is the province of the poet, co-existence in space that of the artist.[7]

Here, Lessing brings the language of metaphysics to painting and poetry half a century after Leibniz and Newton debated the nature of *space*. Explanations of the world in terms of objects and *space* were becoming common at this time. However, in his *Laocoon*, Lessing is not conveying that *space* is important to pictorial construction, or even that it is a pictorial element to represent, but that painting, as an object, and the objects it represents, exist in *space*. It is the outer

forms of *space* and time, in which painting and poetry operate that are different. More to the point, Lessing conceives that for art, 'Truth and expression are taken as its first law.'[8]

In the history of picture making and *space*, at some point after Newton, it became conventionalized that pictorial perspective shows objects in *space*. However, in *Laocoon*, the concept of *space* as necessary for pictorial development, is outside of Lessing's discussion. Even as *space* began to be conceived as part of the objective world, it had not penetrated pictorial sensibilities.

In 1750, Alexander Gottleib Baumgarten (1717–68), a professor of philosophy at Halle University and a friend of Kant, published a treatise *Aesthetica*, which established aesthetics as a new branch of philosophy. He repurposed the ancient Greek *aisthesthai*, which means 'to perceive through sensation' to become what he describes as, the 'science of sensible cognition'. Baumgarten's aesthetics concern not merely raw sensations, but also awareness and interpretation, and ultimately how we judge phenomena. For Baumgarten, the subject of this new science was affect in general, but as distinguished in art, and specifically, poetry. Although Baumgarten's *Metaphysics* served as a textbook for Kant's classes, there is no philosophy of *space* in his book on aesthetics. In the German-speaking world, it was Lessing, the quick-witted and scholarly theater man who brought *space* wrapped in the language of metaphysics to the outer forms of visual art.

Space Within Painting: John Ruskin

John Ruskin's (1819–1900) *Modern Painters* was published in 1843, when he was only twenty four. Initially written as a defence of the paintings of Joseph Mallord William Turner (1775–1851), over the next two decades, Ruskin added four additional volumes, developing the book into a sweeping philosophy of painting, with a particular attention to landscape painting. The first volume was over five hundred pages.

Truths and ideas are preeminent for Ruskin and he returns to these principles throughout the book. Ideas are a measure of artistic achievement, 'He is the greatest artist who has embodied, in the sum of his works, the greatest number of the greatest ideas.'[9]

Ruskin's key ideas, which are methodically explained in the first chapters, are 'Power, Imitation, Truth, Beauty and Relation'. Part II comprises the following three-quarters of the book and is titled 'Of Truth'.

Ruskin's multiple Truths revolve around landscape painting. In the order of chapter headings they are:

Truth of Tone
Truth of Colour
Truth of Chiaroscuro
Truth of Space – dependent on the Focus of the Eye
Truth of Space – dependent on the Power of the Eye
Truth of Skies – of the Open Sky
Truth of Clouds – of the Region of the Cirrus
Truth of Clouds – of the Central Cloud Region
Truth of Clouds – of the Region of the Rain-cloud
Truth of Earth – of General Structure
Of the Central Mountains
Of the Inferior Mountains
Of the Foreground
Truth of Water
Truth of Vegetation[10]

As the list of chapter headings reveals, for Ruskin, *space* has become an explicit concern. Similar to Leonardo's text, which had been available in English for over one hundred years, Ruskin's text takes up two of Leonardo's subjects in his chapter, Truths of Space: 'as dependent on the Focus of the Eye', and 'as its Appearance is dependent on the Power of the Eye'. Here, Ruskin revisits Leonardo's descriptions of the subjects of vapors, clouds, bodies of water and mountains in relation to the softening of outline and color due to the effects of air and limits of the eye. By placing Leonardo's subjects of 'aerial perspective' and 'acuity perspective' within his chapter of Truth of Space, Ruskin unites Leonardo's perceptual observations with Locke's belief in *space* as empirical. To the degree that Ruskin's Truth of Space is experiential, it is through seeing and comprehending the breadth of land and sky. For Ruskin, *space* is a function of distance, which through understanding the 'Focus of the Eye' and 'Power of the Eye' the artist is able to portray landscapes faithfully.

There is an additional and larger role that Ruskin assigns to *space* in painting. Ruskin dedicates his book to English landscape painters. *Space* is tied to the subject of skies, clouds and mountain landscapes in painting (the headings of the chapters following his two chapters on *space*). And so the sensation of *space* is not inherent to painting but to its subject matter. For Ruskin, these subjects contain moral uplift—it is to ponder the sublime and infinity. 'To make us

understand the space of the sky, is an end worthy of the artist's highest powers...'[11] This is Ruskin's value for *space* in painting.

For Ruskin, *space* is more than Lessing's outer category, however, it does not actively inform the picture in the way that de Piles' categories of Harmony or Composition do. Ruskin's feeling of *space* is tied to the sublime vision of landscapes, it is not with the mechanics of painting or the feeling for painting, in and of itself.

For Ruskin, pictorial necessity is Truth, but it is very different from de Piles' 'true painting', which 'ought, as I have observed, to call the spectator, to surprise him [or her], and oblige him [or her] to approach it ...'[12] In the dialogical French tradition, painting has the capacity to enter into intimacy with its viewers – even in its grandest mode, painting is intelligible and sensual. Although Ruskin brings *space* to the discussion of painting, it is as the subject of representation and not as pictorial *space* internal to the sense of painting.

Ruskin's idea of truth gives painting the authority of sublime truth – sublime as that which is beyond the intelligible. Ruskin's great painting is not something that seduces and holds its viewer, but is distant, sublime and upholds an ideal. It is not intimacy but the majesty of *space* that most moves Ruskin. 'Greatness of matter, space, power, virtue, or beauty, are thus all sublime ...'[13]

Notes

1 André Félibien, *Des principes de l'architecture, de la sculpture, de la peinture, et des autres arts qui en dépendent: Avec un dictionnaire des termes propres à chacun de ces arts*, 3rd edn (Paris: A Paris, chez la Veuve & Jean-Baptiste Coignard, fils, 1697), 288.
2 Ibid.
3 Ibid.
4 Ibid.
5 Ibid., 294.
6 Roger de Piles, *The Principles of Painting under the Heads of Anatomy* ... De Piles, Roger. *Cours de peinture par principes, avec un balance de peintres*. Paris: Jacques Estienne, 1708 (London: Printed for J. Osborn, at the Golden Ball, in Pater-noster Row, 1743), 2–3.
7 Gotthold Ephraim Lessing, *Laocoon: An Essay upon the Limits of Painting and Poetry. With Remarks Illustrative of Various Points in the History of Ancient Art*, trans. Ellen Frothingham. Orignally published, Gotthold Ephraim Lessing, Laokoon: oder über die Grenzen der Mahlerey und Poesie (Berlin: Christian Friedrich Voß,

1766). (Boston, MA: Roberts Brothers, 1887; repr. New York, NY: The Noonday Press, 1957), 91.
8 Ibid., 16.
9 John Ruskin, *Modern Painters*, Vol. 1 (New York, NY: John Wiley and Sons, 1879; first edition, 1843), 12.
10 Ibid., lix–lxxi.
11 Ibid., 77.
12 De Piles, *The Principles of Painting*, 3.
13 Ruskin, *Modern Painters*, 41.

13

The German Founding of Art History

As an inheritor of the English tradition of Locke and Newton, it follows that Ruskin sees *space* as an external reality for painting. It is a subject to promote great feeling in painting akin to the sublime drama of Laocoon. In the history of *space* in art, *space* had yet to be considered a category within the sensibility and mechanics of the visual arts – that would originate from a different tradition. In the introduction of Michael Podro's *The Critical Historians of Art* (1982), he speaks of a 'central tradition' that 'stretches from roughly 1827 to 1927', with 'a strong internal coherence'.[1] Significantly, it is this German-language tradition of art history that emerged from the philosophy of Leibniz and Kant.

Kant does not discuss *space* in his aesthetics, which like those of Baumgartener's are primarily involved with judgemnts of form, harmony, and extend to considerations of the nature of art, beauty and the sublime. However, for those focused on pictorial issues, this statement of Kant's could only have resonated:

> Space is a necessary representation, *a priori*, that is the ground of all outer intuitions . . . It is therefore to be regarded as the condition of the possibility of appearances, not as a determination dependent on them, and is an *a priori* representation that necessarily grounds outer appearances.[2]

As such, it makes sense that *space* first established itself as a categorical imperative in the pictorial arts within the philosophically inclined German tradition. This tradition, enthralled by Kant's philosophy, would approach *space* not merely as an external reality to be depicted but also as inherent to perception and representation. It is through the historians writing within Podro's 'central tradition' that *space* was extended into pictorial art to be seen as essential to its comprehension and ultimately its making.

Rumohr's Material

The date, 1827, which Podro assigns as the beginning of the central tradition, marks the publication of *Italienische Forschungen*, three volumes of Italian studies by Carl Friedrich von Rumohr (1785–1843). For Podro, Rumohr initiates the central tradition of art history that continues into the twentieth century with the writings of Riegl, Burckhardt, Wölfflin, Hildebrand, Warburg and Panofsky. This tradition is the foundation for much of art history as it is taught today. Even as German-speaking art historians came to believe in the fundamental nature of *space* in art, this concept was not native to the tradition. Rumohr established several essential elements of art history, however his writings do not apply *space* to artworks.

Rather than having a taste for metaphysics, Rumohr is a keen observer of the materiality of art. Rumohr opens his chapter 'On Giotto' with a poem inscribed on the funerary monument in the Duomo in Florence, which was commissioned by Lorenzo Medici in 1490, featuring an epitaph composed by Agnolo Poliziano:

> I am the one through whom extinct painting was revived,
> Whose hand was as true as it was graceful.
> What Nature lacked, my artistry provided
> None fufilled more! Painting not bested.
> Marvel at this noble tower, resounding with sacred air,
> It too, measured by my design, reaches to the stars.
> In sum—I am Giotto. What more need be reported?
> This name itself embodies boundless magic.
>
> Died 1336. Citizens erected this monument
> in 1490.[3]

Rumohr's quotation serves a dual purpose. Although Rumohr's book lacked pictures, the epitaph offers a clear image of Giotto's significance within the culture of the fifteenth century, while also standing as an artefact in its own right. The tribute underscores Giotto's esteemed position, supporting Rumohr's argument that 'the innovations Giotto introduced into painting continued to influence his students and imitators for an entire century after his death'.[4]

Rumohr was known for his extensive documentary research. In his essay on Giotto, he quotes verbatim writings by Villani, Sacchetti, Bococcio and Ghiberti. Rumohr sets out to present a portrait of Giotto by presenting text as material evidence. Language, with its contexts and consequences, was keenly observed and germane to Rumohr's sensibility. In comparing the agricultural systems of

northern and southern Italy, he says their difference perhaps 'lies in the work of the language. This wonderful element is more powerful than you think. Thanks to it, opinions, views, thoughts, and reasons go from house to house, creating over time a general consensus ...'.⁵ Rumohr's contribution to the discipline was to bring documentary evidence and a recognition of context to the study of art.

Of the writers in Podro's central tradition, Rumohr is the least celebrated. His books were not generally republished or translated. A notable exception was this 1822 practical guide to and philosophy of cuisine *Geist der Kochkunst*, an early and popular cookbook published in English as *The Essence of Cookery* in 1993.⁶ It is not an unfitting legacy as it highlights the material constituents he so values: 'the nutritional element should under no circumstances be suppressed or eliminated by over-contrived preparation ...'.⁷ Rumohr's legacy to the emerging field of art history is that the Truth of Painting is not merely how a painting makes one feel or a function of taste, but inheres in materiality. Accuracy through textual and contextual study is a function of truth. Rumohr's imperative to comprehend the basis of painting through its situation in society in conjunction with materially relevant texts secured a solid foundation for the project of art history. It is consistent with Rumohr's interest in the material matters of painting that he does not forge a concept of pictorial *space*.

Burckhardt's Introduction of *Raumgefühl*

Some years after Rumohr's death, the Swiss-German Jacob Burckhardt (1818–1897) published *Der Cicerone: Eine Anleitung zum Genuss der Kunstwerke Italiens* of 1855 (*The Cicerone: A Guide to the Enjoyment of the Artworks of Italy*). It seems Burckhardt is the first to develop a concept of pictorial *space* and is the first true *spatialist* in the history of art.

His *Cicerone* would seem to follow the established format of a guide book. However, it is a far more ambitious commentary on artworks. Burckhardt includes the history of painting, beginning with the ancient Greeks and concluding with paintings of the sixteenth century. While the book's geographic center is Italy, Flemish, Dutch and French artists are discussed. Burckhardt was a professional academic who was born, educated, made professor and died in Basel. He did not stray for long from his hometown, but at nineteen, a visit to Italy crystallized his commitment to the study of art. While it is only one of

many topics, it is Burckhardt, starting with *Cicerone*, who brings pictorial *space* into art history.

Certainly, how a work of art is linguistically framed and channelled affects how it is perceived. In Burckhardt's writing, *Raumgefühl*, the 'feeling for space', echoes through the text of *Cicerone* and colors its content in several sections. Burckhardt does not acknowledge that this term is novel and it is likely he does not view it as an invention, but only a fresh expression to describe the complexities of painting. Speaking of Giotto and his followers, Burckhardt writes:

> But in another sense also the feeling for space is ideal. For Giotto space exists to be filled as much as possible with rich life, not for the sake of picturesque effect; it is merely a scene for action.[8]

These fascinating two sentences can be interpreted as Burckhardt's acknowledgement that Giotto is indifferent to the 'feeling for space', as it is 'merely a scene for action'. And simultaneously, Burckhardt writes that Giotto's 'feeling for space is ideal'. It is oddly a double conception of Burckhardt's *space* applied to medieval painting. In this passage, Burckhardt's ideal is not perfection per se, or a strictly mimetic image, but a religious schema. He writes about Giottoesque painting:

> The representation of the celestial, holy, supersensual is conceived on the same principle as in the Byzantine period; symmetrical in grouping and position, it seems to descend among earthly things as if it were understood of itself, and accepted with full belief as a revelation; in the ideal mode of conceiving the space, the outward representation also seems the right one.[9]

There is an overlay of modern *space* to the organization of Byzantine painting but Burckhardt's description is precise, informative, even poetic. However, the loss of the meaning of Place – virtually complete by the mid-nineteenth century – created a barrier to understanding the pictures produced when Place was a central organizing principle. Bringing *space* to a pictorial order based on Place deforms interpretation:

> This theological tendency has more than once injured the genuine formative impulse of art. See Pietro di Puccio's God represented as Creator and Lord of the World. It is a gigantic figure holding an immense shield with the concentric spheres of heaven in front of the body; the feet appear below. Such a representation certainly destroys any idea of the immanence of God in the world.[10]

Pietro's fresco does not depict a shield, but a complete and whole Cosmos, revealed through the twin sciences of astronomy and astrology (Figure 24).

Figure 24 Piero di Puccio, Image of the World, fresco, Camposanto, Pisa, 1389–91.

Humankind's earth is at its center, but in the picture, God's geometry is everywhere: He holds the perimeter of the Cosmos while regulating each internal ring. Here, Burckhardt has internalized Kant's belief that *space* is not a theological concern, but human intuition. This intuition is so strong that for Burckhardt, the Christian God of a centered, Place-based Cosmos is dead.

Categorical *Raum*

For Burckhardt, *Raum* is imperative to describing, comprehending and therefore seeing painting. It seems Burckhardt's modelling of art history is the first time

space is presented as a categorical quality of painting as a whole (not merely a constituent subject as Ruskin proposed). At the top of page 759 in the *Cicerone* are the headings:

Colorit. Formenbildung. Gewandung. Raum.

Colorit, with its Latin flair, denotes a color scheme; *Formenbildung* is the studied creation of forms; *Gewandung* are the shapes of draped fabric. These three categories are how painting had been discussed for centuries. The novel category of *Raum*, following Burckhardt's lead, would become a defining feature of the art historical tradition stretching from his *Cicerone* to Panofsky's Albertian window and further into the twentieth century. While the 'feeling for space' builds upon a generalized acceptance of ideas about *space* from Locke to Kant, Burckhardt secures new territory for *space*. *Space*, now conceived as geometric and fundamental to representation, was readily related to perspective and composition. However, for Burckhardt, painting before the fourteenth century seems to challenge the idea that *space* is basic to all painting across history:

> In essence, the art of the 14th-century here shows its greatness in its limitations; it essentially refrained from making the spaceless *spatial* . . .[11]

On the one hand, Burckhardt exalts fourteenth-century painting because it did *not* try to bring historically incompatible 'pictorial space' to painting. On the other hand, Burckhardt implies that *space* was somehow available to Giotto, although artists of the period avoided it. Burckhardt alternates between seeing pre-Renaissance painting as 'spaceless' and seeing it as 'ideal space'. If *space* in painting before the fourteenth century is limited or nascent, Burckhardt finds a new axis of consideration for *space* – the historical. This contradicts Kant, as it would seem the absolute *a priori* intuition of *space* as it would not admit historical varieties of *space*. However, Burckhardt's views are consistent with the expansionist essence of *space*. And so, *space* added historical dimensions to its purview.

Correggio and the Apotheosis of *Space* in Painting

Burckhardt's *Cicerone* weaves together a generous tapestry of evaluation, biography and historical information. Within Burckhardt's measure of painting, *space* is formidable. Burckhardt traces what he calls the 'highest visual pleasure' of the Venetian school to Correggio (Plate 29):

> Is there not that same daemonic [supernatural] effect which Correggio produces by a delighted sensuality made real by space and light?[12]

It is Burckhardt's *Raumgefühl*, his 'feeling for space', that not only depicts the real but serves to create a feeling of the real, even for impossible, mystical events.

Burckhardt is a vivid interpreter of Correggio:

> The main feature of [Correggio's] style, is the consistent mobility of his figures, without which there is no life and no total spatiality for him, the essential measure of which is the human figure that is moving, moving with the perfect appearance of reality, and therefore ruthlessly foreshortened depending on the circumstances. He first gives the glories of the Afterlife a space that can be measured cubically, which he fills with tremendous, undulating forms [or figures]—But this mobility is not just external, but rather it penetrates the figures from within; Correggio imagines, knows and paints the subtlest impulses of nervous life.[13]

Burckhardt notes that Correggio's originality lies in three things: movement, light and *space*. These make Correggio's works as 'sensually convincing as possible'. Correggio's *Raumgefühl* is an essential component of Correggio's mystical *Realismus*. However, *space* for Burckhardt is just one element among several in Renaissance painting's arsenal. What is more, the 'compelling magic' that Correggio generates is ultimately limited:

> In great painting we do not merely demand the real, but the true. We approach it with an open heart and want to be reminded only of the best in us, whose animated form we expect. Correggio does not grant this; Looking at his works therefore becomes an incessant protest; one is tempted to say to oneself: "As an artist, you should have been able to grasp all of this on a higher level." The morally uplifting element is completely missing . . .[14]

Burckhardt criticizes Correggio's work that it does 'not reach [the height of pathos and noble expression] of Titian'.[15] The magical effects of the 'feeling of space', may delight, may even constitute a significant element of painting, but more is required. This is the limit of pictorial *space* for Burckhardt. Burckhardt characterizes *space* as vital to Correggio's painting, but it arrives with a cost:

> The very reality of movement in space, as found and adopted in Correggio's work, made art indifferent to all higher arrangement, to the simple grandeur in construction . . .[16]

Raum versus *Spatium*

As Latin remained the standard language of religion, philosophy and science well into the eighteenth century, the establishment of *space* – conceived as more or less infinite, empty, homogeneous and mathematical – evolved within the linguistic tradition of Latin. The Western concept of *space* developed its complexion from *spatium*, which itself evolved from the proto-Indo-European *speh*: 'to stretch, to pull'. Essentially, *spatium* developed as an expanded (expanse also derives from *speh*) form of extension to 'outstretch'. *Spatium* thus evolved to express a kind of stretched-out or extended dimension. This etymological trajectory is evident in Descartes' entwining of *spatium* with *extensio*, and in the parallel French terms *étendue* and *espace* – where *space* is essentially the inheritor of extension.

For centuries, Latin provided some unity of conception of *space*, but by the nineteenth century, national languages including German had eclipsed Latin within national borders in writing on cultural matters. A 'sense of space' in German would mean a sense of *Raum*, a term that had by then inherited many of the Latin meanings carried by *spatium*. Additionally, *Raum* has an etymology distinct from *spatium* as it emerged from the proto-Germanic *raumaz*. Rather than 'to stretch' or 'to extend', *raumaz* expresses 'to clear away' or 'evacuate', as does the German verb *räumen*. *Raum* implies emptying and so there is an inherent dialectic between object and the emptiness after its removal, or before its emplacement.

Nineteenth-century *Raum*, with its double history of German and Latin, entails both *space* as extension and *space* as the emptied place of an object. It can be observed that the double history of *Raum* informs Burckhardt's inflection of Correggio's pictures with *Raumgefühl*.

Correggio's two great frescoed domes in Parma are similar in their depiction of the heavenward flight of the central figures – the Virgin in the Duomo and St John in San Giovanni Evangelista. It can be noted that in Correggio's depictions, the two senses of *Raum* are united: in the first sense, the paths of the figures form an extension from earth to heaven and, in the second, the figures are evacuated from the here and now (to the Afterlife). That Correggio's pictorial subject matter can be seen to align *Raum* with *Spatium* would have satisfied Burckhardt's *Raumgefühl*.

Burckhardt's *Raumgefühl* is also bound up with Correggio's representation of clouds (Plate 30):

> It was only in the 15th century that the sky began to be represented spatially using the layers of clouds, and it was Correggio who first gave the clouds a

specific cubic content and degree of consistency that made them suitable for the calculation of location and to support angels and saints.[17]

Here, the concept of *Raum* as related to evacuation is reversed. Instead of *Raum* representing an empty place, Burckhardt offers up for depiction, the gaseous atmosphere with clouds as 'cubic' objects. There is an enthusiasm that shades to the erotic inherent in Burckhardt's conceptualization of *Raum* in Correggio's pictorial order. Paradigmatically this can be seen in Correggio's painting of the ancient myth of Jupiter in the guise of a cloud, seducing Io – *Raumgefühl* made urgent.

Wölfflin: Painterly *Space* in Architecture

To the degree that *space* is considered real, it might be expected that 'architectural space' would have entered art history discourse before 'pictorial space'. However, the opposite is true. In Ruskin's *Modern Painters*, *space* was significant as the sublime subject for landscapes. However, in his *Seven Lamps of Architecture* published in 1849, Ruskin does not claim *space* for architecture. The word *space* appears fewer than a dozen times and is limited to references of length, time and surfaces. For Ruskin, the critical issues for architecture were Sacrifice, Truth, Power, Beauty, Life, Memory and Obedience. Just as for Ruskin *space* is a representational subject rather than truly pictorial, he does not conceive of *space* as a significant architecturally.

At the end of the nineteenth century, *Raum* denoted the architectural unit of a room as does 'room' in English. However, while *Raumgefühl* is a key concept in Burkhardt's accounts of painting in the *Cicerone*, it does not appear in his descriptions of buildings except as rooms. It is worth exploring how 'architectural space' emerged, as it is characteristic of the fragmentary and fitful construction of *spatial* discourse in nineteenth-century writing on art and architecture.

Heinrich Wölfflin (1864–1945), the son of a Swiss professor of philology, was a student of Burckhardt's at the University of Basel. In his dissertation of 1886, he brought the recent science of perceptual psychology to architecture and imagines architecture in an anthropomorphic pictorial manner:

> Slight though the resemblance of a house is to a human form we nevertheless regard windows as organs that resemble our eyes.

Continuing, Wölfflin couches the experience of architecture in haptic and psychological terms:

We judge the existential feeling of architectural forms by the physical responses we make to them. Powerful columns arouse us with nervous energy, our breathing responds to the width or the narrowness of a three dimensional space. We are energized as if we were the supporting columns, and breathe as deeply and fully as if our chest were as broad as this hall. Asymmetry often induces in us a feeling of physical pain, as if one of our limbs were missing, or injured, and in the same way we feel discomfort at the sight of a disturbed equilibrium – and so on.[18]

However, while *space* makes a brief entrance in this early piece of writing, Wölfflin's focus is on our haptic reaction and empathy to the physical masses of buildings. *Space* does not take up the role of an essential gestalt of architecture.

Two years after completing his dissertation, in 1888 Wölfflin published *Renaissance und Barock*, a treatise on architectural style. Consistent with his earlier envisioning of the facade of a house as a picture of a human face, Wölfflin titles the first chapter 'Der malerische Stil' (The Painterly Style). This term refers to Baroque architecture, which, according to Wölfflin, developed either from or marked a degeneration of Renaissance forms, depending on one's perspective. Wölfflin begins the chapter by inquiring what 'painterly' means, which he proposes, at its most basic, it 'lends itself to be painted'. It is the painterly Baroque that 'with its chiaroscuro, gives an illusion of physical relief, and the different objects seem to project or recede in space'.[19]

For Wölfflin, Baroque architecture contains in itself a totality of pictorial *space*. Wölfflin, revisiting the views of his mentor Burckhardt, describes how the painterly sensation of the Baroque impels itself on the viewer 'by making the decorative filling too large, so that it overflows its allotted space'. Further, the architectural experience of Baroque is that of forceful *spatial* extension due to the style's extreme effects. For Wölfflin, Baroque architecture induces the feeling for *space* Burckhardt identifies in Correggio's painting to bring *spatial* considerations to architecture.

Wölfflin makes the case that more severe styles of architecture require a picturesque landscape of sky, clouds and effects of light to be painterly. It is the 'free and painterly' style of the Baroque that admits *space* to architecture and so, once it inhabits the Baroque, *space* can be recognized and be extended to other, less capricious styles. 'In a Renaissance ceiling all elements are happily harmonized, everything has air and space; but baroque ceilings are crowded and massive and make us fear that the filling will burst out of the frames.'[20]

Despite the vernacular *Raum* having the traditional architectural association of the English term 'room', historically painting precedes architecture to become

spatialized. This indicates *space* is a cultural convention. Painting, having less technical requirements than architecture, is more nimble in exploiting and playing with conventions. The pattern of 'architectural space' following 'pictorial space' would play out again a quarter of a century later in France with a well-known architect turned painter turned architect as we will see in later in the book.

Hildebrand's Imperative of *Space*

In the 1950s, Barnett Newman was credited with the witticism: 'Esthetics is for artists like ornithology is for the birds.' Similarly, through most of the nineteenth century, artists were as intent on *space* as birds are on ornithology. Eugene Delacroix (1798–1863), recognized in his lifetime as one of the most significant painters of his era, was deeply engaged in the social and cultural life of Paris. He was a regular exhibitor at the French Academy's official salons, his cultural interests extended to music, theater, the poetry of Byron and Dante, and he was involved in the creation of the Société Nationale des Beaux-Arts in 1862. Delacroix kept a journal for over twenty years; it is a document of a thoughtful and successful painter from mid-century; and it contains fascinating details of his life, including his friendships with George Sand, Frederic Chopin, Charles Baudelaire and Victor Hugo, among others. In his journals, Delacroix discusses his subject matter, other painters, material techniques and the necessary elements of painting – expression, color, light, line and form. In his journal from 1857, Delacroix includes notes for a 'Philosophic Dictionary of the Fine Arts, of Painting and of Sculpture' – there he records an ambitious, encyclopedic quantity of historical examples, categories, insights and imperatives, but pictorial *space* is not part of his wide-ranging imagination of painting. Subsequently, but similarly, the Impressionists' interests did not manifest in ideas of 'pictorial space' but in the 'envelope of light'. Even as *space* was gaining interest in science, philosophy, and historical discussions about art, it did not appear as a concern for most nineteenth-century painters, sculptors and architects.

The first to publish a clarion call to consider *space* as part of the making of artworks was the German sculptor, Adolf von Hildebrand (1847–1921). This makes sense as *Raumgefühl* was conceived as an explanatory device for pictures within the German language. Following Kant's conception of *space* as fundamental to perception and representation, Hildebrand, it seems, was the first to insist artists to develop their works in terms of *space*.

Hildebrand travelled to Italy in his early twenties, initiating a lifelong connection to the visual art of Italy which formed the basis for his Neoclassical style. Within a few years, he established a home in a former monastery in Florence. While very much a practicing sculptor (especially expert in working marble), Hildebrand, the son of a professor of economics at the University of Marburg, had a keen interest in academic issues. His social circle in Florence and Munich (where he also lived) included his friend and mentor, the theorist of art Konrad Fiedler (1841–95), and an assortment of young art historians, Bernard Berenson (1865–1959) and Aby Warburg (1866–1929), as well as Wölfflin.

In 1893, Hildebrand produced a treatise, *Das problem der Form in der bildenden Kunst*. It was successful enough to be printed in several editions, translated into French in 1903 and into English in 1907 as *The Problem of Form in Painting and Sculpture*. Hildebrand's book brought the strains of perceptual psychology and philosophy of Fieldler to art history, as well as a distinctly neo-Kantian attitude (unsurprising as the University of Marburg is historically renowned for its Kantian traditions). Although Hildebrand's legacy as a sculptor goes little beyond period interest, his treatise resonated in conservative academies, and further, his theories of art were of particular interest within the developing field of art history. Podro credits Hildebrand's ideas about translating perception as key to Wölfflin's *Principles of Art History* of 1915. Podro's *The Manifold of Perception: Theories of Art from Kant to Hildebrand* of 1972 cites him in title and text.[21] For Podro, the sculptor Hildebrand is a relevant member of the central tradition of art history. As such, Hildebrand was not only involved in creative production of artworks but was also influential in the theory and history of art.

In the introduction to his treatise, Hildebrand writes:

> Our relation to the world of vision consists chiefly of our perception of its spatial attributes. Without this, orientation in the outer world is absolutely impossible. We must, therefore, consider our general spatial ideas and the perception of spatial form as the most important facts in our conception of the reality of things.[22]

With Kantian overtones, Hildebrand insists *space* is the necessary ground for understanding of the world. Further, the 'consciousness of space' is essential to art making, 'In an artistic representation Nature must be expressed as just such a spatial whole . . .'[23] And so:

Pictorial representation, however, has for its purpose the awakening of this idea of space, and that exclusively by the factors, which the artist presents.[24]

For Burckhardt and Wölfflin, *space* was a descriptive tool to evaluate painting and architecture. Hildebrand extends *space* further by introducing a new necessity and urgency for *space* in art that is intimate and practical. As a verb, *räumen* functions as *Raum* in action – 'to evacuate' or 'to empty'. As a sculptor, Hildebrand's process was to remove, 'to evacuate' marble from a block and by this means, create sculptural form. For Hildebrand, *Raum* and *Form* are a natural dialectic.

Hildebrand explains:

> By total space we mean space as extending through all three dimensions, or in all directions. The essential factor in this is continuity. Let us imagine total space as a body of water into which we may sink certain vessels, and thus be able to define individual volumes of the water without, however, destroying the idea of a continuous mass of water enveloping all. In an artistic representation Nature must be expressed as just such a spatial whole . . .[25]

Here, Hildebrand details what he means by *space*: *space* is analogous to water surrounding a submerged vessel. *Space*, like the water, is continuous and three-dimensional. As with a body within water, an object displaces *space* – so that an object is specifically not-*space*, even as *space* is continuous around it. Today, while the term, 'negative space' has currency, it has a whiff of the oxymoronic. Usually those who use 'negative space', use it to mean the *space* that surrounds, but is not an object or form. Hildebrand is clear – it is physical bodies that are surrounded by and displace continuous three-dimensional *space*. In this case, it is *space* that is the positive term. Logically, it is bodies that displace *space*, and so – it is bodies that are in essence 'negative spaces'.

Inversely, an example of a body negated to become a *space* can be seen in one of Hildebrand's carvings. In his marble sculpture of 1886, Philoctetes looks heavenward (a visual echo of the much cited antique sculpture of Laocoon) with an expression of noble suffering (Figure 25). In the myths surrounding Philoctetes, Hera, seeking revenge, sends a serpent that bites Philoctetes' foot, causing it to fester. A staple of Romantic painting, Philoctetes is commonly portrayed with a bandaged foot, however Hildebrand reconceives the depiction. His Philoctetes is missing half his left foot from the serpent's bite. Hildebrand's *space*, conceived as a displaced body, grants a narrative function to Philoctetes' wound. With his sculpture of Philoctetes, Hildebrand adapts the negative body of the missing foot to become *space*.

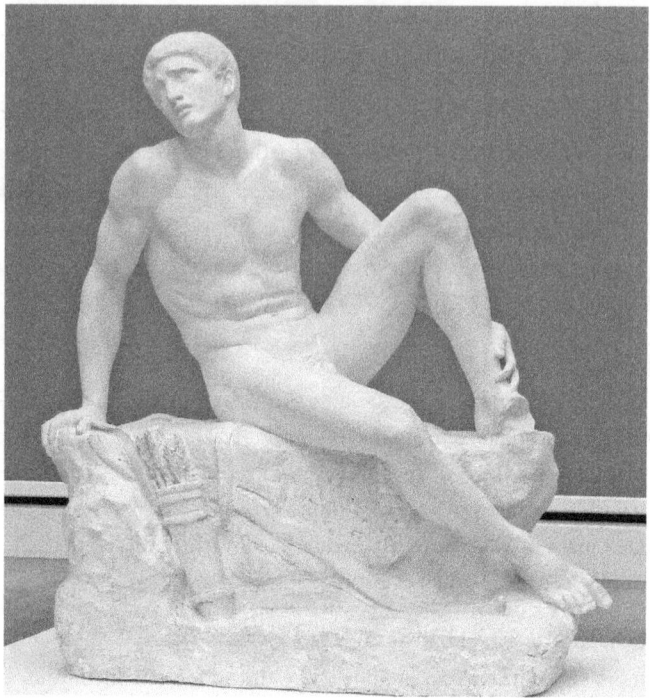

Figure 25 Adolf von Hildebrand, *Philoctetes*, marble, 1886.

Hildebrand's *Space* for Artists

Hildebrand's book engages with more than his advocacy for *space* in the pictorial arts. Podro writes of Hildebrand's text, 'This was the first time someone had given a systematic account of the reciprocal adaptation of subject matter and the material of visual representation.'[26] For Hildebrand, subject matter in the pictorial arts may be literary, but 'sculpture and painting do not borrow their poetic force from other arts, nor do they exist merely to illustrate poetic subjects'.[27] This is Hildebrand as a proto-Modernist, not only advocating for *space* in art but also as an artist arguing for medium specificity and for the aesthetic independence of art.

Hildebrand concludes his book with a discussion of 'Sculpture in Stone'. This is where Hildebrand's dialectic of *space* and form is most fully realized as it bears on the specifics of the 'poetic force' in stone carving. First he acknowledges 'that the material ... must influence [the artist's] technical method'.[28] Here

Hildebrand's idea about 'unity in space' has its reciprocal relationship with stone carving:

> Thus, in the most intimate manner, the process is welded together with the pictorial metamorphosis attending the presentation of the actual form. The general law and immutable condition of the artistic conception is unity in space.[29]

For Hildebrand, unity in *space* is 'formed during the very act of representation'.[30] He describes his process:

> The nature of the technical process demands that the design be freed of its stone surroundings uniformly with respect to the main aspect before the work can proceed into greater depths.[31]

It is through the process of carving away a volume of stone that *space* is revealed and the dialectic of *space* and form is made meaningful.

Hildebrand's treatise presents a concept of *space* that would become generalized for art education in the twentieth century. As Hildebrand's stone-carver specific way of seeing *space* became more popularized, it became less fine-grained. *Space*, with its relentless habit of extension, entered art schools. There, Hildebrand's novel introduction of Kant's philosophical *space* to pictorial thinking would become a dutiful didactic assignment. The 'drawing of space around the figures' and the directive to 'think about the total space of picture' became academic dictates well before the end of the twentieth century.

Hildebrand's *The Problem of Form in Painting and Sculpture* did not resonate immediately with the Parisian avant-garde, which developed its own conceptions of *space* coming from a different tradition. However, with its multiple translations and printings, the ideas in Hildebrand's book – in a simplified conservative form – made their way into academies of life drawing and traditional techniques, continuing even to this day.

Notes

1. Michael Podro, *The Critical Historians of Art* (New Haven, CT, and London: Yale University Press, New Haven and London, 1982), xv.
2. Kant, *Critique of Pure Reason*, 175.
3. Carl Friedrich von Rumohr, *Italienische Forschungen*, 3 vols. (Berlin: Reimer, 1827–1831).

4 Carl Friedrich Rumohr, 'On Giotto', From, Carl Friedrich von Rumohr, *Italienische Forschungen*, 3 vols. (Berlin: Reimer, 1827–1831). In Gert Schiff (ed.) and trans. Peter Wortsman, *German Essays on Art History* (London: Continuum, 1988, The German Library, published in cooperation with Deutsches Haus, New York University), 73.
5 Carl Friedrich von Rumohr, *Drey Reisen nach Italien: Erinnerungen* (Leipzig: F. A. Brockhaus, 1832), 106, trans. Francesco Mazzaferro in *From Carl Friedrich von Rumohr* [Three Journeys to Italy], 1832, Part Two, *Letteratura Artistica: Cross-Cultural Studies in Art History Sources*, https://letteraturaartistica.blogspot.com/.
6 Carl Friedrich von Rumohr, Der Geist der Kochkunst (Stuttgart and Tübingen: J. G. Cotta, 1822). Original publication.
7 Ibid., 63.
8 Jacob Burckhardt, *The Cicerone: An Art Guide to Painting in Italy for the Use of Travellers and Students*, trans. Mrs. A. H. Clough (London: T. W. Laurie, [1855] 1908), 33. Original publication, *Der Cicerone: Eine Anleitung zum Genuss der Kunstwerke Italiens*. Schweighauser'sche Verlagsbuchhandlung, 1855.
9 Ibid., 37.
10 Ibid., 41–2.
11 Jacob Burckhardt, *Der Cicerone: Eine Anleitung zum Genuss der Kunstwerke Italiens* (Basel: Schweighauser'sche Verlagsbuchhandlung, 1855), 771.
12 Ibid., 960.
13 Ibid. 95.
14 Ibid.
15 Ibid., 971–2.
16 Ibid., 1024.
17 Ibid., 766.
18 Ibid., 12.
19 Heinrich Wölfflin, *Renaissance and Baroque*, trans. Kathrin Simon (Ithaca, NY: Cornell University Press, 1964), 31. Original publication: Heinrich Wölfflin, *Renaissance und Barock: Eine Untersuchung über Wesen und Entstehung des Barockstils in Italien* (Munich: Theodor Ackermann, 1888).
20 Ibid., 56.
21 Michael Podro, *Manifold of Perception: Theories of Art from Kant to Hildebrand* (London: Oxford University Press, 1972).
22 Adolf von Hildebrand, *The Problem of Form in Painting and Sculpture*, trans. Max Meyer and Robert Morris Ogden (New York, NY, and London: G. E. Strechert and Co., 1907), 17. Original publication, Adolf von Hildebrand, *Das Problem der Form in der bildenden Kunst* (Strassburg: Heitz & Mündel, 1893), 17.
23 Ibid., 47.
24 Ibid., 49.

25 Ibid., 47.
26 Podro, *The Critical Historians of Art*, xxv.
27 Hildebrand, *The Problem of Form in Painting and Sculpture*, 13–14.
28 Ibid., 124.
29 Ibid., 136.
30 Ibid., 130.
31 Ibid., 129.

Part Five

The Space Age

This book constitutes a history of pictorial space, but what I have presented until now might be described as mostly its prehistory. While my approach is primarily chronological, different sections have distinct premises and methods. As space is entirely absent in early texts, in the first two sections of this book, the paintings of the thirteenth and fifteenth centuries are explored through other narrative tropes that were roughly contemporaneous to the works themselves.

In Part Three, both the approach and premises shift. To explore how pictorial space *itself* came to be naturalized, it was ultimately necessary to understand how modern space came to be. Space is a complicated conception, and so I have offered a basic chronology of the concepts in philosophy, religion and science that were necessary for space to assume its modern form. Once space was recognized to be infinite enough, empty enough, empirical enough, homogeneous, mathematical and secular, it became sufficiently 'real' to be taken up in the arts.

For space to serve as a compelling framework for understanding painting, sculpture and architecture, it first had to have a somewhat stable definition and be normalized. This helps explain why consideration of space in the visual arts only emerged in the latter half of the nineteenth century. Its delayed arrival reflects the slow and often contentious development of the concept itself. Yet inevitably, and true to its nature, the idea of space continued to expand, eventually encompassing the visual arts as part of its extensive purview.

Following the metaphysics of Leibniz and Newton, space became a topic in general culture and subsequently was introduced to the lexicon of pictorial description. In Part Four, we see that the idea of space as inherent to picture making was slow to take hold. In Lessing's 1766 essay **Laocoon**, he wrote about the distinction between poetry based in time, and the pictorial arts based in space. However, space was merely an outer category; it was not yet a conception that could expressively shape sculpture and painting within. Writing almost a century

later, Ruskin discussed the subject of space in painting. Although for Ruskin, space is interior to painting, it is subject a matter to be depicted like the sky, clouds and mountains. Space was a means to convey the feeling of sublimity, not as generally inherent to painting. Pictorial space was slow in coming.

Finally, it is with Burckhardt's Raumgefühl that the idea of space fully enters painting discourse. Burckhardt's 'feeling for space' is an active category intrinsic to picture making. Despite Burchhardt's equivocation between defining pre-Renaissance painting depicting 'ideal space' or being 'spaceless', he sees space as part of the mechanics of painting and a category to qualify and define all painting. Burckhardt's extension of space to painting added a facet to Kant's transhistorical concept of space. Burckhardt's space is not solely archetypal, but was conceived as having historical dimensions. For Burckhardt, space is not only universal but particular to culture.

It then falls to the German academic sculptor Hildebrand to seize on the idea of space as imperative for artists. Earlier, artists were unaware of or indifferent to how an idea of space could shape works of art. Hildebrand, drawing on his own process of carving stone, abstracted a Kantian conception of space to insist on its centrality to art making. In his 1893 treatise on form in the pictorial arts, Hildebrand fully expresses—it seems for the first time—that space is indispensable for the making of art works. With space now conceived as essential to the pictorial, (at least in the German tradition), the necessary elements were in place for the final part of my history—in which I trace how space gained its present popularity in artistic discourse.

The fifth and final part of this history presents a different conception of pictorial space emerging from the French tradition of art and science as distinct from German philosophy. Nineteenth-century theories of painting in France, did not insist space was a concern for artists. For the French painters who were pursuing a scientific basis for painting, particularly those interested in the structure of ocular sensation, space was not part of their imaginings. This changed early in the twentieth century. Enchanted by the new geometric and scientific conceptions of space, Cubism developed ideas of space to shape visual form. It was this tradition of pictorial space derived from science rather than from philosophy that dominated the Paris avant-garde and instituted space as a prominent concept.

This section explores the radical new developments in mathematics and science in the mid-nineteenth century which set the stage for Cubist interest in space. Bernard Riemann's mathematics of Non-Euclidean and n-dimensional geometry decisively overturned the assumptions of Euclidean geometry. Because geometry and space were linked (and to a large extent still are), the new and complex new geometry

forced a confrontation between geometry and reality – and a new imagining of the world. This was the great challenge the Cubists took on.

Once securely established, space *developed in a variety of ways beyond the Cubist theories that first legitimized* space *as Modern. As the twentieth century advanced, increasingly* space *came to be seen as an essential ingredient in art making. Part Five explores how the three varieties of* space *– derived from science, philosophy and mystical variations of religion – were conceived in artworks. From the teens through the 1950s, concepts of* space *were explored creatively in artworks and discussions. However, by the 1960s,* space *was simplified to a single dimension as 'artistic' and detached from its earlier complexities of meaning.*

The final section of Part Five turns from history to a polemic. I argue that space *in its later discursive phase adds little substance to discussions of art. Instead* space *attaches itself indiscriminately to an ever expanding range of terms and concepts functioning in the manner of what William Burroughs called a 'word virus'. In conclusion, I propose that* space *has been so successful in its expansion that its meaning has disintegrated.*

14

Calculating Cubism and *Space*

Space Comes to Paris

In his 1965 book *The Success and Failure of Picasso*, John Berger (1926–2017), writes:

> It is almost impossible to exaggerate the importance of Cubism. It was a revolution in the visual arts as great as that which took place in the early Renaissance. Its effects on later art, on film, and on architecture are already so numerous that we hardly notice them.[1]

This is certainly true in terms of the history of pictorial *space*. Although the Renaissance did not define its pictures in terms of *space*, Cubism did. Cubism claimed and celebrated *space* as part of picture making. The wave of enthusiasm for *space* in art following Cubism is one of its legacies. The Cubist imaginings of *space* through multiple viewpoints and the fourth dimension reflected a broader scientific interest in *space*. These emerged from a distinctly French tradition that regarded science as an authority for visual art.

The French interest in science as it relates to painting can be traced back to the years following the formation of the Académie royale de peinture et de sculpture, when Leonardo da Vinci's *Traité de la peinture* was first edited and published in Paris in 1651. Not only were many of the painterly techniques Leonardo outlined in his *Traité* adopted by the academy but Leonardo's appeal to the authority of science was also instituted in French painting at the beginning of its academic tradition.

Much of the nineteenth-century French painting that is now highly regarded developed outside the academy, where science often played a decisive role for artists seeking new forms of visual inquiry. Paintings of the Impressionists and Divisionists (popularized as Pointillism) look different than Cubist works, but concern with science was continuous. The contrasting styles reflect a focus on different aspects of science. The Impressionist science of light and its sensations

was grounded in a study of phenomena and perception, while the Cubists followed the science of higher-order geometry. By the early twentieth century, geometry and *space* had become virtually synonymous. Though their definitions were not entirely resolved, both geometry and *space* were considered functions of reality. *Space* in its scientific and geometric form was a key idea for science at the turn of the century. With Cubism, *space* emerged through the fascination with the strange new science connected to non-Euclidean geometry. This new science instigated wild and excited imagining of pictorial *space*.

There are two landmark texts on painting in which *space* in its scientific and geometric forms were introduced to the art public. *Space* is celebrated as being at the core of Cubism in *Du "Cubisme"*, a manifesto of 1912 authored by Albert Gleizes (1881–1953) and Jean Metzinger (1883–1956). *Space* is also highlighted in an essay in *Les Peintres Cubistes, Méditations Esthétiques*, published a year later by the poet Guillaume Apollinaire (1880–1981). Apollinaire was part of the circle of artists including Gleizes and Metzinger and was friends with Pablo Picasso (1883–1973) and Georges Braque (1882–1963). Apollinaire was steeped in the experiments in painting and poetry in the heady precincts of Montmartre and Montparnasse for almost a decade when he wrote in 1912:

> Nowadays, scientists have gone beyond the three dimensions of Euclidean geometry. Painters have been led, quite naturally and one might say intuitively, to take an interest in the new possibilities for measuring space which in the modern artist's studio were simply and collectively referred to as the fourth dimension.[2]

The *space* identified here by Apollinaire is starkly different from Hildebrand's philosophically didactic sensibility of *space*. Hildebrand's imagination of *space* – fundamentalist, three-dimensional and practical – was ultimately taken up by academic art programs, but not by progressive artists early in the century. In distinction, the painters that Apollinaire reports on advanced the idea of *space* in opposition to academic sensibilities – it is 'new possibilities' that drives painting here.

In *The Problem of Form in Painting and Sculpture*, Hildebrand refers to the 'anarchists of Art . . . not to be taken seriously', and states, 'It is characteristic of these artists that their incapacity to develop in architectonic manner that which they strive to achieve through imitation alone . . .'[3] Hildebrand is likely referring to several well-known French painters. Camille Pissarro (1830–1903), the 'father of Impressionism', was a professed anarchist, as were the great advocates for the science of painting, Félix Fénéon (1861–1944), Paul Signac (1863–1935) and likely the more private Georges Seurat (1859–91). It can be noted that the

imitation of light effects in Impressionism and its more scientific offspring, Divisionism, would have been at odds with Hildebrand's ideal of architectonic unity.

Even less aligned with Hildebrand's sensibilities were the Fauves. They were awarded their name by the conservative art critic Louis Vauxcelles (1870–1943), who exclaimed on seeing a room at Salon d'Automne of 1905 of the colorful paintings surrounding a Neoclassical sculpture (Hildebrand's style), '*Donatello au milieu des fauves!*' ('Donatello among the wild beasts!').[4]

Although neither the Divisionists nor the Fauves professed interest in pictorial *space*, *space* became a central claim of Cubism. Cubism was successful in a large part due to the channelling of several cultural currents uniting seemingly contradictory values such as the Primitivism of Gauguin and the Fauves, to the science of Divisionism. Through the success of Cubism with its modern geometry, *space* gained momentum as a topic in art making.

Science for Art

Cubism is often thought of as a break with French painting's prime interest in color, an enthusiasm stretching from de Piles to Post-Impressionism. However, despite the different visual cues of Seurat's and Signac's Divisionism to Cubism, both are linked to the tradition of science in French painting. Gleizes and particularly Metzinger worked in a Divisionist style before their conversion to Cubism, and continued advocating for a scientific basis for painting.

The brushily emotive and literary paintings of Delacroix might seem an unlikely model for importance of science to art, but Delacroix's visit to North Africa in 1832 galvanized his interest in color. The revelation of its southern light led him to consider color in paintings in a rational manner and his notebooks from that time include diagrams of color mixtures as aids for developing his much remarked upon sense of color.[5]

Color, which operated as the emotive force of sensibility for de Piles, became the ground for the nineteenth-century French valorization of science in painting. In the nineteenth century, the scientific tradition in painting outside the academy was almost exclusively concerned with color and its perception.

The painter Paul Signac writes:

> It is this simple science of contrast which forms the solid basis of neo-impressionism. Outside of it, there are no very beautiful lines, nor perfect colors.[6]

This passage from Signac's book *D'Eugène Delacroix au néo-impressionnisme* (1899) opens with the claim that his Neo-Impressionist technique of 'division', or the optical mixture of tones and hues, was anticipated by 'the high and clear genius of Eugène Delacroix'.[7] According to Signac, the Impressionists followed Delacroix's technique, which, in turn, led to Signac's own color theories, as well as theories by his Divisionist comrades, Seurat and Henri-Edmond Cross. Signac also writes about the theorists on color, Michel Eugene Chevreul (1786–1889) and Charles Blanc (1813–82) and the scientists Ogden Rood (1831–1902) and Herman von Helmholtz (1821–42).

In his book, Signac portrays painting as progressing like scientific discoveries, in which more 'advanced' painting styles supersede earlier ones. This is distinct from another important strain in the French tradition of conceiving painting as dialogue (de Piles). Although Seurat was reticent about public pronouncements, the younger and more voluble Signac characterizes his own experiments in color as following Seurat's lead. As the defining document of this type of Post-Impressionism, Signac's book frames the style as doubly scientific: Signac and Seurat's Divisionism is based on scientific principles, but it also claims the trope of technical advancement.

In 1824, the chemist Chevreul was appointed director of the Gobelins Manufactory of tapestries to address technical issues with colored dyes. His expansive curiosity led him to produce over 500 pages on the perception of color, not only in tapestries but also in painting, flowers and architecture. Chevreul's 1835 book *De la loi du contraste simultané des couleurs*, based on a series of public lectures, established color as the object of scientific theorization in painting and was embraced by a number of painters. With its lovely diagrams – some printed in color – the book became a leading reference for artists through the early twentieth century, when Sonia and Robert Delaunay (1885–1979, 1885–1941) developed the idea '*simultané*', bringing Chevreul's ideas to their coloristic paintings. The diagrammatic forms of color wheels and triangles resonated with other twentieth-century artists such as František Kupka (1871–1957), Paul Klee (1879–1940), Hilma af Klint (1862–1944) and Wassily Kandinsky (1866–1925).

Signac visited Chevreul late in life, and Chevreul related that around 1850, Delacroix himself had made an appointment to visit the scholar to 'discuss the scientific theory of colors with him and to question him on a few points which still tormented him'.[8] While Signac promotes a tradition of science in painting, the relation of science was not always endorsed, even among the Post-Impressionist artists. Paul Gauguin wrote to a friend, 'In art we have come to a period of aberration brought about by physics, chemistry, mechanics, and

the study of nature.'⁹ For better or worse, science was an authority in art at this time.

The Science and Mathematics of Cubism

Cubists jettisoned color theory and the meticulous observation of light of the Divisionists for a modelling of reality shaped by the reimagining of geometry. Distinct from the earlier observational science, the new geometric science shifted toward a theoretical basis with the testing of mathematical geometric models. The *space* the Cubists were publicly claiming was notably distinct from Hildebrand's. Cubist *space* is scientific, rather than a legacy of Kantian philosophy. It requires imagining rather than recognition; it is projective and experimental, and in that sense, is provisional rather than archetypal.

To understand *space* as it interested the Cubists and other early Modernists, and how it was rendered in picture making, it is worth a cursory look at the scientists that Gleizes and Metzinger cite, those who 'have gone beyond the three dimensions of Euclidean geometry'. The development of European nineteenth-century geometry represents a creative history, especially as there was no firm border between discovery and invention.

The mathematician Carl Friedrich Gauss (1777–1855) is often praised as the 'Prince of Mathematics'. Here he contrasts how philosophers – following Kant – thought about *space* compared to mathematicians:

> But despite the Nothing Saying word-wisdom of the metaphysicians we know too little, even nothing at all about the true nature of space, and we may confuse something which seems unnatural to us with the Absolutely Impossible.[10]

When Gauss wrote this in an 1824 correspondence to a colleague, he had been pondering the exquisite difficulties of testing, perhaps even upending, Euclid's parallel postulate. The postulate can be phrased as: 'In a plane, given a line and a point not on it, at most one line parallel to the given line can be drawn through the point.'[11] For two millennia, this was assumed and the parallel postulate was the intuitive basis for modern *space* before the advent of non-Euclidean geometries. Although Gauss did not publish his research into non-Euclidean geometry, it seems he did not think it absolutely impossible.

In the early nineteenth century, possibilities of a non-Euclidean geometry were in the air. In 1823, the Hungarian mathematical prodigy Janos Bolyai wrote his father, also a mathematician:

> I have made such wonderful discoveries that I have been almost overwhelmed by them, and it would be the cause of continual regret if they were lost. When you see them, you too will recognize them. In the meantime I can say only this: *I have created a new universe from nothing.*[12]

Bolyai's discovery was that a consistent non-Euclidean geometry could be realized. This branch of mathematics, now known as Hyperbolic Geometry, is based on reforming Euclid's parallel postulate. Bolyai proposed that, through a point not on a given line, more than one line can be drawn that does not intersect the original line – contradicting Euclid's parallel postulate. This geometry of lines curving away from each other implies several non-intuitive results, such as the sum of the angles of a triangle being less than 180 degrees, and the possibility of infinite parallel lines intersecting a point not on the originary line that diverge from one another. Bolyai's geometry broke with two millennia of Euclidean geometry and pointed to a strange future for higher mathematics.

Independently and likely slightly earlier than Bolyai, a young Russian, Nikolai Ivanovich Lobachevsky, (1792–1856) discovered the same Hyperbolic Geometry through different means. As this new geometry was developed, yet another form of geometry was subsequently envisioned, in which Euclid's parallel postulate was reconceived so that *no* parallel lines exist intersecting the given line from a point not on that line. This Elliptic Geometry constructs spherical background planes with the angles of triangles having sums larger than 180 degrees.

Perhaps what made the new non-Euclidean geometry extraordinarily exciting was that it offered, to paraphrase Gauss, a mathematics that was not impossible, but was 'unnatural' to the universe of Kepler and Newton. Bolyai's statement has something of the exhilaration of Bruno's speculation of multiple worlds and infinite *space*. However, Bolyai went beyond Bruno to construct a new universe with its own distinct principles and organization: '*I have created a new universe from nothing.*'

Geometric theorems and calculations do not, in themselves, create universes. However, as geometry had now become synonymous with *space*, and further, that *space* was often conceived as the basis of reality itself, the implication was that a new geometry entailed fantastic new universes. Through his rigorous philosophy, Kant conceived that *space* was both beyond and at the root of comprehension, but with the new non-Euclidean geometry, *space* was extended into a different but similarly innovative noetic realm. With the advent of non-Euclidean geometry, *space* now extended deep into the territory of mathematics, beyond the bounds of sensate observation and oriented differently than philosophical reasoning.

Riemann's Expansive Geometry

It is Bernard Riemann (1826–66), a student of Gauss, who most thoroughly impacted the future of geometry, and *space* as tied to geometry. Despite living to only thirty-nine, the devout and shy son of an impecunious minister made significant contributions to a number of branches of mathematics including topology, complex analysis and number theory. To this day, the field of 'Riemannian geometry' continues the exploration of his radical conceptualization of geometry. Unlike Bolyai and Lobachevsky, who opened new geometries by challenging a single Euclidean postulate, Riemann reimagined geometry's foundations. He began with its most basic definitions, then reconstructed its axioms and postulates to form a new basis for geometries – Euclidean, Hyperbolic and Elliptical – in relationship and that could extend into any number of dimensions. In doing so, Riemann not only redefined geometry but reconceived *space* as multiplicity of dimensions.

At Gauss' instigation, Riemann's habilitation lecture in 1854 (his dissertation to qualify for a full professorship) addressed the foundations of geometry. 'On the Hypotheses Which Lie at the Bases of Geometry' opens with:

> It is known that geometry assumes, as things given, both the notion of space and the first principles of constructions in space. She gives definitions of them which are merely nominal, while the true determinations appear in the form of axioms.[13]

After linking geometry to *space*, Riemann proceeds from the nominal definitions of point, line and plane, to elucidate and reconstruct Euclidean axioms including Euclid's parallel postulate. What Riemann was proposing was not merely a new branch of geometry, but a rigorous and comprehensive framework for geometry. This included Euclid's standard geometry and extended to opening fascinating new precincts of manifold dimensions. Riemann continued his mathematical innovations, especially in topology, but in terms of the history of ideas, his comprehensive and expanded definition of geometry is his greatest contribution.

It can be noted that in Riemann's geometry, *space* is not limited to operating within dimensions, but has a greater role – the overseer and master of any and all dimensions. As such, 'two-dimensional space', 'three-dimensional space' or even 'eighteen-dimensional' *space*, can only be recognized as *space* from an outer objective perspective. It is this outside position – entailing a God-like overview – that allows for any number of dimensions to be gathered up to be conceived as

space. While it would take decades to institutionalize Riemann's radical conception of *space*, his lecture can be said to mark the inaugural imagination of the 'age of space'.

Nineteenth-Century Imaginations of *Space*

This new mathematics, envisioning *space* as having any number of dimensions, produced a fascinating burst of imaginative writing. In 1884, the English schoolteacher and theologian, Edwin Abbott Abbott (1838–1926) published *Flatland: A Romance of Many Dimensions*. Today, the novella is primarily known for its mathematics of *space*, but social critique is as much its subject. Abbott describes how the citizens of different dimensions are controlled by their masters and fail to 'see' worlds of higher dimensions. Although the source of Abbott's mathematics is not known, he creates worlds of Riemannian dimensions. This is the fourth dimension from the point of view of a two-dimensional citizen; a Flatlander:

> Well, that is my fate: and it is as natural for us Flatlanders to lock up a Square for preaching the Third Dimension as it is for you Spacelanders to lock up a Cube for preaching the Fourth. Alas, how strong a family likeness runs through blind and persecuting humanity in all Dimensions! Points, Lines, Squares, Cubes, Extra-Cubes – we are all liable to the same errors, all alike the Slaves of our respective Dimensional prejudices . . .[14]

Abbott imagines the difficulties of denizens of one type of *space* perceiving *space*s of higher dimensions. He offers his readers the logic of dimensions:

> In One Dimension, did not a moving Point produce a Line with two terminal points?
> In Two Dimensions, did not a moving Line produce a Square with four terminal points?
> In Three Dimensions, did not a moving Square produce – did not this eye of mine behold it – that blessed Being, a Cube, with eight terminal points?
> And in Four Dimensions shall not a moving Cube – alas, for Analogy, and alas for the Progress of Truth, if it be not so – shall not, I say, the motion of a divine Cube result in a still more divine Organization with sixteen terminal points?[15]

Abbott's narrative dramatizes observers confined to their own dimensional worlds, illustrating the new geometry (and human injustice). Abbott's fiction of

multidimensional *space* relates to Riemann in that observation does not spring from the natural eye but from the mind's imagining. In distinction, the color science of Chevreul, Blanc and Helmholtz is based on the physiology and the measurable physics of light. For Riemann and Abbott, observation turns to projections of worlds determined by a new geometry that lead to new realities linked to an expanded idea of *space*.

Another Englishman, the mathematician Charles Howard Hinton (1853–1907), who today is best known for coining the term 'tesseract' for a four-dimensional cube, followed Abbott's 'ingenious work' with his own 'scientific romances' which address the fourth dimension with greater refinement (Figure 26). Hinton opens the first chapter, 'What is the Fourth Dimension?' of his 1886 book *Scientific Romances*, with:

> At the present time our actions are largely influenced by our theories. We have abandoned the simple and instinctive mode of life of the earlier civilisations for one regulated by the assumptions of our knowledge and supplemented by all the devices of intelligence.[16]

This statement neatly captures the shift in science from physical experience to experience conditioned by the mind. Hinton endorses a 'path which leads us beyond the horizon of actual experience ... of questioning whatever seems arbitrary and irrationally limited in the domain of knowledge'.[17]

The fourth dimension again entered literature in the works of the popular British science-fiction writer H. G. Wells. In 'The Plattner Story' from 1897, a schoolteacher, Gottfried Plattner, is blasted into the fourth dimension during a classroom science experiment and vanishes. Upon his return nine days later, Wells writes, his entire body has been reversed, with right and left sides swapped:

> Mathematical theorists tell us that the only way in which the right and left sides of a solid body can be changed is by taking that body clean out of space as we know it,—taking it out of ordinary existence, that is, and turning it somewhere outside space. This is a little abstruse, no doubt, but anyone with any knowledge of mathematical theory will assure the reader of its truth. To put the thing in technical language, the curious inversion of Plattner's right and left sides is proof that he has moved out of our space into what is called the Fourth Dimension, and that he has returned again to our world.[18]

Wells attributes this uncanny transformation to geometry, suggesting that only by exiting three-dimensional *space* and passing through a higher dimension could such a reversal occur. He makes the fourth dimension palpable by the

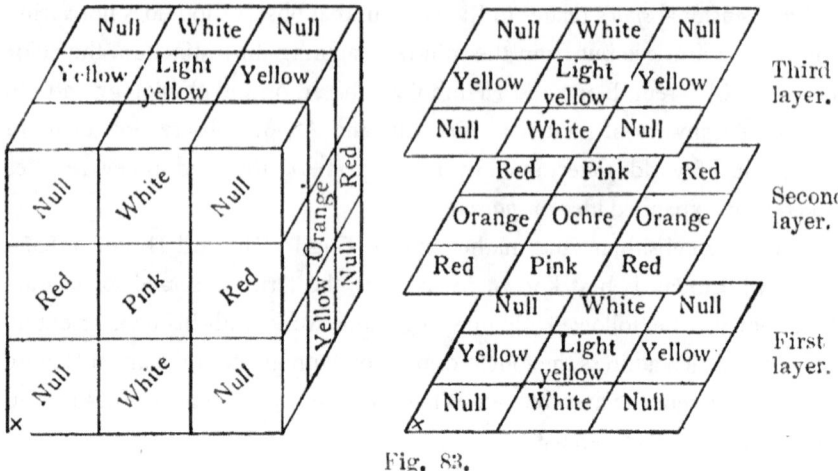

Figure 26 Explanation of the Tesseract Using Color Cubes, Charles Howard Hinton, *The Fourth Dimension*, 1912.

analogy to a figure on the two-dimensional plane of a piece of paper in a three-dimensional world. If the two-dimensional paper is flipped, the figure becomes its mirror image – similar to the inverted three-dimensional body of Plattner after his return from four dimensions.

Wells had an international following and his stories were translated into several languages, including French, providing a literary type for fiction authors to address scientific subjects. Made famous by his 1895 novel, *The Time Machine*, he had become a popular fantasist of science. With the creative questioning of the limits and the very definition of *space*, *space* entered the precincts of entertainment.

Spiritual *Space*

It is understandable that Hinton's idea that there was knowledge and insights 'beyond the horizon of actual experience' could indicate possibilities within spiritualism and the occult. While Hinton's 'instinctive mode' did not go as far as mysticism, the extraordinary fourth dimension – mathematically provable, if hard to imagine – was claimed as a subject of spiritual vision by others.

In 1877, the respected German astrophysicist Johann Karl Friedrich Zöllner (1834–82) and the famously fraudulent American paranormal Henry Slade

(1835–1905), conducted a series of seances attempting to communicate with spirits in the fourth dimension. In this case, the science of higher dimensions opened the imagination to justify spiritual *space* and vice versa.

Charles Webster Leadbeater (1854–1934), an ordained Anglican priest collaborated with founders of the order of Theosophy to produce several manuals (Plate 31) that followed Hinton's ideas about *space*. In his *The Astral Plane: Its Scenery, Inhabitants and Phenomena* (1895), Leadbeater bridges mysticism and science by appropriating Hinton's imagining of four-dimensional *space*:

> It is admitted that some of these vibrations pass through solid matter with perfect ease, so that this enables us to account scientifically for the peculiarities of etheric vision, though for astral sight the theory of the fourth dimension gives a neater and more complete explanation.[19]

In the latter half of the nineteenth century through the early twentieth century, there was considerable interest in imagining the implications of the fourth dimension.

Since Newton, geometry had been secured to the physical world through the medium of *space* as three-dimensional, however with non-Euclidean theorists, geometry became separated from perception and began to follow its own independent logic. This produced a conundrum. If the extrasensory *space* of Riemannian geometry was proven to be (mathematically) true, and if geometry equals *space* equals reality, then there could only be strange new possibilities for conceiving reality. Rather than question the reality of the idea of *space* or its role as the mediator between advanced geometry and the physical world, the Theosophists doubled down on their belief in *space*. For Leadbeater and other spiritualists, it is the middle term of the equation, Geometry = Space = Reality, that underwrites their extrasensory perceptions. Here *space* is the mystical medium.

If in medieval times *space* and God were considered continuous, the spiritualist fascination with *space* is a different species than the immeasurable Christian God. Still, the two are products of faith. Spiritual *space* purloins elements of religion and the multidimensional *space* of Riemann to offer itself as a substitute. Spiritual *space* is the medium for individual empowerment, even if it is not as pious as contemplating an immeasurable God, or as daring and dangerous as Bruno's infinite *space*.

These new imaginings of *space* energized spiritualists (and charlatans), but it also invigorated picture making. The spiritualization of *space* provoked by Riemann's geometry would find expression in the mystical diagrams of Hilma af Klint (Plate 32) and the color forms of Wassily Kandinsky.

Poincaré

By the turn of the century, *space* had become a source of fascination in popular culture, mysticism, science, and mathematics. In France, this cultural moment found a singular figure in Jules-Henri Poincaré (1854–1912). A pioneering scientist in his own right, Poincaré also excelled at making scientific ideas accessible to the general public. His 1902 book *Science and Hypothesis* played a pivotal role in introducing broad audiences to the conceptual challenges of geometry and *space*. In his book, Poincaré distinguishes between 'perceptual space' and 'geometric space', and makes complexities of non-Euclidean geometry and four-dimensional worlds clear and even conceivable. Although Poincaré's *Science and Hypothesis* was basic enough for general readership, Einstein is also said to have poured over the book with great excitement.

Poincaré's remarkable thinking on how *space* is conceptualized traversed mathematical, physical, celestial and philosophical ideas. By the nineteenth century, *space* was firmly established as a subject, but it still was not entirely defined in metaphysics, perception and geometry. Even in advanced physics exactly what *space* entailed was debated. Poincaré weighed in on the dispute over the nature of light and *space* that dated back to a debate between Newton and Christiaan Huygens (1629–95). Newton argued that light consisted of corpuscles moving through a vacuum, while Huygens, noting its wave-like behavior, proposed a fluid-like ether as its medium. Throughout the nineteenth century, increasingly precise experiments failed to detect this 'luminiferous ether'. Although unproven, it retained a degree of credibility. Despite the 1865 findings of James Clerk Maxwell (1831–79) that indicated light was an electromagnetic wave requiring no medium, the ether concept persisted, even for Maxwell himself. Poincaré acknowledged the theory of ethereal existence could be a useful hypothesis, stating:

> It matters little whether the ether really exists; that is the affair of metaphysicians. The essential thing for us is that everything happens as if it existed, and that this hypothesis is convenient for the explanation of phenomena.[20]

In *Science and Hypothesis*, Poincaré offers a new scientific reality related to an expanded and practical definition of *space* – one of the most complete and concise parsing of the difference between perceptual *space* and three-dimensional geometric *space*, even to this day:

> What, first of all, are the properties of space, properly so called? I mean of that space which is the object of geometry and which I shall call *geometric space*.

The following are some of the most essential:

1. It is continuous;
2. It is infinite;
3. It has three dimensions;
4. It is homogeneous, that is to say, all its points are identical one with another;
5. It is isotropic, that is to say, all the straights which pass through the same point are identical one with another.

These five points of '*geometric space*' are useful conventions of space established following Newton's mathematization of *space*. Poincaré follows that '*geometric space*' can be contrasted to '*perceptual space*': 'Compare it now to the frame of our representations and our sensations, which I may call *perceptual space*.'[21]

Poincaré characterizes 'perceptual space, under its triple form: visual, tactile and motor, [as] distinct from geometric space'.[22] Visual *space* is merely the two-dimensional image on the human retina, further:

> *this pure visual space is not homogeneous*. All the points of the retina, aside from the images which may there be formed, do not play the same role. [Within the] ... limited frame, the point occupying the center of the frame will never appear as equivalent to a point near one of the borders.[23]

Poincaré's '"Tactile space" is still more complicated than visual space and farther removed from geometric space'.[24] He continues:

> But part from the data of sight and touch, there are other sensations which contribute as much and more than they to the genesis of the notion of space. These are known to everyone; they accompany all our movements, and are usually called muscular sensations.[25]

Poincaré follows with what amounts to a Riemann joke:

> Each muscle gives rise to a special sensation capable of augmenting or of diminishing, so that the totality of our muscular sensations will depend upon as many variables as we have muscles. From this point of view, *motor space would have as many dimensions as we have muscles*.[26]

He describes 'perceptual space' as 'neither homogeneous, nor isotropic; one cannot even say that it has three dimensions'.[27] Poincaré's broader point is that the general sensation and understanding of *space* is a complex amalgam of both geometric and perceptual *space*. *Space* may seem empirical, perceptual or

absolute, but it is best represented as a convenient convention to provide a means of calculating and intuiting our surroundings.

Poincaré follows his pairing of geometric and perceptual *space* with a brief tour of a non-Euclidean world and a description of how four-dimensional *space* could be experienced. Although these strange worlds of geometry are not easy to imagine, his presentation is generous and comprehensible. This is characteristic of Poincaré as a writer, but also of his conception of *space*. After walking his reader through several worlds with different geometries and numbers of dimensions, Poincaré compares them to our familiar three-dimensional world, 'Experience guides us in this choice without forcing it upon us; it tells us not which is the truest geometry, but which is the most *convenient*.'[28] This is *space* for Poincaré – a complex of conventions, a habit that is true because it can explain ambient conditions at a particular time and place. He fashions a broad conception of *space* that is both real and imaginative rather than fundamentalist, imaginary or mystical.

Poincaré's thinking in *Science and Hypothesis* can be characterized as rigorous but also open and, at times, playful and creative. His conventionalism endorses geometry for geometry's sake, but is mindful of its explanatory value in different contexts. His unusual realist sensibility engages the world constructively with curiosity. In this sense, Poincaré's observation and construction of a world view is parallel to the attitude and visual mechanics of Braque and Picasso's painterly adventures that became Cubism. While it is not known how deeply the two innovators of Cubism delved into Poincaré's texts, it seems Gleizes and Metzinger keenly attended to Poincaré. While it was Riemann who reconceived geometry as a whole, it was Poincaré who made it real for these artists.

Cubist Depiction of *Space*

Spanning the late Middle Ages to the beginning of the Industrial Revolution, the great age of allegorical representation came and went. Unlike Time, Music or Painting, *space* had not mustered an allegorical figure to stand for it or visual forms associated with its name. By the turn of the twentieth century, there were written descriptions of *space* in its freshly conceived manifold extensions, but apart from a few illustrations, *space* was not given a visual form.

It is with Cubism that an imagery of *space* in painting and sculpture is definitively claimed and celebrated. In distinction to Hildebrand's promotion of *space* as the dialectic to form, in Cubism *space* is extensive and projective. This

determines the imagery of *space* in Cubism. Imaginative deformations and reformations of forms caused by *space* in its non-Euclidean and four-dimensional configuration is the subject and drama of Cubist paintings. This can be seen in the fractured forms and stuttering planes in the first Cubist paintings of Braque and Picasso before 1910 and codified by the second wave of Cubists.

The success of Cubism was due in large part to an orchestration of many cultural currents, uniting seemingly contradictory values. With their advocacy of African sculpture, Braque and Picasso appropriated the Primitivism of Gauguin and the Fauves, and joined it to the appeal to science promulgated by the Divisionists. As well as bringing together scientific realism and Primitivism, Cubism brought layers of theory and abstraction together with tactility and the imagery of the mundane as reflected in the genre of still life. Even as the Cubists claimed multiple traditions of painting, they disrupted, even shattered the forms of previous painting. It can be said that if the historical crosscurrents and personalities that defined Cubism were a painted picture, that picture would appear as a Cubist composition – fractured, multifaceted and dynamic.

Concepts of simultaneity and duration, technical advances in the imaging of X-rays, and Picasso's experiments with photographic multiple exposures all fed into Cubism. However, the subject at hand is not Cubism in general, but how it was that Braque and Picasso introduced an imagery of *space*, and how that became a common topic for artists. Duchamp wrote in his memoirs, 'In 1911 two distinct groups of painters were giving form to the new theory of Cubism which was then brooding in an incubating period. Picasso and Braque on one side; Metzinger, Gleizes and Léger on the other.'[29] Unlike Duchamp and his siblings who were comrades with Cubism's public theorists, Gleizes and Metzinger, Picasso and Braque refused to proclaim theories about Cubism, including on the subject of *space*. Duchamp recalled, 'Picasso ... never felt bound to follow through a theory of Cubism, even though he might have been responsible for its elaboration.'[30] Despite Duchamp's statement, Picasso effected more than merely an elaboration of Cubism, as Metzinger, Duchamp's fellow conceptual Cubist acknowledged.

The foundational works that shaped Cubism emerged from the close and intensely collaborative exchange between Braque and Picasso. These early experiments intertwined the interests and personalities of both collaborators. The temperamental differences between Braque and Picasso have been described in various histories: Braque as a taciturn Norman and Picasso as the beguiling Spaniard. Borrowing a phrase from Ortega y Gasset, Berger characterizes Picasso as recognizing himself as a 'vertical invader' – 'a primitive man, a barbarian

appearing on the stage ...',³¹ of the complex center of civilization that was Paris. Before embarking on his Cubist partnership with Braque, Matisse had introduced Picasso to African sculpture by Matisse at Gertrude Stein and Alice B. Toklas' salon in 1907. Picasso was mesmerized. These works 'weren't just like any other pieces of sculpture. Not at all. They were magic things'.³² Picasso related that it was through these African masks and fetishes that 'I understood why I was a painter.'³³ With a fresh commitment to painting, Picasso began his improvisations and explorations through the geometric forms of West African sculpture.

In contrast, Braque was working the progressive edge of the French tradition. Having pursued color in Matisse's orbit as a Fauve, he turned to developing the implications of Cezanne's painting. Braque's paintings display his attentiveness to Cezanne's famous adage to 'render nature with the cylinder, the sphere, and the cone'. Coming from different directions and with dissimilar forms, geometry was the meeting place for Braque and Picasso. Although something of a simplification, it can be said that Picasso's geometry came from what he recognized was the supernatural intelligence of African works, while Braques' geometry was derived from the European tradition of geometric *disegno*.

In his 1910 essay 'Note sur la peinture', Metzinger writes of Braque's perspicacity:

> In abandoning the weighty legacy of dogma, in displacing the poles of habit, in lyrically negating axioms, in skillfully confounding simultaneity and succession, Georges Braque is well aware of the great natural laws that guarantee these liberties.³⁴

On the whole, Braque refrained from theorizing about painting. Rather than issuing a full blown manifesto, Braque wrote a short text titled *Réflexions sur la peinture* in 1917. It opens with, 'In art, progress does not consist in extension, but in the knowledge of limits ... Extension ... leads the arts to decadence.'³⁵ This is Braque arguing for constraint and simplicity in painting and may well have been a rebuke to the Futurists, with their taste for extension and excess. In a later passage, he writes about *space* in his painting:

> The pasted papers, the imitation woods—and other elements of a similar kind—which I used in some of my drawings, also succeed through the simplicity of the facts; this has caused them to be confused with *trompe l'oeil*, of which they are the exact opposite. They are also simple facts, but are created by the mind, and are one of the justifications for a new form in space.³⁶

The intent of the passage is to serve as a corrective to those who saw his material experiments as *trompe l'oeil*,³⁷ but it also shows how he frames *space*. Although his citing of a 'new form in space' is undeveloped, it is clear that the elemental facts are of the mind rather than perceptually optical – in either the form of *trompe l'oeil* or traditional perspective.

In a rare interview in 1954, Braque offers some insight as to the concerns and interests of the two progenitors of Cubism (specifically his own) as they forged what was to become Cubist painting. In the interview, it can be seen that over the years, Braque, always a materialist, became more insistently so:

> I make the background of my paintings with the greatest care because it is the background which is the support for everything else, it is like the foundations of a house. I have always been very engaged and preoccupied with the material because there is as much sensitivity in the technique as in the rest of the painting. I myself prepare my own colors, I do the grinding [of pigments].³⁸

He continues:

> How this sensitivity of grinding comes into play I don't know myself, it's an indefinable thing. I tinker. I work with material and not with ideas.³⁹

Braque takes an anti-conceptual stance, recalling:

> I even wrote: 'A painting is finished when the idea disappears...'⁴⁰

About 'Gleizes, Metzinger and the others', he writes, 'They "cubistized" the paintings, they published books on cubism – and all this naturally distanced me more and more from them...' Unlike Gleizes, Metzinger and Duchamp, Braque is not enchanted by science, 'I affirm that true discovery, as I understand it, only happens outside of science.'⁴¹ Given his stubbornly materialist stance, it is hardly surprising he does not discuss Riemannian geometry and the revolution in pictorial *space* that later artists and writers would claim for it. Still, his 1954 interview includes insights about Cubism's concept of *space* comparing it to traditional perspective:

> The traditional perspective did not satisfy me. Mechanized as it is, this perspective never gives full possession of things. It starts from a point of view and does not leave it. Now, point of view is a very small thing. It's as if one were to spend their whole life drawing profiles, making people believe that man has only one eye... When we came to [rethink] that, everything changed, you have no idea how much! What really attracted me – which was the main direction for Cubism – was the materialization of this new space that I felt.⁴²

In this passage, Braque imparts an elegantly streamlined description of the early Cubist manner of conceiving *space*. We can see how Braque (and presumably Picasso) viewed the limits of traditional perspective in regard to the 'full possession of things'. Here, the strategy of the multiplication of perspectives within a single frame serves to advance 'the materialization of this new space that I felt' to provide depicted objects their materiality.

In Metzinger's 1910 'Note sur la peinture', he also discusses Picasso:

> Picasso admits he is a realist. Cezanne showed us forms living in the reality of light; Picasso gives us a material report of their real life in the mind. He establishes a free, mobile perspective, in such a way that the shrewd mathematician Maurice Princet has deduced an entire geometry from it.[43]

In this passage, Metzinger credits Picasso with painting a 'free, mobile perspective', and Maurice Princet (1875–1973), an enthusiast of the new forms of mathematics with 'deducing' the theoretical geometry from his pictures. Unlike Braque and Picasso, Metzinger champions an intellectual defence of Cubism. Over the course of their long lives, Braque and Picasso commented infrequently about the theoretical underpinnings of Cubism. However, Metzinger, in tandem with Gleizes, became the conceptualizers of Cubism. They issued manifestos and books and assumed the roles of both documenters and promoters. Metzinger, like Princet, was enthralled by mathematics and science.

Whereas Metzinger credits Picasso and Braque as originators of what became Cubist painting, the anti-Modernist Vauxcelles, followed his mockery of the 'Fauves' by promoting the term 'Cubism' as an insult. Even after the movement embraced the moniker, Vauxcelles, ever the gadfly, offered a deflating narrative for the movement's intellectual pretences. In a 1918 review, Vauxcelles begins by conflating Princet's name with his role model Poincaré to belittle him:

> M. Poincet [sic] read Henri Poincaré in the text. M. Princet has studied at length non-Euclidean geometry and the theorems of Riemann, of which Gleizes and Metzinger speak rather carelessly. Now then, M. Princet one day met M. Max Jacob and confided to him one or two of his discoveries relating to the fourth dimension. M. Jacob informed the ingenious M. Picasso of it, and M. Picasso saw there a possibility of new ornamental schemes. M. Picasso explained his intentions to M. Apollinaire, who hastened to write them up in formularies and codify them. The thing spread and propagated. . . . Cubism, child of M. Princet, was born.[44]

The passage drips with delicious bad faith to suggest that Princet, an amateur mathematician and a hanger-on in the *bande à Picasso*, originated Cubism.

However, there may be truth to Vauxcelles' spin. Before Braque and Picasso started to collaborate, neither painter displayed an interest in relating science or higher mathematics to painting. Princet introduced mathematical ideas to his friends and also lent them books, namely Esprit Jouffret's 1903 *Traite elementaire* and his 1906 *Melanges de geometrie a quatre dimensions*. These books contain remarkable illustrations of four-dimensional figures (Figure 27). Although Cubism was to go on to be justified in terms of mathematics and science, it is likely that Picasso and Braque were attracted to the illustrations of Jouffret's books for the visual impact and intelligence of the diagrams more than to the theories.

In the text, Jouffret cites Abbott and Hinton, but his diagrams are uniquely his own. The diagrams – complex but legible – depict related views of geometric figures in four dimensions. Jouffret's schematics show shimmering geometries of solid and dotted lines that form polygons composed of shapes shaded with hatched lines. While not intentionally decorative, they are 'ornamental schemes' worthy of emulation – worthy of Picasso's magpie eye and of Braque's measured approach to painting.

Jouffret's diagrams depict four-dimensional *space* and as such they materialize the 'new space' Braque later described. Jouffret's sharp angles are the image of

Figure 27 *Left*: Diagram from Esprit Jouffret's *Traité élémentaire de géométrie à quatre dimensions*, 1903.

Figure 28 *Right*: Georges Braque, *La Mandore*, oil on canvas, 28 × 22 in, 1909–10.

fragmentation and they produce a multiplicity of views that forms 'a free, mobile perspective' that Metzinger ascribes to Picasso. It is worth spending some time deciphering Jouffret's diagram – follow the points numbered 17 and 19, as well as 21 and 23 – as each of the four figures are turned reflections and variations of the others. If the two painters were keen on deciphering these demanding diagrams, Braque's statement, 'It was rather like a pair of climbers roped together . . . We were both working hard . . .'[45] makes sense.

Like the often-quoted analogy of climbers, Picasso and Braque mediated each other's sensibility. We can see that the differences between Picasso's Primitivism and Braque's Cezannesque sophistication were suspended (Figures 29 and 30), as the demands of the two artists' individual interests entered into a common structure that Jouffret's diagrams provided. There is no documentation of Picasso and Braque studying Jouffret's diagrams, but there is compelling visual evidence that links early (Analytic) Cubism to Jouffret's designs. Comparing Joufrett's diagrams of four-dimensional *space* does not so much split the difference between Picasso's Primitivist geometry and Braque's traditionalist geometry as open new territory for the painters to explore and define.

Looking at the pre-collaborative works of Braque and Picasso, it can be seen that Jouffret's illustrations provided a diagrammatic vocabulary intelligible to both artists. This visual lexicon served as a framework for the development of a new pictorial structure, one that aligns with the Cezannesque construction of *Maisons à L'Estaque* (1907) and the sculptural formulation of *Femme nue*.

From 1909 to 1912, Braque and Picasso collaborated so intensely, that their works could hardly be recognized from one another. Braque's *La madora* (1909–10) is representative of the works of this time. The mandolin is central and declarative – it is sound as image (Figure 28). Around its perimeter a figure in multiple positions plays the instrument. In addition to the interlacing of Braque's earthy tones with Picasso's planar forms, this painting presents a merging of the pictorial views entailed by the landscape of Braque and the sculptural figure of Picasso. The painting of the shadowy musician sculpted in multiple positions is rendered as a landscape of tilting surfaces.

It is not recorded that Braque or Picasso identified four-dimensional *space* with Cubism. It was Princet, in tandem with Gleizes, Metzinger and Duchamp, who conceptualized and advocated for *space* in painting. As such, it is more likely that Braque and Picasso's Analytic Cubism developed, at least in part, from thinking through the visual challenges of Jouffret's schematics (or 'ornamental schemes'). This seems closer to Braque and Picasso's sensibilities than the two painters illustrating Riemannian geometry.

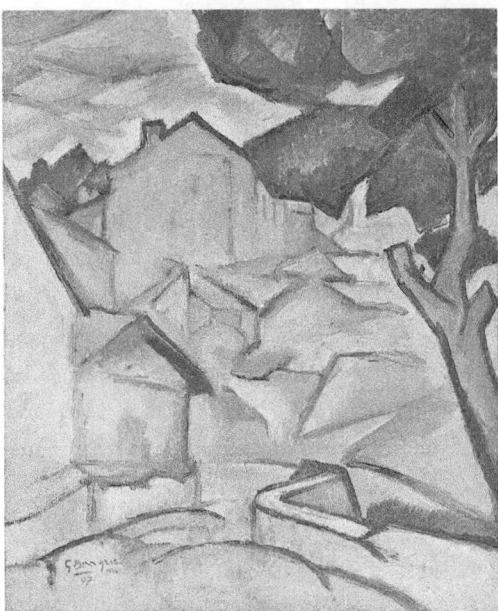 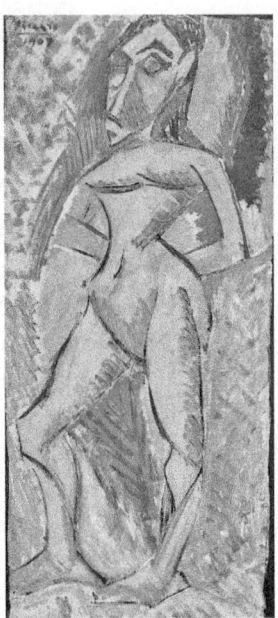

Figure 29 *Left*: Georges Braque, *Maisons à L'Estaque*, oil on canvas, 21.5 × 18 in, 1907.

Figure 30 *Right*: Pablo Picasso, *Femme nue*, oil on canvas, 36.5 × 17 in, 1907.

In *The Success and Failure of Picasso*, John Berger describes Cubism as 'a revolution in the visual arts as great as that which took place in the early Renaissance'. He continues by comparing a Fra Angelico painting to a Cubist still life by Picasso: 'In both paintings the space in which the objects exist is clearly very much part of the artist's concern, although the laws of that space are very different . . .'[46] At the time Berger wrote this in the 1960s, the idea of pictorial *space* had become unquestioned and near universal for descriptions of art. However, setting Renaissance painting alongside Cubism is revealing. Berger notes a common 'delight in clarity', and that, 'In both paintings the substance and texture of the objects is freshly emphasized – as though everything was just newly made.'[47] With characteristic brio, he writes, 'There is nothing comparable in the five centuries between. The similarities between these two paintings are the result of a similar sense of discovery, of newness, which affects the world seen and the artist's view of himself [or herself].'[48]

There is an additional way to view the similarities and distinctions in the works of the two eras. Although painters in the fifteenth century had neither the conception nor the language of pictorial *space*, diagrammatical geometry in

the form of perspective underpinned their pictures. The diagram in the form of painterly perspective continued to develop and inform painting over the centuries. There are two salient features in the way this pictorial perspective functioned with its geometric diagram. First, the geometry was justified by optical appearances. It was also crucial that the diagram was never rawly exposed in the completed painting. Instead, the geometry of the diagram formed the bones of the picture, structuring the flesh of painting forms, cloaked in color. With Braque and Picasso's Cubism, the historical relation between diagram and picture is flipped.

The Cubist diagram and the geometry it subtends announces itself on the surface, not just sublimated within painted forms. Explicitly in Braque and Picasso's early forays into Cubism, the diagram forms an exoskeleton that frames the reality of the world, linking how it is conceived to how it is observed.

Nowhere is this more clearly displayed than in two etchings of 1911: *Fox* by Braque and *Nature morte a la bouteille de marc* by Picasso (Figures 32 and 33). These etchings are not studies like Leonardo's drawings or even the didactic diagrams of Piero. As public artworks, the etchings are fully realized artists' statements. These etchings advocate for a new organization for depictions of the world, with the painterly subject of still life standing as an exemplar of reality. The look of the Cubist etchings bears unmistakable similarities to Jouffret's illustrations (Figure 31). Common to these three works, lines form angles to indicate planes, but also to cut through, creating a transparent glimmer of shapes and areas. Diagrams often contain numerals and words to define and locate what the lines mediate – these are the anchors of diagrams. The Cubist pictures include these markings, as do Jouffret's illustrations. However, their purpose is to open the picture to the concrete daily world – 'facts' as Braque insisted – rather than to elucidate the morphological transformations of a geometric construction in four-dimensional geometry that Jouffret represents. In the etchings of Braque and Picasso, the numbers, words and emblems of playing cards do not participate in the inner workings of the diagrammatic image, but concretize the image to link it to worldly representations.

Advocates of *Space*: The Salon Cubists

As Duchamp noted, Braque and Picasso separated from the Salon Cubists over the new theories of painting. Despite Picasso's and Braque's silence, discussions of *space* and the new geometry were in the air. Picasso was more of a wit than a

Fig. 42. — Les octaèdres I¹ = 1 2 11 . 3 10 19 et II¹ = 1 2 11 . 9 17 20.

Fig. 43. — Les octaèdres II¹ = 2 9 20 . 17 1 11 et II² = 2 9 20 . 23 12 18.

Fig. 44. — Les octaèdres II² = 2 12 18 . 23 9 20 et III² = 2 12 18 . 21 10 3.

Fig. 45. — Les octaèdres III² = 2 3 10 . 4 12 18 et I¹ = 2 3 10 . 19 1 11.

Figures 42 à 45. — Les couples d'octaèdres constituants de l'hypercorps h_2.

Figure 31 Diagram of Four Dimensional Objects from Esprit Jouffret's *Traité élémentaire de géométrie à quatre dimensions*, 1903.

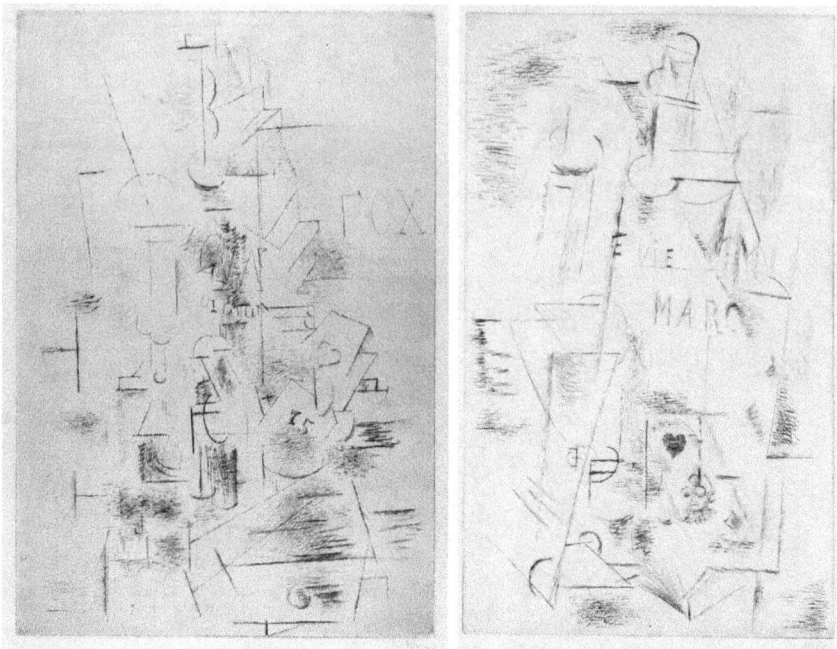

Figure 32 *Left*: Georges Braque, *Fox*, drypoint, 1911.

Figure 33 *Right*: Pablo Picasso *Nature morte a la bouteille de marc*, drypoint, 1911.

theorist, and Braque, judging by his former profession as a house painter, trusted materials more than words. For these innovators, it may have felt that adding a conceptual gloss to what was an intensely painterly adventure was a betrayal of the project's originary intelligence. Or perhaps they thought these grandiose discussions were so much intellectual palaver. Although Picasso and Braques' early collaboration gave visual form to an idea of *space*, they avoided any claim to it.

In a 1923 interview with Picasso, he offered some thoughts on Cubism. It is clear he thought the various theoretical interpretations were 'blinding', 'bringing bad results'. For Picasso personally, 'Cubism has kept itself within the limits and limitations of painting, never pretending to go beyond it'.[49]

By the end of 1912, Braque and Picasso had moved on from making oil paintings with a visual connection to Jouffret's illustrations. Their transition, from what in retrospect was called Analytic Cubism to Synthetic Cubism, was marked by the introduction of physical objects and collage elements to their paintings, although a sense of diagrammatic scaffolding remained. The Salon

Cubists continued their conceptualist oil paintings, their meetings and lectures. A group that included Metzinger, Gleizes, the Duchamps, Robert Delaunay, Francis Picabia and Juan Gris and others met at the homes of the Duchamp brothers and at Gleizes' apartment, where they were an available audience for Princet's lectures on the new geometries of *space*, gleaned from Poincaré and others. It can be observed that throughout their careers, Gleizes, Metzinger and Duchamp retained a theoretical air to their artworks. As Duchamp later noted, Braque and Picasso 'never felt bound to follow through a theory of Cubism'.

Following the inventions of Picasso and Braque, Gleizes and Metzinger continued to present *space* as a topic for painters. In their manifesto of 1912, *Du "Cubisme"*, Gleizes and Metzinger write that Cubist painters 'tirelessly study pictorial form and the space which it engenders'.[50] It is not unlikely that with their intellectual bent, Gleizes and Metzinger had read Hildebrand's treatise which was by then translated into French, and their form / *space* dialectic is perhaps related to Hildebrand. However, the purpose of Hildebrand's advocacy of *space* was to produce architectonic form, very different from the 'mobile perspective' of Picasso that Metzinger approvingly writes about.

In their manifestos, Gleizes and Metzinger contrast Cubist *space* to works they see as based on Euclidean premises which they associate with 'pure visual space':

> This space we have negligently confused with pure visual space or with Euclidean space.
>
> Euclid, in one of his postulates, speaks of the indeformability of figures in movement, so we need not insist upon this point.
>
> If we wished to tie the painter's space to a particular geometry, we should have to refer it to the non-Euclidean scientists; we should have to study, at some length, certain of Riemann's theorems.[51]

The Cubism of Gleizes and Metzinger is willing to 'deform' or reshape pictorial figures to correspond to the effects and impression of movement within the 'painter's space', interpreted as non-Euclidean and Riemannian:

> To establish pictorial space, we must have recourse to tactile and motor sensations, indeed to all our faculties. It is our whole personality which, contracting or expanding, transforms the plane of the picture. As it reacts, this plane reflects the personality back upon the understanding of the spectator, and thus pictorial space is defined: a sensitive passage between two subjective spaces.[52]

In terms of conceiving the relationship of *space* to visual art, there are emphatic differences between the Cubists and Hildebrand, however, they are similar in their insistence that both physicality and touch are necessary to make pictorial vision real. For Hildebrand, *space* manifests itself in the relief carving of stone, and for Gleizes and Metzinger, it provides a sense of pictorial relief in the fluttering planes central to their style of Cubism. As dissimilar as the Cubists and Hildebrand were, they shared a respect for the tactility of vision as essential for the success of 'pictorial space'.

Additionally, the Cubists and Hildebrand shared a respect for tradition. Tradition for Hildebrand was conservative – it meant Michelangelo and Classical art while the Cubists' view of tradition was that it developed sequentially, much as science progresses. However, there was a group of artists who refused tradition and believed the prerogatives of *space* should conquer and consume all that came before.

Space and the Futurists

It is fitting that the Latin conception of *space* – as *extensio* – rather than the more Germanic view of space as fundamental to human cognition was championed by Italian artists active in Parisian circles. Branding themselves Futurists, they radicalized the extensive nature of *space*, to revel in its dynamic force. While extension can be imagined philosophically, mathematically, spiritually and artistically, the Futurists were drawn to its most visceral expression: speed. For them, *space* was less of a cognitive construct than an embodied experience – realized through velocity, momentum and power. Speed is exhilarating, daring and hazardous. In his 'Manifesto of Futurism' of 1909, Fillipo Marinetti opens with:

> We intend to sing the love of danger, the habit of energy and fearlessness.[53]

And he adds:

> We stand on the last promontory of the centuries! . . . Why should we look back, when what we want is to break down the mysterious doors of the Impossible? Time and Space died yesterday. We already live in the absolute, because we have created eternal, omnipresent speed.[54]

With his cosmic intensity, Marinetti reincarnates Bruno but with a fervor for mechanical / animalistic sensation of extension. With operatic flourish, Marinetti relates an automobile crash: 'Damn! Ouch! . . . I stopped short and to my disgust, rolled over into a ditch with my wheels in the air . . .' The car was pulled from the

ditch, 'They thought it was dead, my beautiful shark, but a caress from me was enough to revive it; and there it was, alive again, running on its powerful fins!'[55]

There is danger and exaltation in superseding boundaries and in the breaking down of the 'doors of the Impossible' that accompanies extension. Military articles – the gun and the cannon – are talismans of extension. *Space*, in its habit of relentless extension, sublimates violence.

Here is Marinetti expressing pure extension:

> We will glorify war – the world's only hygiene – militarism, patriotism, the destructive gesture of freedom-bringers, beautiful ideas worth dying for, and scorn for woman [hood].
>
> We will destroy the museums, libraries, academies of every kind, will fight moralism, feminism, every opportunistic or utilitarian cowardice.

Marinetti celebrates breaking received culture. The Futurists realized that imagination is inherent in extension, and as well, destruction and conquest.

However, not all Futurists agreed with Marinetti's disparagement of women. Valentine de Saint-Point (1875–1953), one of the few female Futurists, gave as good as she got. In 1912, she presented her 'Manifesto of Futurist Woman' to a room of (almost entirely male) Futurists, insisting:

> Women are Furies, Amazons, Semiramis, Joans of Arc, Jeanne Hachettes, Judith and Charlotte Cordays, Cleopatras, and Messalinas: combative women who fight more ferociously than males, lovers who arouse, destroyers who break down the weakest and help select through pride or despair, "despair through which the heart yields its fullest return."[56]

Arguing that what 'is most lacking in women as in men is virility', she made explicit what was (barely) sublimated in Futurism. De Saint Point's 1913 'Futurist Manifesto of Lust' states, 'Lust is the expression of a being projected beyond itself. It is the painful joy of wounded flesh, the joyous pain of a flowering.'[57] This manifesto contains the essential expression of Futurism in its seizing of projection, extension, speed and danger as eroticism.

As *space* as extension gained ground in the arts, the preferred means of advertising for the new styles of art was the manifesto. Of all literary forms, the manifesto with its detonation and projection of ideology, most embodies extension. In his *Technical Manifesto of Futurist Sculpture* of 1912, Umberto Boccioni (1882–1916) writes, 'Sculpture should give life to objects by rendering their extension into space palpable, systematic, and plastic . . .'[58] Following that credo, Boccioni sculpted the effects of multiple viewpoints, forms extending

from the body and into its interior. Explicitly, Boccioni lays claim to the idea of *space* as extension in his sculptures, with titles such as *Unique Forms of Continuity in Space*, 1913, *Synthesis of Human Dynamism*, 1913, and *Development of a Bottle in Space*, 1913.

It is revealing to compare Boccioni's *Spiral Expansion of Muscles in Action* to Hildebrand's *Philoctetes* (Figure 25 to Figure 34). Boccioni's forms, which penetrate and extend from the body proper, represent a culmination of *spatium*'s evolution from mere segment to insatiable extension. In contrast, Philoctetes' foot, bitten clean off, is paradigmatic of Hildebrand's *Raum* – as evacuation – (literally) of a body. At the dawn of the 'space age,' these two primary constructions of pictorial *space* were possible.

The semiotic of the Latin inheritance of *spatium* is: *space* defined as the opposition between the body and the extended body. *Space* in its Germanic form entails the opposition of the body to the body's absence. The German type emphasizes *space* as fundamental, while the Latin type, compels *space* to adventure further and further, and through its extension and power. Although Cubism (in its second wave) introduced extensive *space* to artists, it is the Futurists that manifested *space* and celebrated it in its most powerfully essential form.

If there was ever a moment to attempt an allegorical figure for *space*, the *space*-enthused early decades of the twentieth century were the time. Giorgio de Chirico (1888–1978) defined his paintings as Metaphysical after the branch of philosophy that addresses the essence of Time and *Space*. De Chirico's Metaphysical paintings of around 1910 with their clocks (long a symbol of Time) are often paired with vacant piazzas rendered in extreme angles of perspective. If emptiness and perspective do not exactly reach the threshold to qualify as allegorical figures analogous to time-pieces, they can be said to refer to *space*. It is the German philosophical tradition that conceived of *space* as the basis for representation (and thus pictorial perspective), as well as removal or emptiness. And so it should be noted, that de Chirico, the peripatetic Italian, completed his academic training in Munich while studying German philosophy. Certainly, de Chirico's sense of *space* as Classical, empty and elegiac was at odds with his fellow countrymen, the Futurists.

Notes

1 John Berger, *The Success and Failure of Picasso* (Harmondsworth: Penguin Books, 1965), 47–8.

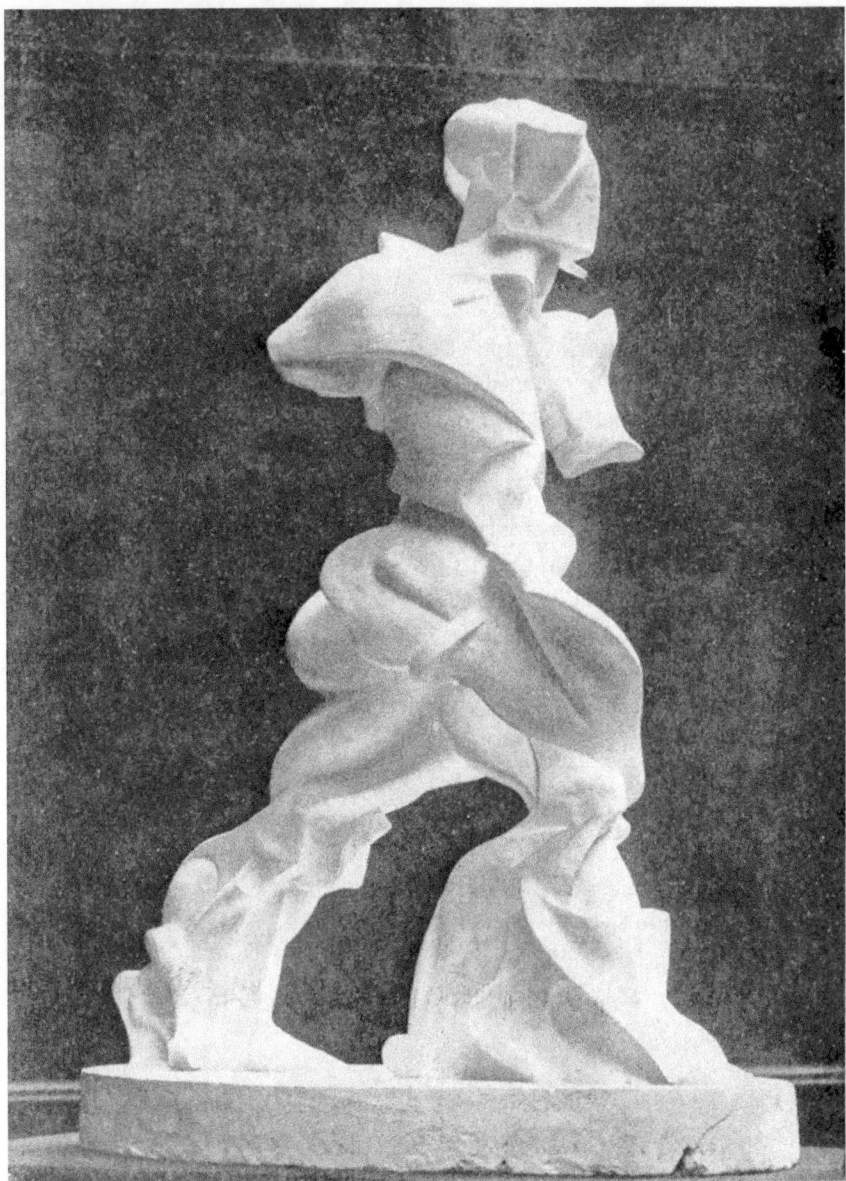

Figure 34 Umberto Boccioni, *Spiral Expansion of Muscles in Action*, plaster, anonymous photographer, c. 1914.

2 Guillaume Apollinaire, *The Cubist Painters*, trans. with commentary by Peter Read (London: Artists.Bookworks, 2002), 15; originally published in French, *Les Paintres Cubistes [Méditatiions Esthétiques]* (Paris: Eugène Figuière et Cie, Éditeurs, 1913).

3 Hildebrand, *The Problem of Form in Painting and Sculpture*, 13.

4 *The Oxford Dictionary of Art*, ed. Ian Chilvers, 3rd edn (Oxford: Oxford University Press, [1988] 2004), 250.
5 Martin Kemp, *The Science of Art: Optical Themes in Western Art from Brunelleschi to Seurat* (New Haven, CT: Yale University Press, 1990), 314.
6 Paul Signac, *D'Eugene Delacroix au neo-impressionnisme*, 3rd edn (Paris: H. Floury, Libraire-Editeur, 1921), 104, First published: Paul Signac, *D'Eugène Delacroix au néo-impressionnisme* (Paris: Eugène Figuière, 1899), 104.
7 Signac, *D'Eugène Delacroix au néo-impressionnisme*, 6.
8 Signac, *D'Eugène Delacroix au néo-impressionnisme*, 104.
9 Gauguin to Charles Morice, April 1903, in Charles Morice, *Paul Gauguin* (Paris: H. Floury, 1919), 121; cited in John Rewald, *Seurat*, original French text from 1946, ed. and published in English (New York, NY: Harry N. Abrams Inc., 1990), 163.
10 Stanley N. Burris, *Gauss and Non-Euclidean Geometry* (Washington, D.C.: Mathematical Association of America, 2003), citing Carl F. Gauss, letter to Franz Adolph Taurinus, 8 Nov. 1824, p. 12.
11 Bernhard Riemann, *On the Hypotheses Which Lie at the Bases of Geometry*, ed. Jürgen Jost (Cham: Springer International Publishing Switzerland, 2016), quoting John Playfair (1748–1819), 'Introduction', 25.
12 Jeremy Gray, *Ideas of Space: Euclidean, Non-Euclidean, and Relativistic*, 2nd edn (Oxford: Clarendon Press, 1989), 107.
13 Bernhard Riemann, *Über die Hypothesen, welche der Geometrie zu Grunde liegen* (lecture delivered 10 June 1854; published in *Abhandlungen der Königlichen Gesellschaft der Wissenschaften zu Göttingen*, vol. 13, Göttingen: Dieterichsche Buchhandlung, 1868), trans. William Kingdon Clifford, Nature 8 (1873): 14–17, 36–37; transcribed by D. R. Wilkins, Preliminary Version, Dec. 1998, "On the Hypotheses Which Lie at the Bases of Geometry."
14 Edwin A. Abbott, *Flatland: A Romance of Many Dimensions*, 2nd edn (London: Seeley & Co., 1884), xxi.
15 Ibid., 88–9.
16 Charles Howard Hinton, *Scientific Romances: First Series*, 1st edn (London: Swan Sonnenschein & Co., 1886), 3.
17 Ibid.
18 H. G. Wells, *The Plattner Story and Others* (London: Methuen, 1897), 5.
19 C. W. Leadbeater, *The Astral Plane: Its Scenery, Inhabitants and Phenomena* (London: Theosophical Publishing House, 1895), 111.
20 Henri Poincaré, *The Foundations of Science: Science and Hypothesis, The Value of Science, Science and Method*, trans. George Bruce Halsted, 1913 (Lancaster, PA: The Science Press, 1946; originally published in French, 1902 and 1908), 174.
21 Ibid., 66–7.

22 Ibid., 69.
23 Ibid., 67.
24 Ibid., 68.
25 Ibid., 69.
26 Ibid.
27 Ibid., 70.
28 Ibid., 79–80.
29 Marcel Duchamp, *Salt Seller: The Writings of Marcel Duchamp (Marchand du Sel)*, ed. Michel Sanouillet and Elmer Peterson (New York: Oxford University Press, 1973), 154, citing *From the Catalog: Collection of the Societé Anonyme*, 1943. Originally published in French as *Marchand du sel* (Paris: Le Terrain Vague, 1958).
30 Ibid.
31 Berger, *The Success and Failure of Picasso*, 40.
32 André Malraux, *Picasso's Mask*, trans. June Guicharnaud with Jacques Guicharnaud (New York, NY: Da Capo Press, 1994), 10; originally published as *La Tète d'obsidienne* (Paris: Gallimard, 1974).
33 Ibid.
34 Jean Metzinger, 'Note sur la peinture', 1910 in Mark Antliff and Patricia Leighten (eds), *A Cubism Reader: Documents and Criticism, 1906–1914*, trans. Jane Marie Todd with Jason Gaiger, Lydia Cochrane, Lois Parkinson Zamora and Ivana Horacek (Chicago, IL: University of Chicago Press, 2008), 76.
35 Georges Braque, 'Pensees et reflexions sur l'art', *Nord-Sud*, 10 (December 1917): 3–5; repr. in 'Reflections on Painting', in Robert John Goldwater and Marco Treves (eds), *Artists on Art, from the XIV to the XX Century*, (New York, NY: Pantheon Books, 1945), 422.
36 Ibid., 422–3.
37 For an alternative to Braque's denial of his relation to *trompe l'oeil*, see Emily Braun and Elizabeth Cowling Braun, with contributions by Claire Le Thomas and Rachel Mustalish, *Cubism and the Trompe l'Oeil Tradition* (New York, NY: Metropolitan Museum of Art; distributed by New Haven, CT: Yale University Press, 2022).
38 Dora Vallier, 'L'intérieur de l'art, entretiens avec Braque', *Cahiers d'Art*, 29, no. 1 (1954): 13–24. Georges Braque and Dora Vallier, 'Braque, la peinture et nous', L'entretien a paru dans *Cahiers d'Art*, 29, no. 1 (1954): 13–24.
39 Ibid.
40 Ibid.
41 Ibid.
42 Ibid.
43 Metzinger, 'Note sur la peinture', 76.
44 As quoted in Linda Dalrymple Henderson, *The Fourth Dimension and Non-Euclidean Geometry in Modern Art*, rev. edn (Cambridge, MA, and London: The

MIT Press; Princeton, NJ: Princeton University Press, 1983, 1st edn), Vauxcelles (aka 'Pincurrichio'), 'Le Carnet des ateliers: Le Pere du cubisme', Le Carnet de la Semaine, IV (29 December 1918), 174.
45 Richard Friedenthal (ed.), *Letters of the Great Artists: From Blake to Pollock*, trans. Daphne Woodward (London: Thames and Hudson, 1963), 264.
46 Berger, *The Success and Failure of Picasso*, 48.
47 Ibid.
48 Ibid.
49 Interview with Marius de Zayas, translated into English and published in The Arts, New York, May, 1923, under the title Picasso 'Speaks.' in 'Reflections on Painting' in *Artists on Art, from the XIV to the XX Century*, edited and translated by Robert John Goldwater and Marco Treves. 419.
50 Albert Gleizes and Jean Metzinger, 'Du "Cubisme"' (1912), in Robert L. Herbert (ed.), *Modern Artists on Art*, 2nd, enlarged edn (New York, NY: Dover Publications, Inc., 2000), 6.
51 Ibid., 6–7.
52 Ibid., 7.
53 Filippo Marinetti, 'Manifesto of Futurism, 1909', *Futurist Manifestos*, ed. and with an introduction by Umbro Apollonio, trans. Robert Brain, R. W. Flint, J. C. Higgitt and Caroline Tisdall (New York, NY: Viking Press, 1973), 21.
54 Ibid., 21–2.
55 Ibid., 22.
56 Valentine de Saint-Point, 'Manifesto of Futurist Woman, 1912', in Mary Ann Caws (ed.), *Manifesto: A Century of Isms* (Lincoln, NE: University of Nebraska Press, 2001), 214.
57 Saint-Point, 'Futurist Manifesto of Lust, 1913', in Caws (ed.), *Manifesto*, 217.
58 Umberto Boccioni, 'Technical Manifesto of Futurist Sculpture, 1912', in *Futurist Manifestos*, ed. Apollonio, 52.

15

The Modernist Institution of *Space*

After the Great War, the optimism that marked Cubism could not be sustained. Jean Arp (1886–1966) recalled,

> Madness and murder were rampant when Dada in the year 1916 rose out of the primordial depths in Zurich. The people who were not directly involved in the monstrous madness behaved as if they did not understand what was going on around them. Like stray lambs they looked out into the world with glassy eyes. Dada wanted to frighten mankind out of its pitiful impotence.[1]

From the unfolding devastation of Europe, Dada emerged as an international force in music, drama, poetry as well as visual art. Science, which forged the colorisms of progressive French painting and brought *space* to Cubist form, was mocked by the Dadaist painters with their cheerfully brutal pictures of sexually voracious machines, allegorical substitutes for the love of science.

Dada was hardly the only response to uncertain times. In 1918, Picasso's friend and sometime collaborator, the poet Jean Cocteau (1889–1963), wrote (in all capitals), 'TACT IN AUDACITY CONSISTS IN KNOWING HOW FAR WE MAY GO TOO FAR.'[2] In 1926, Cocteau published a pamphlet titled *Le Rappel à l'ordre*. The 'return to order' could be described as a counterrevolutionary return to Classical values from not only the excesses of Dada, but from Cubism as well. Leading this return was Picasso. Although his Cubist adventures would continue to inform his work, Picasso took up a Neoclassical style in earnest, but entailing a wink of caricature.

Alongside the newly minted Neoclassicists, a related movement known as Purism formed. While not inflected with explicit Classical imagery nor as flamboyant as Picasso's Neoclassicism, Purism was Classical in its values and, as such, part of the 'return to order' sensibility. Amédée Ozenfant (1886–1966), an originator of Purism, was initially one of the second-wave Cubist painters. Although he had moved in the same circles as Gleizes, Metzinger, Apollinaire and the Duchamps, Ozenfant went in his own direction after the war. In 1917, he met Charles-Edouard Jeanneret (1887–

1965), a Swiss architect who had formed a practice with his cousin in Paris. Jenneret later changed his name to Le Corbusier, and concentrated on architecture, but over the dozen years after meeting Ozenfant, Jeanneret suspended his architectural practice to paint and collaborate with Ozenfant to develop a post-Cubist program for painting – Purism. With Dada and the new Neoclassicism, the interest in *space* had waned, but Purism established a version of *space* in the arts that is a familiar form even to today.

In their 1918 manifesto, *Après le cubisme*, the Purists, Jeanneret and Ozenfant, take a position toward war related to Marinetti and the Futurists. The manifesto opens with:

> After the war, everything is organized, everything is clarified and purified; factories rise, nothing is what it was before the war: competition has tested everything, it has finished off senile methods and imposed in their place those that the struggle has proven the best.[3]

And so, through the purification of war, Futurism becomes Modernism. However, while the Futurists were passionate about the physical sensation of extension – speed – the Purists' extension is a chaste Darwinian process, in which society's labor and its products evolve rationally.

In their manifesto, the Purists endorse Taylorism, the system of efficient industrial management as 'intelligently exploiting scientific discoveries. Instinct, trial and error, and empiricism are replaced by the scientific principles of analysis, organization, and classification.'[4] In terms of the history of *space*, Taylorism reflects a perfect *spatialization* of production. Like Descartes' bodies, workers are deracinated to become objects of production: their place is merely a temporary and evolving position within the three axes of efficiency, profit and product. Although the Purists were painters, they extended the principles and imperatives of painting to society. They purposely reformed the mathematical imagination of the Cubists to shape it to a social type of realism.

In distinction to the Dada and the Neoclassical painters who turned away from the values of science, the Purists doubled down on science but in its technological form. There is creativity and imagination in the technical aspects of science, but technology expunges science's wildest and least practical ideas. Jeanneret and Ozenfant found the idea of four-dimensional space objectionable. In *Après le cubisme*, they write:

> The fourth dimension, if we reflect on it, only affects the gratuitous hypotheses of Cubism theorists; this hypothesis is outside of any plastic reality. Being unmaterializable in painting, it only adds to the misunderstanding.[5]

While Gleizes and Metzinger continued to write on Cubism and painting, they became less concerned with the mathematics of *space* than painterly and historical issues. However, during the teens and twenties, Marcel Duchamp, as part of his preparations for *The Bride Stripped Bare by Her Bachelors, Even (The Large Glass)*, produced private notes that obsessed on Poincaré's explanations to imagine the physical experience of the fourth dimension. Duchamp fabricated imitations of the scraps of paper and published them in *The Green Box* (1934) in a limited edition of 300. Duchamp's notes on the fourth dimension appear earnest, yet they do little to elucidate the visual forms of *The Large Glass*, nor do they offer corresponding imagery for his theories. Coinciding with his abandonment of oil painting, Duchamp's engagement with multidimensional *space* was conceptual and theoretical rather than visual. In context, his mathematical notes might best be read as an ironic mating of the conventions of expansive geometric *space* with the symbolic and institutional dimensions of matrimony. In an interview decades later, Duchamp reflects on his relation to science as 'pseudoscientific': 'If I used the little mathematics I knew, it was just because it was amusing to introduce that into a domain like art ...'.[6] Though Duchamp takes the position that his interest in four-dimensional *space* was merely play, he also confessed that '[w]e weren't mathematicians at all, but we really did believe in Princet'.

Whether Cubist theories of geometry were serious as in the case of Gleizes and Metzinger, or somewhat ironic as in the case of Duchamp's mediations of *space*, the Purists thought such endeavurs were too loose:

Enough play. We aspire to serious rigor.[7]

Jeanneret and Ozenfant continue their dismissive reflection on four-dimensional *space* in art:

Here briefly is why it is absurd to claim to express dimensions other than those perceived by our senses. The third dimension of sensible space, named depth, was for a moment excommunicated by several Cubists, in favor of a certain fourth dimension that a superficial reading of scientific books had caused it to be "invented". It was forgotten that the fourth dimension of mathematicians is a purely speculative abstraction, part of hypothetical geometries, marvelous games of the mind, with no material contact with the real world, conceivable but not representable, since human senses distinguish only three dimensions in space.

Thus, there is a danger for plastic artists, architects of matter, to indulge in superficial scientific speculations. Nature conditions Science; Nature and Science are inseparable; moreover, Science constantly leads back to Nature.[8]

In distinction to Poincaré's conventions of *space* as an evolving dialogue with, and within, the world, the Purists' *space* is staticly three-dimensional, real and representable. *Space* serves the effective application of science – defined as technology. Binding Nature to Science is the Purist requirement for Modern progress.

The Purists take issue with making pictures based on Riemannian geometry and regard four-dimensional *space* as extravagant and too extreme. With their urge for architectonic fundamentals in painting, they state:

> Space is needed for architectural composition; space means three dimensions. Therefore we think of the painting not as a surface, but as a space.[9]

The Purists' 'three-dimensional space' and especially 'architectural composition' echo Hildebrand's position against the 'anarchists of Art . . . [who are] not to be taken seriously', due to 'their incapacity to develop in an architectonic manner . . .'.[10] Whether or not Jeanneret and Ozenfant had studied Hildebrand's treatise, it is notable that the Neoclassicism inherent to Purism and Hildebrand coincide in their conceptualization of pictorial *space* as three-dimensional and architectonic. Both of these conceptions of *space* are fundamentalist and conservative. However, where Hildebrand regards *space* as foundational to classical tradition, the Purists see it as a vehicle for carrying their artistic and social ideals into the future.

Establishing Architectural *Space*

Space in paintings, even if conceived as architectonic, is distinct from *space* in architecture. If it seems peculiar that the historian Wölfflin's introduction of 'architectural space' to art history emerges from his analysis of painterly *space*, this historical sequence – painterly *space* preceding architectural *space* – plays out again in the theories of practicing artists.

At the 1912 Salon d'Automne, Raymond Duchamp-Villon (1876–1918) exhibited a plaster model for the facade of *La Maison Cubiste* (Figure 35). Although it was never built, the project's intention was to bring Cubist ideas of *space* to architectural form. Given the Duchamp brothers shared an apartment and lively discussions about art, it is more than likely that Duchamp-Villon was

Figure 35 Photograph of Raymond Duchamp-Villon's plaster model *La Maison Cubiste*, c. 1913.

following Marcel's interest in higher-dimension geometry in an attempt to create an architectural expression of four-dimensional *space*. It has been noted that the pediment over the entrance appears to be giving physical form to Jouffret's diagrams of four-dimensional *space* that Marcel was studying.[11] As an early attempt at conceiving architectural *space*, *La Maison Cubiste was* tentative at best, the result being a traditional house playfully decorated with geometric ornament.

La Maison Cubiste did not advance an idea of architectural *space* that was a fit for the twentieth century. However, there was an architect who emerged from Purism, with its Cubist roots, to take up the role of innovator for the Space Age. Four years after Jeanneret and Ozenfant published their thoughts on painting in *Apres les cubisme,* Jeanneret authored an architectural manifesto under his new name 'Le Corbusier'. In *Vers une architecture* (known later in English as *Toward a New Architecture: Guiding Principles*), Le Corbusier, who formerly (with Ozenfant) wrote passionately about *space* in pictorial terms, barely includes *space* as important to architecture and certainly without the centrality he accorded it in painting.

If today it seems that *space* must be a major or even the most important consideration in architecture, *space* as understood within the whole of Le

Corbusier's early manifesto plays only a small role. Le Corbusier's opening chapters define what he feels are most urgent for his architecture: 'Three Reminders to Architects': Mass, Surface and Plan and, 'Eyes Which Do Not See', which he argues for the value of Ocean-liners, Airplanes and Automobiles as overlooked inspiration for architecture. Although Le Corbusier writes in *Toward a New Architecture*, 'The elements of architecture are light and shade, walls and space,'[12] *space* occupies a minor position within the larger text. It appears in the fifth chapter under the heading of 'The Illusion of Plans'.

In 1926, toward the end of Ozenfant and Le Corbusier's partnership as painting theorists, Le Corbusier published *Les Cinq points d'une architecture nouvelle*. The five points are: Columns, Roof Garden, Free Plan, Free Facade, Horizontal Windows. In this text, 'theoretical considerations [are] set out ... based on many years of practical experience on building sites'.[13] In this text, *space* is not mentioned. Although it is a short text, in the mid-twenties, Jenneret the painter was volubly endorsing ideas of pictorial *space* while architectural *space* was only a minor element in his theoretization of architecture for his alter ego, Le Corbusier architectural space was only a minor element in his theoretization of architecture. As a painter and an architect Jenneret / Le Corbusier operated at the front of advanced culture. Although *space* had become a passionate topic in painting ten years earlier, in the mid-twenties, 'architectural space' had not yet arrived to the state of interest or coherence of 'pictorial space'. For Le Corbusier, pictorial *space* was architectonic before architecture was *spatial*.

Toward a New Architecture

Le Corbusier's *Vers une architecture* of 1923, translated as *Toward a New Architecture*, is a vibrant polemic for modern architecture. Corbusier's appeal to order and technology is a better fit for architecture than for painting. The demands for housing, as well as construction materials and techniques, had been transformed during Le Corbusier's lifetime, while the techniques of oil on canvas had remained virtually the same over its five-hundred-year history. There were also new demands on architecture in the modern world: 'The technical equipment of this epoch – the technique of finance and the technique of construction – is ready to carry out this task.'[14] Le Corbusier makes his appeal, not only to architects, but also to 'big business men, bankers and merchants',[15] who can effect the large, capital extensive projects Le Corbusier envisions. The last chapter of Le Corbusier's polemic presents a stark choice, almost a threat. It is titled: 'Architecture or Revolution'.

It is indicative of the weak connection between *space* and architecture that even as late as the 1920s, Le Corbusier's texts place little value in the idea of 'architectural space'. However, while architectural *space* is barely conceptualized in *Towards a New Architecture*, the illustrations can be seen as talismanic images of the two strains of *space* that emerged in the early twentieth century.

Le Corbusier includes evocative photographs of the facades and details of marble ruins of Classical temples. His use of these pictures are Hildebrandian in their appeal to tradition, as well as in their materiality – they are pictures of stone which time has carved away. Le Corbusier's book is also filled with images of the other significant strain that began to be associated with *space* – images of technical physical extension. The book opens with Gustave Eiffel's Pont de Garabit (1884), an airy open-truss bridge with its span supported by a parabolic arch, and he continues with photographs of ocean liners, airplanes and automobiles – visceral symbols of extension.

The chapter on automobiles juxtaposes Greek ruins with pictures of early-twentieth-century cars. It is difficult not to share Le Corbusier's delight with these vehicles. Even from our present perch, these objects of Modernist speed, still have a powerful, if primitivist feel. The differences are resonant between the

Le paquebot *Aquitania*, Cunard Line, transporte 3,600 personnes.

Figure 36 From Le Corbusier's *Vers une architecture*, 1923.

Parthenon and a 1911 Hispano Suiza (with bodywork by Le Corbusier's friend Ozenfant). But Le Corbusier recognizes that both artifacts embody a lean, purposeful design and argues that both the cars and the temples are products of evolution toward standardization.

Toward a New Architecture is a remarkably imagistic document. As the sum of its images – photographs of vehicles, old and new buildings, building plans and diagrams – it forms a sprawling and concise picture that is far stranger and more urgent than any of Le Corbusier's Purist paintings.

In the twenties, Le Corbusier did not view *space* as central to his re-envisioning of architecture, certainly as compared to the models of ocean liners, planes and automobiles. However, despite Le Corbusier's general disregard of 'architectural space' in *Toward a New Architecture*, he engages the two principal traditions from which pictorial *space* derived in the 20th century. In this book, Classical order, (Hildebrand's fundamentalism) and technological futurism (*spatial extension*) are fused to form Le Corbusier's conception of Modern architecture but without recourse to thinking of architecture as *spatial* (Figure 36).

If today, 'architectural space' is thought of as 'real space', as opposed to 'pictorial space', the history of conceiving *space* suggests the opposite. Arriving at Western culture first, 'pictorial space', it would seem, is more 'real' or 'natural' than 'architectural space'. If we follow Poincaré and accept that *space* is a convention, this is entirely coherent. Painting, whose practical demands are less than architecture's, is better able to embrace new conventions and play with their effects.

Le Corbusier's *Spatial* Conversion

By mid-century, Le Corbusier takes up issues of *space* in a more contemporary way. Although Le Corbusier's first theories of *space* were firmly against conceiving *space* as four-dimensional, his ideas had mellowed by 1948. Le Corbusier chalked up interest in the fourth dimension to youthful enthusiasm:

> Without making undue claims, I may say something about the 'magnification' of space that some of the artists of my generation attempted around 1910, during the wonderfully creative flights of cubism. They spoke of the *fourth dimension* with intuition and clairvoyance.[16]

If in the twenties Le Corbusier had not quite found an enthusiasm for *space* in architecture, that changed with his 1948 manifesto, *New World of Space*. In the new manifesto, *Space* is granted a mystical/metaphysical existence. The book opens with:

> Taking possession of space is the first gesture of living things...The occupation of space is the first proof of existence.[17]

The second paragraph ends with:

> The essential thing that will be said here is that the release of esthetic emotion is a special function of space.[18]

In the span of twenty-two years, Le Corbusier had abandoned his measured rectitude about *space*. In his 1948 *New World of Space*, Le Corbusier writes ecstatically – and spiritually – about *space*:

> Then a boundless depth opens up, effaces the walls, drives away contingent presences, accomplishes the miracle of ineffable space . . . I am not conscious of the miracle of faith, but I often live that of ineffable space, the consummation of plastic emotion.[19]

Between the somewhat contradictory 'first proof of existence' and 'ineffable space', *space* had become a new artistic religion – that of 'the consummation of plastic emotion'.

By mid-century, Le Corbusier claims space for architecture. Simultaneously he replaces his resonant pairing of Neoclassical fundamentalism to technological extension for a vague spiritual / artistic axis. Although 'artistic' and 'aesthetic' are often used interchangeably, Le Corbusier's idea of *space* is best understood as 'artistic', because Le Corbusier's conception of *space* lacks the criticality associated with 'aesthetic'. As a Modernist, Le Corbusier has no infinite God who occupies and permeates *space*, nor is his 'ineffable space' granted the particulars of such spiritualists as the Theosophists. However, Le Corbusier's *space* is ineffable as a spiritual / artistic concept.

As *space* entered twentieth-century art making through the German philosophical tradition (Hildebrand) and the Latin tradition of *space* as extension (Cubism), a third axis of sublimated religion – spirituality – was adopted by artists such as af Klint and Kandinsky. In addition to what can be seen as three axes of *space* – Philosophical, Scientific and Spiritual, in his *New World of Space*, Le Corbusier articulates a fourth: Artistic Space. Le Corbusier's 'ineffable space' of 'the consummation of plastic emotion' presents not simply a spiritual dimension to *space* but also the spiritual entwined with the separate artistic axis of 'plastic emotion'.

Space in visual art can now be seen as a construction of these four dimensions: Philosophical, Scientific and Spiritual and Artistic. At this point, *space* passes beyond the historical to the expressive. Artists could now express themselves shaping a concept of *space* defined by these four axes with variations of emphasis

and apportionment. *Space* was now available somewhere between science and psychology; philosophy and metaphysics; spirituality and religion; art and society. At this juncture, pictorial *space* stopped developing new content. But in order to maintain its extensivity, *space* now doubles back and folds upon itself. In this involuted four-dimensional cultural matrix, *space* is constructed and construed as 'personal expression'. *Space* projects from the noetic and artistic realms to the social (and back again), finally taking up its present condition as an aesthetic / vernacular grab-bag.

Space-time

The history of *space* is marked by its relentless extension, but it was the twentieth century that saw the greatest expansion of *space* with the formation of *space-time*. In 1908, Hermann Minkowski, building on the implications of Einstein's theories, introduced a grand new framework for calculating the position and velocity of objects in outer-space by replacing the etheric medium with a four-dimensional continuum: *space-time*. The conceptual leap was to define time as a fourth axis of extension within the geometric representation of *space*, rather than its own entity. *Space* had swallowed its metaphysical sibling, Time subsuming its dialectical counterpart. This redefinition found profound physical application in Einstein's Theory of General Relativity (1915), where *space-time* – now modelled through Riemannian geometry – served to explain gravity not as a force but as the curvature of this four-dimensional fabric, warped by mass and energy. *Space*, always voracious, not only absorbed time but also redefined gravity as internal to its structure. Under this model, *space* did not merely expand conceptually; the universe itself was now also understood to be in a state of perpetual physical expansion.

This momentous and radical reformulation of universal order was (mostly) confirmed by astronomical observation. However, in terms of pictorial *space* it had little impact, certainly nothing like the Cubists' zeal to represent four-dimensional *space* as defined by Riemann's geometry. The Purists' argument that for artists, such science is only 'marvelous games of the mind, with no material contact with the real world . . .'[20] reflects an exhaustion with complicated schemas that reached beyond human perception.

Space-time only became a popular concept in the early twenties, and in general, had little impact on ideas about pictorial or architectural *space*. A counterexample from 1936 can serve to illustrate how scientific ideas, linked to

space, became a form of affect rather than having a structural impact on visual art. The *Manifeste Dimensioniste* signed by such luminaries as Francis Picabia, Hans Arp, El Lissitzky, Joan Miró Lazlo Moholy-Nagy, Marcel Duchamp, Robert Delaunay, Sonia Delaunay, Sophie Tauber-Arp and Wassily Kandinsky declares:

> Dimensionism is a general movement in the arts, begun unconsciously by cubism and futurism – continuously elaborated and developed afterward by every people in Western civilization.
>
> Today the essence and the theory of this great movement explode in an absolute conviction.[21]

However, the 'absolute conviction' of Dimensionism is belied by the variety of barely compatible works of the signatories. Although science is invoked, it is more a token than a touchstone:

> At the origin of dimensionism are the new ideas of space-time present in the European way of thinking, promulgated in particular by Einstein's theories as well as the recent techniques of our age.[22]

To the degree the manifesto calls on science to ratify its ideas, it also loudly declares its independence (in all capitals):

ANIMATED BY A CONCEPTION OF THE WORLD, THE ARTS, IN A COLLECTIVE FERMENTATION (Interpenetration of the Arts).

HAVE STARTED MOVING

AND EACH OF THEM HAS EVOLVED WITH A NEW DIMENSION.

EACH OF THEM HAS FOUND A FORM OF EXPRESSION INHERENT TO THE SUPPLEMENTARY DIMENSION OBJECTIFYING THE GRAVE MENTAL CONSEQUENCES OF THIS FUNDAMENTAL CHANGE.[23]

Despite the manifesto's insistence, *space-time* does not inform these post-Cubist artists' work. It functions as an empty signifier, onto which the artists can project their own interests. In the end, the loosely organized Dimensionists' claim of a 'total conquest by art of four-dimensional space' is posture,[24] not a program. Indeed, to loudly proclaim *space* with little actionable content beyond personal assertion also characterizes Le Corbusier's embrace of 'ineffable space' in the late forties.

Notes

1. Hans Arp, 'Dada Was Not a Farce' (1949), in Robert Motherwell (ed.), *The Dada Painters and Poets: An Anthology*, 2nd edn (Cambridge, MA, and London: Belknap Press of Harvard University Press, 1981), 293.
2. Jean Cocteau, *A Call to Order*, trans. Rollo H. Myers, originally published in 1926 by Faber and Gwyer Limited, London; excerpts reprinted in Herbert (ed.), *Modern Artists on Art*, 7.
3. Charles-Édouard Jeanneret and Amédée Ozenfant, *Après le cubisme* (Paris: Édition des Commentaires, 1918), 11, translated from the French by the author.
4. Ibid., 26–7.
5. Ibid., 15–16.
6. Calvin Tomkins, *Marcel Duchamp: The Afternoon Interviews* (New York, NY: Badlands Unlimited, 2013, Kindle Edition), 87.
7. Jeanneret and Ozenfant, *Après le cubisme*, 34.
8. Ibid., 15–16.
9. Le Corbusier and Ozenfant, 'Purism' (1920), in Herbert (ed.), *Modern Artists on Art*, 34.
10. Hildebrand, *The Problem of Form in Painting and Sculpture*, 13.
11. Henderson, *The Fourth Dimension and Non-Euclidean Geometry in Modern Art*, 191–2.
12. Le Corbusier, *Towards a New Architecture*, trans. from the 13th French edn and with an introduction by Frederick Etchells (New York, NY: Dover Publications, 1986). Originally published as *Vers une architecture* Paris: Les Éditions Crès, 1923); and in English (London: John Rodker, 1931), 5.
13. Le Corbusier, 'Five Points towards a New Architecture' (1926), in Ulrich Conrads (ed.), *Programs and Manifestos in Twentieth-Century Architecture* (Cambridge, MA: The MIT Press, 1970), 99–100.
14. Le Corbusier, *Towards a New Architecture*, 53.
15. Ibid., 18.
16. Le Corbusier, *New World of Space*, trans. F. S. Wight (New York and Boston: Reynal & Hitchcock, 1948), 8. Originally published in French as *Le Monde de l'espace* (Paris: Éditions de l'Architecture d'Aujourd'hui, 1943).
17. Ibid., 7.
18. Ibid., 8.
19. Ibid., 9.
20. Jeanneret and Ozenfant, *Après le cubisme*, 15.
21. Caws (ed.), *Manifesto*, 536.
22. Ibid., 537.
23. Ibid.
24. Ibid., 538.

16

Space: The Creative Phase

The Four Dimensions of *Space*: Philosophic, Scientific, Spiritual and Artistic

Just as it distorts Renaissance paintings to discuss the works within the twentieth-century framework of pictorial *space*, it is relevant to explore how Modernist artists conceived and constructed ideas about *space* in their work. As *space* had now become a topic for art making. *Space* was now part of the artistic discourse, but not all artists explicitly defined their work in relation to *space*.

In this chapter, the works of Constantin Brancusi, László Moholy-Nagy, Josef Albers, Lucio Fontana, Yves Klein and Mark Rothko serve to show strategies of imagining *space*. Each of these artists in part defines their individuality through navigating *space* in its fourfold form of (1) spiritual / religious, (2) extensive / scientific, (3) philosophic / metaphysical and (4) artistic. These four axes of *space* were not mutually exclusive – through intermingling of four axes of *space*, artists created a personally expressive type of *space*. This characterizes the creative phase of *space*, lasting from the first decade of the twentieth century into the sixties.

Artists in the middle decades of the twentieth century took up issues of *space*, articulating imaginative connections of their work to *space*. Meanwhile, in academic circles, Panofsky's *Die Perspektive als 'symbolische Form'* initiated further interest in the application of *spatial* concepts to art history. Over the last century, art historical texts have become an integral part not only of the liberal arts, but also of studio art. Few figures have shaped the ideas surrounding *space* in art as profoundly as Erwin Panofsky. As influential as he was imaginative, Panofsky offers a fitting place to begin.

Panofsky's Success and Shadow

In *The Critical Historians of Art*, Michael Podro defines a hundred-year 'central tradition', starting at one end with Rumohr's 1827 text and ending with Panofsky's 1927 essay *Perspective as Symbolic Form*. The essay, 'perhaps the most famous of [Panofsky's early] series of theoretical and critical papers',[1] is remarkable for its intellectual creativity, even as it served to institute (neo-Kantian) *space* as an imposing concept in both painting and its historiography.

Podro writes that Panofsky attempted to construct a viewpoint to turn 'remarks about visible and historical objects into interpretative remarks about works of art'.[2] When Panofsky writes, 'It is the curse and the blessing of the systematic study of art that it demands that the objects of its study must be grasped with necessity and not merely historically,'[3] it is a philosophical viewpoint that is the necessity. Just as *space* is the absolute basis of representation for Kant, for Panofsky in his 1927 essay, *space* provides a philosophical umbrella that permits him to gather a variety of different perspectival styles under its aegis.

Panosky links historical typologies with philosophy and perception: 'One could even compare the function of Renaissance perspective with that of critical philosophy, and the function of Greco-Roman perspective with that of scepticism.'[4] He continues by describing the Renaissance perspective as 'a translation of psychophysiological space into mathematical space . . .'[5] Panofsky is able to make Renaissance and ancient art not only coherent to modern sensibilities but also exciting philosophically and historically. This is Panofsky at his most seductive and misleading.

Although the earlier texts of Hildebrand and Bernard Berenson (1865–1959) promulgated neo-Kantian ideas about *space*, *Perspective as Symbolic Form* was a singular success. While not all art historians fell in line with the *spatialization* of art, following Panofsky's lead, generations of art historians uncritically accepted *space* as the basis of visual art. Today, thousands of books have been written promoting *space* in painting, sculpture and architecture.

Satisfying the penchant of *space* to extend its purview, other books pushed twentieth-century ideas about pictorial and architectural *space* onto works of non-European cultures. Panofsky's text was so effective in its naturalization of *space* to art, that to this day, for many artists, critics and educators it is impossible to see pictures except through a constructed framework of *space*. With *space* securely tied to the study of art, the idea of pictorial *space* became virtually unavoidable. *Space* itself became a powerful 'symbolic form'.

Brancusi's *Bird in Space*

Although Constantin Brancusi (1876–1957) did not publish theories about *space*, his famous sculpture *Bird in Space* of 1923, and the multiple versions that follow, are marked by *space* in their title – *space* was on the sculptor's mind. *Bird in Space* captures the ecstatic extension of the Futurist gestalt without the bluster. Although it is unlikely Brancusi studied Hildebrand's treatise on form and *space*, Neoclassicism was underway at the time, and as a stone carver Brancusi could well have sympathized with Hildebrand's ideas. The initial *Bird in Space* was carved from white marble and its columnar form invites associations with Classicism. The sculpture is consistent with Hildebrand's insistence that it is through carving that 'architectonic space' is established. *Bird in Space* displays its process of reduction and polishing – 'freeing the figure from the stone' so that the bird takes flight through architectonic *space* (Figure 37).

In addition to the marble *Bird in Space*, Brancusi produced versions in polished metal. It can be said that the *space* of the brass *Bird in Space* of 1927 is distinct from the earlier sculpture in marble. The tensility of metal brings the sculpture into relation with such modern objects as suspension bridges, ocean liners and automobiles. Even more emphatically, the polished surface of the brass establishes a different quality of the sculpture's relation to its environment than when the material is stone. While the marble sculpture maintains a Hildebrandian dialectic of object versus *space*, the brass version offers a different paradigm with its reflective metal surface bringing the sculpture's immediate environment into the body of the sculpture. The warped, liquid distortions of the sculpture's reflections are on the order of the parabolic geometry that Riemann defined, and which fascinated the Cubists. Between the marble and metal versions of Brancusi's *Bird in Space*, there is an alternation of two versions of *space*. The marble bird embodies the elementalism of neo-Kantian philosophy, as the metal bird reflects Riemann's geometry of extension.

A case can be made that there is a different sense of time in the marble and brass *Bird in Space* sculptures. The quicksilver reflections of the metal versions make them speedier than the marble versions, with their more absorbent surfaces. Further, it can be seen that Brancusi is portraying a longer and historical *space* of time.

Brancusi's photographs of his studio show he characteristically presented his sculptures with two-part bases. The lower angular wooden base has a primitive aspect like some of the peasant carving Brancusi admired in his native Romania. The next section consists of a Classically geometric white marble cylinder,

Figure 37 Constantin Brancusi, View of the Studio with *Bird in Space*, gelatin silver print, Collection of Museum of Modern Art, 1923.

culminating on top with the Modern *Bird in Space*. This functions as an image of historical sequence – the Primitive supporting the Classical supporting the Modern. If so, Brancusi sought material form to coordinate historical cosmologies. Through these pictorial strategies, the sculptor transforms geometric form into historical and 'psychophysiological' content that relates to Panofsky's historicizing of perspective in his text of a few years later.

Pictorial Abstracts of *Space*

Represented by the shimmering and stuttering manifolds of planes of their paintings, several Cubist artists proudly proclaimed their pictures depicted objects and figures in four-dimensional *space*. The process of representing four-dimensional reality entailed abstracting dimensions – three-dimensional forms in four-dimensional *space* that were then depicted on two-dimensional surfaces. To be clear, abstraction is not the opposite of representation: abstraction is inherent to the process of all representation. In painting, such depicted qualities as mass, color and light are formalized to be transferred and thus abstracted from a scene to the canvas.

The sophistication and complexity of Cubist representation laid bare the basic truth that pictorial representation is a type of abstraction. It should also be noted that while *space* was an issue for some artists at this time, for others, *abstraction* was the crucial question. And there were cases in which an interest in abstraction and *space* overlapped.

In their early experiments, artists such as Theo Van Doesburg (1883–1931) and Piet Mondrian (1872–1944) showed greater interest in the processes of abstraction than the subject of *space*. There is a case to be made that while an idea of *space* is not inherent to pictorial representation, abstraction is. Mondrian and Van Doesburg produced series of works, in which recognizable images such as a tree or a cow are abstracted in stages to almost entirely detach from the original referent. In these paintings, 'abstract' indicates a 'pulling away' in the sense that a limited set of qualities derived from the represented scene are portrayed on the canvas.

There is another sense of abstraction. In an essay or a scientific paper, an 'abstract' is a condensed summation. It is in this sense that two examples of works by Laszlo Moholy-Nagy (1895–1946) and Josef Albers (1888–1976) can be understood as abstracts. In these works, *space* is presented pictorially, but without a worldly referent. Although there is no documentation that Moholy-Nagy and Albers discussed these works in terms of *space*, pictorial *space* was topical for

artists at this time. Elucidating their pictures in terms of *space* may well inform these works.

To begin with, both Moholy-Nagy and Josef Albers' works discussed here present an image of geometric clarity and simplicity, despite cultivating ambiguity. Moholy-Nagy's painting presents two overlapping geometric constructions that include a red circle and three parallelograms rendered in degrees of transparency (Figure 38). These geometric figures share the same shapes, composition and proportions; one is larger and above the smaller one. The figures are composed with diagonals which, in pictorial convention, often indicate linear perspective. By the twenties, linear perspective had become (as Panofsky's famous text was titled) something of a symbolic form for *space*. In Moholy-Nagy's picture, the diagonal edges of the shapes are parallel so that as perspective, it is isometric rather than optical in form. In the painting's isometric perspectival system, neither the top nor the bottom edges of the colored planes are definitively represented as forward edges. It is not even clear if these figures

Figure 38 László Moholy-Nagy, *A II*, oil and graphite on canvas, 46 × 54 in, 1924.

are planes presented in isometric *space* or are simply shapes with diagonal left and right edges.

If this painting is conceived as a composition in three-dimensional *space*, there are further conundrums. Is the smaller figure of planes with its red circle represented in depth as is the convention in linear perspective, or is it merely smaller? If they are represented as separate and not simultaneous, is the interval one of distance or time with one figure enlarging or shrinking to become the other? The painting presents dynamically ambiguous structures alternating between two, three and even four dimensions (perhaps including time), and so it is productive to interpret this picture in terms of *space*. Seen in this way, Moholy-Nagy's painting is an abstract of his essay on the complexities of representational conventions of *space* in pictures.

Albers and Moholy-Nagy were both faculty members at the Bauhaus, so it is not surprising they would share interests in the visual conundrums that isometric rendering makes possible. In a work from 1948, Albers' title, *Twisted but Straight* suggests a quandary (Figure 39). Distilled and honed, the isometrics of the graphic figure twist and turn. If you read it one way, within a fraction of a second it flips to a different reading. The illusion is dizzying. To the degree the illusion is perceptual, it is within the realm of art, specifically the reading of pictures, not within the daily mundane. The illusion here comes under the twentieth-century heading of *space*, but it is a noetic type of *space* that inheres within habits of reading visual structures, in this case, an isometric graphic configuration.

Figure 39 Josef Albers, *Twisted but Straight*, machined engraving on black laminated plastic, 13.5 × 24.75 in, 1948.

Albers' pictorial illusion can be said to function as its emblem of *space*. Like Moholy-Nagy's painting, Albers' graphic does not abstract from our surrounding world, but condenses the symbol of perspective as *space*. However, in Albers' hands, this symbol is a mercurial talisman that cautions *space* resides in interpretation as much as experience. Parallel to Poincaré's philosophy of conventionalism, Albers shows us *space* stripped bare to pictorial convention.

By the twenties, *space* was gaining momentum within art to become a feature of personal artistic expression. Artists of the time, such as El Lissitsky, Albers and Moholy-Nagy, worked within a technological / scientific sensibility to define *space*, while Brancusi operated between technical and fundamentalist modes. Increasingly, *space* in art was becoming defined as a personal aesthetic. *Space* in its fourfold form – Philosophic, Scientific, Spiritual and Artistic – ceased to extend outward, but instead, in various ways, extended back on itself, as seen with Albers' and Moholy-Nagy's mining of the conventions and conundrums of representing *space*.

Notes

1 Michael Podro, *The Critical Historians of Art* (New Haven and London: Yale University Press, 1982), xv.
2 Ibid., 179.
3 Ibid., xiv. Podro quotes from E. Panofsky, 'Der Begriff des Kunstwollens', *Zeitschrift für Ästhetik Und Allgemeine Kunstwissenschaft*, 14 (1920): 321–39.
4 Panofsky, *Perspective as Symbolic Form*, 66.
5 Ibid.

17

Painting Extends to 'Real Space'

'Pictorial Space' and 'Real Space'

Today, there is often a division between 'pictorial space' and 'real space'. As architectural *space* emerged from pictorial *space* to assert its independence, it came to be seen as 'real space'. As such, architectural *space* would no longer be bound to pictorial *space*, and would operate in 'real space'. It is worth retaining the quotations around 'real space' not only because the reality of *space* has a contentious history, but also because 'real space' in architecture and in art is always already aestheticized.

In the second half of the twentieth century, the idea of 'architectural space' gained momentum and concurrently, painters and sculptors began to claim 'real space' for their pictorial endeavours. In theory, 'real space' is made significant as real, through the physical art object's relation to its background outside its physical limits but included as within its esthetic purview. This is the case as when gallery architecture is considered 'part of the work'.

By the mid-century, *space* had no more outer worlds to extend to. In this sense, the history of pictorial *space* had ended. This does not mean *space* had lost its essential nature of extension, but its extension became a series of folds and variations. This can be seen in how Lucio Fontana (1899–1968) and Yves Klein (1928–62) extended pictorial *space* into what was considered 'real space'.

Fontana the Spatialist

Lucio Fontana was an early initiator of the unfurling of pictorial *space* outward to create 'real space' as an aesthetic function. Under the direction of Fontana, the *Manifiesto Blanco* (1946) was written and circulated by artists and students in Buenos Aires, Argentina. Although this manifesto had the swagger that is typical

of manifestos, at times its view on art was doleful. As was common in avant-garde circles of the times, the signatory artists called on the 'world of science' to aid in 'the development of four-dimensional art', but they also lamented that 'everything that could be expressed has been done – all possibilities have come to light and have been developed'.[1]

However, the *Manifiesto Blanco* (later claimed as the 'first manifesto of *spatial art*') was just a starting point. Within half a decade, a new manifesto was disseminated. Fontana and others declaim with force:

> These five years have permitted artists to shift to our own direction: to consider reality, that space, that vision of universal matter, about which science, philosophy, and art based on knowledge and intuition have nourished the human spirit.[2]

Titled *Manifesto Spaziale*, the text calls out Science, Philosophy, Spirit and Art, the four expressive strands of *space* defined in the last chapter.

Within the manifesto, the imperatives of the Spatialists are vague, and offer only such commonplace statements as, 'We reaffirm today the priority of art as an intuitional force of creation and . . . intuit practically the aspects of the mind which will be joined by knowledge.'[3] Although this is about as anodyne a statement about creativity in art as could be fit into a manifesto, it serves a purpose. In contrast to the *Dimensionist Manifesto*'s generalities of *space* which serve as an umbrella for the varying expressions of its avant-gardist artists, Fontana's claim to *Spazialismo* does something else – it functions as his own personal brand, even as Fontana was eager to share the franchise. From 1948 to his death twenty years later, virtually every one of Fontana's titles includes *space*. Fontana's co-opting of *space* as insignia is indicative of the increasing cachet of the term.

That said, there is little in Fontana's creative output that can be construed as pictorial *space* if 'pictorial space' is considered as operating within the pictorial object. Having arrived at painting through the study of architecture and extensive experimentations with ceramics, Fontana's paintings inherit the practical physicality of building construction and something of the elemental materialism of clay. If, at times, Fontana's pictures intimate landscape painting, his works present nothing that could be said to visually depict *space* – even on the abstract level of Albers' *Twisted but Straight*. Instead, Fontana's advertising of *space* in art seeks to remove *space* from its interior pictorial position and extend it to signify 'real space'. This is then reconstituted as a new form of the pictorial and proclaimed as *Spazialismo*.

This can be recognized in Fontana's chthonically material *Ceramica Spaziale* of 1949. The sculpture is not coherent in terms of interior pictorial *space*, but by claiming its surroundings as part of its aesthetic, the object and its 'real space' are made whole. The sculpture's cubic objectness and its hyper-materiality construct 'real space' in opposition to interior pictorial *space*, while at the same time, extend its pictorial imagination to the surrounding environment.

Fontana's *Concetto Spaziale*, the generic title for his artworks after 1948, meant that Fontana's brand of *space* could extend beyond the art object and still be within his painterly program. Pictorial *space* would no longer be limited to the interior of the picture.

Fontana methodically literalizes 'pictorial space' and co-opts it as his personal trademark. The materiality of Fontana's *Ceramica Spaziale* banishes interior pictorial *space* only to aesthetically reconstitute its surroundings as 'real space' which its title signifies (Figure 40).

Fontana's architectural environments pursue the same ends with a different strategy. He created his first ambient work *Ambiente spaziale a luce nera* in 1949,

Figure 40 Lucio Fontana, *Ceramica Spaziale*, ceramic, 24 × 25 × 24 in, 1949.

at the Galleria del Naviglio in Milan. With his use of the new technology of black light which creates altered perceptions of color, Fontana's 'spatial environment' extended painting into a new structure of experience. For Fontana, painting is not limited to the surface and frame of the object, but is now environmentally *spatial*.

Although there are commonalities with Fontana's *Ambiente spaziale* to the aesthetic of *Gesamtkunstwerk* of Kurt Schwitters' Merzbau, the aesthetic direction is different. In Schwitters' case, there is a longing for a wholeness – this is what defines a 'total work of art' in terms of culture and experience. Fontana was not looking for totality, but in the tradition of extension, he desires the new:

> To this end, using the resources put at our disposal by modern technology, we shall produce in the sky:
> Artificial shapes
> Miraculous rainbows
> Luminous writing.
> By means of radio, television we shall transmit a new kind of artistic expression.[4]

This reflects the scientific / technological dimension to Fontana's work, and an element of Futurism can be detected in Fontana's statements. Yet, while the Futurists delighted in breaking tradition, their artworks were mostly fashioned in the traditional forms of paintings and sculptures. In comparison, Fontana's works are more radical. If painting can be said to function as a reflection and reconstruction of the world and its effects, Fontana's *concetto spaziale* offers a new equation: the art object plus the world equals the artwork. Fontana is not against tradition, but proposes a pictorial process in which artworks fold back onto, and into, the world. Fontana reflects on *spatial* extension:

> Today we spatialist artists have escaped from our tower, we have broken out of our corporeal bodies, our chrysalis, and we have looked down upon ourselves from above, photographing the earth from a rocket in full flight.[5]

Fontana's best known works, the paintings with holes and slashes, have a related imagination. With Fontana's claims of *space* as his brand in the craft of painting, the punctures and cuts are ciphers for marks – literally his trademarks for *space*. In his own words: 'The cuts, or rather the hole, the first holes, did not signify the destruction of the canvas – the abstract gesture of which I have been accused so often ... it introduced a dimension beyond the painting itself...'[6]

Fontana explains,

At a time when people were talking about 'planes' – the surface plane, the depth plane etc – making a hole was a radical gesture which broke the space of the canvas as if to say: after this we are free to do what we like. The surface cannot be confined within the edges of the canvas, it extends into the surrounding space.[7]

Here Fontana conflates *space* with the value of freedom, and certainly the tradition of extension can express freedom. More pointedly though, the holes and the cuts open pictorial *space* to the surrounding 'real space', by claim, implication and performance (Figure 41).

Figure 41 Lucio Fontana, Milan, Italy, April 1955. Photo by Giorgio Lotti / Archivio Giorgio Lotti / Mondadori via Getty Images.

Yves Klein's Return of the Spirit to 'Real Space'

The concept of extending pictorial *space* to enfold 'real space' was taken up by Yves Klein, Fontana's younger fellow traveller in the European avant-garde. In a 1959 lecture at the Sorbonne, Klein states: 'The work must be like a volumetric wake of penetration caused by the impregnation in the immaterial space of life itself.'[8] Klein's famous leap into the void was publicized in *Dimanche – Le Journal d'un Seul Jour*, his newspaper of a single day (Sunday, 27 November 1960) for the Festival d'Art d'Avant-garde. Below the headline on the right is the photograph of Klein poised in mid-air like the winged Victory of Samothrace. Its caption reads: *'Le peintre de l'espace se jette dans 'e vide!'* (The painter of space launches himself into the void!) (Figures 42 and 43).

In the newspaper, he quotes himself:

> Yves: "I am the painter of space. I am not an abstract painter but, on the contrary, a figurative artist, and a realist. Let us be honest, to paint space, I must be in position. I must be in space."[9]

Klein describes how the idea of his monochromes ('monochrome' is a term Klein added to painting's lexicon) came to him in 1947:

> I ought to say that at that time it was rather through my intellect that it came; it was the result of all the passionate researches I was then engaged in. Pure, existential space was regularly winking at me, each time in a more impressive manner, and this sensation of total freedom attracted me so powerfully that I painted some monochrome surfaces just to "see," to "see" with my own eyes what existential sensibility granted me: absolute freedom![10]

In a late interview, Fontana endorses Klein as 'the one who understands the problem of space with his blue dimension'.[11] Just as Fontana seized upon punctures and cuts as trademarks for his artistic brand of 'real space', Klein adopted a powerfully celestial color – an ultramarine blue (*'sacre bleu'*, a modern form of lapis lazuli) – as his trademark which he entwined with his ideas of *space* and the Void. In 1960, he registered his blue, 'International Klein Blue' – IKB – as he labelled it, with the National Industrial Property Institute of France. Klein's major works were performed outside the studio and workshop and extended the site of production into the world of factories and commerce to aestheticize 'real space' as a creative center for his painterly project. With Klein's brand of *space* (as ever, linked to his trademark blue), he takes 'real space' further than Fontana by installing it at the artwork's site of creation. Klein's *Le journal*

d'un seul jour shows the painter in (or above) the street caught in the act of miraculous (self) creation. In contrast, even as Fontana's Spatialist program extended pictorial *space* to an idea of 'real space', he worked within a specialized workshop – the studio.

Klein's Anthropometry painting event of 1960, brought the (usually private) studio into the public realm by siting the creation of a group of paintings in the 'real space' of a gallery. Klein's event for the creation of the paintings, titled *Anthropometrie de l'époque bleue*, was staged at Galerie Internationale d'Art Contemporain; it included an invited audience and was filmed. Klein, dressed in a tuxedo, conducted three nude young women who slathered themselves with IKB paint, and imprinted their bodies on blank canvases on the floor and on the wall. Seven musicians in evening wear accompanied the action, performing Klein's *Symphonie Monoton-Silence*.

Klein literalizes the representation of bodies in *space* with this gallery performance of painting. Klein presented it as a formal cultural event, but even today, after almost seventy-five years, an aspect of hilarity remains. The relationship of the women's bodies to the pictures to the painting process is complex and scrambled. Are these actors or models the 'nudes', the pictorial subjects or, 'human brushes', objects within Klein's pictorial system? Or are they prime agents in the sense of performing actors? As the conductor of these paintings, and unlike most painters, Klein is 'hands off' (the exception is Klein helping one woman dismount from a pedestal that had allowed her to imprint her figure high on a wall canvas). Klein's pictorial structure constitutes an expanded frame that includes the figurative blue paintings, but also the documentation of the event, and the stories, rumors and critiques that follow from the spectacle. This is all constituted in Klein's expanded and aestheticized 'real space'. If Klein's leap into the void is something of a self-portrait, in which he is artist, subject and image, the *Anthropometrie de l'époque bleue* paintings are certainly, as he claimed, figurative works.

There is an ironic and critical dimension to Klein's melange of avant-garde culture and commercial promotion. However, Klein's Anthropometry paintings follow a path of significance that is as old as the roots of Christianity. Klein's Anthropometry paintings create spiritual value in a related manner to relics by establishing his tactile figure painting as a physical trace of the creative act. The canvases, subsequently stretched, serve as reliquaries for the remains of the originary (miraculous) artistic creation. Just as Christian icons are at the intersection of the physical, the tactile and the imagistic, so are the Anthropometry paintings. Most specifically, these paintings present images, 'not made by human

hands' – a reprise in form, image and technique of *Acheiropoieta* images such as the Shroud of Turin and the Veronica Veil.

Although both Fontana and Klein extend *space* by folding it into personal expression, their brands were developed from different dispositions of *space*. Of the four dimensions that define *space* in the twentieth century – Spirituality, Philosophy, Science and Art – Fontana's claim to *space* is, like his predecessors the Futurists, primarily defined along the axis of science in the form of technology. In Fontana's works, the Futurist passion for sensation infused with sex and destruction is re-performed aesthetically on the physical body of the paintings as cuts and punctures. In contrast to Fontana's intimations of iconoclasm, Klein's paintings, especially the monochrome panels of a heavenly blue (which Klein associated with Giotto), are iconophilic. Klein establishes his brand of *space* along the axis of religious spirituality. He quotes Gaston Bachelard, 'in the realm of blue air more than elsewhere, we feel that the world may be permeated by the most indeterminate reverie'.[12]

Klein was an earnest Catholic, who attended to the Cult of St Rita and enjoyed being photographed in the uniform of the Knights of St Sebastian. Although Rosicrucianism developed from German Protestants, Klein became an adherent to the order with the tutelage of Max Heindel, whose writings are reflected in Klein's attitude. Heindel began his spiritual career as a Theosophist enamored with the lectures and writings of Leadbeater. Heindel writes, 'We are so accustomed to speaking of 'empty' space, that we have entirely lost the grand and holy significance of the word, and are thus incapable of feeling the reverence that this idea of Space and Chaos should inspire in our breasts.' And that 'space is Spirit in its attenuated form; *while matter is crystallized space or Spirit*'.[13]

In a work from 1961, Klein links Heindel's twentieth-century spiritualism with Catholicism. In the *Ex-Voto per Santa Rita da Cascia* (The Saint of Lost Causes), Klein makes the logic of the reliquary and the icon – a logic which in varying degrees charges all his works – explicit. In the *Ex-Voto*'s Plexiglas box Klein deposited a rosy-pink pigment emblematic of the order of the 'Rosy Cross' and gold leaf, the material of Rosicrucian alchemy, flanking the center compartment filled with IKB pigment. Below the three compartments, an encased handwritten note proclaims:

> The BLUE, the GOLD, the PINK, the IMMATERIAL, the VOID, the architecture of air, the city of the air, the climate of grand geographical spaces for a return to human life in the nature of the legendary Edenic state . . .[14]

Klein's work is exemplary of *space* in its creative phase. Klein extends painting into 'real space' and made his brand of *space* significant by folding the history of *space* back to its religious roots. Klein revisits the ancient religious and spiritual origins of *space* as his personal artistic expression (Figure 44).

From his religious commitment to fabricated miracles, Klein's work operates most intensely within the spiritual / religious dimension of *space*, although additionally he is philosophically minded, and the technical dimension of his project includes the proto-science of alchemy. Klein brings his painterly artworks to overlay 'real space' as a means to re-enchant the world.

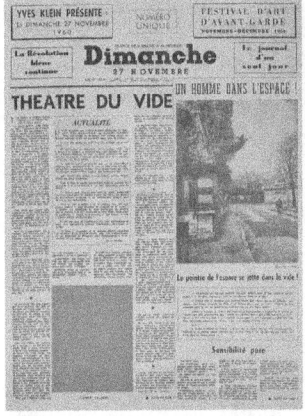

Figure 42 *Top*: Preparatory photographs by Shunk-Kender for Yves Klein's *Saut dans le vide*, 1960, Roy Lichtenstein Foundation.

Figure 43 *Below left*: Le Dimanche, 27 Novembre 1960: Le journal d'un seul jour.

Figure 44 *Below right*: Yves Klein buried under *Ci-gît l'Espace*, 1962, photo: Harry Shunk.

Rothko's 'Tactile Space' as Real

Although Mark Rothko (1903–70) belonged to the same generation as Fontana (who was born four years later), the two artists seem from different worlds in terms of their sensibility. While Fontana embraced branding and the pleasures of success, Rothko had a fear of commerce and commodification, and was prone to rejecting business dealings. Fontana welcomed technology and the future, while Rothko sought elemental truths of the mythic past. Rothko takes up the subject of *space* in his painting, but does not claim *space* as a personal brand. Following the neo-Kantian variety of space as elemental, he advocates for *space* more in the tradition of *Raum* than of *spatium*. Rothko's *space* also moves outward to 'real space', but in the form of a universal and fundamental saturation of reality.

In a posthumously published section of a book that his son and daughter date to 1940–1, Rothko writes about the 'Philosophical Basis' of *space*:

> If one understands, or if one has the sensibility to live in, the particular kind of space to which a painting is committed, then he [or she] has obtained the most comprehensive statement of the artist's attitude toward reality. Space, therefore, is the chief plastic manifestation of the artist's conception of reality. It is the most inclusive category of the artist's statement and can very well be called the key to the meaning of the picture. It constitutes a statement of faith, an *a priori* unity, to which all of the plastic elements are in a state of subservience.[15]

Rather than the idea of pictorial extension of *space* into 'real space', Rothko sees *space* as '*a priori* unity' – a distinct echo of Kant's definition of *space* as an '*a priori* intuition'. For Rothko, pictorial *space* does not need to extend into 'real space', but needs to reflect, channel and manifest the universality of *space*. This is also in line with Hildebrand's ideas. As such, *space* is already real to art, as 'the chief plastic manifestation of the artist's conception of reality' and exists to be recognized – and claimed – as shaping artworks which, by definition, are subservient to *space*. Rothko's statement about *space* presents a very different order of imagination than Fontana's or Klein's constructions of *space*.

Although ambitious in scope, Rothko's ruminations on *space* could be contradictory. In an informal interview with William Seitz in 1952, Rothko claimed that his paintings 'do not deal in space'.[16] In 1954, Rothko writes to Katherine Kuh, 'the actual fact is that I do not think in terms of space in painting my pictures'.[17] By the 1950s, speaking about *space* in painting had become commonplace, but Rothko, ever on guard against what he perceived as pretentious, writes, 'If . . . I were to undertake the discussion of "space" I would first have to disabuse the

word from its current meanings in books on art, astrology, atomicism and multidimensionality; and then I would have to redefine it ... in order to attain a common meeting ground.'[18] While this is not entirely a rejection of *space* in painting, Rothko is certainly rejecting extensive *space* as it emerged after the Cubists, instead aligning himself with the neo-Kantian tradition of *space* as a foundational 'meeting ground'.

There is a traceable genealogy from Kant's philosophy to Hildebrand and Bernard Berenson. Berenson channelled Hildebrand's ideas about *space* as essential to art making and defined *space* kinaesthetically as well as visually. In his unpublished book from the early forties, Rothko quotes Berenson from *The Florentine Painters of the Renaissance* (1896):

> Psychology has ascertained that sight alone gives us no accurate sense of the third dimension. In our infancy, long before we are conscious of the process, the sense of touch, helped on by muscular sensations of movement, teaches us to appreciate depth, the third dimension, both in objects and in space.[19]

These were not new ideas when Rothko was writing. The science of psychophysics that interested Berenson and Hildebrand had been established for half a century and concentrates on measuring human perception including the 'sensation of space'. While Riemann's science of geometry constructed an expanded imagination of *space*, the psychophysicists' focus was turned in the opposite direction, testing how the human sensory apparatus grasped three-dimensional *space*, which was assumed to be foundational to experience. Rothko quotes Berenson on *space* as it applies to painting:

> Now, painting is an art which aims at giving an abiding impression of artistic reality with only two dimensions. The painter must, therefore, do consciously what we all do unconsciously,— construct his [or her] third dimension. And he [or she] can accomplish his [or her] task only as we accomplish ours, by giving tactile values to retinal impressions. His [or her] first business, therefore, is to rouse the tactile sense, for I must have the illusion of being able to touch a figure, I must have the illusion of varying muscular sensations inside my palm and fingers corresponding to the various projections of this figure, before I shall take it for granted as real, and let it affect me lastingly.[20]

Rothko concludes:

> Actually Mr. Berenson is only hinting at an idea which is the foundation of plasticity in modern painting carried to its logical conclusion. It is this same notion of tactile reality as championed by modern painters which allows us now to better accept the space of the Egyptians or Chinese.[21]

Following Berenson, Rothko grasps the term 'tactile space' for 'the foundation of plasticity in modern painting' and for artworks outside the European canon. Rothko's uncritical (but affectionate) ascription of (European) *space* to other cultures allows him to link his Modern painting to both an originary concept of *space* as imagined in childhood and in 'primitive art'. Within the neo-Kantian tradition in which Rothko operated, *space* is universal, and so cannot admit historical and cultural limits to its idea of *space*, only qualifications and variations. But as a painter, Rothko's division of 'visual space' and 'tactile space' is productive. The chapter in Rothko's book titled 'Space' opens with this paragraph:

> Now what is the essential difference between the sort of space which is characteristic of tactile painting and that which is characteristic of illusory plasticity? And why do we designate one as tactile and the other as illusory? That is, why does one kind of space actually give us the sensation of things that can be felt by touch while the other can be perceived only by the eye.[22]

Like Fontana and Klein – although by a different logic – Rothko intends to stake a claim on 'real space'. He writes that 'tactile space, or, for the sake of simplicity, let us call it air . . . is painted so that it gives the sensation of a solid'. 'Tactile space' is granted the actuality of air. His point is that this invisible 'air in a tactile painting is represented as an actual substance rather than as an emptiness'.[23] Rothko's 'tactile painting' performs a miraculous act of transubstantiation – 'emptiness' is transformed into 'actual substance'.

It can be noted that in Rothko's writing there are two central thematic interests that relate to his personal construction of *space*. Early in his career, Rothko taught children and was fascinated by children's art as a foundation for art and as a representation of 'tactile space'. Additionally, Rothko had a lifelong interest in myth and religion. For Rothko, these two interests coalesce in an idea of *space* as foundational and archetypal.

As Rothko evolved, he progressively stripped religion and myth of its narratives and anecdotes from his painting. Like the *spatial* paradigm of Philoctetes' missing foot – *space* as the absent object – the specifics of mythology in Rothko's work are evacuated leaving *space* as the abstracted object. For Rothko, *space* is not merely a void but a 'sensation of a solid'. Rothko goes further than Hildebrand's dialectic of 'form and space'. Rothko grants *space* – 'tactile space' – the physicality of objects, allowing it to emerge as a kind of 'real space' and simultaneously a tactile substance. Through this transubstantiation (by way of tactile *space*) pictorial *space*, which was once defined as evacuated form is transformed into substance.

Rothko's creative defining of *space* through reduction entails an emotional cost. As Rothko maintains, his 'tactile space' communicates with feeling. Its

object, like Philoctetes' foot, can only be felt as loss – if not in a cry of pain, then as longing or mourning. Rothko claimed he made his paintings large so that they would be intimate, and liked to present his paintings so viewers would be pressed up against the surface to better feel the tactility. The subjects Rothko claimed to express were 'tragedy, ecstasy, doom and so on'.[24] These are feelings based on the mythic symbols that he substituted for abstracted, generic signs. This is the sense of Rothko's presence in absence: symbolic form removed, and dissolved into a generalized 'tactile space'.

Fontana is explicit about *space* as scientific and technological and Klein articulates his spiritual dimension of *space*. Rothko is also explicit, 'Space is the philosophical basis of a painting. . .'[25] Rothko's 'tactile space' has the characteristic fundamentalism of the neo-Kantian philosophical tradition. Working within the creative phase of *space*, Fontana, Klein and Rothko each construct an individually expressive form of *space* from its four expressive dimensions.

The twentieth century offered *space*, in Philosophic, Scientific, Spiritual and Artistic varieties, and each artist, with a different focus and intensity, fleshed out an individual relationship to these different directions. Even with their stated interest in a particular heritage of *space*, that type is coordinated to manifest in the artistic dimension of *space*. Fontana and Klein are disciplined thinkers, whose work contains a philosophic sensibility. Both Klein and Rothko claim spirituality (this dimension is less developed by Fontana with his scientific emphases). Klein and Rothko both operate within the spiritual dimension, however, their spirituality goes opposite directions. Klein's spirituality is centrifugal; his spiritual *space* is advertised, miraculous and utopic. In contrast, with Rothko's interest in myths, archetypal symbols and the collective unconscious he directs his spiritual *space* inward and toward the past.

As different as the claims for 'real space' are for Fontana, Klein and Rothko, they share a conviction of the value of the pictorial. In common, their creative construction of 'real space' is not opposed to their pictorial concerns but is extrapolated directly from these concerns. Their creative construction of 'real space' retains its connection to the pictorial so that their pictorial *space* radiates from their painterly objects extending to, and capturing 'real space'.

Twentieth-Century Art Historians of *Space*

The relationship between art historians and artists has not always been cordial. Nevertheless, it is consistent with Rothko's intellectual curiosity to quote Bernard Berenson, who, though not an enthusiast of modern art, offered sophisticated

thinking about painting. By the 1940s, art history had established itself in American universities. Erwin Panofsky had begun teaching at New York University in the early 1930s and his 1939 *Studies in Iconology: Humanistic Themes in the Art of the Renaissance* became a model for the discipline. While Panofsky's *spatial* ideas became increasingly popular, *space* did not instantly take a prime role in art historical writing.

The accelerating enthusiasm for concepts of *space* in visual art can be noted in Rosalind Krauss' seminal *Passages in Modern Sculpture*. By its publication date in 1977, *space* as an artistic concern had been definitively established. Krauss begins the introduction with: 'Although it was written in the eighteenth century, Gotthold Lessing's aesthetic treatise *Laocoon* applies directly to the discussion of sculpture in our time.'[26] Krauss' subsequent statement that, 'Lessing asserts that sculpture is an art concerned with the deployment of bodies in space,'[27] extends Lessing's concerns well beyond Lessing's eighteenth-century interests. Although it is elegant for Krauss to open with a long view, Lessing's essay (some 200 pages in its first English translation) does not propose the relation of *space* to the arts of painting and poetry as its primary purpose. The discussion Krauss only appears midway through the text. As very much within the culture of the twentieth century, Krauss elevates Lessing to endorse the habits of applying *space* to art.

The subject of Lessing's essay is not the *spatial* content of sculpture, but the Classical subject of *ut pictura poesis*—the comparison of poetry to the pictorial arts. He opens the essay with a discussion about the ancient sculpture of Laocoon to differentiate it from Virgil's description of the tragedy. The sculpture portrays the Trojan priest and his two sons being attacked by two sea serpents sent by Minerva to sabotage Laocoon's warning against bringing the Greek horse within the walls of Troy. The event is described in Virgil's *Aeneid*: as Laocoon is attacked, 'His roaring fills the flitting air around.'[28] In distinction, the sculptural rendition of Laocoon portrays him emitting a pained groan or sigh. Lessing contrasts the two. Lessing's interest is not in 'bodies in space', but in the drama of 'bodily pain, [which] is not inconsistent with nobility of soul . . . and why the artist has refused to imitate this cry in his marble.'[29] The question Lessing poses is, why in poetry is it appropriate for Laocoon to roar in pain while in sculpture a mere sigh is suitable.

Lessing concludes:

> The master was striving to attain the greatest beauty under the given conditions of bodily pain. Pain, in its disfiguring extreme, was not compatible with beauty, and must therefore be softened. Screams must be reduced to sighs, not because screams would betray weakness, but because they would deform the countenance

to a repulsive degree. Imagine Laocoon's mouth open, and judge. Let him scream, and see. It was, before, a figure to inspire compassion in its beauty and suffering. Now it is ugly, abhorrent, and we gladly avert our eyes from a painful spectacle, destitute of the beauty which alone could turn our pain into the sweet feeling of pity for the suffering object.[30]

This essay was written by a man of the theater and the basis of his discussion is drama. Lessing's normative criticism takes place not in terms of time and *space* but on the plane of sensibility, in which 'Truth and expression are taken as its first law.'[31] For Lessing, time and *space* are, as Krauss acknowledges, merely 'the limiting conditions of the separate arts',[32] but not their inherent subjects.

In Lessing's essay, it is the emotional and dramatic distinctions between painting and poetry that is the topic (he writes, 'under the name of painting, I include the plastic arts generally . . .'[33]). The criteria motivating Lessing's lengthy and detailed discussion of the sculpture of Laocoon are the proper expression of the sculpture's subject matter in relation to beauty and truth. In the eighteenth century, the dialectic of form and *space* was at best nascent in European consciousness. Krauss' appropriation of Lessing to burnish a discourse on twentieth-century sculpture exemplifies the deformation of art history through the injection of universalist, neo-Kantian *space*. As such she reflects Panofsky's legacy.

From its muted beginnings in Jacob Burckhardt's *Der Cicerone* (1855), *space* as a painterly and sculptural gestalt developed slowly, before gaining momentum in the twentieth century. This acceleration of applying *space* to art is evident in the two editions of a book by Carola Giedion-Welcker, footnoted by Krauss. Krauss claims, 'Giedion-Welcker, is entirely concerned with the *spatial* character of the sculptural task.'[34] However, this is not so in the first edition of *Modern Plastic Art, Elements of Reality, Volume and Disintegration*.[35] In Giedion-Welcker's original essay of 1937, *space* is an ancillary term, often referred to as 'space-time', which is more aligned with the *Dimensionist Manifesto* of 1936 than Krauss' 'spatiality of the medium'.

By the time Giedion-Welcker released an expanded second edition in 1955, *space* had taken on a more prominent role. This seems to be the book Krauss is referring to, not the original edition. The change of title to *Contemporary Sculpture: An Evolution in Volume and Space* is paradigmatic of the time; in the eighteen years between the two editions, thematic interest in *space* ballooned. *Space* now takes pride of place in the title and the expanded additional text now emphasizes the 'spatiality of the medium'. In this second edition, Giedion-Welcker declares, 'A new and fundamental sense of space seems to be manifesting itself.'[36] She speaks of 'bringing space to life' and of 'The "Poetry" of Space'.[37]

As a disciplined critic and historian, Krauss does not let enthusiasm get the best of her, still *space* is an ingrained concept. She compares Anthony Caro's sculptures to David Smith's, and writes that they seem 'to exist in an esthetic space far removed from Smith's own'.[38] Krauss' 'esthetic space' suggests that the 'new and fundamental sense of space' can best be defined as a linguistic array.

In Krauss' book, the reader will find: 'simultaneous space', 'formal space', 'virtual space', 'plastic space', 'dramatic space', 'open space', 'ideal space', 'literal space', 'conceptual space', 'mental space', 'coherent space,' 'transcendental space', 'natural space', 'ideated space', 'stereometric space', 'literary space', 'invisible space', 'psychological space', 'shared space', 'customary space', 'landscape space', 'background space', 'psychically fractured space', 'ambient space', 'geometrically conceived space', 'undifferentiated space', 'confrontational space', 'slices of space', 'viewer's space', 'interior space', 'illusionistic space', 'public space', 'private space', 'cultural space', 'negative space', 'external space', 'sculptural space', 'closed space', 'imagined space', and quoting Robert Smithson, 'gyrating space'. The reader of contemporary art history, art criticism or art journalism will note there are many additional phrases that *space* opportunistically inflects. *Space* in its recent and contemporary manifestation is a linguistic sprawl that could be fairly, if unattractively termed, 'discursive space'.

Notes

1. Lucio Fontana, '*Manifiesto blanco* (White Manifesto) (1946)', in Charles Harrison and Paul Wood (eds), *Art in Theory, 1900–1990: An Anthology of Changing Ideas* (Malden, MA: Blackwell, 1993), 642–7.
2. Lucio Fontana and others, 'Manifesto of Spatialist Art, 1951', in Caws (ed.), *Manifesto*, 540.
3. Ibid.
4. Lucio Fontana, *Lucio Fontana*, 1948, trans. Caroline Beamish, ed. Sarah Whitfield, Hayward Gallery, in association with the Fondazione Lucio Fontana, 1999. Exhibition catalogue published on the occasion of the exhibition *Lucio Fontana*, Hayward Gallery, London, 14 October 1999–9 January 2000. Texts by Sarah Whitfield. Extracts of interviews © Fondazione Lucio Fontana, Milan, 1999, 97.
5. Ibid.
6. Ibid., Interview by Carla Lonzi, Autoritratto, Bari, 1969, 122.
7. Interview by Daniele Palazzoli, 'Bit Arte Oggi in Italia / Art: What's Happening Today in Italy', October/November, 1967, No. 5, as quoted in Press Release for 'Lucio Fontana', at Sperone Westwater Gallery, 2000, New York.

8 Yves Klein, 'The Evolution of Art Towards the Immaterial', lecture at the Sorbonne, 3 June 1959, in *Overcoming the Problematics of Art: The Writings of Yves Klein*, trans. and with an introduction by Klaus Ottmann (Putnam, Conn.: Spring Publications, 2007), 76.
9 Yves Klein, *Dimanche*, 1960, as quoted in *Overcoming the Problematics of Art*, 105.
10 Yves Klein, *1928–1962 Selected Writings*, trans. Barbara Wright (ubuclassics, 2004; originally published by The Tate Gallery, London, 1974), 15.
11 Lucio Fontana, 'The Last Interview Given by Fontana', with Tommaso Trini, 1968, as quoted in the catalogue for *Lucio Fontana* at Sperone Westwater, New York, 2000.
12 Gaston Bachelard, 'Air and Dreams', 163–8, as quoted in *Overcoming the Problematics of Art*, 86.
13 Max Heindel, *The Rosicrucian Cosmo-conception: Or, Mystic Christianity; An Elementary Treatise Upon Man's Past Evolution, Present Constitution and Future Development*, Rosicrucian Fellowship, Oceanside, CA (London: L. N. Fowler, 1920), 247.
14 http://nouveaurealisme.weebly.com/ (accessed 2025).
15 Mark Rothko, *The Artist's Reality*, introduction by Christopher Rothko, afterword by Makoto Fujimura, ed. Kate Rothko Prizel and Christopher Rothko (New Haven, CT: Yale University Press, 2004), 59.
16 Selden Rodman, *Conversations with Artists* (New York, NY: Devin-Adair, 1957), 92–4, quoted in *Mark Rothko: Writings on Art*, ed. Miguel López-Remiro (New Haven, CT: Yale University Press, 2006), 78.
17 Ibid., 93.
18 Ibid., 92.
19 Rothko, *The Artist's Reality*, 44.
20 Ibid.
21 Ibid., 39.
22 Ibid., 56.
23 Ibid.
24 Rodman, *Conversations with Artists*, 92–4, quoted in *Mark Rothko*, ed. López-Remiro, 119.
25 Rothko, *The Artist's Reality*, 55.
26 Rosalind E. Krauss, *Passages in Modern Sculpture* (New York, NY: Viking Press, 1977), 1.
27 Ibid., 3.
28 Lessing, *Laocoon*, 4.
29 Ibid., 7.
30 Ibid., 13–14.
31 Ibid., 16.
32 Krauss, *Passages in Modern Sculpture*, 3.

33 Lessing, *Laocoon*, xi.
34 Krauss, *Passages in Modern Sculpture*, 3.
35 Carola Giedion-Welcker, *Modern Plastic Art, Elements of Reality, Volume and Disintegration* (Zurich: Dr. H. Girsberger, 1937).
36 Carola Giedion-Welcker, *Contemporary Sculpture: An Evolution in Volume and Space*. Modern Art and Sculpture, *Documents of Modern Art*, ed. Robert Motherwell, Vol. 12 (San Francisco, CA: George Wittenborn, Inc., 1955), xxiv.
37 Ibid.
38 Krauss, *Passages in Modern Sculpture*, 181.

18

The Last Hurrah of *Space*

Discontents of *Space*

The evolution from Giedion-Welcker's *Modern Plastic Art: Elements of Reality, Volume and Disintegration* of 1937 to Krauss' *Passages in Modern Sculpture* of 1977, demonstrates *space* had become a linguistic condition. In visual art, *space* was freeing itself from the axes of Science, Spirituality and Philosophy, which defined it earlier in the century to become the single dimension – the Artistic. *Space* was also becoming more and more able to attach itself to other words, inflecting more affect than content. In art, the creative phase of *spatial* thinking was coming to a close. As *space* lost its resonant historical dimensions, it became increasingly more common in the general vernacular. With this linguistic expansion, *space* became what William Burroughs called a 'word virus'.

The progress of *space* to its present-day state of 'discursivity' was inexorable. However, there was some resistance. When confronted about the *space* and his painting, Rothko was almost as ready to deny *space* outright as to formulate his 'tactile space'. Ad Reinhardt, in his 1946 'How to Look at Space' (fifth in his series of 'How to Look' cartoons for *PM*) begins with a conventional conception that *space* is the underlying control of pictorial organization, 'All through history a man's [and woman's] idea of what was "real" depended mainly on how he [or she] felt and what he [or she] thought about "space". Each age developed its own ways of describing its space (and time).'[1] However, by the last frames of the cartoon strip, Reinhardt is on to his real interests and states, 'Abstract painting areas are real spaces – lofty, alive, emotionally ordered and intellectually controlled.' Reinhardt's 'How To' guide is as playful as it is high-minded. He concludes with a cartoon of a businessman confounded and rendered prone: 'An abstract painting will react to you if you react to it . . . It represents something and so do you. YOU, SIR, ARE A SPACE TOO.' By 1957, in his 'Twelve Rules for a New Academy', Reinhardt was more severe about the concept of *space* in painting. Rule number eight is:

No space. Space should be empty, should not project, and should not be flat. "The painting should be behind the picture frame." The frame should isolate and protect the painting from its surroundings. Space divisions within the painting should not be seen.[2]

Although Reinhardt does not refute the notion that *space* is somehow natural to painting, he denies *space*. Rather than Rothko's equivocation between repudiating *space* and personalizing its expression, Reinhardt does more. He does both.

Clement Greenberg is well known and controversial in his opposition to *space* in art through his insistence on 'flatness' as specific to painting. Greenberg stakes out his position in his 1940 essay 'Towards a Newer Laocoon', although he does not refer to Lessing's framing of *space* and time in the arts as Krauss would do thirty-seven years later. For Greenberg, Lessing's essay is a pretext for his thinking about the material conditions of visual art. He brushes past Lessing without much consideration, writing that Lessing 'recognized the presence of a practical as well as a theoretical confusion of the arts. But he saw its ill effects exclusively in terms of literature, and his opinions on plastic art only exemplify the typical misconceptions of his age.'[3] Greenberg is ungenerous, but accurately allows that Lessing's (mis)conceptions are of his age – he does not turn Lessing into a prophet of *spatial* Modernism.

In the essay, Greenberg argues that 'flatness' is the fundamental condition of painting, and that just as importantly, there is a historical necessity to fulfil its material and medium specific destiny:

> The history of avant-garde painting is that of a progressive surrender to the resistance of its medium; which resistance consists chiefly in the flat picture plane's denial of efforts to "hole through" it for realistic perspectival space.[4]

Greenberg does not reject what he calls 'realistic pictorial space' so much as he advocates a teleological view, affirming that the essentials of each art form must historically progress toward each's material essentials. In a statement like, 'The purely plastic or abstract qualities of the work of art are the only ones that count,' Greenberg seems to be making a case for abstract painting and sculpture. However, he also insists that '[w]e can only dispose of abstract art by assimilating it, by fighting our way through it'.[5] And he is against 'certain partisans of abstract art [who would] legislate it into permanency'.[6] At this moment in his career, Greenberg advocates not for abstraction per se, but for the way that it can advance what he regards as the two great values of art: its materialist reality and its historical necessity. As such, *space* is an obstacle.

Here Greenberg is concerned with the shape of history as revealed in the materiality and 'medium specificity'. Rothko proposes a dialectic between 'tactile space' (or 'real space') and 'illusionistic space'. For Fontana and Klein, it is aestheticized 'real space' versus pictorial *space*. For Greenberg, the dialectic is the literary 'realistic pictorial space' versus historically evolved 'flatness'. For the painters, their dialectics play out in their visual medium, but for Greenberg, history is the medium of painting. While the genre of History Painting was anathema for Greenberg, he reframes painting as internalizing history. For Greenberg, history is the essential medium and ground of painting. Flatness is simply a function of painting in its teleological medium of history.

Greenberg is forceful in insisting on flatness as the material condition toward which painting is advancing. However *space* was beginning its viral, discursive stage. It required the slightest of semiotic twists to convert 'flatness' to 'flat space' and thus to internalize flatness to *spatial* discourse. Obdurately after mid-century the 'space age' was established in art studios, art academies and the academies of art history.

'Real Space' without History

Despite some resistance, *space* was increasingly normalized through the growth of art history and art education. By the middle of the middle of the twentieth century, *space* in art had become – and to this day remains – not so much a concept related to its history, but a condition. As *space* in art came to be conceived as transparently factual, *space* separated from its roots – its historical dimensions of Philosophy, Science and Spirituality – to become seen as real and secured to its single Artistic dimension. For the early adopters of 'real space', Fontana, Rothko and Klein, 'real space' was an extension of each of their pictorial programs anchored within the four part historical dimensions of *space*. By the 1960s, the situation was reversed, so that *space* was now the originary term, not only for Renaissance perspective, but also for a range of genres and discourses, from academic life drawing to rarefied critical discussion.

Rather than recognizing that *space* emerged from religion, philosophy and mathematics, *space* became unmoored from its historical roots to become little more than a flavor. By the 1960s, *space* could attach itself at will, setting the stage for another expansion of *space* into art, in the form of the seemingly neutral idea of 'real space' that is the premise for Minimalism and its inheritors.

The 1960s in New York City have become a storied decade for art. While this was the period in which 'real space' became an institution in visual art, it was also a lively moment for artists and art making. In 2003, Frank Stella (1936–2024) recalled:

> Today people may look back at the sixties and see a division between abstract painting and painters who were doing Pop, but at the time it wasn't a question of taking sides, because there really weren't any sides. Everybody was in it together. By and large, the scene, including Minimalists, Pop artists, Color Field painters, and leftover Abstract Expressionists, was fluid and well integrated.[7]

Stella's recollection captures the vibrant mood of the New York scene. As well as the bonhomie, the art of the sixties was itself expansive. This was true across the smorgasbord of styles and subjects in the arts of the era. Pop brought the heated visuality of advertising that was powering the burgeoning consumer society to painting. Movies, billboards, cartoons, television, industrial design, architecture, factory production and promotional texts were absorbed into a variety of pictorial forms and styles ranging from traditional types of painting to Conceptualism.

Ideas about visual art were expanding. If a painter was making artworks within the medium of history – exemplified by Greenberg's insistence on medium specificity – there were stakes that mattered. Painting was an issue in the sixties. In the midst of the expansion of the possibilities of art, how to define boundaries of the pictorial became an urgent subject. In 1962, Greenberg wrote:

> But now it has been established, it would seem, that the irreducible essence of pictorial art consists in but two constitutive conventions or norms: flatness and the delimitation of flatness; and that the observance of merely these two norms is enough to create an object that can be experienced as a picture: thus a stretched or tacked-up canvas already exists as a picture—though not necessarily as a successful one.[8]

This is Greenberg delimiting flatness as an objective border. He continues, and although he places this insight in parentheses, this observation is a revelatory key to the pictorial imagination of the sixties:

> (The paradoxical outcome of this reduction has been not to contract, but actually to *expand the possibilities of the pictorial*: much more than before now lends itself to being experienced pictorially or in meaningful relation to the pictorial: all sorts of large and small items that used to belong entirely to the realm of the arbitrary and the visually meaningless.)[9]

Five years later, Michael Fried quotes Greenberg's passage on flatness and responds:

> To begin with, it is not quite enough to say that a bare canvas tacked to a wall is not "necessarily" a successful picture; it would, I think, be less of an exaggeration to say that it is not conceivably one. It may be countered that future circumstances might be such as to make it a successful painting; but I would argue that, for that to happen, the enterprise of painting would have to change so drastically that nothing more than the name would remain.[10]

Against Greenberg, Fried proposes that taste is the essential limit for painting. In the essay from which this passage is taken, 'Art and Objecthood', Fried is making a case for his preferred Color Field painters, such as Jules Olitski and Kenneth Noland against Minimalist or 'literalist' artists such as Donald Judd and Robert Morris. In retrospect, whether or not one feels Fried's taste is justified, one can sympathize with his feeling that painting is slipping away. Fried wrote this in the decade when Ad Reinhardt was painting 'the last paintings that could be painted' and the refrain, 'painting is dead' was current. Fried's intuition is not wrong; the boundaries that defined painting, as Fried cherishes and understands them, were falling. At the same time, as Greenberg noted, 'possibilities of the pictorial' were expanding.

Fried recognized the real and the pictorial are conflated in the case of the expansion of the parameters of pictorial art in Minimalist or 'literalist' works to claim 'real space'. He writes: 'The concept of a room is, mostly clandestinely, important to literalist art and theory. In fact, it can often be substituted for the word "space"...'[11] Fried realizes that what he conceives of as 'pictorial space' is reconstituted as the architectural background for Minimalist works. The surrounding context is then claimed as 'real space' by (clandestinely) denying its pictorial nature.

Judd writes in his 1965 essay 'Specific Objects' that, 'The new work obviously resembles sculpture more than it does painting, but it is nearer to painting.'[12] As such, Judd's argument is that his 'specific objects' function as painting but not traditionally and at a distance. For Judd the problem is, 'Almost all paintings are *spatial* in one way or another.'[13] This is where Judd and Fried are at odds – Judd dislikes the narrow definition of pictorial *space* that is essential for Fried – and desires that his pictorial art objects function in 'real space'. Famously, Judd expresses the *spatial* conditions of the new work he conceives of and defines where these objects operate:

> Three dimensions are real space. That gets rid of the problems of illusionism and of literal space, space in and around marks and colors—which is riddance of one of the salient and most objectionable relics of European art.[14]

For Judd, 'real space' displaces pictorial *space*, with its 'problems of illusionism and of literal space'. Revealingly, he also claims in this essay, 'Yves Klein's blue paintings are ... unspatial,'[15] a point that is opposite to Klein's assertions about his paintings. In valorizing 'real space' as opposed to pictorial *space*, Judd declares, 'Actual space is intrinsically more powerful and specific than paint on a flat surface.'[16] Judd's assertion in 'Specific Objects' is that his new work, as he sees it, although painterly, displaces pictorial *space* for the more powerful territory of real or actual *space*. However, he does not make the connection (as Klein did) that aestheticized 'real space' is an extension of pictorial *space*, nor that the pictorial can extend beyond paint on a flat surface (as Fontana knew).

In distinction to Judd, Fried is an enthusiast for paintings with a limited pictorial sense, and rejects the expansion of the pictorial that Greenberg posits. For Fried to find a painting 'successful' it can only inhabit a narrow field of paint on canvas, and so Judd's painterly 'specific objects' are merely literal and, as such, cannot be pictures or even art in a significant way. At the same time, Judd does not recognize that the 'real space' in which his specific objects operate is hypostatized pictorial *space*. Fried can see this process of the transubstantiation of pictorial *space* to a gallery environment, framed as 'real space' – but he will not have it.

After supporting an initial group of painters, Fried lost interest in painting. Moving on for Fried meant that 'pictorial space' would thrive within the even tighter physical boundaries of photography. It is possible to admire the imaginative pictorial expansion of Judd and others in the 1960s and still see something misleading about the extension of pictorial logic reframed and claimed as objects operating in 'real space'. It proceeded, as Fried points out, clandestinely. Unlike Fontana, Klein and Rothko whose 'real space' was acknowledged as attached to the pictorial, in the case of Minimalism, through its valorization of 'real space', its expansive pictorial dimension is denied.

With the Minimalist severing of the pictorial from 'real space', the last of the four strains of *space* – its Artistic dimension – was dispensed with. And so, with the practices of art that Judd advocates for, his 'real space' has lost its (European) historical roots (religion, philosophy, science); even its artistic dimension. *Space* in art is made immediately and insistently real through amnesia. By erasing connections to its history, *space* is less constrained and more able to attach itself to various terms promiscuously.

Now unencumbered by history, *space* could claim objectivity – 'real space' as a fact. 'Pictorial space' of course remains, but without the imaginative sweep that defined pictorial *space* in art in the first half of the twentieth century. It became

a sinecure in traditionalist art writing and art education with its subcategories of 'negative space', 'deep space' and 'shallow space'. In its progressive form, *space*, now made 'real space' by its separation from the pictorial, could freely operate as a word virus, and perform discursive post-Modern hijinks.

As distinct from the concept of *space*, the pictorial exists at the nexus of seeing, thinking (and feeling) and making. It predates human history and is as deep and broad as human culture.

Frank Stella's Working

There is no artist who straddled the concept of *space* and the pictorial at the same level of complexity and duration as Frank Stella. He was singular in that he was at the center of discussions about paintings as objects and / or pictorial. With the inclusion of his *Black Paintings* in the *Sixteen Americans* exhibition of 1959 at the Museum of Modern Art, Stella, then twenty-three, made a propitious entrance. Despite their disagreements, Greenberg, Judd and Fried could all agree on the significance of Stella's paintings of the 1960s. For Greenberg, these paintings embodied elemental 'flatness'. Judd saw Stella's paintings as leading to his painterly objects. Fried saw the paintings going the opposite direction. With their 'deductive structure' they contained the values of Modernism, which Fried (who admired the more senior Stella when they were both in college) believed was a historical necessity. However, it was unsustainable for Stella's work to continue to accommodate such divergent interests. It is to Stella's credit that he followed his internal sensibility rather than that of Greenberg, Judd or Fried.

After the black paintings at the Museum of Modern Art, Stella began painting on shaped canvases, giving the panels interest as objects and making the context of the room and its walls significant to the paintings' pictorial system. For those in the camp of 'real space', this was exciting. However, having come of age at Princeton University, the town Panofsky where made his home and a bastion of neo-Kantian art history, Stella inherited an advocacy for *space* in painting. In a lecture he gave to art students when he was barely a year out of college, he explains the 'spatial problem' he faced with 'relational painting',

> i.e. the balancing of the various parts with and against each other. The obvious answer was symmetry—make it the same all over. The question still remained, though, of how to do this in depth. A symmetrical image or configuration placed on an open ground is not balanced out in the illusionistic space. The solution I

arrived at . . . forces illusionistic space out of the painting at a constant rate by using a regulated pattern.[17]

If the painting mechanics Stella describes are not entirely clear, it shows him pinioned between those who would reject the idea of *space* in painting and those who believed in it. Even when forcing the 'illusionistic space out of the painting', Stella sees an essential role for *space* in painting. In the tradition of Panofsky, Stella endorses that *space* is always already in painting, but perhaps its 'illusionistic' quality could be forced out.

Stella's early black paintings were crucial for the imagination of not only Judd, but, as well, for a generation of artists who pursued pictorial objects in the Minimalist vein. However, Stella's program of painting swerved to offer new pictorial adventures. This entailed progressively compromising the orthogonal simplicity of his early work. By the end of the seventies, Stella had begun to cut out shapes and use shards of corrugated aluminium panels to compose his paintings (as in his *Indian Birds* series). At the time, this was viewed as a move away from painting toward sculpture. Regardless of issues of *space*, sculpture and 'flatness', these works distinctly embody what Greenberg recognized as the expanded 'possibilities of the pictorial'.

In the winter of 1983, Frank Stella presented the Charles Eliot Norton Lectures at Harvard, a series of talks later published as *Working Space* (1986). The lectures are peculiar with equal parts artist talk and art history lesson. Within the history of pictorial *space* it is a singular document. In its expansiveness, the text is the epitome of late-twentieth-century 'discursive space'. The published lectures open urgently:

> After Mondrian abstraction stands at peril. It needs to create for itself a new kind of pictoriality, one that is just as potent as the pictoriality that began to develop in Italy during the sixteenth century.[18]

Stella's drama is understandable. At the time he gave the lectures in the early 1980s, the intellectual tradition of painting that characterized the art world when he arrived, and in which he had flourished, was being swept away. Referring to the eighties, Stella recounts, 'It was apparent the decade's narcissism / romanticism wanted to obviate the most obvious fact of its existence – that it was engendered by an accomplished and meaningful past.'[19] Opposing this denial of the 'meaningful past' Stella insists on the relevance of history and invites sixteenth-century Italy and Mondrian into his discussions. Stella's sense of history is idiosyncratic and it permeates these lectures.

To rescue the future of abstract painting, Stella reaches back to what he sees as the historical foundation of Western painting – the Italian Renaissance. He states: 'we believe that great painting – painting that is illustratively full, substantial, and real – was born with the Renaissance and grew with its flowering'. Thus Stella returns to the period that traditional art history imagined was the origin of pictorial *space*.

In *Working Space*, there is plenty of narrative drama. The early Baroque painter, Caravaggio acts as the heroic protagonist. Stella does not intend to emulate Caravaggio as a 'realist' or an 'illusionist'. Rather, he celebrates Caravaggio in terms of his historical position as, not only the savior of painting, but as the prophet of what Stella calls 'modern pictorial space'. To do this, Stella has to ignore the pictorial specifics of Caravaggio's painting. For Stella, 'pictorial space' is the universal solvent that suspends historical time and difference. Stella conjures 'pictorial space' as the medium for the transfer of Caravaggio's pictures and his historical position to the present.

And so, Caravaggio is the relevant model that will revitalize abstract painting through what Stella sees as his newly conceived sense of pictorial *space*. Comparing Caravaggio to Venetian and Roman painting, Stella writes:

> Caravaggio . . . offers a kind of cinemascopic depth and an ovoid delimitation of space that enables painting to enhance the theatrical flatness of Venetian muralism, while in another vein his Vatican Deposition shows clearly how to activate a classicist void without falling into Mannerist excesses. . . . Caravaggio signals the advent of modern pictorial space.[20]

By setting up terms such as 'cinemascopic depth and an ovoid delimitation of space', Stella swings between the language of art history and a contemporary idiom of informal persuasion used in studios and art openings. As such, Stella's reference to movies is not inappropriate when discussing Caravaggio – it is a vivid image that Stella's contemporaries can 'see'. From the other direction, the 'ovoid delimitation of space' echoes this passage in Panofsky's *Perspective as Symbolic Form*:

> Thus in an epoch whose perception was governed by a conception of space expressed by strict linear perspective, the curvatures of our, so to speak, spheroidal optical world had to be rediscovered.[21]

Here, Panofsky is discussing the seventeenth-century scientific realization that curved lines – representing a 'spheroidal optical world' – rather than straight

lines – better reflect the present science of perspectival optics. He brings this into the context of ancient Greek optics, in which the field of vision was conceived to mathematically correspond to a sphere. Panofsky then cites the optically refined curves of Doric columns and the *entasis* of the base of the Parthenon to underpin his concept of the 'translation of psychophysiological space into mathematical space . . .',[22] and vice versa.

Panofsky was of the generation that was constructing *space* creatively and he uses the notion of *space* for imagining and defining perspective. Both Stella and Panofsky hew to the conception that *space* is humankind's 'universal sense of the world'. However, while Panofsky applies spherical geometry to discuss historically specific forms of perspective, Stella is being impressionistic and colloquial:

> To be able to carry in our minds the space of Caravaggio's large commanding works . . . we need some kind of image to help form an idea about the design and purpose of Caravaggio's pictorial space. The image that comes to mind is that of the gyroscope—a spinning sphere, capable of accommodating movement and tilt. We have to imagine ourselves caught up within this sphere, experiencing the moment and motion of painting's action. Fanciful as this space may be, it has the cast of reality; we have to take it seriously.[23]

Again, Stella provides a stimulating image: that of a gyroscope. Stella does not insist that this is how Caravaggio conceived his paintings. Rather, this is how Stella imagines himself painting abstract updates of Caravaggio's *space*. And he wants us to take it seriously. Indeed, the large painterly objects that Stella showed just before he died in 2024, bear a striking resemblance to gyroscopes.

In *Working Space*, then, Stella is performing Caravaggio for his audience in order to display his own personal sense of gestalt. Stella channels Panofsky, with 'spheroidal space', and with the phrase 'the theatrical flatness of Venetian muralism', he is speaking in the language of Greenberg and Fried. *Space* allows Stella to work the room filled with peers and historical figures. As such, freewheeling conversation is more appropriate to Stella's approach than historical rigor. This is a prime example of how 'discursive space' inserts itself into the medium of painting.

The Profligacy of Stella's *Space*

In Stella's *Working Space*, there is little, if any, of Fontana's imagination of *space* as science, or Klein's belief in *space* as spiritual, or Rothko's interest in philosophically defined *space*. Instead Stella operates performatively within the

Artistic dimension of *space*. It is apparent that Stella's avid and extensive use of *space* is derived from art history, although he does not explore its historical meanings. However, in an interview shortly after his lectures he offers a specific definition of pictorial *space*:

> Pictorial space is one in which you have two-dimensional forms tricked out to give the appearance of three-dimensional ones.[24]

Stella continues in a direction unexplored in *Working Space* to make the case that with the transition between the two-dimensional and three-dimensional:

> The space you actually perceive comes down somewhere in-between. And somewhere in-between isn't a bad analogy for my work. I work away from the flat surface but I still don't want [it] to be three-dimensional; that is, totally literal . . . more than two dimensions but short of three so, for me, 2.7 is probably a very good place to be.[25]

Stella is likely channelling Benoit Mandelbrot's fractal geometry in which dimensions can be conceived as fractions. If Stella is uninterested in the mathematics behind fractional dimensions, the statement indicates a pivot from his freestyle art historical concepts of *space* to something stranger and more imaginative.

This is reflected in Stella's painting. By 1990, Stella's paintings were going in several directions. Colorful schematic patterns in multiple states of and facture dominate in the wall works and in his large technically advanced and visually complex prints (Plate 33). A number of works come off the walls to inhabit something like a fractal dimension. Resting on the floor, Stella's *Raft of Medusa, Part I*, 1990, is unpainted and composed of the sometimes lustrous, sometimes dull surfaces of tangled aluminium shapes (Figure 45). The *Raft of Medusa*, and the many works follow in this vein, could be defined as sculpture. But to turn Stella's phrase around, it might be said that in the case of the *Raft of Medusa*, 'we have three-dimensional forms tricked out to take on the role of two-dimensional ones'.

Whether the *Raft of Medusa* is defined as sculpture or painting is not relevant: instead, it should be seen as an object 'to expand the possibilities of the pictorial'. Like Judd's works, it is a pictorially specific object, but it insists on its painterly context, rather than occlude it with a semiotic of 'real space'. Stella gives his work the title of Géricault's painting, but it does not rely on art history or historical painting to justify its pictorial nature. Whether or not these results are to one's taste, with this work and others that followed, Stella embodies the 'new kind of pictoriality' that he proposed in *Working Space*.

Figure 45 Frank Stella, *Raft of Medusa, Part I*, steel and aluminium, 167.5 × 163 × 159 in, 1990.

By the 1990s, more than a decade after the lectures, Stella's concept of pictorial *space*, in *Working Space* lectures, had fractured. Starting with the expansion of types and dimensional structures of his paintings, its break-up continued as Stella's order of two and three dimensions was fractured, elided and made provisional in subsequent works. In this sentence from 1991, illusion, *space*, normal and artistic vision splinter:

> The habitable illusion is really pictorial space that is expansive rather than restrictive, space that is more easily understood in terms of normal vision than in terms of artistic vision.[26]

Stella continues and attempts to organize the complex situation:

It is pictorial space that takes into account a fuller range of our visual perceptual abilities, for example, our unforced ability as we work at our desk, say, to look out the window, take in a painting by Mondrian on the wall, and still read our own reflected facial grimace on the polished chrome lamp face immediately in front of us. Normal vision actually has a greater knack than we give it credit for in terms of handling sensations of what might be called multidimensional space. Sitting at our desk, penning a note, we ticked off about eight dimensions – three out the window, at least two from the Mondrian on the wall, and three plus in our reflection from the luxor lamp face.[27]

There is a sea change between Stella's consideration of pictorial *space* in *Working Space* and its later incarnation with tricked-out fractional dimensions multiplying to as many as eight dimensions. Earlier, Stella maintained that 'the aim of art is to create space – space that is not compromised by decoration or illustration, space in which the subjects of painting can live'.[28] Later, with Stella citing 'multidimensional space', he indicates that pictorial *space* has exploded into florid profusion. 'Space in which the subjects of painting can live' has become a 'habitable illusion'.

Stella's idea in *Working Space* that 'space means three dimensions', dissolves into an unstable, fractional, multidimensional idea of *space*. This idea of *space* he espouses for the final three decades of his career is yet wilder than the Cubist appropriation of the fourth dimension. Even if Stella's multiple and proliferating dimensions of *space* may seem an echo of Riemannian *n*-dimensional geometry, there is a distinction. A Riemannian hyperbolic *space* of, for example, twenty dimensions is beyond human experience – this mathematical 'space' is a convention effective only for propositional calculations. Stella wants *space* to be attached to experience. At the same time, as *space* multiplies its dimensions at will and whim, it disintegrates its reality. This dissolution of *space* was inevitable. *Space*, as a 'word virus' replicates itself to attach to a host of meanings, could only be left with solipsistic significance.

Even as Stella's sense of *space* became less coherent, his faith in the pictorial always was unshakable. Rather than an idea of *space*, it is Stella's commitment to an expanded sense of the pictorial that better defines his decades-long career. 'Pictorial space' is the primary subject of *Working Space* and it gives the lectures their intellectual gloss. However, a close look reveals the text is more concerned with the urgency of the pictorial than the *spatial*. In *Working Space*, if one splits the trope of 'pictorial space' into its constituent parts, 'pictorial' or 'pictoriality' appears half again as many times as 'space'.

It is useful to compare Judd to Stella in terms of the pictorial and *space*. Judd committed himself to 'real space'. By keeping the pictorial essence of 'real space' closeted, it pushed Judd to find more picturesque backgrounds for his specific objects – as in his scenic compound in Marfa. This condition of 'real space' can be seen in earth works like Robert Smithson's *Spiral Jetty*. 'Real space' gains its power and radicality through denying its pictorial content, but covertly recoups the pictorial through a picturesque context. In the contest between the pictorial and 'real space', it is salient that 'real space' emptied of its history, extended its authority. Judd retreated from the fraught relationship of *space* and the pictorial to concentrate on 'real space', while Stella remained fascinated by the problems of the pictorial, even as his ideas about *space* were spinning and becoming tangled up. When the chips were down, Stella believed that the

> pictorial both as an adjective and noun ... is the best word to describe what art making should acknowledge from its past and make available to its present and its future. The necessary pictorial quality or qualities in painting stand for the visually transmitted information we absorb as we look at a painting. What's important about this information is that it is unique to its situation, i.e., it is information that is created in the process of, if not by the process of, picture making.[29]

It is worth noting in the passage above that Stella introduces a new subject for the pictorial. What Stella calls 'visually transmitted information' is at work in 'artistic vision', and there is the implication that information 'unique to the situation' is even more intensive in multidimensional 'normal vision'. In the larger world, as *space* loses its cohesion, it seems hardly possible that the wholeness represented by the idea of 'objects in space' can hold, as the power of informational systems – computers, the internet, cell phones, GPS, social and shopping networks – inevitably become more domineering and apparent. It is to Stella's credit that as *space* is being dissolved into information, he is confident that picture making will weather the change.

The Dissolution of *Space*

The chronology of the chapters on the Space Age bring us to the present, in which anything is a *space*. *Space* has so saturated our culture that its complex and subtle contradictions and histories, which once gave it meaning, are exhausted. If one Googles 'Painting, Space' there are 1.8 billion results; 'Architecture, Space' returns 2 billion results; and 'Society, Space' well over 2 billion – these searches are

concluded in less than half a second. This proliferation of *space* is indicative of its transformation from early-twentieth-century meaning to ambient vacuity.

As committed to the traditionalist idea of pictorial *space* as Stella was, he could not maintain its coherence faced with its proliferation of dimensions and disintegration. However, Stella does not retreat to the fantasy of artistic 'real space'. As his passion for historical painting indicates, it is picture making – the pictorial – where his true allegiance lies. In the early 1980s, Stella sought his 'new kind of pictoriality' in the historical past, but within a decade he finds the pictorial in the present-becoming-future. For Stella, his sense of the pictorial took care of itself. A short passage by a visionary of a different stripe, Michel Foucault (1926–84), offers an image that can be applied to the latter works of Stella with their weaves of networks and shards:

> The present age may be the age of space . . . We are in an era of the simultaneous, of juxtaposition, of the near and the far, of the side-by-side, of the scattered. We exist at a moment when the world is experiencing, I believe, something less like a great life that would develop through time than like a network that connects points and weaves its skein.[30]

Foucault's 'network that connects points and weaves its skein' is now literalized in computer systems that produce billions of results in a fraction of second. The present momentum of this condition both amazes and is banal. From the vantage of the twenty-first century, what Foucault describes in his last sentence – the skeins of connectivities – can be seen to have pushed the world of the 'of the near and the far, of the side-by-side, of the scattered' to a different place. The 'age of space' held the promise of a new 'great life', but this is not the condition Foucault is delineating. The near and far have collapsed into juxtaposed simultaneous networks of information. This is how the Space Age ends.

Notes

1. Ad Reinhardt, 'How to Look at Space', *PM*, 29 January 1946.
2. Ad Reinhardt, *Art as Art: The Selected Writings of Ad Reinhardt*, ed. and introduced by Barbara Rose (New York, NY: Viking Press, 1975), 203.
3. Clement Greenberg, 'Towards a Newer Laocoon', in Francis Frascina (ed.), *Pollock and After: The Critical Debate* (New York: Harper and Row, 1985); originally published in *Partisan Review*, 7, no. 4 (July–August 1940).
4. Greenberg, 'Towards a Newer Laocoon', 37.

5 Ibid.
6 Ibid.
7 Frank Stella, 'Feature Title', *Artforum*, 42, no. 2, October 2003, 230.
8 Clement Greenberg, 'After Abstract Expressionism', *Art International*, 6, no. 8, 25 October 1962, 30.
9 Ibid., emphasis added.
10 Michael Fried, 'Art and Objecthood', *Art and Objecthood: Essays and Reviews* (Chicago, IL: University of Chicago Press, 1998), 148–72, see 169 n. 6.
11 Ibid., see p.170 n.14.
12 Donald Judd, 'Specific Objects', *Donald Judd: Complete Writings 1959–1975* (New York, NY: New York University Press, 1975), 183.
13 Ibid., 182.
14 Ibid., 184.
15 Ibid., 182.
16 Ibid., 184.
17 Text of a lecture, by Frank Stella at the Pratt Institute, Winter 1959–60, published in Robert Rosenblum, *Frank Stella* (Harmondsworth: Penguin Books Ltd., 1971), 57.
18 Frank Stella, *Working Space* (Cambridge, MA, and London: Harvard University Press, 1986), 1.
19 Frank Stella, 'Grimm's Ecstasy' (1991), in *The Writings of Frank Stella / Die Schriften Frank Stella* (Cologne: König, 2001), 151. Published on the occasion of the exhibition *Heinrich von Kleist by Frank Stella*, Galerie der Jenoptik AG und ehemalige Arbeiter- und Bauern-Fakultät vordem Thüringer Oberlandesgericht, 27 March–4 June 2001. Originally published in Bonnie Clearwater and Frank Stella, *Frank Stella at Two Thousand: Changing the Rules* (Miami, FL: Museum of Contemporary Art, 2000), and first exhibited at the Museum of Contemporary Art North Miami, 1991.
20 Stella, *Working Space*.
21 Panofsky, *Perspective as Symbolic Form*, 34.
22 Ibid.
23 Ibid., 11.
24 William Rubin, *Frank Stella 1970–1987*, Museum of Modern Art, New York, distributed by New York Graphic Society Books / Little, Brown and Company, Boston, MA, 1987, 77.
25 Ibid.
26 Stella, 'Grimm's Ecstasy', 167.
27 Ibid.
28 Stella, *Working Space*, 5.
29 Ibid., 157.

30 Michael Foucault, 'Different Spaces', in *Aesthetics, Method, and Epistemology*, ed. James D. Faubion, trans. Robert Hurley et al., *Essential Works of Foucault 1954–1984*, Vol. 2 (New York, NY: The New Press New York, 1998), 175; from a lecture presented to the Architectural Studies Circle, 14 March 1967, first published in *Architecture, Mouvement, Continuité*, 5 (October 1984): 46–9

Afterword

Regardless of the moment in time, picture making cannot help but embody its surrounding world view. The trouble with *space* is less with artists and those who write about art than with the state of *space* itself. As something that cannot be seen, *space* is not an object to be painted. But that was never the idea behind pictorial *space* – its job was always to *inform* the picture. The implications of Foucault's text, along with the works and statements of Stella, suggest that as *space* disintegrates, it loses its value to meaningfully inform painting. Having arrived in the twenty-first century, *space* inhabits an unnecessary middle term between the process of informing and the picture. With the closing of the 'age of space', it may be time to reflect on the present state of information that now dynamically shapes picturing.

The current condition of *space* in the arts reflects either a nostalgia for a history that never was or is a semiotic fantasia of literary performance. Even in the most *space*-obsessed decades, there were always artists who resisted *spatial* interpretation. Agnes Martin disposes of the whole mess, saying, 'My paintings have neither object nor space nor line nor anything – no forms.'[1] Robert Ryman defined his painting against pictorial 'illusion': 'So lines are real, and the space is real, the surface is real and there is an interaction between the painting and the wall plane.'[2] Although Ryman worked within the 'real space' aesthetic following the sixties, the statement shows his lack of interest in modelling *space*, instead 'real space' led to his real interest – the painting object and its material relationships. Further, it is hard to see that discussions of pictorial *space* do much to inform Alex Katz's and Andy Warhol's complex reframing of figures in painting through the mechanics of fashion and advertising. Gerhard Richter, when questioned about 'painterly spatiality', replied succinctly, 'It simply doesn't exist. It's a false problem.'[3]

A question remains: How can a world without *space* be imagined? I can refer the reader to Vilém Flusser (1920–91), who wrote critically and poetically about what he saw as the emerging world view. What Flusser calls the 'pure information

society', 'will no longer be found in any place or time but in imagined surfaces, in surfaces that absorb geography and history'. He continues, 'this dreaming state of mind as it has begun to crystallize around technical images: the consciousness of a pure information society'.[4]

Flusser's book *Into the Universe of Technical Images* offers a visual metaphor of the evolution of consciousness in the form of a schematic ladder. On the first rung, 'Animals and "primitive" people are immersed in an animate world – a four-dimensional *space-time* continuum. It is the level of concrete experience.' Between the second and third rung is the three-dimensional era of graspable objects, 'such as stone blades and carved figures' and cave paintings. With the fourth rung, the world becomes two-dimensional through the structure of understanding and explanations that 'Linear texts, such as Homer and the Bible' provide. Flusser's final rung represents how he sees today and what follows from the vantage of 1985, when he wrote the book: texts have collapsed 'into particles that must be gathered up. This is the level of calculation and computation, the level of technical images'.[5] A single dimension.

This one-dimensional world is not to be taken literally as if our fate is now to be figures in Abbott's *Flatland*. But it presents an image of the diminishment of experience that evolved within the ecosystem of creating and inhabiting technologies of mediation that shape our world. It is a parable of how technical images have come to dominate. Today we can wonder if a painting is really finished or even exists until its photograph is logged into a database or it is shared as a jpeg. In the present information society, it is apparent that 'the production of information is society's actual function'.[6] Although this was scarcely so before the last decade of the twentieth century, harvesting and processing information, personal and otherwise, exists on an industrial scale. This new structure of information is not a static noun, but a dynamo of forming, transforming, reforming, deforming and informing. It is the image of Foucault's 'network that connects points and weaves its skein'.[7]

Remarkably, despite Flusser's primary focus on technical images in this 'telematic society', he is attentive to painting. He writes:

> The painter becomes real in the gesture of painting, because in it, his [or her] life is directed toward a change in the world. It is directed toward the painting to be painted and, through it, toward others who are there with the painter: toward the future.[8]

He continues, observing that painting with its

dialogue of gestures, this interweaving of concrete events, is a changing of the world, a being there in the world for others. For, of course, "the world" is not an objective context of "objects" but a context of interacting concrete events, some of which have meaning in as much as they give it.[9]

These sentences are both an evocative and exact observation of painting. Further, I am tempted to substitute 'painting' for Flusser's 'information society' in the first passage above to claim that the place of painting is 'in imagined surfaces, in surfaces that absorb geography and history'. Good words for painting.

I cite Flusser's 'information society' not to argue that painters should substitute information for *space*. Flusser takes a long view – we can recognize that the information society is replacing the Space Age as paradigmatic for experiencing the world. Perhaps this will encourage artists to speak about and envision their work in relation to information rather than *space* – in terms of visual reading as well as perception. As a painter, it seems to me that while analogies of the effects of information may offer fresh opportunities for imagination (or, as it were, imaging), it is no more essential to picturing than *space* was.

Consider the Studio

I am sure there are painters who think about *space* when they make their paintings. By now it is clear I am not one of them. I am a studio artist and it is the traditional specifics of painting that interest me. The size and texture of the painting support, the viscosity of paint and its drying time, the shape of the brush and where and how to hold it may be urgent, or may be ignored to be constituted into my painting process as intuition. Sometimes it is more productive to suspend attention to details and let the momentum of painting lead. In painting, forgetting can be as important as focus. As an inheritor of the sixties' expanded sense of the pictorial, I am as comfortable (or uncomfortable) reworking the traditional frameworks of painting as working within them.

In the course of my work in various formats (and analogies or allegories) of painting, glass boxes can fill in for the idea of transparency in painting; colored bands of fabric can substitute for brushstrokes and the wall behind can serve as the support for these paintings. Or the painting support can be stretched linen, but in the form of an oversized pillow. Recent works entail photographic prints as an imagistic and technical premise for where and how painting takes place.

My painting is always materialist and pictorial. In the case of a couple of my painterly augmented reality works, it is the looking through and waving of one's smartphone that is the matter. Picture, as imperative or noun, has been key to my thinking about painting, rather than imagining that the pictures represent dimensions – either two, three or four.

Although *space* has never been a concern of my painting, place is significant though it is very different from the relevance of Place in traditional Christian Painting. The action of placing is how I find the intimacy of painting and define its gestalt. Placing is my process for constructing the compositional framework of the painting. A painting need not be finished, but it becomes itself when it has established its place. Studio work can be banal and sloppy but it is a form of enchantment to both instigate and watch the turning of base material into a painting. Because this is a form of modern alchemy, it is the lure that turns people to painters. In terms of my process, I think it is a good painting when it becomes independent to the extent that it's hard to recall making it – so that its place is distinct from my own.

The painting studio is, as well, always a place. In it I am not a body moving in three-dimensional *space*, instead my studio is defined by its practical axes – what walls are free, the angles of light at different times of the day, where the pencils and tape are kept and do I really have to relocate those buckets to work comfortably? Temporary and provisional studios are also defined by practical axes. When artists paint outside, the studio is reduced and miniaturized to a kit and, with luck, the 'walls' which are now views of the landscape can enter the painting. While it has its own complexities, the camera, a 'room' that looks out to the world, can function as a studio. And, while it is my least favorite, the computer is paradigmatic of an informational studio. It is an Alice-in-Wonderland studio, in which the artist's physicality is diminished and abstracted to greedy eyeballs, keyboard clicks and tiny whirls of the mouse.

Studio Metaphysics

Like painting, like the camera, the studio faces onto the world. An attitude of speculation is, as much as paint and canvas, the stock in trade of painters. Irresistibly, painting is wrapped around speculation manifesting in matters, large and intimate: other artists live or dead, culinary or sexual interests, current events, philosophy, science, spirit, sports, money, music or real estate. An artist's subject of speculation is revealing and can often be surprising.

Speculation is fairly wild and artists cage it at their peril. It is in that spirit I offer a speculative metaphysics of the studio. It is better to consider what follows as a picture, performance or parable rather than a philosophical proposal.

To begin: no *space* (of course). Time, always more relentless than its metaphysical sibling, *space*, remains. In this context time, can be considered sets of fluxes that move differently at different rates in different contexts. Time then, is not a singular absolute frame. It is generally understood that time moves in the direction of 'forward'. In certain instances, time can go 'backwards', depending on the parameters and mechanics of its framework. In the case of a white canvas with a blue shape that is then overpainted white, time is reset.

Time is at the origin of my ruminations. Sometimes I listen, and sometimes I forget to listen, but my studio always has music. A compelling 2002 song by Blackalicious, 'First in Flight' integrates a sample of Gil Scott-Heron's voice to serve as the refrain, "Cause all we got is rhythm and timin". It is poignant to reflect on these words as they come from Scott-Heron. The message I get is: time is existential. Rhythm and timing are the shapes of time – how time is informed and informs.

Following Flusser, information is elevated as an axis in my provisional studio metaphysics. The action of informing myself and the painting – a process of forming through observation – is key to this idea. In politics and war, information can be a matter of life and death. And so it is for Schrödinger's cat. At present, the mechanics of information are only beginning to emerge. My speculative model is anchored in the studio and the specifics of science are distant, as such these physics of information are intuitive.

Take Einstein's equation $E=mc^2$, which is foundational for modern physics – it conveys there is an equivalence of matter and energy. It would seem the difference between object and energy is time and how each informs the other. So energy and matter are transformed through information in time.

Reflecting on our present information society, from my studio perspective it seems the effects of *space* are residual. The meaning of distance comes only as some aspect of an object informs another. To be recognized, distance requires information. A moving object is informed by matter, energy and measurement.

In this speculative model, *space* may be included, but in a subsidiary role. By organizing a number of dimensions (extensions) to inform each other, an idea of *space* can be produced. But within the model of matter and energy that are informed by time and by informational frames, *space* is shunted from its privileged position. After a fashion, it is a reprise of the loss of Place that presaged the rise of *space*.

Although I close the book with a fantasia of studio metaphysics, the purpose of writing this book is to better see painting in its historical medium. It is to let painting shine by removing the obscuring overlay of pictorial *space*. There is a truism that I endorse – paintings should speak for themselves. In writing this book, I've attempted as much as possible to let the historical figures speak with their own words. It is a necessity to be critical, but I've tried not to be judgemental and so not to occlude the context of the paintings. If it seems painting – or picture making – is perpetually in crisis, it can be observed that painting has endured from before civilization in myriad forms. Being at the intersection of looking, thinking and making, painting exemplifies empathy and imagination. It is an honor and privilege to participate.

Notes

1 Agnes Martin, *Writings*, ed. Dieter Schwarz (Winterthur: Kunstmuseum Winterthur, 1993), undated quote by Dieter Schwarz, 7.
2 Robert Ryman, 'On Painting', in *Robert Ryman*, ed. Christel Sauer and Urs Raussmüller (Schaffhausen: Hallen für neue Kunst, 1991), 59.
3 Gerhard Richter, 'Interview mit Irmeline Lebeer, 1973', in *Gerhard Richter: Text 1961–2007. Schriften, Interviews, Briefe*, ed. Dietmar Elger and Hans Ulrich Obrist (Cologne: Walther König, 2008), 81.
4 Vilém Flusser, *Into the Universe of Technical Images*, trans. Nancy Ann Roth, introduction by Mark Poster (Minneapolis, MN: University of Minnesota Press, 2011), 4; originally published as *Ins Universum der technischen Bilder* (Göttingen: European Photography, 1985).
5 Flusser, *Into the Universe of Technical Images*, 7.
6 Ibid., 92.
7 Michel Foucault, 'Of Other Spaces,' in *Aesthetics, Method, and Epistemology*, ed. James D. Faubion, trans. Robert Hurley and others, Essential Works of Foucault, 1954–1984, vol. 2 (New York: The New Press, 1998), 175. This is the text of a lecture presented to the Architectural Studies Circle on 14 March 1967; it was not published until 1984 in *Architecture, Mouvement*, Continuité 5 (October 1984): 46–49.
8 Vilém Flusser, *Gesten: Versuch einer Phänomenologie* (Mannheim: Bollmann Verlag, 1991); trans. Nancy Ann Roth as *Gestures* (Minneapolis: University of Minnesota Press, 2014), 69–70.
9 Ibid., 70.

Bibliography

'81 Canons of the Synod of Elvira'. *Strannik Journal*, strannikjournal.wordpress.com/historic-confessions/81-canons-of-the-synod-of-elvira/. Accessed 2024.

Abbott, Edwin A. 1884. *Flatland: A Romance of Many Dimensions*. 2nd edn. London: Seeley & Co.

Agamben, Giorgio. *Infancy and History: On the Destruction of Experience*. Trans. Liz Heron. London and New York, NY: Verso, 1993.

Alberti, Leon Battista. *De pictura*. Italy, [*Della pittura*, 1435–6] 1439–41.

Alberti, Leon Battista. *On Painting: A New Translation and Critical Edition*. Trans. and ed. Rocco Sinisgalli. Cambridge: Cambridge University Press, 2011.

Alberti, Leon Battista. On Painting *and* On Sculpture: *The Latin Texts of* De pictura *and* De statua. Ed. Cecil Grayson. London: Phaidon, 1972.

Alberti, Leon Battista. *On the Art of Building in Ten Books*. Trans. Joseph Rykwert, Neil Leach and Robert Tavernor. Cambridge, MA: MIT Press, 1991.

Alighieri, Dante. *Purgatorio*. c. 1321.

Alpers, Svetlana. *The Making of Rubens*. New Haven, CT: Yale University Press, 1995.

Apollinaire, Guillaume. *The Cubist Painters*. Trans. with commentary by Peter Read. London: Artists.Bookworks, 2002. Originally published in French as, *Les Paintres Cubistes [Méditatiions Esthétiques]* (Paris: Eugène Figuière et Cie, Éditeurs, 1913).

Aquinas, St Thomas. *Summa Theologica*. Question 102, 1st article. Trans. Fathers of the English Dominican Province, Sacred Texts, 1947. archive.sacred-texts.com/chr/aquinas/summa/sum112.htm.

Aristotle. *Physica*. Trans. R. P. Hardie and R. K. Gaye. *The Works of Aristotle*. Ed. W. D. Ross. Oxford: Oxford at the Clarendon Press, [350 BCE] 1930.

Arp, Hans. 'Dada Was Not a Farce'. (1949). In Robert Motherwell (ed.), *The Dada Painters and Poets: An Anthology*. 2nd edn. Cambridge, MA, and London: Belknap Press of Harvard University Press, 1981.

Auerbach, Erich. *Mimesis: The Representation of Reality in Western Literature*. Trans. Willard R. Trask. Princeton, NJ: Princeton University Press, [1946] 1953.

Bachelard, Gaston. 'Air and Dreams'. Quoted in *Overcoming the Problematics of Art: The Writings of Yves Klein*, trans. with an introduction by Klaus Ottmann. Putnam, CT: Spring Publications, 2007.

Batchelor, David. *Chromophobia*. London: Reaktion Books, 2000.

Baxandall, Michael. *Painting and Experience in Fifteenth-Century Italy: A Primer in the Social History of Pictorial Style*. Oxford: Oxford University Press, 1972.

Baxandall, Michael. 'Alberti and the Humanists: Composition'. In *Giotto and the Orators*. Oxford: Oxford at the Clarendon Press, 1973.

Belting, Hans. *Likeness and Presence: A History of the Image before the Era of Art*. Trans. Edmund Jephcott. Chicago, IL, and London: Chicago University Press, [German original 1990] 1994.

Berger, John. *The Success and Failure of Picasso*. Harmondsworth: Penguin Books, 1965.

Boccaccio, Giovanni. *Decameron*. Trans. Richard Aldington. New York, NY: Garden City Publishing Company, Inc., [c. 1349–51] 1930. 6th Day, 5th Tale.

Boccioni, Umberto. 'Technical Manifesto of Futurist Sculpture, 1912'. *Futurist Manifestos*. Ed. and with an introduction by Umbro Apollonio, trans. Robert Brain, R. W. Flint, J. C. Higgitt and Caroline Tisdall. New York, NY: Viking Press, 1973.

Bolyai, John. *The Science of Absolute Space*. Trans. Dr. George Bruce Halsted. Mineola, NY: Dover Publications, 1955.

Bonaventure, Saint. *The Life of Saint Francis of Assisi*. Trans. E. Gurney Salter. Boston, MA: E. P. Dutton, 1904. eCatholic2000, www.eCatholic2000.com. Accessed 2024.

Bonola, Roberto. *Non-Euclidean Geometry: A Critical and Historical Study of Its Development*. Trans. H. S. Carslaw, with an introduction by Federigo Enriques. LaSalle, IL: The Open Court Publishing Company, 1912.

Bostock, John, and H. T. Riley. *The Natural History of Pliny*. By Pliny the Elder. Trans. with notes and illustrations by John Bostock and H. T. Riley. London: Henry and Bohn, 1855.

Braque, Georges. 'Pensees et reflexions sur l'art'. *Nord-Sud*, 10 (December 1917): 3–5. Repr. in 'Reflections on Painting', in Robert John Goldwater and Marco Treves (eds), *Artists on Art: From the XIV to the XX Century*. New York, NY: Pantheon Books, 1945.

Braque, Georges, and Dora Vallier. 'Braque, la peinture et nous'. In 'L'entretien a paru dans *Cahiers d'Art*'. *Cahiers d'Art*, 29, no. 1 (1954): 13–24.

Braun, Emily, and Elizabeth Cowling, with contributions by Claire Le Thomas and Rachel Mustalish. *Cubism and the Trompe l'Oeil Tradition*. New York, NY: Metropolitan Museum of Art. Distributed by New Haven, CT: Yale University Press, 2022.

Bruno, Giordano. 'Cantus Circaeus'. In *Opera Latine Conscripta*. Ed. V. Imbriani and C. M. Tallarigo, Vol. 2. Neapoli: Apud Dom. Morano, 1886.

Bruno, Giordano. *De l'infinito, universo e mondi*. Printed in Venice, 1584.

Bruno, Giordano. *De l'infinito, universo e mondi*. In *Dialoghi italiani I: Dialoghi metafisici*. Ed. Giovanni Aquilecchia, with notes by Giovanni Gentile. 3rd edn, 2nd repr. Florence: Sansoni, 1985. Electronic edn published by Liber Liber, 31 October 2006. www.liberliber.it. Accessed 2025.

Bruno, Giordano. *The Expulsion of Triumphant Beast*. Trans. and ed. Arthur D. Imerti, with an introduction and notes. New Brunswick, NJ: Rutgers University Press, 1964.

Bruno, Giordano. *The Ash Wednesday Supper,* La Cena de Le Ceneri. Ed. and trans. Edward A. Gosselin and Lawrence S. Lerner. Hamden, CT: Archon Books, 1977.

Bruno, Giordano. *The Ash Wednesday Supper: A New Translation*. Trans. and annotated Hilary Gatti. Lorenzo Da Ponte Italian Library. Toronto: University of Toronto Press, 2018.

Burckhardt, Jacob. *Der Cicerone: Eine Anleitung zum Genuss der Kunstwerke Italiens.* Basel: Schweighauser'sche Verlagsbuchhandlung, 1855.

Burckhardt, Jacob. *The Cicerone: An Art Guide to Painting in Italy, for the Use of Travellers and Students.* Trans. Mrs. A. H. Clough. London: T. W. Laurie, [1855] 1908.

Carrier, David. *Principles of Art History Writing.* University Park, PA: Penn State University Press, 1991.

Casey, Edward S. *The Fate of Place: A Philosophical History.* Berkeley and Los Angeles, CA, and London: University of California Press, 1997.

Caws, Mary Ann, ed. *Manifesto: A Century of Isms.* Lincoln, NE: University of Nebraska Press, 2001.

Clarke, Samuel, and Gottfried Wilhelm Leibniz. *The Leibniz-Clarke Correspondence: Together with Extracts from Newton's Principia and Opticks.* Ed. H. G. Alexander. Manchester: Manchester University Press, and New York, NY: Barnes & Noble, 1956.

Clearwater, Bonnie, and Frank Stella. *Frank Stella at Two Thousand: Changing the Rules.* Miami, FL: Museum of Contemporary Art, 2000.

Coccia, M., and L. Morozzi, eds. 'Arnolfo di Cambio: Il Monumento del Cardinale Guillaume De Bray dopo il Restauro: Atti del Convegno Internazionale (Rome-Orvieto, 9–11 December 2004)'. *Bollettino d'Arte.* Special edn, 2009.

Cocteau, Jean. *A Call to Order.* Trans. Rollo H. Myers. First published in 1926 by Faber and Gwyer Limited, London. Made and printed in Great Britain by The Westminster Press, London. Excerpts reprinted in Robert L. Herbert (ed.), *Modern Artists on Art: Ten Unabridged Essays.* 2nd edn, New York, NY: Dover Publication, 2000.

Conlon, Thomas E. *Thinking about Nothing: Otto von Guericke and the Magdeburg Experiments on the Vacuum.* Kington: The Saint Austin Press, 2011.

Cooper, Donal, and Janet Eileen Robson. *The Making of Assisi: The Pope, the Franciscans, and the Painting of the Basilica.* New Haven, CT: Yale University Press, 2013.

Copernicus, Nicolaus. *De Revolutionibus Orbium Coelestiu.* Libri VI. Trans. Edward Rosen. Reed College Mathematics Department. Warsaw: Polish Scientific Publications, 1978.

da Vinci, Leonardo. *Treatise on Painting* [Codex Urbinus Latinus *1270*]. Trans. and annotated by A. Philip McMahon, with introduction by Ludwig H. Heydenreich. Princeton, NJ: Princeton University Press, 1956.

Darke, Diana. *Stealing from the Saracens: How Islamic Architecture Shaped Europe.* London: Hurst & Company, 2020.

de Piles, Roger. *The Principles of Painting under the Heads of Anatomy . . .* London: Printed for J. Osborn, at the Golden Ball, in Pater-noster Row, 1743.

Delacroix, Eugène. *The Journal of Eugène Delacroix.* Trans. Lucy Norton and Hubert Wellington. London: Phaidon Press, 1995.

Descartes, René. *The Philosophical Works of Descartes: Rendered into English.* Trans. Elizabeth S. Haldane and G. R. T. Ross. Vol. 1. London: Cambridge University Press, 1911.

Donne, John. *Selected Poetry and Prose.* London and New York, NY: Methuen, 1986.

Duchamp, Marcel. *The Writings of Marcel Duchamp*. Boston, MA: Da Capo Press, 1989. Originally published as *Salt Seller: The Writings of Marcel Duchamp*. Ed. Michal Sanouillet and Elmer Peterson. New York, NY: Oxford University Press, 1973.

Duhem, Pierre. *Le Système du Monde: Histoire des doctrines cosmologiques de Platon à Copernic*. 10 vols. Paris: Librairie Scientifique A. Hermann et Fils, 1913–59. Cited in 'Pierre Duhem', *Stanford Encyclopedia of Philosophy*, plato.stanford.edu/entries/duhem/#HisSci. Accessed 2024.

Duhem, Pierre. *Le système du monde: Histoire des doctrines cosmologiques de Platon à Copernic*. Vol. 2. Paris: Librairie Scientifique A. Hermann et Fils, 1914.

Duhem, Pierre. *Le système du monde: Histoire des doctrines cosmologiques de Platon à Copernic*. Vol. 3. Paris: Librairie Scientifique A. Hermann et Fils, 1915.

Engel, F., and P. Stackel. Theorie der Parallellinien von Euklid bis auf Gauss. Leipzig: Teubner, 1985.

Farago, Claire. 'On the Origins of the *Trattato* and the Earliest Reception of the *Libro di pittura*'. In Claire Farago, Janis Bell and Carlo Vecce, *The Fabrication of Leonardo da Vinci's* Trattato della Pittura: *With a Scholarly Edition of the* editio princeps *(1651) and Annotated English Translation*. Vol. 1. Leiden: Koninklijke Brill NV, 2018.

Farago, Claire, Janis Bell and Carlo Vecce. Foreword by Martin Kemp. *The Fabrication of Leonardo da Vinci's* Trattato della pittura: *With a Scholarly Edition of the* editio princeps *(1651) and Annotated English Translation*. 2 vols. Leiden: Koninklijke Brill NV, 2018.

Farago, Claire, ed. and introduced. *Re-reading Leonardo: The Treatise on Painting Across Europe, 1550–1900*. Aldershot: Ashgate Publishing, 2009. London and New York, NY: Routledge, 2016.

Félibien, André. *Des principes de l'architecture, de la sculpture, de la peinture, et des autres arts qui en dépendent: Avec un dictionnaire des termes propres à chacun de ces arts*. 3rd edn. Paris: A Paris, chez la Veuve & Jean-Baptiste Coignard, fils, 1697.

Finley, M. I. *Aspects of Antiquity: Discoveries and Controversies*. New York, NY: Viking Press, 1968.

Flusser, Vilém. *Gestures*. Trans. Nancy Ann Roth. Minneapolis, MN: University of Minnesota Press, 2014.

Flusser, Vilém. *Into the Universe of Technical Images*. Trans. Nancy Ann Roth. Introduction by Mark Poster. Minneapolis, MN: University of Minnesota Press, 2011. Originally published as *Ins Universum der technischen Bilder*. Göttingen: European Photography, 1985.

Fontana, Lucio. *Lucio Fontana*. Trans. Caroline Beamish, ed. Sarah Whitfield. Hayward Gallery, in association with the Fondazione Lucio Fontana. Milan: Fontana, [1948] 1999.

Fontana, Lucio. '*Manifiesto blanco* (White Manifesto) (1946)'. In Charles Harrison and Paul Wood (eds), *Art in Theory, 1900–1990: An Anthology of Changing Ideas*. Malden, MA: Blackwell, 1993.

Fontana, Lucio. 'The Last Interview Given by Fontana'. With Tommaso Trini, 1968. As quoted in the catalogue for *Lucio Fontana* at Sperone Westwater, New York, 2000.

Fontana, Lucio, et al. 'Manifesto of Spatialist Art, 1951'. In Mary Ann Caws (ed.), *Manifesto: A Century of Isms*. Lincoln, NE: University of Nebraska Press, 2001.

Foucault, Michel. *Aesthetics, Method, and Epistemology*. Ed. James D. Faubion, trans. Robert Hurley et al. *Essential Works of Foucault 1954–1984*. Vol. 2. New York, NY: The New Press, 1998.

Foucault, Michael. 'Different Spaces'. In *Aesthetics, Method, and Epistemology*, ed. James D. Faubion, trans. Robert Hurley et al., *Essential Works of Foucault 1954–1984*, Vol. 2 (New York, NY: The New Press New York, 1998). From a lecture presented to the Architectural Studies Circle, 14 March 1967, first published in *Architecture, Mouvement, Continuité*, 5 (October 1984): 46–9.

Frascina, Francis, ed. *Pollock and After: The Critical Debate*. New York: Harper and Row, 1985.

Fried, Michael. 'Art and Objecthood'. In *Art and Objecthood: Essays and Reviews*. Chicago, IL: University of Chicago Press, 1998.

Friedenthal, Richard, ed. *Letters of the Great Artists: From Blake to Pollock*. Trans. Daphne Woodward. London: Thames and Hudson, 1963.

Ghiberti, Lorenzo. *I commentarii*. Ed. Lorenzo Bartoli. Florence: Giunti Gruppo Editoriale, 1998.

Giedion-Welcker, Carola. *Contemporary Sculpture: An Evolution in Volume and Space*. Modern Art and Sculpture. *Documents of Modern Art*. Ed. Robert Motherwell. Vol. 12. San Francisco, CA: George Wittenborn, Inc., 1955.

Giedion-Welcker, Carola. *Modern Plastic Art, Elements of Reality, Volume and Disintegration*. Zurich: Dr. H. Girsberger, 1937.

Gleizes, Albert, and Jean Metzinger. 'Du "Cubisme"' (1912). In Robert L. Herbert (ed.), *Modern Artists on Art: Ten Unabridged Essays*. 2nd, enlarged edn. New York, NY: Dover Publications, Inc., 2000.

Gleizes, Albert, and Jean Metzinger. 'The Cubist Painters'. In Joshua C. Taylor (ed.), trans. Lionel Abel, *Cubism*. New York, NY: Museum of Modern Art, 1959.

Grabar, Oleg. *The Formation of Islamic Art*. New Haven, CT: Yale University Press, 1973.

Grant, Edward. *Much Ado about Nothing: Theories of Space and Vacuum from the Middle Ages to the Scientific Revolution*. Cambridge: Cambridge University Press, 1981.

Grant, Edward, trans. and ed. *The Condemnation of 1277: A Selection of Articles Relevant to the History of Medieval Science*. A Source Book in Medieval Science. Cambridge, MA: Harvard University Press, 1974.

Gray, Jeremy. *Ideas of Space: Euclidean, Non-Euclidean, and Relativistic*. 2nd edn. Oxford: Clarendon Press, 1989.

Gray, Jeremy. *Worlds Out of Nothing: A Course in the History of Geometry in the 19th Century*. London: Springer Undergraduate Mathematics Series, 2010.

Greenberg, Clement. 'Towards a Newer Laocoon'. *Partisan Review*, 7, no. 4 (July–August 1940): 296–310.

Greenberg, Clement. 'After Abstract Expressionism'. *Art International*, 6, no. 8, 25 October 1962, 30.

Hanover Historical Texts Project. *Concilium Tridentinum: Documenta Omnia*, 87. Documenta Catholica Omnia. https://www.documentacatholicaomnia. eu/03d/1545-1563,_Concilium_Tridentinum,_Documenta_Omnia,_EN.pdf. Accessed 2024.

Heindel, Max. *The Rosicrucian Cosmo-conception: Or, Mystic Christianity; An Elementary Treatise upon Man's Past Evolution, Present Constitution and Future Development*. Rosicrucian Fellowship, Oceanside, CA. London: L. N. Fowler, 1920.

Henderson, Linda Dalrymple. *The Fourth Dimension and Non-Euclidean Geometry in Modern Art*. Vauxcelles (aka 'Pincurrichio'), 'Le Carnet des ateliers: Le Pere du cubisme'. Le Carnet de la Semaine, IV. 29 December 1918.

Henderson, Linda Dalrymple. *The Fourth Dimension and Non-Euclidean Geometry in Modern Art*. Princeton, NJ: Princeton University Press, 1983.

Henderson, Linda Dalrymple. *The Fourth Dimension and Non-Euclidean Geometry in Modern Art*. Rev. ed. Cambridge, MA, and London: The MIT Press, [1983] 2013. Reintroduction.

Hildebrand, Adolf von. *The Problem of Form in Painting and Sculpture*. Trans. Max Meyer and Robert Morris Ogden. New York, NY, and London: G. E. Stechert and Co., 1907.

Hinton, Charles Howard. *Scientific Romances: First Series*. 1st edn. London: Swan Sonnenschein & Co., 1886.

Holy Bible, New International Version. Grand Rapids, MI: Zondervan, 2011. Colossians 1:15.

Hyde, James. 'Against Space'. *The Brooklyn Rail*, September 2017. https://brooklynrail. org/2017/09/art/AGAINST-SPACE. Accessed 2025.

Jeanneret, Charles-Édouard, and Amédée Ozenfant. *Après le cubisme*. Paris: Édition des Commentaires, 1918.

Judd, Donald. 'Specific Objects'. In *Donald Judd: Complete Writings 1959–1975*. New York, NY: New York University Press, 1975.

Kant, Immanuel. 'New Doctrine of Motion and Rest'. In *Natural Science*. Ed. Eric Watkins, trans. Lewis White Beck, Jeffrey B. Edwards, Olaf Reinhardt, Martin Schönfeld, and Eric Watkins. Cambridge: Cambridge University Press, [1758] 2012.

Kant, Immanuel. *Critique of Pure Reason*. Trans. Paul Guyer and Allen W. Wood. Cambridge: Cambridge University Press, 1998.

Kant, Immanuel. *Natural Science*. Ed. Eric Watkins, trans. Lewis White Beck, Jeffrey B. Edwards, Olaf Reinhardt, Martin Schönfeld, and Eric Watkins. Cambridge: Cambridge University Press, [1758] 2012.

Kemp, Martin. *The Fabrication of Leonardo da Vinci's Trattato della pittura*. London: Warburg Institute, University of London, 1989.

Kemp, Martin. *The Science of Art: Optical Themes in Western Art from Brunelleschi to Seurat*. New Haven, CT: Yale University Press, 1990.

Kennedy, Trinita, ed. *Sanctity Pictured: The Art of the Dominican and Franciscan Orders in Renaissance Italy*. London: Philip Wilson Publishers. Published in conjunction with the exhibition at the Frist Center, Nashville, TN, 2014.

Kepler, Johannes. *Harmonies of the World*. Apple Books ebooks. Trans. Charles Glenn Wallis, [1619] 1939. Global Grey ebook, 2019.

Kepler, Johannes. 'Letter (9/10 Apr 1599) to the Bavarian Chancellor Herwart von Hohenburg'. *Johannes Kepler: Life and Letters*. Ed. Carola Baumgardt and Jamie Callan. Oxford: Philosophical Library, 1953.

Kepler, Johannes. Mysterium Cosmographicum*: The Secret of the Universe*. Trans. A. M. Duncan. New York, NY: Abaris Books, 1981.

Kepler, Johannes. *New Astronomy*. Trans. William H. Donahue. Cambridge: Cambridge University Press, 1992.

Klein, Yves. 2004. *1928–1962 Selected Writings*. Trans. Barbara Wright. ubuclassics. Originally published, London: The Tate Gallery, 1974.

Klein, Yves. 'Lecture at the Sorbonne'. As quoted in *Overcoming the Problematics of Art: The Writings of Yves Klein*. Trans. with an introduction by Klaus Ottmann. Putnam, CT: Spring Publications, 2007.

Koyré, Alexandre. *From the Closed World to the Infinite Universe*. Baltimore, MD: Johns Hopkins University Press, 1957.

Krauss, Rosalind E. *Passages in Modern Sculpture*. New York, NY: Viking Press, 1977.

Krautheimer, Richard. *Lorenzo Ghiberti*. Vols 1 and 2. Princeton, NJ: Princeton University Press, 1983.

Kubler, George. *The Shape of Time: Remarks on the History of Things*. New Haven, CT: Yale University Press, 1962.

'Session 1'. Second Council of Nicæa. Ed. Labbe and Cossart, *Concilia*. Vol. 7, col. 53. Published in 787. www.newadvent.org/fathers/3819.htm. Accessed 2024.

Le Corbusier. *New World of Space*. Trans. F. S. Wight. New York, NY, and Boston, MA: Reynal & Hitchcock, 1948.

Le Corbusier. 'Five Points towards a New Architecture' (1926). In Ulrich Conrads (ed.), *Programs and Manifestos in Twentieth-Century Architecture*. Cambridge, MA: The MIT Press, 1970.

Le Corbusier. *Towards a New Architecture*. Trans. from the 13th French edn, with an introduction by Frederick Etchells. New York, NY: Dover Publications, 1986. Originally published as *Vers une architecture*, Paris: Les Éditions Crès, 1923; and in English, London: John Rodker, 1931.

Le Corbusier and Ozenfant. 'Purism' (1920). In Robert L. Herbert (ed.), *Modern Artists on Art: Ten Unabridged Essays*. 2nd, enlarged edn. New York, NY: Dover Publications, 2000.

Leadbeater, C. W. *The Astral Plane: Its Scenery, Inhabitants and Phenomena*. London: Theosophical Publishing House, 1895.

Leadbeater, C. W. *Clairvoyance*. London: Theosophical Publishing House, 1899.

Lessing, Gotthold Ephraim. *Laocoon: An Essay upon the Limits of Painting and Poetry. With Remarks Illustrative of Various Points in the History of Ancient Art*. Trans. Ellen Frothingham. Boston, MA: Roberts Brothers, 1887. Repr., New York, NY: The Noonday Press, 1957.

Lichtenstein, Jacqueline, and Christian Michel, eds. *Conférences de l'Académie royale de Peinture et de Sculpture. Tome III: Les Conférences au temps de Jules Hardouin-Mansart 1699–1711*. Paris: Beaux-Arts de Paris éditions, 2009.

Locke, John. *An Essay Concerning Humane Understanding*. Vol. 1. 1690. Based on the 2nd edn. Books 1 and 2. London: Eliz. Holt for Thomas Basset, 1690. Chapter XIII, section 10. Project Gutenberg. www.gutenberg.org/ebooks/10615. Accessed 2025.

Luther, Martin. *Table Talk*. Vol. 54, *Luther's Works*. Ed. and trans. Theodore G. Tappert. Minneapolis, MN: Fortress Press, 1967.

'Luther, Copernicus, and Models for Faith-Science Dialogue'. Lutheran Alliance for Faith, Science, and Technology. www.luthscitech.org/luther-copernicus-models-faith-science-dialogue/. Accessed 2024.

Lyfaber. 11 November 2008. lyfaber.blogspot.com/2008/11/st-bonaventure-on-veneration-of-images.htm. Accessed 2024.

Malraux, André. *Picasso's Mask*. Trans. June Guicharnaud with Jacques Guicharnaud. New York, NY: Da Capo Press, 1994. Originally published as *La tète d'obsidienne*, Paris: Gallimard, 1974.

Marinetti, Filippo. 'Manifesto of Futurism, 1909'. In *Futurist Manifestos*. Ed. and with an introduction by Umbro Apollonio, trans. Robert Brain, R. W. Flint, J. C. Higgitt and Caroline Tisdall. New York, NY: Viking Press, 1973.

Martin, Agnes. *Writings*. Ed. Dieter Schwarz. Winterthur: Kunstmuseum Winterthur. Quoted by Dieter Schwarz, 1992.

Masheck, Joseph. *Modernities: Art-Matters in the Present*. University Park, PA: Pennsylvania State University Press, 1993.

McEvilley, Thomas. 'Yves Klein, Messenger of the Age of Space'. *Artforum*, 20, no. 5, January 1982.

Meiss, Millard, and Tintori, Leonetto. *The Paintings of the Life of St. Francisco in Assisi with Notes on the Arena Chapel*. New York, NY: New York University Press, 1962.

Metzinger, Jean. 'Note sur la peinture'. 1910 in Mark Antliff and Patricia Leighten (eds), *A Cubism Reader: Documents and Criticism, 1906–1914*. Trans. by Jane Marie Todd with Jason Gaiger, Lydia Cochrane, Lois Parkinson Zamora and Ivana Horacek. Chicago, IL: Chicago University Press, 2008.

Morice, Charles. *Paul Gauguin*. Paris: H. Floury, 1919.

Newton, Isaac. *The Mathematical Principles of Natural Philosophy*. Trans. Andrew Motte. 2 vols. London: Printed for Andrew Motte, 1729.

Newton, Isaac. *A Selection from the Portsmouth Collection in the University Library, Cambridge*. Chosen, ed. and trans. A. Rupert Hall and Marie Boas Hall. Cambridge: Cambridge University Press, 1962; paperback edn, 1978.

Palazzoli, Daniele. 'Bit Arte Oggi in Italia / Art: What's Happening Today in Italy'. October/November, 1967, No. 5. As quoted in Press Release for 'Lucio Fontana', at Sperone Westwater Gallery, New York, 2000.

Panofsky, E. 'Der Begriff des Kunstwollens'. *Zeitschrift für Ästhetik Und Allgemeine Kunstwissenschaft*, 14 (1920): 321–39.

Panofsky, Erwin. *Renaissance and Renascences*. Stockholm: Almqvist & Wiksell, 1965. Also published by Norwich: Paladin, 1970, 10: Petrarch, Africa, IX, line 453ff., reprinted in Theodore E. Mommsen, 'Petrarch's Conception of the Dark Ages', *Speculum*, 17 (2): 226–42.

Panofsky, Erwin. *Perspective as Symbolic Form*. English trans. Christopher S. Wood. New York, NY: Zone Books, 1991. Originally published as 'Die Perspektive als 'symbolische Form', in *Vortrage der Bibliotek Warburg*, 1924–5.

Piles, Roger de. Dialogue sur le Coloris. Chez Nicolas Langlois, rue Saint-Jacques, à la Victoire, avec privilège du Roi, 1699.

Plato. *Symposium*. Trans. Benjamin Jowett, Project Gutenberg, 2008. www.gutenberg.org/ebooks/1600. Accessed 2024.

Plato. *Timaeus*. Elpenor, c. 360. https://www.ellopos.net/elpenor/physis/plato-timaeus/space.asp?pg=4. Accessed 2024.

Podro, Michael. *Manifold of Perception: Theories of Art from Kant to Hildebrand*. London: Oxford University Press, 1972.

Podro, Michael. *The Critical Historians of Art*. New Haven, CT, and London: Yale University Press, 1984.

Poincaré, Henri. *The Foundations of Science: Science and Hypothesis, The Value of Science, Science and Method*. Trans. George Bruce Halsted, 1913. Lancaster, PA: The Science Press, 1946. Originally published in French,1902 and 1908.

Pope-Hennessy, John Wyndham. *Paradiso: The Illuminations to Dante's Divine Comedy by Giovanni di Paolo*. London: Thames & Hudson, 1993.

Puttfarken, Thomas. *The Discovery of Pictorial Composition: Theories of Visual Order in Painting, 1400–1800*. New Haven, CT: Yale University Press, 2000.

Reinhardt, Ad. 'How to Look at Space'. *PM*, 29 January 1946.

Reinhardt, Ad. *Art as Art: The Selected Writings of Ad Reinhardt*. Ed. and introduced by Barbara Rose. New York, NY: Viking Press, 1975.

Reinhardt, Ad. *Art as Art: The Selected Writings of Ad Reinhardt*. Ed. Barbara Rose. Berkeley and Los Angeles, CA: University of California Press, 1991.

Rewald, John. 1990. *Seurat*. New York, NY: Harry N. Abrams Inc.

Richter, Gerhard. 'Interview mit Irmeline Lebeer, 1973'. In *Gerhard Richter: Text 1961–2007. Schriften, Interviews, Briefe*. Ed. Dietmar Elger and Hans Ulrich Obrist. Cologne: Walther König, [1973] 2008.

Riemann, Bernhard. 'On the Hypotheses Which Lie at the Bases of Geometry'. Trans. William Kingdon Clifford, *Nature*, 8, nos. 183, 184 (1873): 14–17, 36–7. Transcribed by D. R. Wilkins, Preliminary Version, December 1998.

Riemann, Bernhard. *On the Hypotheses Which Lie at the Bases of Geometry*. Ed. Jürgen Jost. Cham: Springer International Publishing, 2016. Quoting John Playfair (1748–1819), Introduction.

Rodman, Selden. *Conversations with Artists*. New York, NY: Devin-Adair, 1957. Quoted in Mark Rothko, *Writings on Art*, ed. Miguel López-Remiro. New Haven, CT: Yale University Press, 2006.

Rood, Ogden N. *Modern Chromatics, with Applications to Art and Industry*. New York, NY: D. Appleton and Company, 1879.

Rosenblum, Robert. *Frank Stella*. Harmondsworth: Penguin Books Ltd., 1971.

Rothko, Mark. *The Artist's Reality: Philosophies of Art*. Introduction by Christopher Rothko. Afterword by Makoto Fujimura. Ed. Christopher Rothko. New Haven, CT: Yale University Press, 2004.

Rubin, Patricia Lee. *Images and Identity in Fifteenth-Century Florence*. New Haven, CT: Yale University Press, 2007.

Rubin, William. *Frank Stella 1970–1987*. The Museum of Modern Art, New York. Distributed by New York Graphic Society Books / Little, Brown and Company, Boston, MA, 1987.

Rumohr, Carl Friedrich von. *Drey Reisen nach Italien: Erinnerungen*. Leipzig: F. A. Brockhaus. Trans. Francesco Mazzaferro. In '*From Carl Friedrich von Rumohr* [Three Journeys to Italy], 1832, Part Two'. *Letteratura Artistica: Cross-Cultural Studies in Art History Sources*. https://letteraturaartistica.blogspot.com/. Accessed 2025.

Rumohr, Carl Friedrich von. 'On Giotto'. In Gert Schiff (ed.) and trans. Peter Wortsman, *German Essays on Art History*. London: Continuum. The German Library, published in cooperation with Deutsches Haus, New York University, 1988.

Rumohr, Carl Friedrich von. *The Essence of Cookery*. Trans. Barbara Yeomans. London: Prospect Books, 1993.

Ruskin, John. *Modern Painters*. Vol. 1. 2nd edn. London: George Allen, 1904.

Ruskin, John. *Modern Painters*. Vol. 1. New York, NY: John Wiley and Sons, 1879.

Ryman, Robert. 'On Painting'. In *Robert Ryman*. Ed. Christel Sauer and Urs Raussmüller. Schaffhausen: Hallen für neue Kunst, 1991.

Saint-Point, Valentine de. '"Futurist Manifesto of Lust, 1913". In Mary Ann Caws (ed.), *Manifesto: A Century of Ism*. Lincoln, NE: University of Nebraska Press, 2001.

Saint-Point, Valentine de. 'Manifesto of Futurist Woman, 1912'. In Mary Ann Caws (ed.), *Manifesto: A Century of Isms*. Lincoln, NE: University of Nebraska Press, 2001.

Schönberg, Nicholas. *Letter to Copernicus*. 1 November 1536. Trans. Edward Rosen, 1472–1537. WebExhibits, www.webexhibits.org//calendars/year-text-Copernicus.html. Accessed 2024.

Schriften, Interviews, Briefe. Ed. Dietmar Elger and Hans Ulrich Obrist. Cologne: Verlag der Buchhandlung Walther König, 2008.

Schwarz, Michael Viktor. *Giotto the Painter, Volume 2: Works*. Vienna: Böhlau Verlag, 2023.

Signac, Paul. *D'Eugène Delacroix au néo-impressionnisme*. 3rd edn. Paris: H. Floury, Libraire-Editeur, 1921.

St Augustine. *Confessions*. Book VI, chapter XIV. Trans. Albert C. Outler. Grand Rapids, MI: Christian Classics Ethereal Library.

St Augustine. Confessiones. Liber III, Caput VII. Georgetown University Faculty Web Pages. 'et utrum forma corporea deus finiretur, et haberet capillos et ungues'. faculty.georgetown.edu/jod/latinconf/latinconf.html. Accessed 2024.

St Bonaventura. *The Life of Saint Francis*. London: Published under the auspices of the International Society of Franciscan Studies, J. M. Dent and Co. Aldine House, 1905.
'St. Bonaventure on the Veneration of Images'. *Lyfaber*, 11 November 2008. lyfaber.blogspot.com/2008/11/st-bonaventure-on-veneration-of-images.htm. Accessed 2024.
Steinberg, Leo. *Leonardo's Incessant Last Supper*. New York, NY: Zone Books, 2001.
Stella, Frank. *Working Space*. Cambridge, MA, and London: Harvard University Press, 1986.
Stella, Frank. 'Grimm's Ecstasy'. (1991). In *The Writings of Frank Stella / Die Schriften Frank Stella*. Cologne: König. Published on the occasion of the exhibition *Heinrich von Kleist by Frank Stella*, Galerie der Jenoptik AG und ehemalige Arbeiter- und Bauern-Fakultät vordem Thüringer Oberlandesgericht, 27 March–4 June 2001. Originally published in Bonnie Clearwater and Frank Stella, *Frank Stella at Two Thousand: Changing the Rules*. Miami, FL: Museum of Contemporary Art, 2000.
Stella, Frank. 'Feature Title'. *Artforum*, 42, no. 2, October 2003, 230.
The Council of Trent: The Canons and Decrees of the Sacred and Oecumenical Council of Trent. 1848. Ed. and trans. J. Waterworth. London: Dolman.
The Oxford Dictionary of Art. Ed. Ian Chilvers. 3rd edn. Oxford: Oxford University Press, [1988] 2004.
'The Second Council of Nicaea of 787'. Papal Encyclicals Online, www.papalencyclicals.net/councils/ecum07.htm. Accessed 2024.
Thomas of Celano. *The First Life of St Francis*. Trans. A. G. Ferrers Howell. London: Methuen, [c. 1229] 1908. http://franciscanseculars.com. Accessed 2024.
Thomas of Celano. *First Life of St. Francis of Assisi*. Trans. with an introduction and notes by Christopher Stace. London: Society for Promoting Christian Knowledge, 2000.
Tomkins, Calvin. *Marcel Duchamp: The Afternoon Interviews*. New York, NY: Badlands Unlimited, 2013.
Vallier, Dora. 'L'intérieur de l'art, entretiens avec Braque'. *Cahiers d'Art*, 29, no. 1 (1954): 13–24.
Vasari, Giorgio. *Lives of the Painters, Sculptors and Architects*. Trans. Gaston du C. de Vere. London: Macmillan and Co. and The Medici Society, [1568] 1912–14.
Vasari, Giorgio. 'Giovanni Cimabue'. In *Lives of the Most Eminent Painters, Sculptors & Architects*. Newly trans. Gaston Du C. De Vere, 10 vols. London: Macmillan and Co., Ltd. and The Medici Society, Ltd., 1912–14.
Vitruvius. *The Ten Books on Architecture*. Trans. Ingrid D. Rowland. Cambridge: Cambridge University Press, 1999.
Voelkel, James R. *Johannes Kepler and the New Astronomy*. Ed. Owen Gingerich. Oxford and New York, NY: Oxford University Press, 1999.
Wells, H. G. *The Plattner Story and Others*. London: Methuen, 1897.
Westfall, Richard S. *Never at Rest: A Biography of Isaac Newton*. Cambridge: Cambridge University Press, 1983.
Wölfflin, Heinrich. *Renaissance and Baroque*. Trans. Kathrin Simon. Ithaca, NY: Cornell University Press, 1964.

Index

Page numbers in **bold** refer to figures.

Abbott, Edwin, *Flatland*, 3, 200–1, 282
absolute space, 142, 143, 143–4, 148, 151, 155
abstraction, 241–4, **242**, **243**
Académie Royale de Peinture et de Sculpture, 83, 84, 161, 164, 193
acuity perspective, 168
aerial perspective, 80, 84, 168
Agamben, Giorgio, 121
Albers, Josef, 3, 237
Alberti, Leon Battista, 33–4, 55, 60, 80, 82, 87, 99, 241–2, 245
 conception of perspective, 74, 76–7
 De pictura, 8, 28–9, 63, 67–76, **69**, **72**, **73**, 76–7, **76**, 159
 De re aedificatoria (On the Art of Building), 61
 and *istoria*, 74–5
 model for painting, 70–2, **72**, **73**
 on space, 72–5
 vision rays, 68, 71, **72**, 74
 window paradigm, 67–70, **69**, 72
Allegri da Correggio, Antonio, *Vision of St John on Patmos*, 123–4, **124**
altarpieces, 39
Apianus, Petrus, *Cosmographia*, 95–6, **96**
Apollinaire, Guillaume, 194, 195
architecture and architectural space, 3, 179–81, 228–34, **229**, 245, 274
Aristotle, 1, 2, 111–2, 112, 119, 132–3, 140, 143
 concept of Place, 88, 91–9, 101, 103, 107
 the Cosmos, 88, 93, 94–7, **95**, **96**, 127
 Metaphysics, 94
 'On the Heavens', 91
 Physics, 88, 91, 94
 Sóma, 92, 92–3
 Chora, Diastema & Kenos, 92
 Tópos, 91–3

Arnolfo di Cambio, Plate with his Sculpture 11
Arp, Jean, 225
art historians, twentieth-century, 257–60
art history
 central tradition of German-language art history, 171–85
artistic mode, 4, 191, 233, 237, 244, 264–5, 268
artistic vanity, 14
artists, Hildebrand's space for, 184–85
Auerbach, Erich, 17–8
 Mimesis, 45
Augustine of Hippo, St, 18, 88, 99–101, 103, 107, 132, 155, 160
authorship of the frescoes in San Francesco, 46–7

Bachelard, Gaston, 252
Baroque architecture, 180–1
Basilica San Marco, Venice, 14
Baumgarten, Alexander Gottleib, 167
Baxandall, Michael, 14, 71, **72**
Belting, Hans, 22
Berenson, Bernard, 182, 238, 255–6
Berger, John, THE SUCCESS AND FAILURE OF PICASSO, 193, 213–4
Bernard of Clairvaux, St, 18
Blackalicious, Gil Scott-Heron
Boccaccio, Giovanni, 10
Boccioni, Umberto, 220
 Spiral Expansion of Muscles in Action, 220, **221**
Body: in Place (Aristotle), 93; extended, (Decartes),133; deracinated, (Decartes), 133, 134 plenum of corpusles (Decartes), 132; relational (Leibniz), 146, 147; as opposed to place and space, (Locke), 139, 140; as opposed to place and space, (Newton, 141–42

Bolyai, Janos, 198, 199
Bonaventure, St, 20–1, 50, 99
Boniface VIII, Pope, 54
Borromeo, Carlo, 83
Boullée, Etienne-Louis, 151
Bourdon, Sebastien, 84
Brancusi, Constantin, 237
 Bird in Space, 3, 239, **240**, 241
Braque, Georges, 194, 206, 207, 208–10, 211–2, 213–4, 216–7
 Fox, 214, 216, **216**
 La Mandore, **211**, 212–3
 Maisons à L'Estaque, 212, **213**
Bruno, Giordano, 88, 114, 115, 119–26, **125**, 129, 133, 140, 204, 219
 The Ash Wednesday Supper, 121–2
 De l'Infinito, Universo e Mondi, 121
 One Hundred and Sixty Articles against the Mathematicians and Philosophers of This Time, 125, **125**
 and painting, 123–5
 Songs of Circe, 120
Buffalmacco, Buonamico, 57, 58
Burckhardt, Jacob, 2, 183, 190, 245
 Der Cicerone: Eine Anleitung zum Genuss der Kunstwerke Italiens, 173–9, 259
Burroughs, William, 263

Caravaggio, 83, 271–2
Cartesian space, 132–5, **134**, 147
Casey, Edward S., 97
Charlemagne, 61
Chevreul, Michel Eugene, 196–7
Christian Painting
 Cimabue San Francesco murals, 26, 28–30, 31, 32
 essentials, 37–8
 function, 38
 Monreale, Sicily, 35–7, 40
 physicality and tactility, 30–1
 and place, 97–101, 284
 presentational framework, 25–8
 simplicity, 39
 symmetry, 30
 traditional, 31–3, 37–8, 39, 50, 87
 transformations in, 38–40
 see also icons; *istoria*

Cimabue (Bencivenni di Pepi), 14, 25, 46
 The Madonna and Child, 29–30
 San Francesco murals, 26, 28–30, 31, 32, 39
Clarke, Samuel, 145–6
Classicism and the Classical Revival, 1–2, 10–2, **11**, 22, 58, 60, 65
Cocteau, Jean, 225
color perspective, 80
color theory, 195–7
Composition, invention as a term in painting, 72–73
Constantinople, sack of, 1204, 14
Constructivists, 3, 4
Copernicus, Nicolaus, 96, 120, 132
 De revolutionibus orbium coelestium, 114–6, **116**
Coppo di Marcovaldo, 49
Correggio, 123, Figure 15, 124 176–7, 178–9
Cosmos, the, 88, 93, 94–7, **95, 96**, 103, 174–5, **175**
 St Augustine model, 99–101
 Bruno and, 120–1
 challenges to geocentricism, 113–4
 Copernican, 114–6, **116**
 Giovanni di Paolo's, 103–4, 109–11
 mathematization of, 126–31, **129, 131**
Counter-Reformation, 83
Cristus Patiens, 20–1, 49, 83
Cristus Triumphans, 20–2
crucifix icons, 12–4, **13**, 20–2
crusades, the, 112
Cubism, 3, 190, 206, 225, 227, 234, 241
 celebration of space, 193
 foundational works, 208
 geometry, 197–200
 mathematics, 197–203, **202**
 scientific basis, 194, 195–7
 and space, 193–5, 197, 207–14, **211, 213, 215**, 216–8, **216**
Cultural, Social and Practical Forces, 1–2, 14–5

Dada, 225, 226
Dante Alighieri, 14, 25
dark ages, the, 10
De Chirico, Giorgio, *Metaphysical Paintings*, 220–1

de Piles, Roger, 196
 Balance de peintres, 164
 Cours de peinture par principes avec un balance de peintres, 162, **163**, 164–5, 166, 168, 169
de Saint-Point, Valentine, 219–20
Delacroix, Eugene, 181, 195
Democritus, 91, 94, 99, 123, 132
Descartes, René, 88, 139, 141, 147
 La Géométrie, 132–5
 Principiorum Philosophie, **134**, 135
diagrammatical perspective, 60, 64–65
diagrams and diagramming, 63–5, **65**
Dimensionism, 234–5
discursive space, 260, 263–5
Divisionists, 193–4, 195, 196, 207
Donne, John, 129
drawing, 162
Du Bos, Jean-Baptiste, 166
Duchamp, Marcel, 207–8, 216, 217, 227, 228
Duchamp-Villon, Raymond, 228–9, **229**
Duhem, Pierre, 111

Eden, the Expulsion from, 103–4, 108, 109, 109–10
Einhard, 61
Einstein, Albert, 149, 234, 285
Elias of Cortona, 13–4, 14, 26
Ellipitic Geometry 198
Elvira, Synod of, 97
Epicurus, 91, 99, 112, 132
Euclid, 151, 198, 200
 Elements, 64

Fauves, the, 195, 207
Félibien, André, *Des principes de l'architecture, de la sculpture, de la peinture, et des autres arts qui en dépendent: Avec un dictionnaire des termes propres à chacun de ces art*, 161–2, 166
flatness, 264, 265–6, 270
Flusser, Vilém, *Into the Universe of Technical Images, Gestures*, 282–3, 285
Fontana, Lucio, 3, 4, 237, 245, **249**, 250, 252, 254, 257, 265, 272
 Ambiente spaziale a luce nera (Spatial Environment in Black Light), 248–9
 Ceramica Spaziale, 247, **247**
 Concetto Spaziale, 247
 Manifiesto Blanco, 246
form, Hildebrand's, and space, 182–5
Foucault, Michel, 277, 281, 282
fractal geometry, 273
Francis of Assisi, St, 8, 14, 17–20, 21, 22, 26, 47–53
fresco, 28, 43, 46
Fried, Michael, 267, 268, 269
Futurism, 209, 218–21, 226, 239, 248

Galileo Galilei, 114, 132
Gauguin, Paul, 195, 197, 207
Gauss, Carl Friedrich, 197–8
Gautier de Metz, 94–5, 103
General Relativity, Theory of, 149, 234
Genius, 1–2
'geometric space' vs 'perceptual space' (Poincare), 204–6
geometry, 3, 52, 64, 71, 126–7, 130, 132, **134**, 142, 152, 190–1, 194, **202**, 214, 227
 Cubism, 197–200
 fractal, 273
 Hyperbolic, 198
 non-Euclidean, 198–9, 204–6
 Riemannian, 199–200, 209, 228, 234, 255, 275
Gesamtkunstwerk, 248
Ghiberti, Lorenzo, 60, 77, 80
Giedion-Welcker, Carola, 259, 263
Giese, Tiedemann, Bishop, 114
Giotto Bondone, 1, 8, 25, 40, 59
 Boccaccio on, 10
 Burckhardt on, 174
 depiction of empyreum heaven, 97, Plate 21
 Isaac story frescoes attribution, 46–7
 the *Navicella*, 8, 53–7, **56**, 74, 87
 Rumohr on, 172
 San Francesco murals, 26, 28, 159
 Scrovegni Chapel, 53, 55, 57, 96–7
Giovanni di Paolo, 105
 Guelfi Altarpiece, 103–4, 105, 106–11

Metropolitan Museum of Art
 mistitling of The *Creation and the Expulsion* 104–106
Giunta Pisano, 28, 47, 48
 Crucifix, Basilica of Saint Dominic, 12–4, **13**, 14, 21, 22
Giusto de' Menabuoi, 104–5
Gleizes, Albert, 210, 227
 Du "Cubisme", 194, 195, 217–8
 Christian God, 99–101, 103, 103–5, 106–7, 109–11, 112, 120, 123, 127, 131, 132, 141, 145–6, 155, 160, 174–5, **175**, 204
Gothic style, 26–7, 39
Grayson, Cecil, 73
Greenberg, Clement, 264–6, 268–70
Guelfi Altarpiece (Giovanni di Paolo), 103–4, 105, 106–11
Guericke, Otto von, 88, 135–6
 De Vacuo Spatio, 136

Heindel, Max, 252
heliocentrism, 114–6, **116**, 120
Hermeticism, 121
Hesiod, 92–3
Hildebrand, Adolf von, 2–3, 4, 181–5, 190, 218, 228, 233, 255
 Philoctetes, 183, **184**, 220
 The Problem of Form in Painting and Sculpture, 182–5, 194–5, 217, 238, 239
Hinton, Charles Howard, *The Fourth Dimension*, 201, **202**, 203
Hogarth, William, *Enthusiasm Delineatd*, 164, **165**
Huygens, Christiaan, 204
Hyperbolic Geometry, 198

Ibn Rushd (Averroes), 107–8, **108**
iconodulity, 30–1
icons, 12–4, **13**, 33–4, 38, 47, 99
 crucifix, 12–4, **13**, 20–2
 power of, 22
illusion and illusionism, 9–10, 9, 243–4, **243**, 274–5
Impressionism, 193–4, 195, 196
Individual Genius, 9, 12–4, **13**
infinite extension, power of, 123, 129
infinite space, 88, 119–26, **125**
information, and space, 281–3
Ingres, Jean-Auguste-Dominique, 58

Islamic Place and artistry, 91
 'Saracen style', 26–27
istoria, 8, 33–4, 34–5, 37, 38, 39, 43–7, 68
 Alberti and, 74–5, 99
 Bruno and, 125
 Giotto's new structure, 57–8
 the *Navicella*, 53–7, **56**
 pictorial strictures, 51–2
 St Francis cycle, 43, 46, 47–53

Jouffret, Esprit, *Traité élémentaire de géométrie à quatre dimensions*, 211–2, **211**, 214, **215**, 217
Judaism, and opposition to images, 97
Judd, Donald, 267–8, 269, 276

Kandinsky, Wassily, 204
Kant, Emmanuel, 1, 2, 151–6, 171, 175, 176, 181, 185, 190, 199, 238, 281
 'Concerning the Ultimate Ground of the Differentiation of Directions in Space', 152–3
 Critique of Pure Reason, 153–4
 God, 155
 'New Doctrine of Motion and Rest', 152
 Transcendental Idealism, 154
Katz, Alex, 281
Kemp, Martin, 83
Kepler, Johannes, 127–31, 132, 134–5, 142, 143
 Astronomia nova, 129–31, **131**
 Mysterium Cosmographicum, 127–9, **129**
Klein, Yves, 4, 237, 245, 250–3, **253**, 254, 257, 265, 268
 Anthropometrie de l'époque bleue, 251
 Anthropometry paintings, 251–2
 Ex-Voto per Santa Rita da Cascia (The Saint of Lost Causes), 252
Klint, Hilma af, 197, 204
Krauss, Rosalind, *Passages in Modern Sculpture*, 258–60, 263
Kupka, František, 197

Le Corbusier, 180–1, 225–7, 227, 234–5
 Les Cinq points d'une architecture nouvelle, 230
 New World of Space, 232–4
 Vers une architecture, 228–32, **231**
Leadbeater, Charles Webster, 203

Leibniz, Gottfried, 88–9, 161, 166, 189
 conceptions of space, 146–9
 dispute with Newton, 144–6, 148–9, 152
Leonardo da Vinci, 8, 60, 127–8, 168
 conception of perspective, 77, 80, **81**
 Last Supper, 39–40, 58
 legacy, 82–4
 notion of space, 81–2, 84
 Traité de la peinture, 161, 193
 Trattato di pittura, 79, 82
 Vitruvian Man, 61
Lessing, Gotthold Ephraim, 166–7, 168, 189, 258–9, 264
linear perspective, 80, 242–3
Lissitsky, El, 244
liturgical theater, 45
Lobachevsky, Nikolai Ivanovich, 198, 199
Locke, John, 88, 131, 139–41, 141, 152, 154, 161
Lorenzetti, Ambrogio, 57, 58
Louis XIV, King, 84
Lucretius, 112
Luini, Bernardino, 82
Copernicus, Martin, 114, **116**

Mandelbrot, Benoit, 273
Mannerists, 83
Marinetti, Fillipo, 'Manifesto of Futurism', 218–9
Martin, Agnes, 281
Marx, Karl, 122
mathematics, 3, 71, 115, 126–31, **129**, **131**, 134–5, 141–9, **150**, 151, 190–1, 197–203
Maxwell, James Clerk, 204–5
Melzi, Francesco, 79
metaphysics, 130, 132, 139–41, 142, 147, 155, 189, 284–6
methodology, 1
Metzinger, Jean, 208, 210–1, 212, 227
 Du "Cubisme", 194, 195, 217–8
Michelangelo, 12, 83
Minimalism, 265, 267, 268
 minaturazation, Gothic style, 39
Minkowski, Hermann, 234
Modernism, 226
Moholy-Nagy, László, 237, 241–2, 245
 A II, 242–3, **242**, 244
Mondrian, Piet, 241, 270, 275

Monreale, Sicily, 35–7, 40, 45, 53
More, Thomas, St, *Utopia*, 113, 113–4
multidimensional space, 3, 199–200, 200–3, **202**, 227, 275

Naturalism, 1–2, 9–10, 10, 59
Nature, representation of, 9–10
'negative space', 183
Neoclassicism, 225–6, 226
Newman, Barnett, 181
Newton, Isaac, 3, 88–9, 131, 161, 166, 167, 189, 204
 conception of space, 141–9, **150**, 151, 155
 dispute with Leibniz, 144–6, 148–9, 152
 God's sensorium, 141, 143–5, 145–6
 mechanical frame, 141
Nicaea, Second Council of, 33, 98–9
Nicholas of Cusa, 123
Nicola Pisano, 10–1
 Presentation of the Christ Child in the Temple, **11**
non-Euclidean geometry, 198–9, 204–6

Ozenfant, Amédée, 225–7, 227, 228

Padua, 104–5
Padua, Scrovegni Chapel, 53, 55, 57
painting
 object of, 165–7
 principles of, 161–2
 space within, 167–9
 truth of, 173
 vocabulary, 161, 164–5
Panofsky, Erwin
 historicization of perspective, 271–2, 241, 238
 influence, xvi, 3, 238, 259, 269–70
 171–2, "Perspective as Symbolic Form" 3, 67–8, 237–8, 271
 St Denis, 26, 27, 35, 39
perspectival space, 60, 64–5
perspective
 acuity, 168
 aerial, 80, 84, 168
 Alberti's conception of, 74, 76–7
 color, 80
 construction of, 2

304 *Index*

diagrammatical, 65
Leonardo's conception of, 77, 80, **81**
linear, 80, 242–3
Renaissance, 65
Vitruvius on, 62–3, 64–5
Petrarch (Francesco Petrarca), 10, 12
Picasso, Pablo, 194, 206, 207–8, 210–1, 211–2, 213–4, 216–7, 225
 Femme nue, 212, **213**
 Nature morte a la bouteille de marc, 214, 216, **216**
pictorial space, 2
 first appearance, 2, 173–6
 and real space, 245–57
 Stella and, 271, 273–6, 277
Piero della Francesco, 69, 77, 80, 82, 127–8
Pietro di Puccio, 174–5, **175**
Pissarro, Camille, 194
Place
 Aristotelian model, 2, 88, 91–9, 101, 103, 107
 artistic significance, 97
 and Christian Painting, 97–101
 and Christian painting, 284
 decentring of, 103–16, 154–5, 159–60, 174–5, 285
 logic of, 88
 potency of, 95, 110
 status diminished, 139–40
Plato, 110–1, 127
Pliny the Elder, 9
Podro Michael, 182
 The Critical Historians of Art, 171, 172–3, 238
Poincaré, Jules-Henri, 1, 3, 210–1, 227, 228
 Science and Hypothesis, 204–6
 and Cubism, 206, 210–11, 217, 227–8
 conventionalism, 206232, 244
 'perceptual space' as opposed to 'geometric space'
Poussin, Nicholas, 79, 83–4
Primitivism, 195, 207, 212
Ptolemy, 115
punchbowl, Kepler's, 128
Purism, 225–6, 227–8, 234

Raum, 175–6, 178–9, 179, 180–1, 220
Raumgefühl, 174, 177, 178–9, 179, 181, 190, 245

Ravenna, Sant'Apollinare Nuovo, Basilica, 32–3, 34–5
'real space', 265, 265–9, 273, 276, 277
 and pictorial space, 245–57
Realism, 9, 21
Reinhardt, Ad, 263–4, 267
relational space, 146–9
relative space, 142–3
Renaissance perspective, 7, 62–5, 67–8, 71, 75, 80–1, 87, 160
Richter, Gerhard, 281
Riemann, Bernard, 190–1, 199–200, 255
Riemannian geometry, 199–200, 209, 228, 234, 255, 275
Romanesque, the, 27–8
Rome
 Santa Costanza, 31–2
 Santa Maria Maggiore, 34–5, 36, 37
 St Peter's Basilica, 8, 53–7, **56**
Rosicrucianism, 252
Rothko, Mark, 4, 237, 254–7, 263, 265
Rumohr, Carl Friedrich von, 172–3
Ruskin, John, 171, 190
 Modern Painters, 167–9, 179
 Seven Lamps of Architecture, 179
Ryman, Robert, 31, 281

St Denis, Paris, 26, 27, 35, 39
St Francis cycle, San Francesco, Basilica, Assisi, 43, 46, 47–53
St Peter's Basilica, Rome, 8, 53–7, **56**
Salon Cubists, the, 216–8
San Damiano crucifix, PLATE 2, xiii 20–2
San Francesco, Basilica, Assisi
 architecture, 27–8
 Cimabue murals, 26, 28–30, 31, 32, 39
 Giotto murals, 26, 28, 43, 46, 47–53, 159
 Isaac story frescoes, 43–7
 The Madonna and Child, 29–30
 presentational framework, 25–8
 St Francis cycle, 26, 28, 43, 46, 47–53, 159
Santa Costanza, Rome, 31–2
Santa Maria Maggiore, Rome, 34–5, 36, 37
Sant'Apollinare Nuovo, Basilica, Ravenna, 32–3, 34–5
scenography, 62–3

Schönberg, Nicholas, 114
Schrödinger's cat, 285
Schwarz, Michael Viktor, 54
Schwitters, Kurt, Merzbau, 248
Scrovegni Chapel, Padua, 55, 57, 96–7
Seurat, Georges, 194, 195, 196
Signac, Paul, 194, 195, 196, 197
Sinisgalli, Rocco, 73
Société Nationale des Beaux-Arts, 181
Sóma, 92–3
space
 absolute, 142, 143, 143–4, 148, 151, 155
 architecture and architectural, 179–81, 228–34, 245
 Hildebrand's space for artists, 2–4, 181–5, 190, 194–5, 207, 217–9, 220, 228, 231, 233, 238, 239
 Augustine's deistic conception, 99–101, 103
 axes of, 237
 and body, 132–5, **134**
 Cartesian, 132–5, **134**, 147
 Cubist, 193–5, 197, 207–14, **211**, **213**, **215**, 216–8, **216**
 definition, 3–4
 discursive, 4, 260, 263–5
 dissolution of, 276–7
 enters discussions about art, 2–4, 165–85, 193–5, 193–218
 experimental, 139–41
 feeling for, 174, 177, 190
 and form, 182–5
 geometric, 204–6
 German-language tradition, 171–85
 Giotto's depiction of, 97
 Hildebrand and, 181–5, 190, 194–5
 infinite, 88, 119–26, **125**
 and information, 281–3
 Kant's conception of, 151–6
 lack of allegorical figure, 88
 Leibniz's conceptions of, 146–9
 Leonardo and, 81–2, 84
 mathematization of, 126–31, **129**, **131**, 134–5, 141–9, 151
 multidimensional, 199–200, 200–3, **202**, 227, 275
 naturalization, 238
 Newton's conception of, 141–9, **150**, 151, 155
 nineteenth-century imaginations of, 200–3, **202**
 oxymoronic, 183
 Panofsky's, 67
 perceptual, 2, 204–6
 Poincaré's, 204–6
 power of, 101
 proliferation of, 277
 real, 245–57, 265, 265–9, 273, 276, 277
 relational, 146–9
 relative, 142–3
 representations of Newton's, 149, **150**, 151
 Riemannian geometry, 199–200
 Rothko on, 254–7
 spiritual, 203–4
 Stella and, 269–77, **273**
 and the studio, 283–4
 tactile, 256–7, 263, 265
 triumph of, 139–41, 159–60, 286
 truth of (Ruskin), 167–9
 twentieth-century art historians of, 258–60
 twentieth century pictorial roots:
 1. science/ technology.
 2. philosophy/ metaphysics and
 3. spirituality/ religion, 3, 6, 233–4, 246, 252, 263, 265, 268
space-time, 234–5
spatial empiricism, 139–41
spatial extension, 3, 248–9, 252
spatialist revisionism, 15
spatium, 73, 74, 92, 94, 99–101, 103, 119, 161, 178–9, 220
Spazialismo, 246–9, **247**, **249**
spiritual space, 203–4
Stefaneschi, Cardinal Jacopo, 55
Steinberg, Leo, 39–40
Stella, Frank, 265, 269–72, 276–7
 Black Paintings, 269, 270
 Indian Birds series, 270
 and pictorial space, 273–6, 277
 Raft of Medusa, Part I, 272, **273**
 Working Space, 270–1, 272, 272–6
stigmata, 19–20
studio, the, 283–4
studio metaphysics, 284–6
Subiaco, 48, **48**
Suger, Abbe, 26, 35, 39

Tabula Peutingeriana, 94, **95**
tactile space, 256-7, 263, 265
tactility, 30-1, 44
Taylorism, 226
Tempier, Etienne, Bishop of Paris, Condemnations, 106-12, 123
Theosophy, 203
Thomas Aquinas, St, 33-4, 107-9, **108**
Thomas of Celano, 19, 50
time, 285
Titian, 177
Tópos, 91-3, 112, 113, 133
Transcendental Idealism, 154
Trent, Council of, 30-1

Urania, Muse of astronomy, 130-1, **131**
Utopia, 113

vacuum, 135-6
Vasari, Giorgio, 12, 21, 25, 28, 29

Vauxcelles, Louis, 195, 210-1
viewing point, 52-3
vision, pyramid of, 68-9, 69-70, **69**
vision rays, 71, **72**, 74
Vitruvian Man, 61, 64, **65**, 87
Vitruvius, 82, 100, 160
 De architectura, 60, 61-5, **65**, 87, 94
 diagrams and diagramming, 63-5, **65**
 on perspective, 62-3, 64-5
void, the, 92, 132-3, 139

Warburg, Aby, 182
Warhol, Andy, 281
Wells, H. G., 201-2
Winckelmann, Johann Joachim, 166
window paradigm, 67-70, **69**, 72
Wölfflin, Heinrich, 179-81, 182, 183, 228
Wren, Christopher, 26

Zöllner, Johann Karl Friedrich, 203

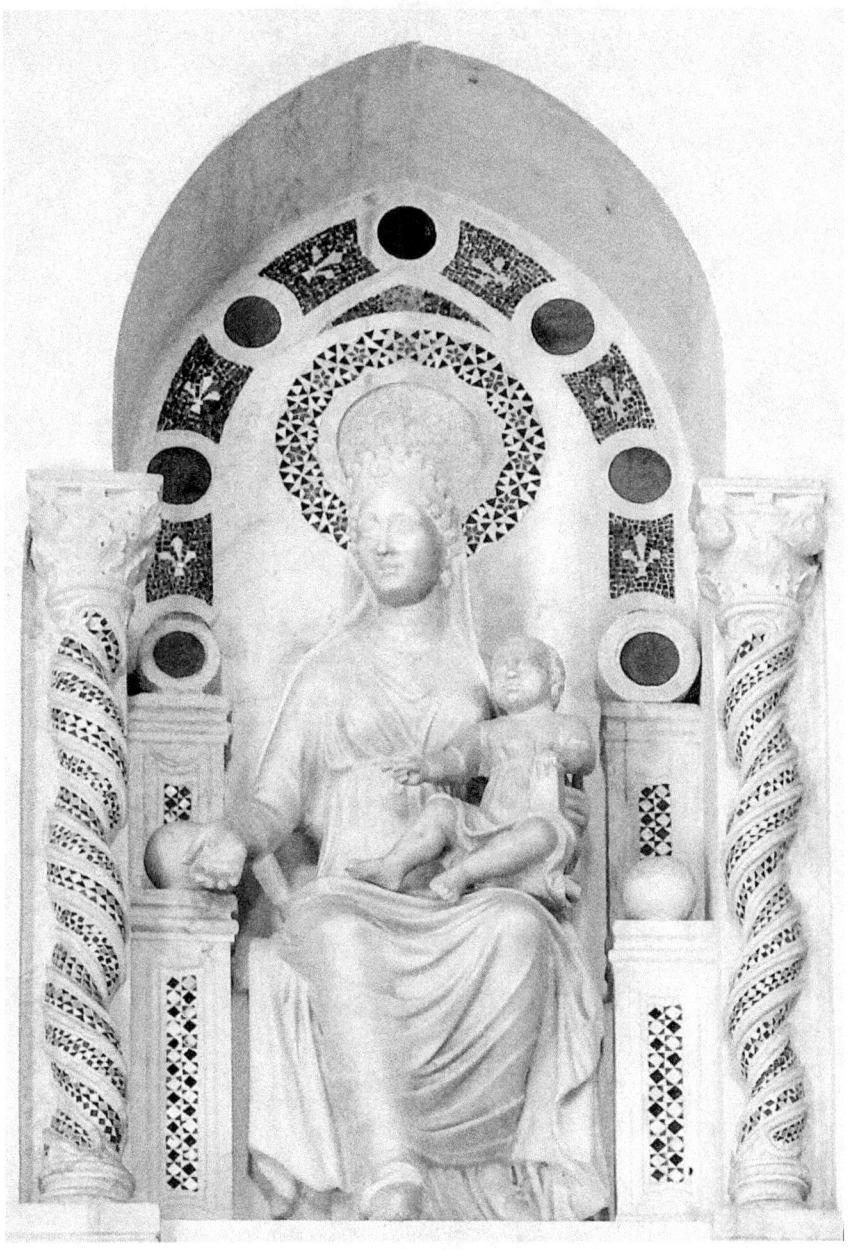

Plate 1 Arnolfo di Cambio, Detail of Tomb Monument for Cardinal de Braye, San Domenico, Orvieto, *c.* 1282.

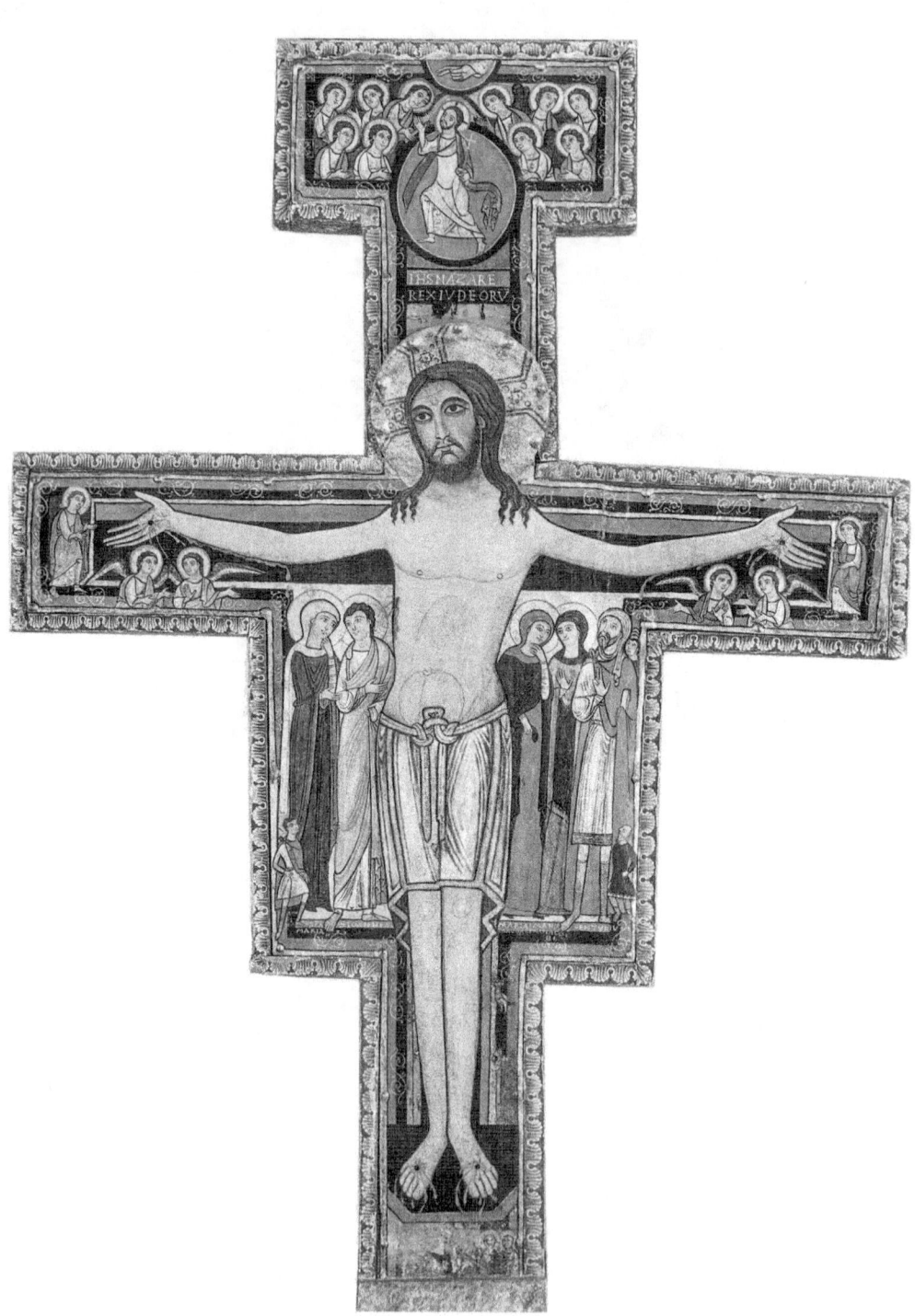

Plate 2 San Damiano Cross, tempera, on wood panel, 70 × 50 in, Basilica Santa Chiara, Assisi, twelfth century.

Plate 3 Giotto, Legend of St Francis: Panel 4. Miracle of the Crucifix, fresco, Basilica San Francesco, Assisi, 106 × 90 in, 1297–9.

Plate 4 Cimabue, Christ and Madonna Enthroned, fresco *secco*, east wall of the nave, 10 × 106 in, Upper Church, San Francesco, Assisi, 1277–80.

Plate 5 Cimabue, The Madonna and Child (Maestà), fresco *secco*, Lower Basilica San Francesco, Assisi, c. 1280.

Plate 6 *Tradio Legis*, Christ giving the Law to St Paul as St Peter awaits the keys to the church, mosaic, Santa Costanza, Rome, fourth century.

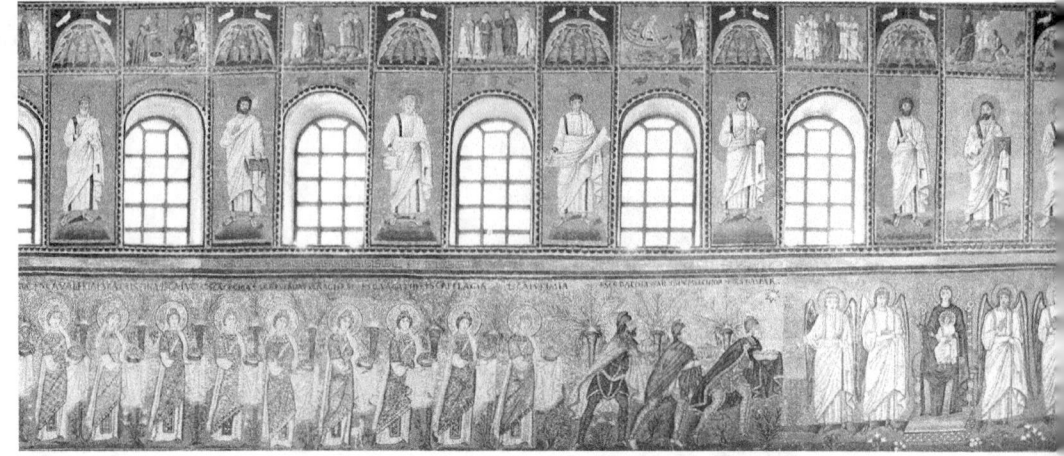

Plate 7 North wall of the nave, mosiac, Basilica of Sant'Apollinare Nuovo, Ravenna, sixth century.

Plate 8 View of the nave facing the apse, Basilica of Sant'Apollinare Nuovo, Ravenna, sixth century. The ap is a twentieth-century reconstruction of a Baroque renovation.

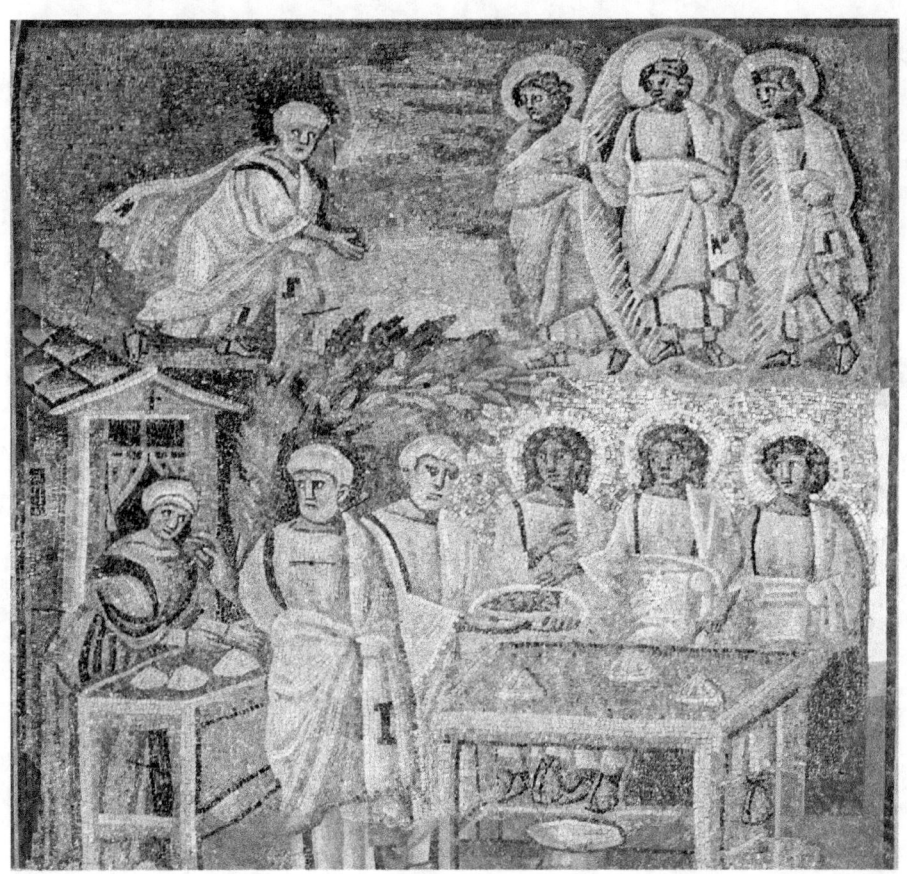

Plate 9 The Hospitality of Abraham, *istoria* mosaic, Santa Maria Maggiore, Rome, 432–40.

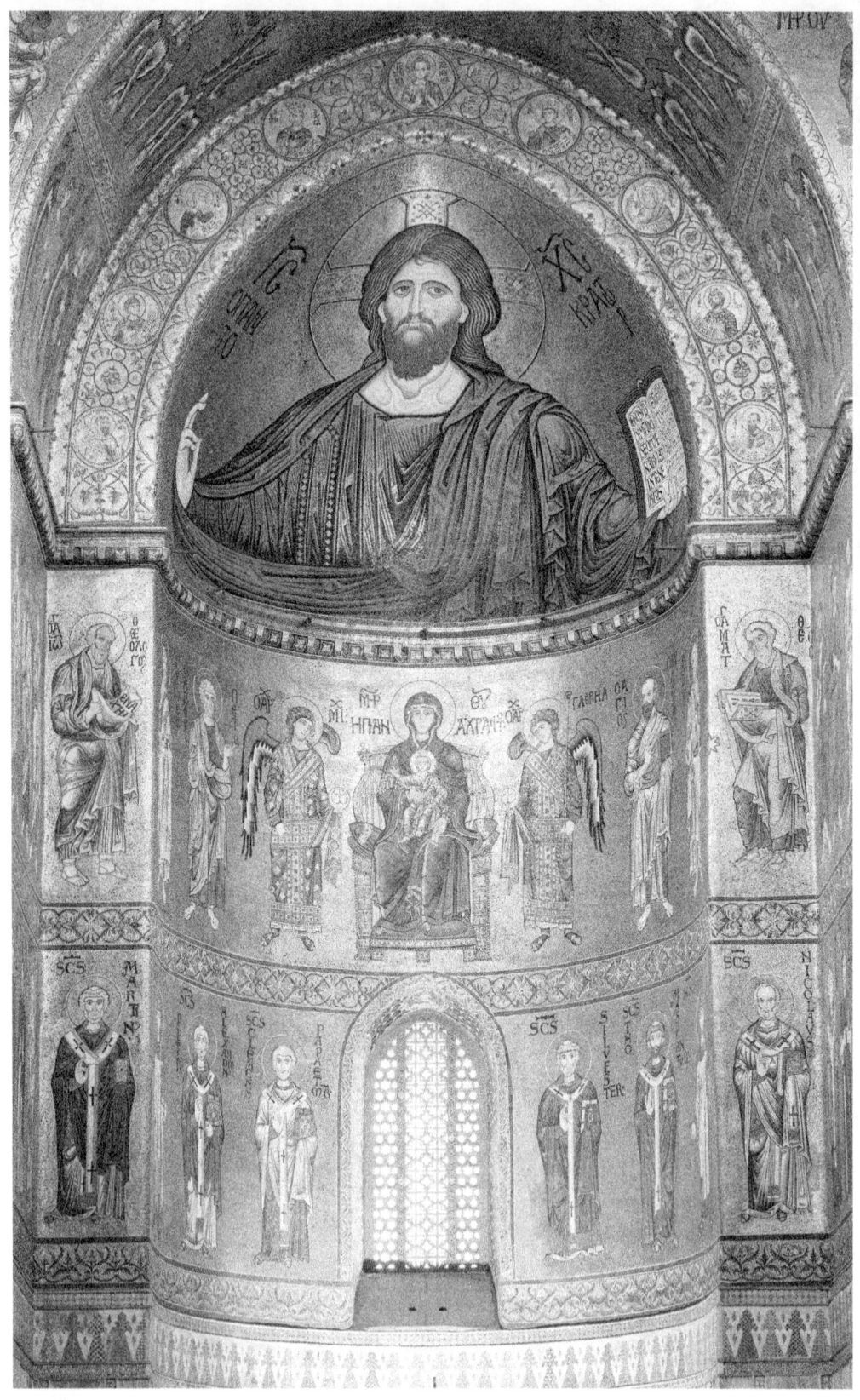

Plate 10 Apse depiction of Christ Pantocrator, mosaic, Monreale, Palermo, late twelfth century.

Plate 11 Section of the north nave mosaic, Monreale, Palermo, late twelfth century.

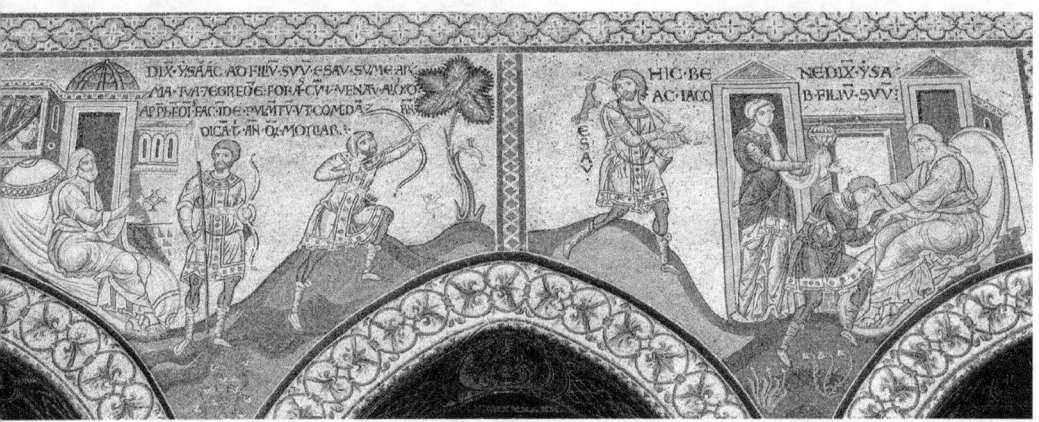

Plate 12 Detail of the north nave mosaic, Isaac story, Monreale, Palermo, late twelfth century.

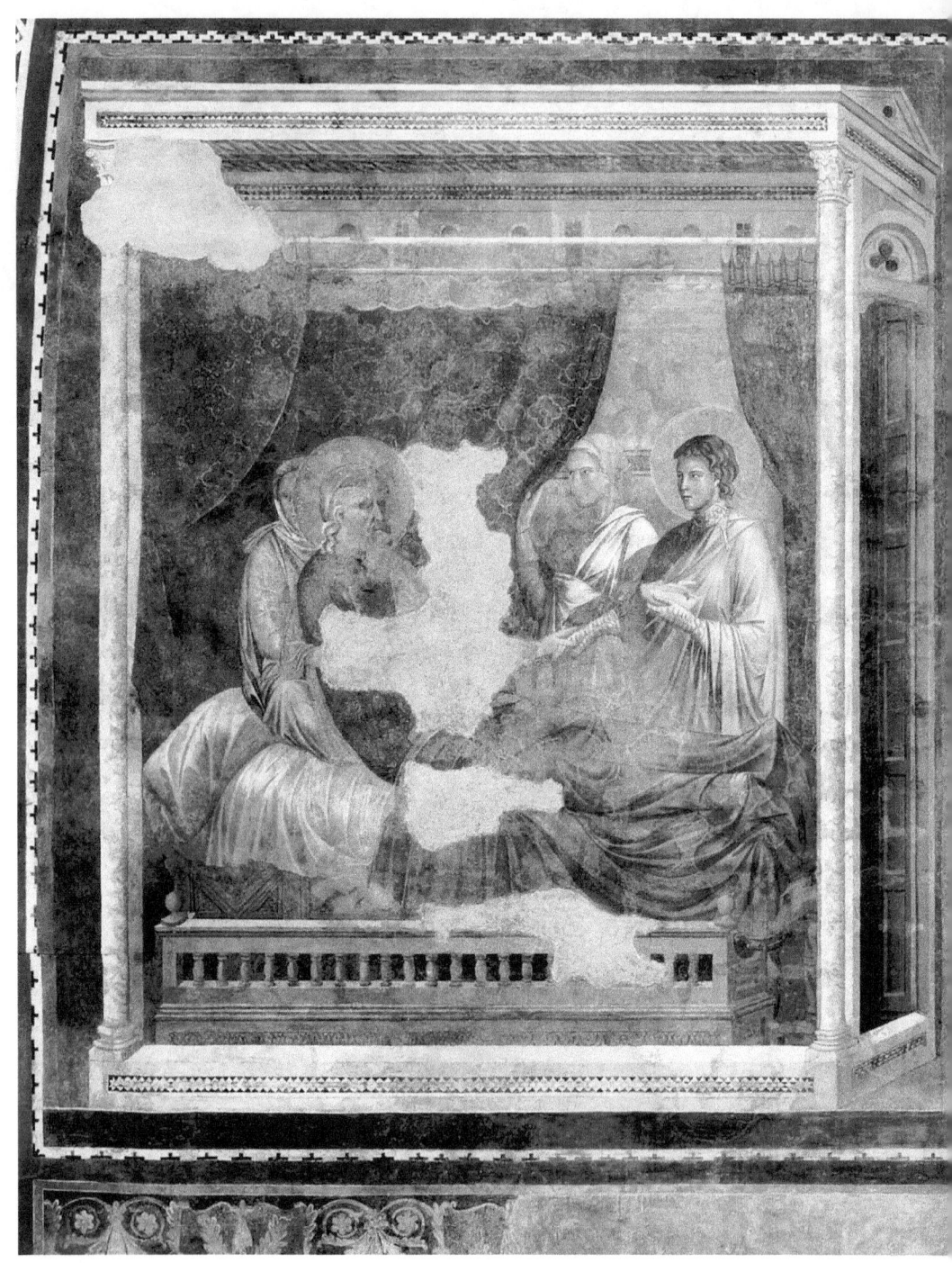

Plate 13 The Isaac Story, fresco, Plate 3, Basilica San Francesco, Assisi, *c.* 1280–95.

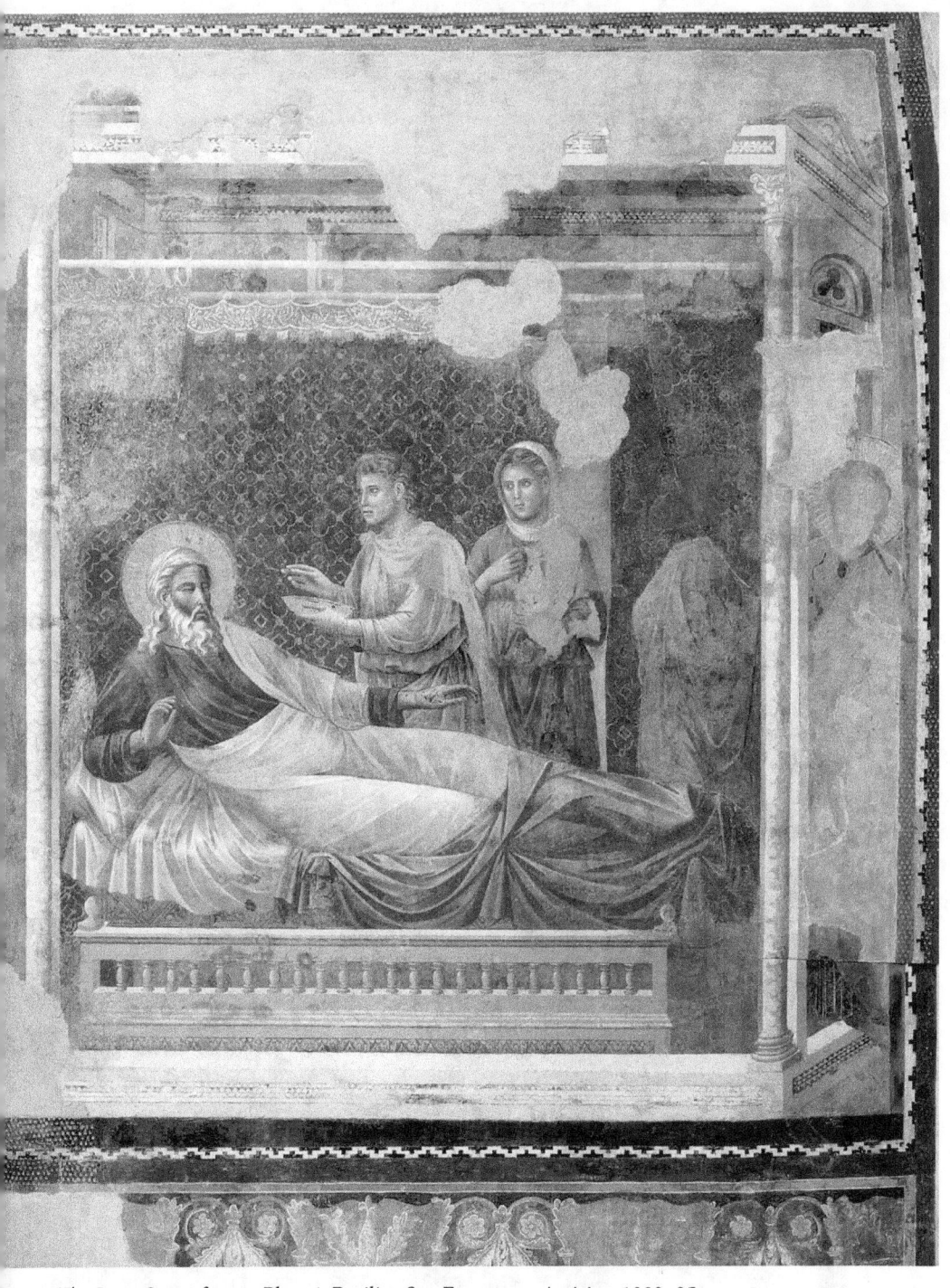

Plate 14 The Isaac Story, fresco, Plate 4, Basilica San Francesco, Assisi, *c.* 1280–95.

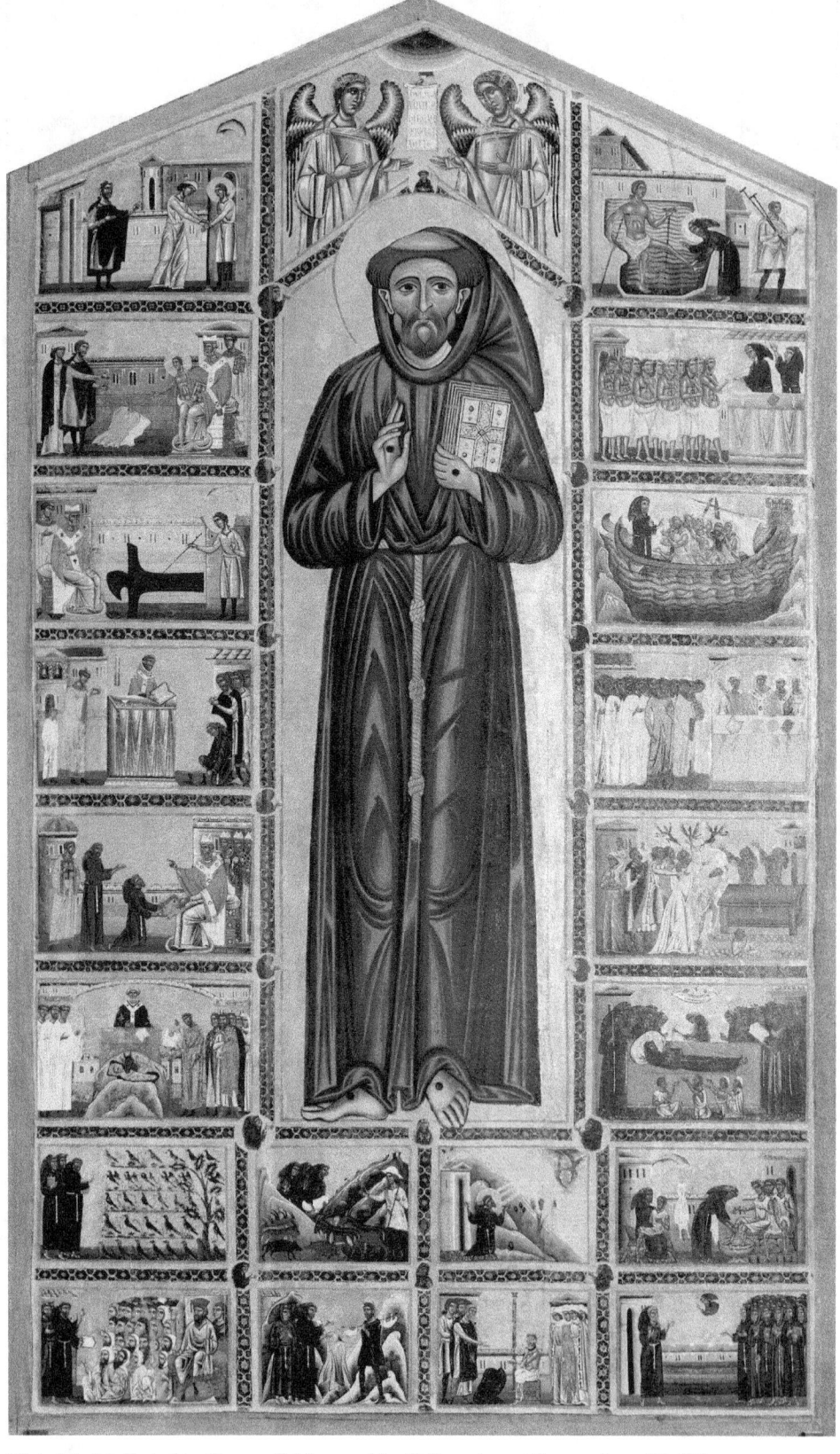

Plate 15 Attributed to Coppo di Marcovaldo, St Francis and Scenes from His Life, tempera on wood panel, 90 × 48 in, Santa Croce, Florence, c. 1225–76.

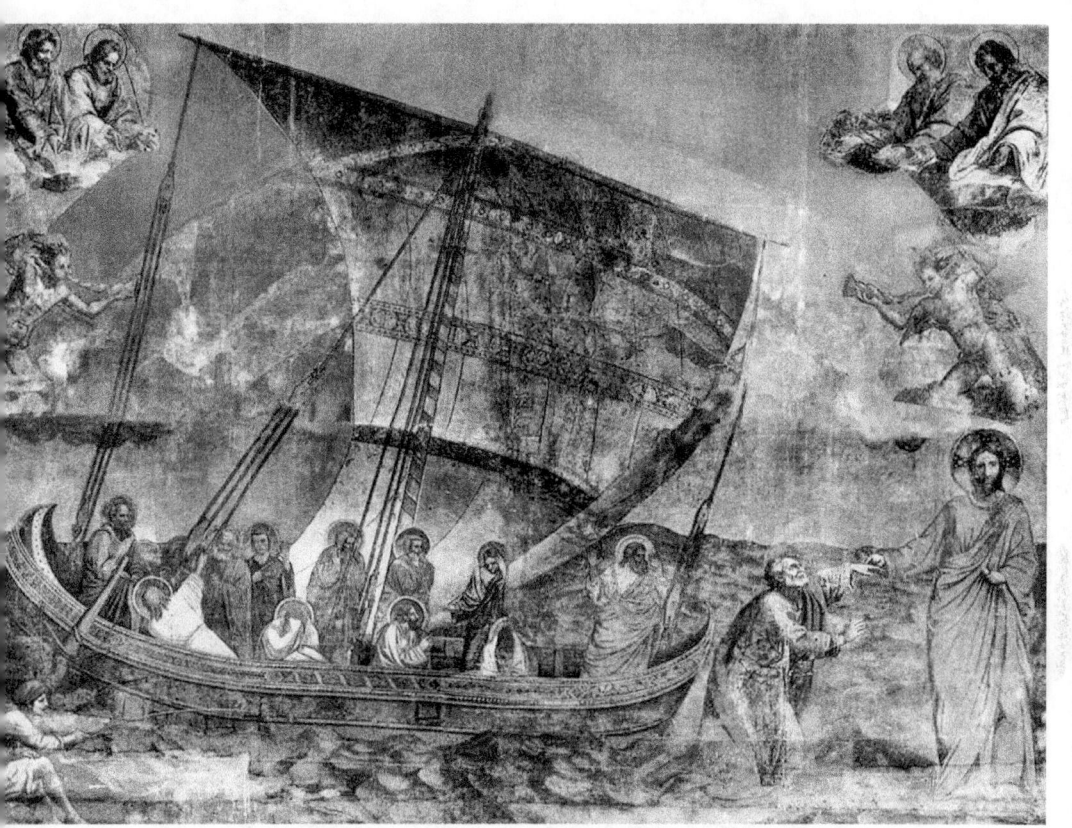

Plate 16 Full-size copy of the central portion of the *Navicella*, oil on canvas, 291 × 390 in Vatican, Rome,

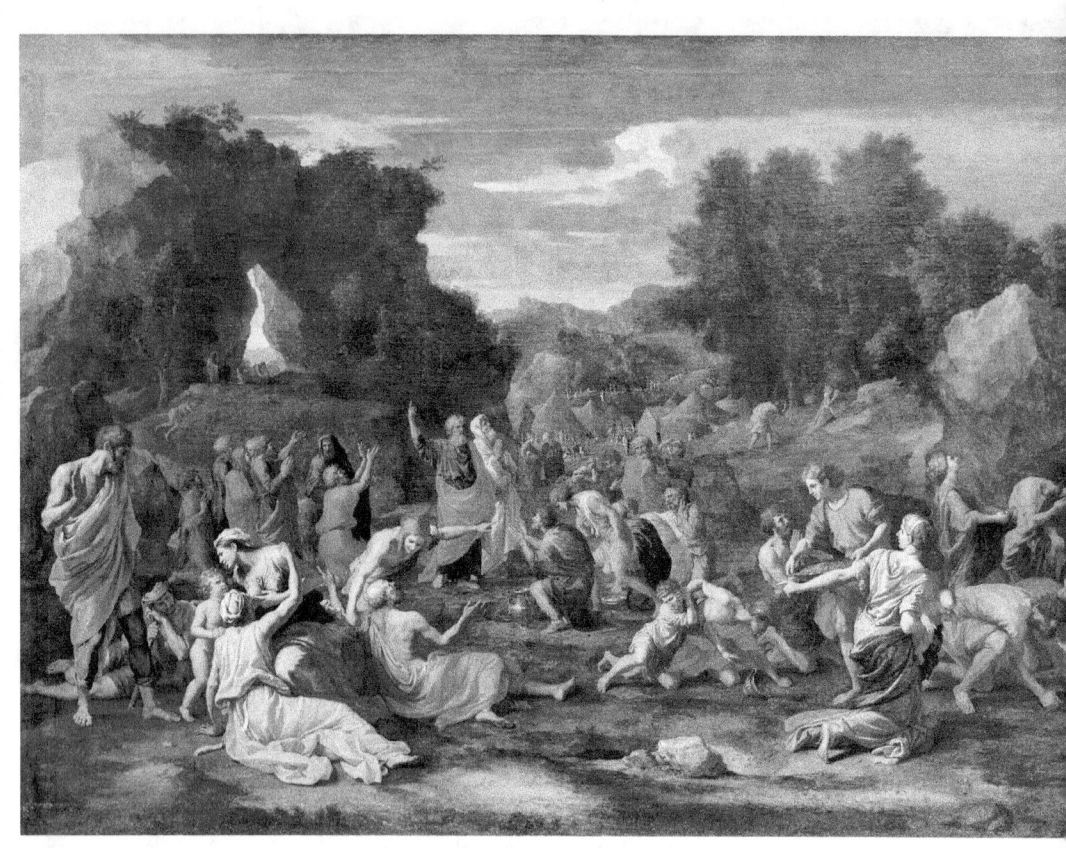

Plate 17 Nicholas Poussin, The Israelites Gathering Manna in the Desert, oil on canvas, 60 × 79 in, 1637–9.

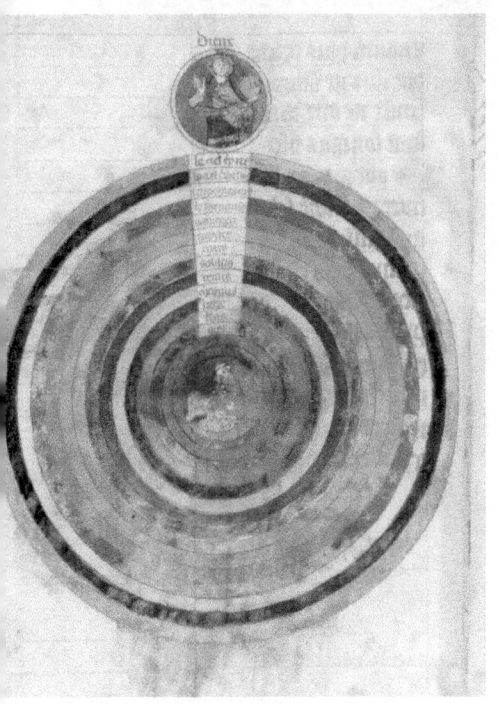

Plate 18 Romanian illuminator, Gautier de Metz, *Image of the World*, c. 1301–1400.

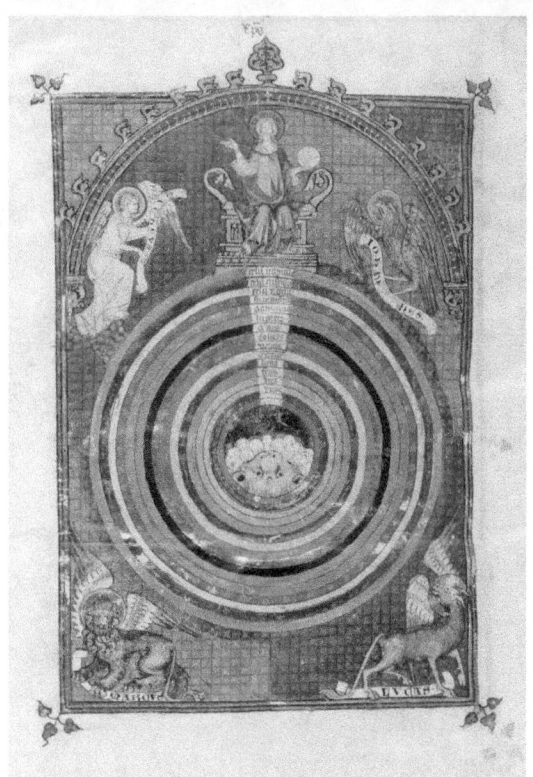

Plate 19 Master of Fauvel, illuminator, Gautier de Metz, *Image of the World*, c. 1320–5.

Plate 20 Giotto, details of the upper left and right of the exit wall of the Scrovegni Chapel depicting the Last Judgment, fresco, Padua, 1305.

Plate 21 Giovanni di Paolo, predella scene from the Guelfi Altarpiece (The Cosmos and the Expulsion from the Paradise), tempera on wood panel, 18.25 × 20.5 in, c. 1445.

Plate 22 Giovanni di Paolo, predella scene from the Guelfi Altarpiece (Paradise), tempera on wood panel, 18.5 × 16 in, c. 1445.

Plate 23 Giusto de' Menabuoi, Padua Baptistry's frescoed dome, *c.* 1378. Note below the feet of the Virgin is the Creation.

Plate 24 Giusto de' Menabuoi, detail Padua Baptistry's frescoed dome, *c.* 1378.

Plate 25 Metropolitan Museum of Art's reconstruction of Giovanni di Paolo's Guelfi Altarpiece.

Top: Giovanni di Paolo, Madonna and Child with Saints, Galleria degli Uffizi, Florence, 1445.

Below left: The Cosmos and the Expulsion of Adam and Eve from Paradise, The Metropolitan Museum of Art, 1445.

Below right: Paradise, The Metropolitan Museum of Art, 1445.

Plate 26 Giovanni di Paolo, St Thomas Aquinas, detail of the Guelfi Altarpiece, tempera on wood panel, 1445.

Plate 27 Anonymous, the frontispiece of *Bible Moralisee*, c. 1220–30. (Interesting to note: despite the lids of God's eyes being closed, He still 'sees'.)

Plate 28 Antonio Correggio, The Assumption of the Virgin, frescoed cupola, Duomo di Parma, 1526–30.

Plate 29 Antonio Correggio, detail of the St Bernard lunette, The Assumption of the Virgin, frescoed cupola, Duomo di Parma, 1526–30.

Plate 30 Thoughtform of the Music of Gounod, according to Annie Besant and C. W. Leadbeater in *Thought-Forms*, 1901.

Plate 31 Hilma af Klint, *The Ten Largest, No. 3, Youth*, tempera on paper, mounted on canvas, 126 × 94.5 in, 1907.

Plate 32 Frank Stella, *Lomb*, paper collage, 60 × 83 × 10 in, 1994.

www.ingramcontent.com/pod-product-compliance
Lightning Source LLC
Chambersburg PA
CBHW060821170526
45158CB00001B/47